Theories of Contemporary Art

Second Edition

Theories of Contemporary Art

Richard Hertz

Art Center College of Design

PRENTICE HALL *Englewood Cliffs, New Jersey 07632*

Library of Congress Cataloging-in-Publication Data

Hertz, Richard.
 Theories of contemporary art / Richard Hertz. — 2nd ed.
 p. cm.
 Includes bibliographical references and index.
 ISBN 0–13–012618–7
 1. Art, Modern—20th century—Philosophy. I. Title.
N6490.H466 1993
709′.04—dc20 92–35703
 CIP

Credits: *Page 31*: Excerpted from Richard Marshall, "New Image Painting," catalogue essay, © 1979 Whitney Museum of American Art, New York. *Page 105*: From Lisa Phillips, "Image World—Art and Media Culture," © 1989 Whitney Museum of American Art, New York.

Acquisitions editor: Bud Therien
Editorial/production supervision and
 interior design: Colby Strong
Copy editor: Liz Pauw
Cover designer: Patricia Kelly
Prepress buyer: Herb Klein
Manufacturing buyer: Bob Anderson

© 1993, 1985 by Prentice-Hall, Inc.
A Simon & Schuster Company
Englewood Cliffs, New Jersey 07632

Printed in the United States of America
10 9 8 7 6 5 4 3 2 1

ISBN 0-13-012618-7

Prentice-Hall International (UK) Limited, *London*
Prentice-Hall of Australia Pty. Limited, *Sydney*
Prentice-Hall Canada Inc., *Toronto*
Prentice-Hall Hispanoamericana, S.A., *Mexico*
Prentice-Hall of India Private Limited, *New Delhi*
Prentice-Hall of Japan, Inc., *Tokyo*
Simon & Schuster Asia Pte. Ltd., *Singapore*
Editora Prentice-Hall do Brasil, Ltda., *Rio de Janeiro*

For Feliza, Pamela, Melissa,
Julia, and Nicholas

Contents

Introduction to First Edition

The essays in this anthology respond in different ways to "modernism," a complex theory of art which was developed in England in the writings of Clive Bell and Roger Fry and promoted most influentially in the United States by Clement Greenberg and Michael Fried.

Greenberg believed that the task of art was to oppose the infiltration of kitsch into contemporary life, where kitsch is understood to be a popular art of instant assimilation—art produced for mass consumption. Greenberg viewed kitsch as a complete compromise of aesthetic standards, an art of mere entertainment. The alternative that Greenberg proposed (in "Modernist Painting") was modernism's pursuit of purity through self-criticism.

> The task of self-criticism became to eliminate from the effects of each art any and every effect that might conceivably be borrowed from or by the medium of every other art. Thereby each art would be rendered "pure," and in its "purity" find the guarantee of its standards of quality as well as of its independence. "Purity" meant self-definition, and the enterprise of self-criticism in the arts became one of self-definition with a vengeance.

Greenberg concentrated on self-criticism in painting, which became a preoccupation with the medium of painting. He argued that when painters emphasized the literal qualities of the paint materials, reinforced the objecthood of the canvas, applied paint in an impersonal way by spraying, rolling, or pouring, and created optically "flat" paintings which did not bring to mind three-dimensional objects, they were discovering the irreducible essence of painting.

Michael Fried (in "Shape as Form: Frank Stella's New Paintings") developed Greenberg's insistence on quality and medium without, however, sharing Greenberg's view that the essence of painting is timeless.

> What the modernist painter can be said to discover in his work—what can be said to be revealed to him in it—is not the irreducible essence of all painting, but rather that which, at the present moment in painting's history, is capable of convincing him that it can stand comparison with the painting of both the modernist and the pre-modernist past whose quality seems to him beyond question.

For Fried, the criteria of ambitious painting, comparable with those of the old Masters, are "self-sufficiency" and "presentness," qualities which emphasize the instantaneous apperception of a work and discourage any reflections on narrative content. Narration is rejected because it is associated by Fried with the "theatrical" in the broadest sense—art forms that develop in time. For Fried, the distinguishing characteristic of the best painting is that it is self-sufficient—that it does not address the concerns of its viewers. These characteristics of modernism—the opposition to popular culture, the emphasis on high art and self-sufficiency, the preoccupation with medium and purity, the desire to maintain a rigid distinction between art and popular culture—are debated, and usually opposed, in the essays collected here.

If "modernism" has developed a coherent meaning over the years, "postmodernism" is much less well defined. It has taken on the generic function of signaling a contrast to modernism, in particular to modernism's insistence that the standards of judgment and criticism pertain to a work's medium. Some of the characteristics of postmodern art, the specifics of which are developed in the forthcoming essays, include a preoccupation with the deconstruction of "real life" ideology, especially the languages of television, advertising, and photography; the recognition that fine art exemplifies the prevalent political, cultural, and psychological experience of a society; the acknowledgment and analysis of the usually hidden contexts of art—museums, dealers, critics, and art markets; the willingness to borrow indiscriminately from the past; and a realization that more than one approach to art and artmaking is necessary in order to reflect contemporary life.

In short, rather than exclusivity, purity, and removal from societal and cultural concerns, the emphasis is on inclusivity, impurity, and direct involvement with the content of contemporary experience.

In choosing the essays included in this book, all of which deal with these themes, I wanted to make sure that the material would be readily understood by people who are receiving their first introduction to contemporary art theory. I chose articles which were influential when first published, which were an especially clear statement of a widely held point of view, or which provided a provocative, and even extreme, analysis. I had originally intended to divide the essays into four sections; I also wished to include an extensive selection of art criticism concerning particular artists and their work in order to relate theory to practice. Because of limitations of space I have not been able to carry out this plan.

The articles are ordered in a loosely thematic way, focusing first on painting in general and neoexpressionist painting in particular; second on the use of art as a tool in cultural analysis; third on the revised meanings of contemporary sculpture; and finally on time-dependent performance modes of art. The articles are for the most part from "mainstream" American art journals and reflect their biases. There is little material specifically on ethnic arts, mural art, mail art, photography, video, and much else, even though all of these practices

have had a decided effect on contemporary art. There simply is not enough room to do justice to all of these influential modes of contemporary art.

I am grateful to the authors and publishers of the articles for granting me permission to reproduce their material. For clerical assistance, I am indebted to Mary Morris. For recommendations of specific articles, I am obliged to my students at Art Center College of Design as well as to Linda Burnham, David Carrier, Laurence Dreiband, Thomas Lawson, Stephen Nowlin, Peter Plagens, Stephen Prina, and Robert Rosenblum. For their encouragement and friendship over the years, I thank Ali Acerol, Diane Buckler, John King-Farlow, Don Kubly, Robert Rosenstone, Robert Rowan, and Imogen Sieveking. For her advice, love, and support, I especially thank my wife, Pamela Burton.

R. H.

Introduction to Second Edition

In contemporary culture, traditional oppositions between the true and the false, the orthodox and the heterodox, and between high and low have disintegrated. Just at the moment when long-term political and economic oppositions began to crumble, for example between the U.S.S.R. and U.S.A. and between the East and West, it became apparent that truth and fiction, the "real" and the "represented," were merging. As explicated by Japanese scholar Akira Asada, "The real situation of communication presents aspects of rupture, fictionality, and slippage. Yet the meta-masses are those that see this condition positively, as one of 'play.' In the meta-mass age, mass communication has lost its former functions, and has become instead 'mass garbage.' "[1]

In the United States, French theory—in particular that of Baudrillard, Derrida, Deleuze, and Gauttari—gave artists the theoretical underpinnings for various kinds of "investigations." "Deconstruction," "appropriation," and "simulacrum" became buzz words, leitmotifs for studies of patriarchal constructions of identity and meaning. As stated by Susan Suleiman, "The appropriation, misappropriation, montage, collage, hybridization, and general mixing-up of visual and verbal texts and discourses, from all periods of the past as well as from multiple social and linguistic fields of the present, is probably the most characteristic feature of what can be called the 'postmodern style.' "[2] But do these visual and verbal strategies in the art of John Baldessari, Cindy Sherman, Barbara Kruger and Richard Prince create politically effective art or are they examples of "stylistic indirection and innovation"?

Can any art be politically effective, or have a critical political meaning, if it has become submerged in the art market? Achille Bonito Oliva notes that "the art system tends to grow increasingly international by exploiting a circuit that mimics the circulation of consumer goods."[3] As a result, American and European art "have ceased to exist as separate visions of the world. An art of Western coexistence now shares the field with an art that comes from the East."[4] Whether or not art can be politically effective in a nonoppositional consumer market, many artists attempt to aestheticize social theory to promote an overtly social agenda: feminism, multiculturalism, gay and lesbian liberation, AIDS awareness. . . . And while "quite a few women artists achieved visible careers as painters (Susan Rothenberg, Jennifer Bartlett, and Elizabeth Murray), none achieved the high critical or market status of, in New York for exam-

ple, Julian Schnabel, David Salle, Eric Fischl, Ross Bleckner, or Leon Golub."[5] Laura Cottingham asks, do women simply "choose" to work in alternative media, especially in photography and installation, or do alternative media provide a more effective framework to challenge patriarchally defined culture?

Many artists work around the edges of the spiritual possibilities of art, for example artists as different as Ross Bleckner, Christian Boltanski, and Robert Ryman. In an interview, Bleckner states, "The kind of paintings that I like have to do with a certain kind of density. It's like looking for hope in this place that has a tragic dimension. . . . Basically painting is living in the world of constant discovery, where things are amazing but not true. . . ." The personal can also become the political when "painting or making any kind of cultural production becomes this libidinal map. That's how art can become very political. It creates certain insights into how the culture works and doesn't work."[6]

Speaking about the "absolute art" of Robert Ryman, Donald Kuspit writes, "The silence of Ryman's square, the condition of incommunicado it articulates, bespeaks a mysticism—in the strict sense of communion with the core of the self—that is the necessary antidote to the tiresome communicativeness of the world."[7]

Semiotics, the political, the global art market, and a sense of spirituality are all ingredients in an art world in which the apparently stable is brought into question, including the very notion of the art object itself.

French curator and critic Eric Troncy states about an exhibition he curated: "What struck me about the majority of artists participating in 'No Man's Time' was their relative disregard for the 'work of art.' . . . 'No Man's Time' is patently not aimed at highlighting the oeuvre of each artist concerned—it is not a publicity oriented vehicle with commercial ends. Once again, it is a spectacle, a discussion, and while the protagonists may be enthralled by their subject matter, it may prove boring for some of the public. . . . These given facts make for no 'conclusion' but a kind of 'justice' or 'balance' of temporary truth. . . ."[8]

The Second Edition of *Theories of Contemporary Art* can similarly be considered one person's "weighing" of temporary truth. I introduce contemporary practice within the often conflicting frameworks of contemporary theory, always insisting on the primacy of practice over theory. As Asada suggests, it is in the slippage or rupture of meaning that "play" takes place and creates new possibilities and new paradigms for communication and understanding. In assembling the articles, I want to acknowledge the suggestions of Debbe Goldstein and Amelia Jones and to thank Diana Thater for compiling the index and bibliography.

Notes

1. Akira Asada, quoted in Marilyn Ivy, "Critical Texts, Mass Artifacts: The Consumption of Knowledge in Postmodern Japan," *The South Atlantic Quarterly* (Summer 1988), p. 432.

2. Susan Suleiman, "Opposition in Babel? The Political Status of Postmodern Intertextuality," *Subversive Intent: Gender, Politics and the Avant-Garde* (Cambridge, Mass.: Harvard University Press, 1990), p. 191.

3. Achille Bonito Oliva, "The Game Continues," *Flash Art* (Summer 1991), p. 128.

4. Marlis Grueterich, "The Art of Coexistence," *Flash Art* (November/December 1991), p. 82.

5. Laura Cottingham, "The Feminine De-Mystique," *Flash Art* (Summer 1989), p. 92.

6. Ross Bleckner interviewed by Lawrence Chua, *Flash Art* (November/December 1989), pp. 123, 124.

7. Donald Kuspit, "Red Desert & Arctic Dreams," *Art in America* (March 1989), p. 124.

8. Eric Troncy, "No Man's Time," *Flash Art* (November/December 1991), pp. 119, 122; reprinted in this volume.

Theories of
Contemporary Art

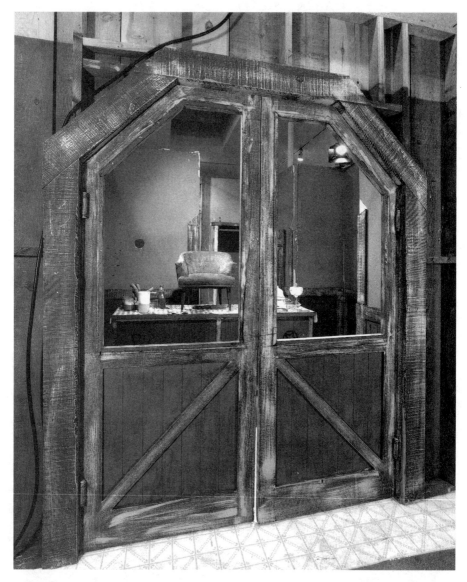

Paul McCarthy, *Bossy Burger*. 1991 (detail) Television studio set, 1 TV monitor, ¾″ U-Matic VCR, various performance props, 59-minute video tape. As installed: 10′ x 23′6″ x 28′3″

Courtesy of Rosamund Felsen Gallery, Los Angeles. © Douglas M. Parker.

Farewell to Modernism

Kim Levin

Critic Kim Levin argues that seventies' art, which seemed so ill-defined, in fact marked a transition in consciousness from those qualities associated with modernism—ahistorical, scientific, self-referential, reductionistic—to some of the multiple emphases of eighties' art—historical, psychological, narrational, political, synthetic. Modernist dogma and purity were overthrown by an openness to form and content, a revolt against a *priori* norms governing what is or is not "allowable" art.

The '70s has been a decade which felt like it was waiting for something to happen. It was as if history was grinding to a halt. Its innovations were disguised as revivals. The question of imitation, the gestural look of Abstract Expressionism, and all the words that had been hurled as insults for as long as we could remember—illusionistic, theatrical, decorative, literary—were resurrected, as art became once again ornamental or moral, grandiose or miniaturized, anthropological, archeological, ecological, autobiographical or fictional. It was defying all the proscriptions of modernist purity. The mainstream trickled on, minimalizing and conceptualizing itself into oblivion, but we were finally bored with all that arctic purity.

The fact is, it wasn't just another decade. Something did happen, something so momentous that it was ignored in disbelief: modernity had gone out of style.[1] It even seemed as if style itself had been used up, but then style—that invention of sets of forms —was a preoccupation of modernism, as was originality. The tradition of the New, Harold Rosenberg called it. At the start of the '70s there were dire predictions of the death of art by modernist critics and artists. By now it is obvious that it was not art that was ending but an era.

Reprinted from Kim Levin, "Farewell to Modernism," *Arts Magazine* (October 1979). © 1979 by Kim Levin.

We are witnessing the fact that in the past ten years modern art has become a period style, an historical entity. The modernist period has drawn to a close and receded into the past before our astonished eyes. And because the present was dropping out from under us, the past was being ransacked for clues to the future. The styles of modernism have now become a vocabulary of ornament, a grammar of available forms along with the rest of the past. Style has become a voluntary option, to be scavenged and recycled, to be quoted, paraphrased, parodied—to be used as a language. Modernist and pre-modernist styles are being used as if they were decorative possibilities or different techniques—breeding eclectic hybrids and historicist mutations—by narrative artists and pattern painters, by post-conceptualists and former minimalists and unclassifiable mavericks.[2] For many artists, style has become problematic: it is no longer a necessity.

The art establishment is still uneasy with the idea.[3] It is more comfortable searching short-sightedly for the trends of the decade—as if it were just another decade—or calling it "pluralistic," or proclaiming, as Philip Lieder did recently, that pure abstraction is still the new paradigm.[4]

Nevertheless, post-modernism is fast becoming a new catchword, and it is full of unanswered questions and unacknowledged quandaries. What is it that has so irrevocably ended, and why, and when did the break occur? If we are going to talk about post-modernism, we should start by defining modernism, by questioning how we can recognize whether something is—or isn't—modernist. For those who have stepped outside modernism, the successive styles of the modern period, which seemed so radically different from each other at the time, are beginning to merge together with shared characteristics—characteristics that now seem quaintly naive.

Modern art was scientific. It was based on faith in the technological future, on belief in progress and objective truth. It was experimental: the creation of new forms was its task. Ever since Impressionism ventured into optics, it shared the method and logic of science. There were the Einsteinian relatives of Cubist geometry, the technological visions of Constructivism and Futurism, de Stijl and Bauhaus, the Dadaists' diagrammatic machinery. Even Surrealist visualizations of Freudian dreamworlds and Abstract Expressionist enactments of psychoanalytical processes were attempts to tame the irrational with rational techniques. For the modernist period believed in scientific objectivity, scientific invention: its art had the logic of structure, the logic of dreams, the logic of gesture or material. It longed for perfection and demanded purity, clarity, order. And it denied everything else, especially the past: idealistic, ideological, and optimistic, modernism was predicated on the glorious future, the new and improved. Like technology, it was based all along on the invention of man-made forms, or, as Meyer Schapiro has said, "a thing made rather than a scene represented."

By the 1960s, with Pop art embracing the processes and products of mass production and Minimalism espousing the materials and methods of industry,

the ultimate decade of technology had arrived. By the time men were traveling to the moon, art was being assembled in factories from blueprints, Experiments in Art and Technology (E.A.T.) was showing the results of its collaborations at the Armory and the Brooklyn Museum, the Whitney had a light show, MOMA had a machine show, Los Angeles had a technology show, and at the ICA in London there was an exhibition of cybernetic art made by machines.[5] It seemed as if the glorious technological future the early modernists dreamed of had arrived.

But at the height of this optimism, modernism fell apart. The late '60s was also the time of Vietnam, Woodstock, peace marches, race riots, demonstrations, and violence. 1968 may have been the crucial year, the year we stopped wanting to look at art as we knew it, when even the purest form began to seem superfluous, and we realized that technological innovation wasn't enough. The work of a great many artists underwent radical changes. Minimalism, the last of the modernist styles, collapsed in heaps of rubble on gallery floors as scatter pieces proliferated, the Castelli Warehouse opened, the Whitney had its anti-form anti-illusion exhibition, earthworks went into the wilderness, Conceptualism came out of the closet, and art became documentation.[6] In a sense it was the ultimate god-like act of modernism: creating a work out of nothing. In another sense it was obvious that something was over.

It may have been especially obvious to the surviving Surrealists who had spent a lifetime interpreting the unconscious. In September 1969, on the third anniversary of André Breton's death, "a group of followers announced that the historical period of Surrealism had ended but that it had eternal values."[7] At the time it seemed a belated Surrealist joke. In retrospect it proves uncannily accurate: the modernist era, within which Surrealism had existed somewhat unwillingly,[8] had actually just ended. It could be argued that the precise moment of its demise was signaled a few months earlier by the revelation of Duchamp's *Etant Donnés*—with all its hybrid impurity, illusionistic theatricality, narrative insinuations, and counter-revolutionary contradictions—opening a peephole into a magical natural world as if predicting the concerns of postmodern art.

It has taken ten years to realize we had walked through the wall that was blocking out nature. Modernism, toward the end of its reign, came to be seen as reductive and austere. Its purity came to seem puritanical. It was in the terminology—in a word, formalism—which implied not only the logical structures of modernist invention but also the strictures of rigid adherence to established forms. "There is no other democracy than the respect for forms," one of the new French philosophers has remarked. Like democracy, modernist art is now being reinterpreted in terms of its insistence on forms and laws rather than in terms of liberty and freedom. The modernist vision may have had democratic aims—a progressive emancipation of the individual from authority in an age of unlimited possibilities, as Schapiro has noted—but in practice it was

elitist: the public never understood abstract art. It was as specialized as modern science. And emphasis on structure rather than substance is what we came to see in it. Like science, modernist art has begun to seem dogmatic and brutal.

Because it was competitive and individualistic, it saw everything in terms of risk. Like capitalism, it was materialistic. From its collage scraps and fur-lined teacup to its laden brushstrokes, I-beams, and Campbell's soupcans, modernist art insisted increasingly on being an object in a world of objects. What started as radical physicality turned into commodity; the desire for newness led to a voracious appetite for novelty. Post-modernism began, not just with a disillusionment in the art object, but with a distrust of the whole man-made world, the consumer culture, and the scientific pretense of objectivity. It began with a return to nature. The mood was no longer optimistic. Logic no longer sufficed. Technology has undesirable side-effects and in a world threatened by defoliated land, polluted air and water, and depleted resources, by chemical additives, radioactive wastes, and space debris, progress is no longer the issue. The future has become a question of survival.

Only now can we begin to realize just how widespread this shift of consciousness was. In 1967 the art magazines were full of sleek cubic forms; by 1969 those steel and plastic objects had been replaced by natural substances, ongoing processes, photographic images, language and real time systems. It wasn't simply the appearance of another new movement, as in the past. It was a crucial change that affected artists of all persuasions. For a large cross-setion of the artworld it was a turning point.[9] And all the changes can be traced, by various circuitous routes, to a strong desire to make things real, to make real things. Those photographs from the moon of a marbleized little blue earth may have altered our perception. In diverse and unexpected ways, art was going back to nature. But having been absent for so long, nature was unrecognizable. In the beginning it looked like demolition. But the post-minimal movements—statements against formal purity that were modernist reductions as well—were not just an issue of withholding goods from the marketplace, an embargo on the object.[10] Returning materials to their natural state, subjecting them to natural forces, sending art back to the land or internalizing it within the body,[11] they were evidence that time and/or place were becoming crucial, clearing the way for the psychological and the narrational, for personal content, lifelike contexts, and subjective facts. The feeling against style and objectivity proved more subversive than the antipathy toward objects and form: post-modernism arose out of conceptualist premises—that art is information—while protesting its modernist aridity.

Post-modernism is impure. It knows about shortages. It knows about inflation and devaluation. It is aware of the increased cost of objects. And so it quotes, scavenges, ransacks, recycles the past. Its method is synthesis rather

than analysis. It is style-free and free-style. Playful and full of doubt, it denies nothing. Tolerant of ambiguity, contradiction, complexity, incoherence, it is eccentrically inclusive. It mimics life, accepts awkwardness and crudity, takes an amateur stance. Structured by time rather than form, concerned with context instead of style, it uses memory, research, confession, fiction—with irony, whimsy, and disbelief. Subjective and intimate, it blurs the boundaries between the world and the self. It is about identity and behavior. "That the artist is now ready to lay his life on the line over a silly pun begins to define the sensibility of the Seventies," commented *Esquire* magazine early in the decade.[12] The return to nature is not only an involvement with the natural world but an acceptance of the frailties of human nature. Which may have something to do with the fact that, if the artist as god-like Creator[13] was the leitmotif of modernism, the absent artwork—non-visual, shrunken or expanded beyond visibility, hiding out in the world or within the artist—has been a theme of the '70s.

But just what is post-modernist? Separating late modernist works from post-modern ones is no easy task at this juncture of periods. As in late Roman and early Christian art, or late Gothic and early Renaissance, they coexist. And right now a great deal of what is passing as post-modern is really late modernist or else transitional—a confusing mixture of both. The '70s has been a hybrid decade in more ways than one.

Doug Davis jokingly called post-modernism the fast-food chain of art, a phenomenon of late capitalism. And, with its accessibility, its informality, its unpretentious self-service and self-deprecating banality, it is certainly more like a Big Mac or a Whopper than the formal feast of modern art. But fast-food is all form and no content, preformed and packaged, reduced to a scientific formula, technological and sterile—exhibiting all the qualities of late modernism. And that is where the confusions lie. Because we thought the severity of Minimalist sculpture, of Ryman and Marden and Conceptualist art, signaled the ultimate reduction and the end of modern art, we have not been prepared to recognize that the appearance of decorativeness and ornamentation can be another manifestation of the late stage of a period—traditionally characterized by extremes and excesses, and veering from severity to over-elaboration.[14] Playing with modernist forms, elaborating on them, making them mannered and extreme, sacrificing structural honesty to appearance and decorative effects is—in art and architecture and hamburgers—a late modernist trait. Where is the line to be drawn between the late modernist excess and post-modern recycling?

The intricate mannered space and ambiguous spatial illusions of the '70s are even more perplexing, for in those distortions and compressions the elastic space of post-modernism begins: an irrational, inclusive, and warping space has entered art during the past ten years, curving to encompass the totality of vision, and it can be seen either as a late modernist stylistic trait or as a post-modern perception of an insecure earth.[15] In the same way, mimicking the

methods of science and technology or parodying their procedures, as some recent art has done,[16] may be another late-modernist excess, but at the same time the romanticization of science and technology into something personal and mystical—into a doubtful fiction—is post-modern. But, then, I should also point out that the act of defining and analyzing and trying to categorize is probably modernist. Old habits die hard. The modernist era may be over, but modernist art is still being made, sometimes by self-proclaimed post-modernists, just as post-modern work is being done by artists who still think of themselves as modernists. Almost everybody during the '70s has been transitional and hybrid.

If the grid is an emblem of modernism, as Rosalind Krauss has proposed—formal, abstract, repetitive, flattening, ordering, literal—a symbol of the modernist preoccupation with form and style, then perhaps the map should serve as a preliminary emblem of post-modernism: indicating territories beyond the surface of the artwork and surfaces outside of art; implying that boundaries are arbitrary and flexible, and man-made systems such as grids are superimpositions on natural formations; bringing art back to nature and into the world, assuming all the moral responsibilities of life. Perhaps the last of the modernists will someday be separated from the first post-modernists by whether their structure depended on gridding or mapping. But because the substructure of any terrain re-created on another scale depends on lines of longitude and latitude (the grid with which we have ordered the earth), maps are the secret and not-so-secret grids of reality, grids gone back to nature, hugging the earth, delineating content. The graph-paper diagrams of the '60s reduced the grid to its final stages: it became useful, a blueprint for making instead of a formal device. In our transitional time, the grid—when it is not elaborated into a decorative motif—has become a tool for making scale flexible, a device for mapping the features of an imagery, the memory of an experience, a place somewhere else, or a visionary plan.

And if psychoanalysis is the mode of self-discovery analogous to modernism, perhaps we should look to the self-awareness movements that have become popular during the '70s for a terminology appropriate to the new art.[17] Based not on scientific reason and logic and the pretense of objectivity but on presence, subjective experience, behavior, on a weird kind of therapeutic revelation in which it is not necessary to believe or understand—it is enough if it works. Or should we say that these fast-food chains of enlightenment are late modernist too? And instead of structuralism, linguistics, semiotics, what shall we propose? For the grid-like mental structures of those fashionable systems of analysis are already a little outmoded. They too belong to the transition.

Ten years after the end of the modernist age—but end sounds too final, age too grand—ten years after, the last modernists are still clinging to power

and the post-modern forces are still a ragged band lurking in the underbrush, to put it in purple art prose. They don't always even recognize themselves, or each other, for mostly they are caught in the middle with sympathies on both sides of this metamorphosis that is taking place. Post-modernism has barely begun. It is too early to predict whether it will open a new era in art's history, or merely provide a final perverse coda to modernism.

Notes

1. And it wasn't just art. In fashion, the decade that marched in on space-age platform shoes is ending up in classic clothes and a series of revivals of past styles. In music, too, the past is being scavenged for alternate sounds.

2. Artists as apparently unlike as Frank Stella and Lucas Samaras, Charles Simonds and Scott Burton, Dottie Attie and Eleanor Antin, Peter Saari and Roland Reiss, Jennifer Bartlett and Alexis Smith, for example, are joined by this attitude toward style.

3. The architectural world, however, has openly welcomed post-modernism, perhaps because of the sterility of modern architecture or the writings of Robert Venturi and Charles Jencks. Or perhaps during the '70s—with sculpture largely a matter of natural structures, habitations, observatories, miniaturized villages, rearranged landscapes or imaginary civilizations, and painting often moving directly onto the wall to deal with the support structure—architecture has become the dominant art. Nevertheless, the genealogy of post-modern architecture is at variance with that of art. For example, Venturi traces the origins of post-modernist architecture to Pop art. Hilton Kramer erroneously follows that cue for art, claiming that Pop art was anti-modernist while dismissing post-modernism as "revisionism from within." On the contrary, Pop art was thoroughly within the modernist tradition in its acceptance of technology, and its formal use of contemporary objects from everyday life as abstract signs was not essentially unlike that of the Cubists.

4. In his catalogue essay on Frank Stella's work of the '70s.

5. And at Wise on 57th Street there was always a show of electronic or kinetic art. Rauschenberg's *Soundings* at MOMA and Whitman's *Pond* at the Jewish Museum were two of the more memorable works fusing sound and light.

6. The language shows at Dwan focused attention on words, and in January 1969 Seth Siegelaub opened and closed his hit-and-run gallery with a show of things that weren't there. Heubler's statement in the catalogue ("The world is full of objects, more or less interesting: I do not wish to add any more. I prefer, simply, to state the existence of things in terms of time and/or place.") defined the new mood.

7. According to Nicolas Calas.

8. The position of Surrealism within modernist art is complex. The Surrealists had contempt for Cubism, they scorned Art Deco, their space was borrowed from the Renaissance, and though they were revolutionaries, they didn't quite share the modernist faith in progress and objectivity. But their use of the unconscious derived from scientific technique. And, as Motherwell noted in 1944, "plastic automatism . . . is actually very little a question of the unconscious. It is much more a plastic weapon with which to invent new forms. As such it is one of the twentieth century's greatest formal inventions." And now, as we move beyond modernism, the question of Surrealism is cropping up. Stella's most recent reliefs have Surrealist traits; so do Morris' irrational mirrors. Lichtenstein has been using Surrealist motifs. Samaras, whose art has often anticipated post-modern concerns, has always been accused of being a Surrealist. And there are Surrealist overtones in the work of the Poiriers, the Harrisons, Baldessari, Acconci, Oppenheim, Jonathan Borofsky, Jared Bark, and many other recent artists. It may be significant that the big Surrealist exhibition at MOMA took place in 1968.

9. A glance at almost anyone's chronology reveals this shift. It isn't only the long list of artists whose careers start at that time, or the many artists who gave up painting or sculpture for process work, documentation or performance, who shifted to natural substances and gave in to gravity. To name just a few, Baldessari burned his paintings and began painting lettered statements; Irwin started using light instead of paint; Eva Hesse's work became snarled and visceral; Newton Harrison switched from technology to ecology; Samaras gave up the box form and began his chair transformations. Others gave up art entirely. Super-realist objects and images began to emerge. Renegade artists like Beuys and Haacke, like Nauman, Morley, and Les Levine, and eccentrics like Cornell and Westermann began receiving attention. Steinberg's cartoons began to be accepted as art. And long-established artists like Guston, Held, and Tworkov gave up Abstract Expressionism for idiosyncratic illusions or ominous personal imagery.

10. Nor was the new randomness and informality simply a formal move. Barbara Rose's recent theory of the influence of the 1967 Pollock exhibition on scatter works is somewhat misleading. In 1969 Robert Morris wisely warned against identifying the new art with Pollock's fields on the grounds that this would be a formalistic misunderstanding. Robert Pincus-Witten's collection of essays on Post-Minimalism locates the shift in sensibility in the late '60s, but places it within the modernist tradition; and indeed most of the artists he chose to write about were still primarily involved in reductive modernist logic—in the analysis of pure form. His own style of writing since 1976, however, has been diaristic and narrative, more post-modern than the art it discusses.

11. The photographic documentation of this work, along with the snapshot imagery of Photo-Realism, led to photography becoming the new medium for art by the early '70s. Susan Sontag, viewing the popularity of photography as a result of the destruction of modernism, has said, "I wasn't writing about photography so much as I was writing about modernity." The same could be said of art's sudden enthusiasm for the photograph: it was another sign of the demise of modernism and the acceptance of nature.

12. The comment referred to a piece by Chris Burden, whose body works at the time were literalizing the modernist idea of risk.

13. The Matisse chapel at Venice, the Rothko chapel in Houston, the Citicorp Nevelson chapel are not anachronisms, and recent *Artforum* articles comparing abstract art and religious icons are not irrelevant: the modernist condition alternated between puritanical denial and endless desire. Each style had its catechism of sins, its pantheon of saints. It is just that, religion having withered away, what was being worshipped was the spirit of invention.

14. The late Minimalist proliferation of forms seen in the work of artists like Sol LeWitt and Jackie Ferrera belongs to this final stage of late modernism, but so does the pattern painters' multiplication of minimal forms into ornamental designs, and the decorativeness of recent work by Mel Bochner and Dorothea Rockburne, who started out with the severest of notions, and the wild profusion of elements in Stella's metal reliefs and in Samaras' aptly titled fabric "reconstructions." "Structural excess," Arthur Drexler called it in recent architecture, and in fact, much so-called post-modern architecture would seem to be late modernist, for a facade that tilts wildly or a reflective shiny surface may negate modernist functionalism with its excesses, but basically it is nothing other than an elaboration of modernist forms.

15. This space can be found in Chuck Close's heads and in Al Held's geometry, in the three-dimensionalization of painting by Ralph Humphrey and Stella and in Lichtenstein's two-dimensionalized sculpture, in the spatial distortions of Samaras' Polaroids and the undulating space of Morris' recent mirror works and Kenneth Snelson's photographs, and in Morley's "plastic drift." There is even something of it in the bloated mannerism of Pearlstein, Leslie and Beal, in the awkward foreshortenings of Alex Katz and Alice Neel, in the violent perspectives of Estes and Cottingham.

16. For example, work by Les Levine, Arakawa, the Harrisons, Chris Burden.

17. Along with their counterparts, the self-effacing mystical religious cults of the '70s, these searches for fulfillment and meaning in life parallel art's new concerns with human potential. "This self-absorption defines the moral climate of contemporary society," writes Chris-

topher Lasch in *The Culture of Narcissism,* viewing it as a desperate concern for personal survival, a symptom of the late 20th century. Even in science, the trend is away from objectivity. A noted astronomer recently remarked that perhaps it was time to stop seeking the origins of the universe in logical systems and turn instead to mysticism for explanations.

Julian Goldwhite, *Untitled.* **1992 Acrylic on wood 9′ x 9′**

Courtesy of Thomas Soloman's Garage, Los Angeles.

Beginning Again

Marcia Hafif

For painter Marcia Hafif, monochromatic painting can function as a method of gaining knowledge, as a deconstruction of the process of painting into its component parts—ground, paint, brush, and support. The resulting "esthetic primitivism," which allows for signs of the artist's hand, can be a personal search for the foundations of painting, not a blind application of modernist theory.

The options open to painting in the recent past appeared to be extremely limited. It was not that everything had been done, but rather that the impulses to create which had functioned in the past were no longer urgent or even meaningful. Tracing magic images, storytelling, reporting, representing in a one-to-one relationship a scene or figure in paint—none of these acts was credible in the way it once had been. Abstraction appeared to be used up; expression through shape and color was very familiar and had become meaningless. The process of flattening out the canvas had reached an end; formalist painting had soaked color into the canvas and moved shape to the edge, presenting an almost, but not quite, unbroken field. We no longer believed in the transcendency of paint and saw little reason to use the medium of painting for making art.

In the middle '60s some expressed surprise that I was still using a brush. By 1975 Max Kozloff could say, "for at least five years . . . painting has been dropped gradually from avant-garde writing, without so much as a sign of regret"[1] (an odd situation was implied as he went on to admit that there were still plenty of artists painting).

The enterprise of painting *was* in question, *was* "under erasure." I use this term of Derrida's[2] to denote a state in which painting appeared to be no

Excerpted from Marcia Hafif, "Beginning Again," © *Artforum* (September 1978).

longer relevant, not quite right, and yet the only possible activity for one who has been or is a painter—an artist deriving satisfaction from painting, drawing, the ordering of space, with a sensibility directed to paint, to pencil, to materials in general. But there was no dialogue, no discourse.

It was necessary to turn inward, to the means of art, the materials and techniques with which art is made. Artists still interested in painting began an analysis—or deconstruction—of painting, turning to the basic question of *what painting is*, not so much for the purpose of defining it as to actually be able to vivify it by beginning all over again. That question led to examination of the discipline of painting, the taking apart of it as an activity; it led to a restatement of what we already knew along with an investigation of it in depth. We pretended in a certain way that we didn't know anything about painting. We studied and rediscovered it for ourselves.

This pretending resulted in a kind of extraconsciousness, a looking in from the outside. We were no longer "involved" in painting in the sense of engagement, but now saw clearly what we were doing from an exterior position—an attitude appropriate for the interim period of work which some saw this to be.

The notion that this was the last painting was not difficult to hold. And this greater consciousness could allow parody and the easy summation of painting, including the idea that it was actually possible for its relevance to have expired. Art could merge with other disciplines—science or religion—and cease existing as an independent activity. The idea of the end of painting had been around for a long time, long before Ad Reinhardt talked about the one size, the one color. . . .

Much of what I am talking about has had to do with the emptying of the field of work. A surface apparently without incident reveals to the artist the impossibility of eliminating it altogether and gives to the viewer the experience of seeming emptiness and the option of dealing with her/himself in that emptiness. What is there when we have taken everything away? What happens when there is very little to see? Painting has long flirted with emptiness. Think of Malevich, Humphrey, Reinhardt, Marden, Ryman. We could not say of any of these painters' work that everything else but one color has been removed. It is not a difficult task to distinguish between these "empty" paintings. The removal of known subject matter opened the way for other content to enter in. A painting without interior relationships of color and shape is not empty.

Although in these new explorations decisions are limited, one painting being very much like another—perhaps otherwise the same, but with minor changes—a differentiation should be made here between repetition and series. In order to treat one concern in depth the artist may indeed repeat work, knowing that repetition leads to a similarity and not to the *same*. This is very different from extending permutations, working in series. Every painting is

complete in itself and, rather than being a variation on earlier work, is more like the earlier work than it is different—although it is different. The desire is not to work out all the possibilities so much as to refine central decisions, not to search for the new and different so much as to move toward the *one*.

With the elimination of drawing on the surface, painting is freed from the structural necessity, so strongly felt in the '60s, of relating shapes to the outside edge. The painting *is* the shape, and the horizontals and verticals of the canvas shape relate to the space it is expected to be seen in; but the surface is, in a sense, free. The use of the grid in the '60s also represented that kind of rigid structure, although it could be used with a certain purity and a retaining of the personal—at least by Agnes Martin. In relation to the new work, however, the grid—as well as its atomized expression, the all-over—represents a control far too structural for acceptance of integral imagery that is now searched for. The grid provides a way to divide things into manageable chunks that is too easy. It is now too *known*.

The new, often monochrome work, insisting on a restatement of the essentials of painting, was begun with the idea that quality might be in some way definable, that at least painting must have meaning, must have credibility to our present way of seeing. The issue of "quality" has been discussed at length in recent years and I do not want to go into the entire question now. The quality which is felt to be definable here is felt in a wholeness existing in the work, through an integrity of the factors involved in its making, and it is measurable by the criteria set up in the work itself. Although the work is not pushing a message, the meaning inherent in it is crucial to its viability, and, on some levels at least, is very direct.

Painting can be understood on at least four important levels. First, the painting exists physically, as an object in the world which can be responded to directly; it is tactile, visual, retinal. Secondly, technical factors exist in the making of the painting; inherent qualities of material determine method; formal aspects of the work can be examined and understood, and therefore must stand up to certain criteria. Thirdly, a painting also exists as an historical statement; it is made at a particular time and represents the artist's view of the state of painting at that time, whether consciously or not. Finally, the painting represents a form of thought, indirectly reflecting the worldview of the artist and the time and transmitting philosophical and spiritual experiences. . . .

The work I am talking about is involved with the experience of *being*. It begins with givens. The material exists; decisions are made as to format, combinations of materials, tools, arena. Given one choice, others are made on the basis of that. A certain integrity pervades the whole. The artist is involved in *being* as a way of doing and in letting *be*, developing the materials worked with. The experience is one that few other activities allow us to know: the possibility of direct action in work with final materials, of seeing what was visualized materialize itself in our own hands. In that search for the present, for

perception of being, the artist discovers a wholeness, a means of deriving beauty from within the area set out, from the nature of the materials together with the techniques and human attributes chosen to be dealt with.

I use the word "beauty" cautiously. One wonders if the term is valid, if it any longer has meaning, but we do need some way of indicating the psychotropic action of visual stimuli. It is undeniable that an effect is felt in the presence of certain phenomena—an awe, an excitement. That can be as simple as a reaction to a landscape undergoing the change of autumn colors, or the sense of grandeur felt in the face of dramatic mountain scenery. The courtyard of an Islamic mosque can provoke that feeling, as can a simple bowl with a calligraphic inscription. We respond to the ingenious economies of Shaker furniture and to present-day work in similar ways.

This work is quiet, contemplative, and, as I have suggested, even meditative. This is a most difficult quality to discuss. We are used to talking in terms of materials and formal elements, but not of subjective content. Perhaps we feel that too much discussion dissipates the fact of it. We are trying to talk about an experience which is essentially personal. All monochromatic painting has something of this in it. (Other artists one might think of here are James Bishop and Susanna Tanger.)

Recent monochrome has been called Minimal or Reductivist. Because of the apparently reduced surface, it has been easy to relate this work to Minimalism. However, the recent work is not involved in modules, fabrication or industrial finish. This differentiates it, too, from Suprematism and Constructivism, where the goal was to eliminate the marks of the hand. The new painting accepts the marks of human touch and idiosyncrasies of the artist in conjunction with the varying results obtainable from given materials.

From process art such work took its tendency to set up a procedure, and accepting the results of carrying it out. Conceptual drawing also works this way: rules are given, and the work carried out. The product is the result of that action, although here personal content *is* allowed to enter. Art Povera contributed another concept, that of using simple methods and materials rather than difficult and costly ones. A term to consider is "esthetic primitivism" (borrowed from Robert Goldwater's *Primitivism in Modern Art*), which Carter Ratcliff says, "appears whenever an artist of any period intends to work with formal 'essentials,' either to establish the fundamentals of his medium or to engage perception at the deepest levels."[3] Both of these intentions are basic to recent work.

There have been in Europe in recent years such shows as "Fundamental Painting," "La Peinture en Question," "Analytische Malerei," "Bilder ohne Bilder," "Pittura." The Support/Surface group and related artists, analyzing the materials of painting and influenced by color-field painting, have written and theorized about their work. Claude Viallat has made work out of the elements of canvas, the stretcher, color, location. Dezeuze elaborates on the components of the stretcher. Louis Cane last year showed paintings in which even

elements from figurative art were abstracted and incorporated in his generally flat color surfaces. Work shown in Italy, Holland and Germany, as well as the American work discussed here, grew largely out of a rejection of color-field painting and its atmospheric quality. More than the French, it tends to put elements together into a whole, rather than opposing them; it is less involved in binary opposition and Structuralism.

The artist I am talking about keeps work whole and within the vision of one author, rarely using an assistant, ordering work from a factory or working in a group. Painting has been able to gather new energy by throwing things out and starting afresh. Although much of it has seemed to continue reduction, it has been, more precisely, involved in a deconstruction, an analysis of painting itself. With belief remaining in the potentialities of abstraction, and in reaction to the apparent exhaustion of painting, the artists cited above, and others, began the inventory—the cataloging, the examination—of the parts I have spoken of. Painting became demonstrative, conceptual, a thing to be examined, more passive than it had been. The artist was making personal work. Thus certain changes came about. The format became generally smaller. Color became opaque, seen for itself rather than being used to create an illusion or to express. Line was used for itself rather than to delineate shape or form. Personal touch was readmitted; the sign of the brush and the artist's hand were again visible. These are elements of *painting*.

A certain span of this analytic period appears to be concluded now, although much about painting remains to be investigated. The whole area of relational color and shapes has barely been touched upon. Devices for creating illusion, and the history of painting itself, could provide further subject for study. Individual artists will decide whether or not this is necessary. But there has been through this analysis a reaffirmation of the strength of nonobjective means of artistic expression. If one phase of this period of analysis is coming to an end, we may be ready to enter still another phase of abstraction, a synthetic period.

References

1. Max Kozloff, "Painting and Anti-Painting: A Family Quarrel," *Artforum* (September 1975), p. 37.
2. Jacques Derrida, *Of Grammatology*, trans. Gayatri Chakravorty Spivak (Baltimore: Johns Hopkins Press, 1974).
3. Carter Ratcliff, "On Contemporary Primitivism," *Artforum* (November 1975), p. 58.

American Painting: The Eighties

Barbara Rose

Like Clement Greenberg, critic Barbara Rose believes that art should resist popular culture with its emphasis on innovation and novelty, and instead should employ visionary imagery that expresses universal truths. Rejecting the idea of art as social comment, her exhibition "American Painting: The Eighties" focused on painters whose work was sensuous, imagistic, and metaphorical, without resorting to the "regression" of realist illusion. Rose champions art which is generated by the subjective unconscious to reveal the metaphysical and transcendent content of the imagination.

You know exactly what I think about photography. I would like to see it make people despise painting until something else will make photography unbearable.
—MARCEL DUCHAMP (Beinecke Library, Yale)
Letter to Alfred Stieglitz, May 17, 1922

To hold that one kind of art must be invariably superior or inferior to another kind means to judge before experiencing; and the whole history of art is there to demonstrate the futility of rules of preference laid down beforehand: the impossibility, that is, of anticipating the outcome of aesthetic experience . . . connoisseurs of the future may be able, in their discourse, to distinguish and name more aspects of quality in the Old Masters, as well as in abstract art, than we can. And in doing these things they may find much more common ground between the Old Masters and abstract art than we ourselves can yet recognize.
—CLEMENT GREENBERG,
"Abstract, Representational and so forth," 1954

Reprinted from Barbara Rose, "American Painting: The Eighties," catalogue essay, Grey Art Gallery, 1980.

Ten years ago, the question, "Is painting dead?" was seriously being raised as artist after artist deserted the illusory world of the canvas for the "real" world of three-dimensional objects, performances in actual time and space, or the secondhand duplication of reality in mechanically reproduced images of video, film and photography. The traditional activity of painting, especially hand painting with brush on canvas, as it had been practiced in the West since oil painting replaced manuscript illumination and frescoed murals, seemed to offer no possibility for innovation, no potential for novelty so startling it could compete with the popular culture for attention, with the capacity of the factory for mass production, or the power of political movements to make history and change men's minds. In the context of the psychedelic sixties and the post-Viet Nam seventies, painting seemed dwarfed and diminished compared with what was going on outside the studio. In the past, of course, the painter would never have compared his activity with the practical side of life; but by the time Senator Javits presented President Kennedy with an American flag painted by Jasper Johns, the idea that art was an activity parallel in some way with politics, business, technology and entertainment was on the way to becoming a mass delusion.

Once Andy Warhol not only painted the headlines, but appeared in them as well, the potential parity of the artist with the pop star or the sports hero was stimulating the drive to compete instilled in every American by our educational system. In the past, a painter might compete with the best of his peers, or in the case of the really ambitious and gifted, with the Old Masters themselves; but now, the celebrated dissolution of the boundary between art and life compelled the artist to compete with the politician for power, with the factory for productivity, and with pop culture for sensation and novelty.

Perhaps most pernicious, the drive toward novelty, which began to seem impossible to attain within the strictly delimitative conventions of easel painting, was further encouraged by the two dominant critical concepts of the sixties and seventies: the first was the idea that quality was in some way inextricably linked to or even a by-product of innovation; the second was that since quality was not definable, art only needed to be interesting instead of good. These two crudely positivistic formulations of critical criteria did more to discourage serious art and its appreciation than any amount of indifference in the preceding decades. The definition of quality as something that required verification to give criticism its authority contributed to the identification of quality with innovation. For if quality judgments had any claim to objectivity, they had to be based on the idea that an artist did something *first*—an historical fact that could be verified through documentation. The further erosion of critical authority was accomplished in other quarters by the denial that quality was in any way a transcendent characteristic of the art work; for if a work validated its existence primarily by being "interesting" (i.e. novel), then qualitative distinctions were no longer necessary. Far more aligned than they might

appear at first, these two materialist critical positions conspired to make painting less than it had ever been, to narrow its horizons to the vanishing point.

Thus, in the sixties and seventies, criticism militated on two fronts against styles that were based on continuity instead of rupture with an existing tradition. The term "radical" vied with "advanced" as the greatest accolade in the critic's vocabulary. Slow-moving, painstaking tortoises were outdistanced by swift hares, hopping over one another to reach the finish line where painting disappeared into nothingness. Such an eschatological interpretation of art history was the inevitable result of the pressure to make one's mark through innovation; for those who could not be first, at least there was the possibility of being the first to be last.

I. Reducing Recipes

This drive toward reductivism, encouraged and supported by a rigorously positivist criticism that outlawed any discussions of content and metaphor as belonging to the unspeakable realm of the ineffable, was a surprising finale to Abstract Expressionism, which had begun with an idealistic Utopian program for preserving not only the Western tradition of painting, but also the entire Graeco-Roman system of moral and cultural values. Of course this was to ask of art more than art could deliver; the revulsion against such rhetoric was a primary reason for the rejection of Abstract Expressionist aesthetics by pop and minimal artists beginning around 1960.

To be accurate, however, one must recall that the subversion of Abstract Expressionism began within the ranks of the movement itself. A popular art world joke described the demise of "action painting" as follows: Newman closed the window, Rothko pulled down the shade, and Reinhardt turned out the lights. A gross over-simplification of the critique of gestural styles by these three absolutist artists, this pithy epithet indicates the superficial manner in which the works of Newman, Rothko and Reinhardt were interpreted by art students throughout America, anxious to take their places in the limelight and the art market, without traveling the full distance of the arduous route that transformed late Abstract Expressionism into simplified styles subsuming elements from earlier modern movements into a synthesis that, while reductive, was still a synthesis. What lay behind Abstract Expressionism was forgotten ancient history in the art schools, where recipes for instant styles (two tablespoons Reinhardt, one half-cup Newman, a dash of Rothko with Jasper Johns frosting was a favorite) pressed immature artists into claiming superficial trademarks. These styles in turn were authenticated by art historians trained only in modern art history, and quickly exported to Europe, where World War II and its aftermath had created an actual historical rupture and an anxiety to catch up and overtake American art by starting out with the *dernier cri*. Soon the minimal, monochromatic styles that imitated Newman, Rothko and Reinhardt in a way no less shameless than the manner de Kooning's Tenth Street admirers

copied the look of his works, gave a bad name to good painting on both sides of the Atlantic.

Yet more disastrous in its implications was the haste to find a recipe for instant innovation in Pollock's complex abstractions. Not well represented in New York museums, rarely seen in the provinces at all, these daring works were essentially known through reproduction and in the widely diffused photographs and films Hans Namuth made of Pollock at work. The focus on Pollock as a performer in action rather than as a contemplative critic of his own work and student of the Old Masters—which was closer to the truth—meshed perfectly with the American proclivity to act first, think later. With little or no idea of what had gone into the making of Pollock's so-called "drip" paintings, which vaulted him into international celebrity as the last artist to genuinely *épater le bourgeois*, young artists turned to Happenings, the "theater of action", and other forms of public performance. Later, Namuth's photographs, which made the liquid paint look solid, promoted a series of random "distributional" pieces of materials poured, dropped or dumped on the floor of museums and galleries. These ephemera signaled the end of minimal art in a misguided attempt to literalize Pollock's "drip" paintings in actual space.

This is not to say that all the artists of the sixties and seventies who interpreted Abstract Expressionism literally—seizing on those aspects of the works of the New York School that seemed most unlike European art—were cynical or meretricious. But they were hopelessly provincial. And it is as provincial that most of the art of the last two decades is likely to be viewed when the twentieth century is seen in historical perspective. By provincial, I mean art that is determined predominantly by topical references in reaction to local concerns, to the degree that it lacks the capacity to transcend inbred national habits of mind to express a universal truth. In the sixties and seventies, the assertion of a specifically American consciousness was an objective to be pursued instead of avoided. The Abstract Expressionist by and large had European or immigrant backgrounds; they rejected the strictly "American" expression as an impediment to universality. Beginning around 1960, however, the pursuit of a distinctively American art by native-born artists provided the rationale for the variety of puritanically precise and literalist styles that have dominated American art since Abstract Expressionism. A reductive literalism became the aesthetic credo; the characteristics of painting as mute objects were elevated over those of painting as illusion or allusion.

II. Technique as Content

Even those artists who maintained closer contact with the European tradition, like Bannard and Olitski, avoiding the provincial American look, were unable to find more in painting than left-overs from the last banquet of the School of Paris, *art informel*. However, *tachiste* art, with its emphasis on materials, was nearly as literal as the local American styles. The absence of imagery in Yves Klein's

monochrome "blue" paintings, the ultimate *informel* works, identifies content not with imagery or pictorial structure, but with technique and materials. In identifying image and content with materials, *informel* styles coincided with the objective literalist direction of American painting after Abstract Expressionism.

The identification of content with technique and materials rather than image, however, also had its roots in Abstract Expressionism. In seeking an alternative to Cubism, the Abstract Expressionist, influenced by the Surrealist, came to believe that formal invention was primarily to be achieved through technical innovation. To some extent, this was true; automatic procedures contributed in large measure to freeing the New York School from Cubist structure, space and facture. But once these automatic processes were divorced from their image-creating function, in styles that disavowed drawing as a remnant of the dead European past to be purged, the absence of imagery threw the entire burden of pictorial expression on the intrinsic properties of materials. The result was an imageless, or virtually imageless, abstract painting as fundamentally materially oriented as the literal "object art" it purported to oppose.

The radicality of object art consisted of converting the plastic elements of illusion in painting—i.e., light, space and scale—into actual properties lacking any imaginative, subjective or transcendental dimension. No intercession by the imagination was required to infer them as realities because they were *a priori* "real". This conversion of what was illusory in painting into literal realities corresponds specifically to the process of reification. As the fundamental characteristic of recent American art, anti-illusionism reveals the extent to which art, in the service of proclaiming its "reality", has ironically been further alienated from the life of the imagination. The *reductio ad absurdem* of this tendency to make actual what in the past had been a function of the imagination was so-called "process art", which illustrated the procedure of gestural painting, without committing itself to creating images of any permanence that would permit future judgment. In conceptual art, the further reification of criticism was undertaken by minds too impotent to create art, too terrified to be judged, and too ambitious to settle for less than the status of the artist.

Thus it was in the course of the past two decades that first the criticism, and then the art that reduced it to formula and impotent theory, became so detached from sensuous experience that the work of art itself could ultimately be conceived as superfluous to the art activity—which by now epitomized precisely that alienation and reification it nominally criticized. Such were the possibilities of historical contradiction in the "revolutionary" climate of the sixties and seventies. In painting, or what remained of it, a similar process of reification of the illusory was undertaken. Edge had to be literal and not drawn so as not to suggest illusion; shape and structure had to coincide with one another to proclaim themselves as sufficiently "real" for painting to satisfy the requirements of radicality. In reducing painting to nothing other or more than its material components, rejecting all forms of illusionism as *retardataire* and European, radical art was forced to renounce any kind of illusive or allusive

imagery simply to remain radical. And it was as *radical* that the ambitious artist felt compelled to identify himself. In its own terms, the pursuit of radicality was a triumph of positivism; the rectangular colored surface inevitably became an object as literal as the box in the room. Even vestigial allusions of landscape in the loaded surface style that evolved from stained painting in gelled, cracked or coagulated pigment—reminiscent of Ernst's experiments with decalcomania—express a nostalgia for meaning, rather than any convincing metaphor. For radicality demanded that imagery, presumably dependent on the outmoded conventions of representational art, was to be avoided at all costs. The result of such a wholesale rejection of imagery, which cut across the lines from minimal to color-field painting in recent years, was to create a great hunger for images. This appetite was gratified by the art market with photography and Photo-Realism.

III. Against Photography

Photography and the slick painting styles related to it answered the appetite for images; but they did so at the enormous price of sacrificing all the sensuous, tactile qualities of surface, as well as the metaphorical and metaphysical aspects of imagery that it is the unique capacity of painting to deliver. Pop art, which is based on reproduced images, had self-consciously mimicked the impersonal surfaces of photography, but Photo-Realism rejected this ironic distance and aped the documentary image without embarrassment. In a brilliant analysis of the limitations of photography ("What's All This About Photography?" *ARTFORUM*, Vol. 17, No. 9, May, 1979), painter Richard Hennessy defines the crucial differences between photographic and pictorial imagery. A devastating argument against photography ever being other than a minor art because of its intrinsic inability to transcend reality, no matter what its degree of abstraction, the article makes a compelling case for the necessity of painting, not only as an expressive human activity, but also as our only present hope for preserving major art, since the subjugation of sculpture and architecture to economic concerns leaves only painting genuinely "liberal" in the sense of free.

According to Hennessy, photography, and by inference painting styles derived from it, lacks surface qualities, alienating it from sensuous experience. More than any of the so-called optical painting styles, photography truly addresses itself to eyesight alone. Upon close inspection, the detail of photography breaks down into a uniform chemical film—that is, into something other than the image it records—in a way that painterly detail, whether an autonomous abstract stroke, or a particle of legible representation as in the Old Masters, does not. Thus it is the visible record of the activity of the human hand, as it builds surfaces experienced as tactile, that differentiates painting from mechanically reproduced imagery. (Conversely, the call for styles that are exclusively *optical* may indicate a critical taste unconsciously influenced in its preference by daily commerce with the opticality of reproduced images.)

The absence of the marks of the human hand that characterizes the detached automatic techniques of paint application with spraygun, sponge, spilling, mopping and screening typical of recent American painting, relates it to graphic art as well as to mechanical reproductions that are stamped and printed.

IV. Example of Hofmann

Among the first painters to insist on a "maximal" art that is sensuous, tactile, imagistic, metaphorical and subjective, Hennessy himself painted in a variety of styles, examining the means and methods of the artists he most admired—Picasso, Matisse, Klee, Miró, and above all Hans Hofmann. The latter has come to symbolize for many younger painters the courage to experiment with different styles, to mature late, after a long career of assimilating elements from the modern movements in a synthesis that is inclusive and not reductive. Indeed, Hofmann's commitment to preserving all that remained alive in the Western tradition of painting, while rejecting all that was worn out by convention or superseded by more complex formulation, has become the goal of the courageous and ambitious painters today.

Who could have predicted in 1966, when Hofmann, teacher of the Abstract Expressionists, who brought Matisse's and Kandinsky's principles to New York, died in his eighties, that the late-blooming artist would become the model for those ready to stake their lives on the idea that painting had not died with him? Hofmann's example was important in many ways, for he had remained throughout his life an easel painter, untempted by the architectural aspirations of the "big picture" that dwarfed the viewer in its awesome environmental expanse. Conscious of allover design, Hofmann nevertheless chose to orient his paintings in one direction, almost always vertically, the position that parallels that of the viewer. The vertical orientation, which implies confrontation, rather than the domination of the viewer by the painting, is also typical of many of the artists of the eighties, who accept the conventions of easel painting as a discipline worthy of preservation. Moreover, Hofmann had also turned his back on pure automatism, after early experiments with dripping. Like Hofmann, with few exceptions, the artists who follow his example maintain that painting is a matter of an image that is frontal and based on human scale relationships. They paint on the wall, on stretched canvases that are roughly life-size, working often from preliminary drawings, using brushes or palette knives that record the marks of personal involvement and hand craft, balancing out spatial tensions by carefully revising, as Hofmann did.

Of course, not all the artists I am speaking of have a specific debt to Hofmann. In fact, the serious painters of the eighties are an extremely heterogeneous group—some abstract, some representational. But they are united on a sufficient number of critical issues that it is possible to isolate them as a group. They are, in the first place, dedicated to the preservation of painting as a transcendental high art, a major art, and an art of universal as opposed to

local or topical significance. Their aesthetic, which synthesizes tactile with optical qualities, defines itself in conscious opposition to photography and all forms of mechanical reproduction which seek to deprive the art work of its unique "aura." It is, in fact, the enhancement of this aura, through a variety of means, that painting now self-consciously intends—either by emphasizing the involvement of the artist's hand, or by creating highly individual visionary images that cannot be confused either with reality itself or with one another. Such a commitment to unique images necessarily rejects seriality as well.

V. The Painter as Image Maker

These painters will probably find it odd, and perhaps even disagreeable, since they are individualists of the first order, to be spoken of as a group, especially since for the most part they are unknown to one another. However, all are equally committed to a distinctively humanistic art that defines itself in opposition to the *a priori* and the mechanical: A machine cannot do it, a computer cannot reproduce it, another artist cannot execute it. Nor does their painting in any way resemble prints, graphic art, advertising, billboards, etc. Highly and consciously structured in its final evolution (often after a long process of being refined in preliminary drawings and paper studies), these paintings are clearly the works of rational adult humans, not a monkey, a child, or a lunatic. Here it should be said that although there is a considerable amount of painting that continues Pop Art's mockery of reproduced images—some of it extremely well done—there is a level of cynicism, sarcasm and parody in such work that puts it outside the realm of high art, placing it more properly in the context of caricature and social satire.

The imagery of painters committed exclusively to a tradition of painting, an inner world of stored images ranging from Altamira to Pollock, is entirely invented; it is the product exclusively of the individual imagination rather than a mirror of the ephemeral external world of objective reality. Even when such images are strictly geometric, as in the case of artists like Susanna Tanger, Lenny Contino, Peter Pinchbeck, Elaine Cohen, Georges Noel and Robert Feero, they are quirky and sometimes eccentrically personal interpretations of geometry—always asymmetrical or skewed, implying a dynamic and precarious balance, the opposite of the static immobility of the centered icon, emblem or insignia. The rejection of symmetry and of literal interpretations of "allover" design, such as the repeated motifs of Pattern Painting, defines this art as exclusively *pictorial;* it is as unrelated to the repetitious motifs of the decorative arts and the static centeredness of ornament as it is to graphics and photography. For the rejection of the encroachments made on painting by the minor arts is another of the defining characteristics of the serious painting of the eighties.

Although these artists refuse to literalize any of the elements of painting, including that of "allover" design, some, like Howard Buchwald, Joan Thorne, Nancy Graves and Mark Schlesinger are taking up the challenge of Pollock's

allover paintings in a variety of ways without imitating Pollock's image. Buchwald, for example, builds up a strong rhythmic counterpoint of curved strokes punctuated by linear slices and ovoid sections cut through the canvas at angles and points determined by a system of perspective projections referring to space in front of, rather than behind, the picture plane. Thorne and Graves superimpose several different imagery systems, corresponding to the layers of Pollock's interwoven skeins of paint, upon one another. Schlesinger, on the other hand, refers to Pollock's antecedents in the allover stippling of Neo-Impressionism, which he converts into images of jagged-edged spiraling comets suggesting a plunge into deep space while remaining clearly on the surface by eschewing any references to value contrasts or sculptural modeling. These original and individual interpretations of "allover" structure point to the wide number of choices still available within pictorial as opposed to decorative art. For in submitting itself to the supporting role that decorative styles inevitably play in relationship to architecture, painting renounces its claims to autonomy.

VI. The Legacy of Pollock

To a large number of these artists, Pollock's heroism was not taking the big risk of allowing much to chance, but his success in depicting a life-affirming image in an apparent state of emergence, evolution and flux—a flickering, dancing image that never permits the eye to come to rest on a single focus. Like Pollock's inspired art, some of these paintings emphasize images that seem to be in a state of evolution. Images of birth and growth like Lois Lane's bulbs, buds and hands and Susan Rothenberg's desperate animals and figures that seem about to burst the membrane of the canvas to be born before us, or Robert Moskowitz' boldly hieratic windmill that stands erect in firm but unaggressive confrontation—a profound metaphor of a man holding his ground—are powerful metaphors. In the works of Lenny Contino and Dennis Ashbaugh, as well as in Carol Engelson's processional panels, a kind of surface dazzle and optical excitement recall the energy and sheer physical exhilaration that proclaimed the underlying image of Pollock's work as the life force itself. Because he was able to create an image resonant with meaning and rich with emotional association without resorting to the conventions of representational art, Pollock remains the primary touchstone. The balance he achieved between abstract form and allusive content now appears as a renewed goal more than twenty years after Pollock's death.

As rich in its potential as Cubism, Abstract Expressionism is only now beginning to be understood in a profound instead of a superficial way. What is emerging from careful scrutiny of its achievements is that the major areas of breakthrough of the New York School were not the "big picture," automatism, action painting, flatness, et al., but the synthesis of painting and drawing, and a new conception of figuration that freed the image from its roots in representational art. For Cubism, while fracturing, distorting and in other ways

splintering the image (something neither Abstract Expressionism nor the wholistic art that came from it did) could never free itself of the conventions of representational art to become fully abstract.

Drawing on discoveries that came after Pollock regarding the role of figuration in post-Cubist painting, artists today are at ease with a variety of representational possibilities that derive, not from Cubist figuration, but from the continuity of image with surface established by Still, Rothko, Newman and Reinhardt, who embedded, so to speak, the figure in the carpet, in such a way as to make figure and field covalent and coextensive.

In the current climate of carefully considered re-evaluation, the rejection of figure-ground relationships, which artists of the sixties labelled as superannuated conventions inherited from Cubism, is being reviewed and reformulated in more subtle and less brutal terms. Cutting the figure out of the ground to eliminate the recession of shapes behind the plane was an instant short-cut solution to a complex problem. Ripping the figure from the ground eliminated figure-ground discontinuities in a typically Duchampesque solution of negating the problem. (Interestingly, Johns, usually considered Duchamp's direct heir, backed off from the objectness of the *Flag*, in which he identified image with field, and found another solution to reconciling representation with flatness by embedding the figure in the ground in later works such as *Flag on Orange Field*.)

Short-cuts, recipes, textbook theorizing and instant solutions to difficult problems are being rejected today as much as trademarks and the mass-produced implications of seriality. Today, subtler modes of dealing with the relationship between image and ground without evoking Cubist space are being evolved. Even artists like Carl Apfelschnitt, Sam Gilliam and Ron Gorchov, who alter the shape of the stretcher somewhat, do so not to identify their painting as virtual objects, but to amplify the meaning of imagery. Apfelschnitt and Gorchov, for example, make totemic images whose sense of presence relies on metaphorical associations with shields and archaic devices; Gilliam bevels the edge of his rectangular canvas to permit freer play to his landscape illusion, insuring that his dappled Impressionism cannot be interpreted as the naive illusion of a garden through a window.

VII. Post-Cubist Representation

The difficulties of reconciling figuration, the mode of depicting images whether abstract or representational, with post-Cubist space has been resolved by these painters in a variety of ways. Precedents for post-Cubist representation exist in Pollock's black-and-white paintings, and more recently in Guston's figurative style. Drawing directly in paint, as opposed to using drawing as a means to contour shape, has given a new freedom to artists like Nancy Graves, Richard Hennessy, William Ridenhour, Anna Bialobroda, Steven Sloman and Luisa Chase. In that post-Cubist representation is not based on an abstraction from

the external objective world, but on self-generated images, it is a mental construct as conceptual in origin as the loftiest non-objective painting. Lacking any horizon line, Susan Rothenberg's white-on-white horse, Lois Lane's black-on-black tulips, and Robert Moskowitz' red-on-red windmill, or Gary Stephan's brown-on-brown torso have more in common with Malevich's *White-on-White* or Reinhardt's black crosses in black fields than with any realist painting. Like Dubuffet's *Cows*—perhaps the first example of post-Cubist representation—and Johns' targets and numbers, these images are visually embedded in their fields, whose surface they continue. This contiguity between image and field, enhanced by an equivalence of facture in both, identifies image and field with the surface plane in a manner that is convincingly modernist.

The possibility of depicting an image without resorting to Cubist figure-ground relationships greatly enlarges the potential of modernist painting for the future. No longer does the painter who wishes to employ the full range of pictorial possibilities have to choose between a reductivist suicide or a retrenchment back to realism. By incorporating discoveries regarding the potential for figuration with an abstract space implicit in Monet, Matisse, and Miró, as this potential was refined by Pollock and the color-field painters, an artist may choose a representational style that is not realist.

Today, it is primarily in their pursuit of legible, stable, imagistic styles—both abstract and representational—structured as indivisible wholes (another legacy of color-field painting) rather than composed in the traditional Cubist manner of adding on parts that rhyme and echo one another that modernist painters are united. Even those who make use of loosely geometric structures for painterly brushwork like Mark Lancaster, Pete Omlor and Pierre Haubensak, do so in a highly equivocal way that does not allude to Cubic figure-ground inversions, but rather recalls Impressionist and Fauve integrations of the figure into the ground. Their images suggest poetic associations with the grid of windows, a play on the illusion of the picture as window; but they do not pretend in any way that the picture *is* in any way a window. Still others, like Thornton Willis, Vered Lieb, Susan Crile, and Frances Barth, are even freer in their use of geometry as a structuring container for color, rather than as a rigid *a priori* category of ideal forms.

In all of these cases, the representation of an image never invokes naive illusionism; to remain valid as a modernist concept, figuration is rendered compatible with flatness. This may mean nothing more radical than Clive Bell's assumption that a painting must proclaim itself as such before it is a woman, a horse or a sunrise, or Serusier's definition of a painting as a flat surface covered with patches of color. However, it does necessitate conveying the information that the depicted image is incontrovertibly two-dimensional, that it lies on the plane, and not behind it. The contiguity of image with ground is established often as the Impressionists did, by an allover rhythmic stroking. All that in Cubism remained as vestigial references to the representational past of painting—value contrast, modeling, perspective, overlapping, receding planes, etc.—is

eliminated so that the space of painting cannot be confused with real space. Once the truth of the illusion of painting is acknowledged—and *illusion, not flatness, is the essence of painting*—the artist is free to manipulate and transform imagery into all manner of illusions belonging exclusively to the realm of the pictorial, i.e., the realm of the imagination. Moreover, since the depicted illusions belong to the imagination, i.e., they are registered by the brain and the eye, surface, perceived as constituted of pigment on canvas, can be manipulated to evoke a tactile response that has nothing to do with the experience of a third dimension, but is entirely a matter of texture.

The difference between a painting that is composed, a process of addition and subtraction, and one that is constructed, through a structuring process that takes into consideration the architecture of the frame, continues to be a primary consideration. These artists take a responsibility to structure for granted, just as they reject the random, the chance and the automatic as categories of the irresponsible. In this sense, decision-making, the process of deliberation, becomes a moral as well as an aesthetic imperative.

Sifting through the modern movements, panning the gold and discarding the dross, the painters of the eighties, as we have seen, retain much from Abstract Expressionism. In many cases, there is a commitment to a kinetic or visceral metaphor. However, this appeal to empathy in the energetic and muscular images of Elizabeth Murray, Dennis Ashbaugh, Stewart Hitch, Georges Noel, Howard Buchwald, Robert Feero and Joan Thorne, or in the movement implied by Susan Rothenberg, Edward Youkilis and Joanna Mayor, has more in common with the "life-enhancing" quality Bernard Berenson identified as our empathic identification with Signorelli's nudes than with the documentary and autobiographical gestures of "action painting."

VIII. The Function of the Imagination

Today, the essence of painting is being redefined not as a narrow, arid and reductive anti-illusionism, but as a rich, varied capacity to birth new images into an old world. The new generation of painters who have matured slowly, skeptically, privately, and with great difficulty, have had to struggle to maintain conviction in an art that the media and the museums said was dying. Today, it is not the literal material properties of painting as pigment on cloth, but its capacity to materialize an image, not behind the picture plane, which self-awareness proclaims inviolate, but behind the proverbial looking-glass of consciousness, where the depth of the imagination knows no limits. If an illusion of space is evoked, it is simultaneously rescinded. In one way or another, either in terms of Hofmann's "push–pull" balancing out of pictorial tensions, or by calling attention to the actual location of the plane by emphasizing the physical build-up of pigment on top of it, or by embedding the figure into its contiguous field, serious painting today does not ignore the fundamental

assumptions of modernism, which precludes any regression to the conventions of realist representation.

Not innovation, but originality, individuality and synthesis are the marks of quality in art today, as they have always been. Not material flatness—in itself a contradiction, since even thin canvas has a third dimension and any mark on it creates space—but the capacity of painting to evoke, imply and conjure up magical illusions that exist in an imaginative mental space, which like the atmospheric space of a Miró, a Rothko or a Newman, or the cosmic space of a Kandinsky or a Pollock, cannot be confused with the tangible space outside the canvas, is that which differentiates painting from the other arts and from the everyday visual experiences of life itself.

The idea that painting is somehow a visionary and not a material art, and that the locus of its inspiration is in the artist's subjective unconscious was the crucial idea that Surrealism passed on to Abstract Expressionism. After two decades of the rejection of imaginative poetic fantasy for the purportedly greater "reality" of an objective art based exclusively on verifiable fact, the current rehabilitation of the metaphorical and metaphysical implications of imagery is a validation of a basic Surrealist insight. The liberating potential of art is not as literal reportage, but as a catharsis of the imagination.

The Surrealists believed, and no one has yet proved them wrong, that psychic liberation is the prerequisite of political liberation, and not vice-versa. For most of the twentieth century, the relationship between art and politics has been an absurd confusion, sometimes comic, sometimes tragic. The idea that to be valid or important art must be "radical" is at the heart of this confusion. By aspiring to power, specifically political power, art imitates the compromises of politics and renounces its essential role as moral example. By turning away from power and protest, by making of their art a moral example of mature responsibility and judicious reflection, a small group of painters "taking a stand within the self," as Ortega y Gasset described Goethe's morality, is redeeming for art a high place in culture that recent years have seen it voluntarily abdicate for the cheap thrill of instant impact.

Because the creation of individual, subjective images, ungoverned and ungovernable by any system of public thought or political exigency, is *ipso facto* revolutionary and subversive of the status quo, it is a tautology that art must strive to be radical. On the contrary, that art which commits itself self-consciously to radicality—which usually means the technically and materially radical, since only technique and not the content of the mind advances—is a mirror of the world as it is and not a critique of it.

Even Herbert Marcuse was forced to revise the Marxist assumption that in the perfect Utopian society, art would disappear. In his last book, *The Aesthetic Dimension*, he concludes that even an unrepressed, unalienated world "would not signal the end of art, the overcoming of tragedy, the reconciliation of the Dionysian and the Apollonian. . . . In all its ideality, art bears witness to the truth of dialectical materialism—the permanent non-identity between sub-

ject and object, individual and individual." Marcuse identifies the only truly revolutionary art as the expression of subjectivity, the private vision:

> The "flight into inwardness" and the insistence on a private sphere may well serve as bulwarks against a society which administers all dimensions of human existence. Inwardness and subjectivity may well become the inner and outer space for the subversion of experience, for the emergence of another universe.

For art, the patricidal act of severing itself from tradition and convention is equally suicidal, the self-hatred of the artist expressed in eliminating the hand, typical of the art of the last two decades, can only lead to the death of painting. Such a powerful wish to annihilate personal expression implies that the artist does not love his creation. And it is obvious that an activity practiced not out of love, but out of competition, hatred, protest, the need to dominate materials, institutions or other people, or simply to gain social status in a world that canonizes as well as cannibalizes the artist, is not only alienated but doomed. For art is labor, physical human labor, the labor of birth, reflected in the many images that appear as in a process of emergence, as if taking form before us.

The renewed conviction in the future of painting on the part of a happy few signals a shift in values. Instead of trying to escape from history, there is a new generation of artists ready to confront the past without succumbing to nostalgia, ready to learn without imitating, courageous enough to create works for a future no one can be sure will come, ready to take their place, as Gorky put it, in the chain of continuity of "the great group dance."

This is a generation of hold-outs, a generation of survivors of catastrophes, both personal and historical, which are pointless to enumerate, since their art depends on transcending the petty personal soap opera in the service of the grand, universal statement. They have survived a drug culture that consumed many of the best talents of their time; they have lived through a crisis of disintegrating morality, social demoralization and lack of conviction in all authority and tradition destroyed by cultural relativism and individual cynicism. And they have stood their ground, maintaining a conviction in quality and values, a belief in art as a mode of transcendence, a worldly incarnation of the ideal. Perhaps they, more than the generations who interpreted his lessons as license, have truly understood why Duchamp was obsessed by alchemy. Alchemy is the science of trans-substantiation; the tragedy of Duchamp's life was that he could only study alchemy because he could not practice it. To transform matter into some higher form, one must believe in transcendence. As a rationalist, a materialist and a positivist, Duchamp could not practice an art based on the transformation of physical matter into intangible energy and light. Those who perpetuate an art that filled him with ennui are the last of the true believers; their conviction in the future of painting is a courageous and constructive act of faith.

New Image Painting

Richard Marshall

In 1979, Richard Marshall was the curator of an influential exhibition of paintings at the Whitney Museum of American Art that included the works of Nicholas Africano, Jennifer Bartlett, Denise Green, Michael Hurson, Neil Jenney, Lois Lane, Robert Moskowitz, Susan Rothenberg, David True, and Joe Zucker. The excerpt from his catalogue statement which is included here describes the use of ambiguous, manipulated, and isolated imagery in order to force viewers to engage their imaginations and give their own meanings to the paintings. Indeterminacy and pictorial illusion are seen as the key elements in depicting the complexities of contemporary experience—elements which were forbidden by modernist theory.

Much of the art of the 1970s has been characterized by artists' inclination toward the use of recognizable images. This has occurred most readily and obviously in those disciplines predisposed to image-making—performance, video, film, photography—and has also become increasingly apparent in recent painting and sculpture. Although the use of imagery in painting and sculpture was often discredited and discouraged, a number of artists began to incorporate recognizable forms into their work in a way that is both opposed to and an assimilation of the predominant modes of abstraction and figuration of the '50s and '60s. This catalogue and the exhibition which it accompanies focus on the work of ten painters who utilize imagery in non-traditional and innovative ways, and make images the dominant feature of their paintings. The artists assembled here are related more in sensibility than in style, and an aim of this exhibition is to present their paintings with a view toward understanding them individually rather than collectively.

Excerpted from Richard Marshall, "New Image Painting," catalogue essay, © 1979 Whitney Museum of American Art.

Although each artist's use and treatment of imagery is different, the conceptualization and function of the image is often similar. By exploring the choice and treatment of recognizable forms in painting, certain descriptive generalizations can be made about the work of these imagists. Familiar adjectives used to describe an artistic style—representational, figurative, realist—do not differentiate these artists' ways of using images nor adequately convey the distinct painterly qualities manifested in the work. Conversely, labels such as abstract, non-objective, and expressionistic do not allow for the appearance of familiar shapes and forms. The type of painting discussed here draws upon and rejects aspects of each of these styles of painting. The images used fluctuate between abstract and real. They clearly represent things that are recognizable and familiar, yet they are presented as isolated and removed from associative backgrounds and environments. The paintings do not attempt to duplicate an object as it exists in nature or to interpret reality, but to depict an image that is drastically abbreviated or exaggerated, retaining only its most basic identifying qualities. The images are radically manipulated through scale, material, placement, and color. Because of their isolation and alteration, they create a distance between themselves and the viewer. This is confounded by the wavering equilibrium established between form and content—often weighted more toward form. The image becomes released from that which it is representing. The imagery is non-normative and often non-referential to specific interpretation. The paintings contain a narrative quality only to the extent that a narrative is implied or suggested—but not stated. When two or more images are used simultaneously, any narrative aspect present is non-linear and non-sequential, and therefore does not readily lend itself to simple, obvious explanation.

What becomes most apparent in these works is the interplay between the emotive content of the image and its formal structure and characteristics. The use of imagery brings into play the imagination and psychology of the viewer to a greater degree than the analytical and perceptual considerations encouraged by other work of the recent past. In some ways, imagistic painting confounds the viewer because expectations and associations with the suggested illusion are not readily discernible or explicable. A viewer's response is not made directly to an image but is based on the meanings that he attaches to such images. A viewer responds to meanings of objects that are defined within a cultural system and social organization and which are mediated by the use of symbols. Through classification of these symbols one carries with them the knowledge and associations experienced when encountering these images. The essence, value, or nature of an image resides not in the image but in the relation between it and the viewer. As a result of this, when an image is presented in an unusual, unexpected, or altered manner, its predictable or specific allusion is not elicited. When confronted with an illusion of an object that is devoid of the surroundings that provide clues and keys to its meaning, the viewer's interpretation becomes undefined and open-ended. Although broad

and commonly held definitions are at hand, numerous variables are present. The viewer's participation in experiencing the work is enhanced to the extent that, when introduced to a new terminology, one must draw upon memory for possibly analogous experiences and conceptions. Even though these images are recognizable and contain many psychological associations, they become obtuse to rational explanation based on their content. The paintings, then, are not reliant on the references inherent in the meanings attached to the image but can also bring into play formal, intellectual, and painterly factors. The image becomes neutralized and is freed from its usual functions; it can be used to expand into other capacities. The artist is free to manipulate the image on canvas so that it can be experienced as a physical object, an abstract configuration, a psychological associative, a receptacle for applied paint, an analytically systematized exercise, an ambiguous quasi-narrative, a specifically non-specific experience, a vehicle for formalist explorations, or combinations of any.

The meanings and associations applied to an image cannot be completely obliterated, nor is it advantageous that they be. The viewer attempts to find meaning in an image by correlating previously classified associations, and the lack of obvious meaning will consequently elicit the application of potential and possible meanings. Paired, multiple, or successive images will invariably educe a narrative or implied relationship between images. Because of this, the artist is able to either enhance, promote, or control this direction or attempt to further negate relationship and story. The artist will often encourage speculation on the relationship between images but control the external references and extraneous details to the point of keeping its reading immediate and specific. All additional clues and props for the development of a linear and sequential narrative are eliminated so that flexibility in interpretation is simultaneously restricted and yet activated.

Although the appearance of images in contemporary painting may seem reactionary and contrary to a viewer accustomed to the highly visible abstract presentations of recent American art, these image painters exhibit a closer affinity to Abstract Expressionist, Pop, Minimal, and Conceptual concerns than to traditional figurative and realist work. Pictorial illusion, previously considered a foe of contemporary sensibility, has emerged with new strength, vigor, and impact.

American art since the mid-'40s has been distinguished by a striving toward the reduction and clarification of all but the most essential qualities of art. Paring down to the most cogent aspects of visual, emotional, formal, and intellectual components has been a consistent objective of recent art. The Abstract Expressionists' preoccupation with the demands of paint and canvas in conjunction with its emotional and self-reflective characteristics; Pop Art's blatant and ironic use of disjointed and disparate public imagery with its instant cultural associations and meanings; and the emphasis of the Minimalist sensibility on perceptual phenomena and physicality, though seemingly dissimilar, share certain basic intentions. The imagists, toward the same end,

have drawn from these varying features of recent art and have conjoined seemingly different attitudes and concerns. By acknowledging and assimilating the salient aspects of recent American art, these contemporary artists have been able effectively to employ, manipulate, and revitalize imagery. . . .

The Academy of the Bad

Peter Plagens

Critic and painter Peter Plagens examines the formal strategies of figurative painting which, in Marcia Tucker's words, "Defies, either deliberately or by virtue of disinterest, the classic canon of good taste, draftsmanship, acceptable source material, rendering, or illusionistic representation." Plagens goes over the ways in which one can make a "good" painting— ambitious, balanced, learned, and skillful—without cliches. Drawing on popular cultural sources, "bad" painting turns its awkwardness into an asset by its ability to defy predictability and to engage viewers' interest. Apparent ineptness and a "catalogue of disguises" can make paintings more effective as art only if they are accompanied by aesthetic distance. In time, the genuine innovations of the "bad" become integrated into, and serve to revitalize, "good" painting.

There is now a phenomenon abroad in the land, called among other things, " 'bad' painting," "new image" painting, "new wave" painting, "punk art" and "stupid" art. Although it takes many forms, it is primarily realized in painting, where its trademarks are what looks like inept drawing, garish or unschooled color, tasteless or trivial or bizarre imagery, odd and impractical assemblage, maniacally vigorous or disinterested paint application, dubious craft and materials, and a general preference for squalor over reason. Concurrent interpretations of its cause range from the end of modern art itself, to simple spillover from the loudest rock music played at the grungiest clubs. Most art world developments have, however, something to do with other art, and are most profitably illuminated by comparison. "Bad" painting is best seen next to "good" painting.

Reprinted from Peter Plagens, "The Academy of the Bad," *Art in America* (November 1981).

During Minimalism and its aftermath, painting was in a weak theoretical position because, being bound to the convention of that flat, static, indoor rectangle, it didn't appear to do much to advance the precious dialectic of modernism. That is, in the outward-bound imperative of contemporary art (i.e., the further from a conventional objet d'art the better, whether it be in a mainstream straight line from grid to field to box to blueprint to specifications to prose, or in the variegated hook rugs, laser beams, rituals, huts and fences of "pluralism"), painting stayed home and minded the store. Now that modernism has either pooped out because its audience is more revolutionary than it is, or is just catching its wind in the backstretch, painting breathes free of the avant garde, and is making a comeback. In this artistic recession, conventions are being disinterred—reopened, like old gold mines.

Nevertheless, exhumed conventions can still be exhausted ones. The problem with painting, particularly abstract painting, is that by now all the possible significant variations on neat/messy, thick/thin, big/little, simple/complex, or circle/square have been done. You've got your basic Mondrian, basic Frankenthaler, basic Pollock, basic Reinhardt, basic Kline, and basic Pousette-Dart. (Granted, there are an infinite number of occupiable points between zero degrees and 180 degrees, but who really cares about that which comes along late in the day and blithely situates itself two degrees, 12 minutes down the dial from *perpendicular*?)

We all know by now what the deliberately "good" painting looks like: its scale is physically ambitious within a human limitation; its composition is interlocked and balanced; its color, whether loud or muted, displays a knowledge of key; and its paint handling evidences the presence of a nimble wrist. "Good" painting looks, at its most orthodox, like one of Richard Diebenkorn's *Ocean Park* pictures, at its most agitated like one of Joan Mitchell's works, or, at its most attenuated, like a Brice Marden triptych. The trouble with "good" painting, especially that by artists holding a reverse idea of the avant garde (i.e., in the face of pluralism, the closer to the most moribund late Cubist mannerism the better), is that it quickly becomes predictable and boring.

(Straight figurative painting is somewhat immune to all this. Since it's closely connected with the passing, visible, real world, it can float on iconography, with Robert Bechtle pursuing successive models of Chryslers at a constant time lag, or Jack Beal updating our sins with each new L. L. Bean catalogue. Yet straight figurative painting is also somewhat prey to all this, as the insistent timelessness of William Bailey or the aggressive tours de force of Al Leslie, each trying to deodorize the lingering scent of journalism, testify.)

Painters painting since the heyday of Abstract Expressionism have been aware of the pitfalls of deliberately "good" painting which hangs its hat on nothing but a manifest definition of "good" painting itself, and they have tried by various means to work through, or around, the dangers of staleness and cliché. One approach has been *elegance*, usually got by playing up one or two of "good" painting's properties while neutralizing or eliminating, as nearly as

possible, the others. A vintage, ca. 1970 Ken Noland stripe painting, for instance, goes big in scale and juicy in color, while mechanizing paint handling and (almost) obviating composition. It looked fresh in its time (and still does), but the present-day strike-offs—all those paintings resembling off-the-rack Peruvian skirts—beggar our sensibilities and are about as interesting as four A.M. static on channel nine.

Another tack has been *straightforwardness*—painting so self-effacing and guileless that it charms us into forgetting this may be the umpteenth footnote to a theme by earlier full-disclosure painters like Robert Motherwell or Barnett Newman, or even a good recent one like Frances Barth. Straightforwardness, however, subverts itself quite easily; it slips into either pseudo-straightforwardness (an inside joke demanding an up-to-the-minute knowledge of art world fashion in order to perceive why a particular painting is innocent, that is, straightforward instead of trendy) or a form of needlessly visual Conceptual art. (The "Painting of the Eighties" exhibition was filled with such duplicitous or tactical paintings.)

A third approach simply and unabashedly celebrates painting's ability (or, more accurately, *paint's* ability) to create illusion; without dipping back into the fetid pot of figuration, it augments frothy impasto with low-angle spray, masks out areas which end up looking like masking tape, and, as seemingly necessary to an Abstract Illusionist work as an alligator to a polo shirt, throws in airbrushed shadows under squiggles of paint to make them appear to hover three inches off the picture's surface. It is ostensibly time-honored (although the difference between the Abstract Illusionists and William Harnett is that his devices didn't work *automatically*) and certainly arresting (if the double-take is our most profound esthetic experience, then these are the masterpieces of the '80s), but there is a great pitfall: the failure to distinguish between a work of art and a stunt. The *everything-but-the-kitchen-sink* gambit has no need for restraint; if a painting is a circus, three rings must be ten times better than one. Ultimately, there is no need to confine such compilations to paintings, especially when an artist like John Okulick can make a sculpture look like a painting trying to look like a sculpture.

One final way of attacking the problem of making a "good" painting without succumbing to its manifest clichés might, for lack of a more precise term, be called *fetish-ism*: adopting the look of obsessive, or ritualistic, or simply non-Western art-making activity. It can remain close to the bone of painting, restricting itself to the metronomically numbing task of applying, in hundreds or thousands, the visceral *Om* of an identical dab of paint, or roam as far afield as room-filling installation pieces flaunting beads, ribbons, feathers, stones, sticks and bones. Sometimes the conscious or semiconscious acquisition of primitive materials or devices to juice up urban art (i.e., whenever either the artist or the intended audience lives in a big city) doesn't seem expedient or exploitative; once in a while it results in a "good" painting which slips around the rules. But stealing pictorial modes from whole cultures or dressing up as a

shaman is not more noble or insightful than ripping off Malevich. A source is a source is a source.

Approaches like elegance, straightforwardness, everything-but-the-kitchen-sink and fetishism work for a while, but they become increasingly ineffective against the nagging doubt buzzing louder and louder in the painter's inner ear: what's the point in trying to defy predictability and boredom by painting a "good" painting, when a satisfying feeling of expression, or attracting a lot of attention, can be had by painting an *effective* painting? ("Effective," here, is admittedly something of an umbrella term—it covers paintings which get attention by being other things than "good"—and something of a tautology, i.e. an "effective" painting is discerned as such simply by its causing the question of what an effective painting is to occur in the first place.) Against the ever-diminishing effectiveness of the "good," the great, tempting counterweight of the "bad" is too good to resist.

By the "bad," I mean something a little broader than the same quotation-barnacled word used in The New Museum's exhibition, "Bad Painting," of 1978, which was limited to painting based on inept-looking drawing: I mean all those qualities *not* usually associated with the "good." I mean the opposite of the elements of "good" painting sketched above: trivially small or uselessly large scale, graceless or inert or unbalanced composition, garish or sour or random-seeming color, and indifferent or seemingly out-of-control paint handling. And I also mean something a little more calculated than painting which inadvertently redefines "good" by (to use an inappropriate metaphor) marching to the sound of a different drummer. "Bad" painting is more strategy than obsession (more strategic, in fact, than the devices used to expand the parameters of "good" painting), and it is so because it takes into account, indeed depends upon, the probable inability of its audience's taste to accept it as an enlarged version of "good."

The real world, because it is the real raw world and not the filtered one of art, offers more cultural sources for "bad" painting than it does for "good" painting: everything from the tackiness of commercial art imitating clichéd forms of fine art (e.g., those emporia hawking portrait sculpture made by a mechanized carving process based on a sequence of photographs of the model), to the raw, untutored, spleenish imperatives of restroom graffiti; everything from junior high school study-hall drawing (e.g., the excruciatingly detailed but proportionately awry ballpoint pen drawing of a drag racer, bathing beauty or decapitation scene done by a restless 14-year-old who forgot his textbooks for the free period), to the T-square-less layouts of fan magazines and depilatory advertisements; everything from yard sales of blond motel furniture to the crude modeling of chewing tobacco barn signs. (One form of "bad" is curiously absent from art galleries hip enough to traffic in irony: misinformed or expedient pastiches of "good" painting which fail critically but succeed commercially. The reason is the difficulty in trying to outflank the debilities of overused

"good" painting with painting which only exaggerates those flaws. How would the audience tell the difference among "good bad" painters, "bad good" painters, and the genuine article on both sides? On the other hand, a dose of Leonardo Nierman or Frank Gallo in some museum surveys of an even newer new wave might bring on a tide of revisionist sentiment for critically neglected masters like Fritz Scholder, M. C. Escher, Leroy Nieman and Yaacov Agam—to equal the historical reappraisal of Bouguereau and Cabanel.)

The inclusion, or adoption, of the "bad" is not new with American artists like Julian Schnabel, David Salle, Donald Sultan, Jonathan Borofsky, Jedd Garet, Kim MacConnel, Fred Escher, Robert Colescott, or Charles Garabedian (who made people in Los Angeles wonder whether he could *really* paint if he wanted to way back in the '50s); nor is it new with Europeans like Georg Baselitz (expressionism turned literally on its head), Markus Lupertz (whose "badness" is more like studentness), Sandro Chia or K. H. Hödicke. Francis Picabia, probably the best "bad" painter who ever lived, tried to stuff a stuffed monkey still-life up the noses of Rembrandt, Renoir and Cézanne (three of the most notoriously "good" painters, and therefore the kind of anathema to Picabia that, say, Jake Berthot, Robert Motherwell or Sharon Gold represent to the present-day "bad" sensibility), and then went on through a few decades' worth of edgily clumsy mechanical semiabstractions. The "bad" of Philip Guston's late paintings consists of his simple, awkward, psychologically charged figuration; though always, within the boundaries of his figural shapes, Guston's handling of paint is extremely "good," or decidedly accomplished. Larry Rivers, beginning in the late '50s, and Roy Lichtenstein, in the early '60s, made banality, the food of the "bad," a decisive part of their paintings, but Rivers artsified his French money and Camel packs with enough bits of "good" painterly business to satisfy the same Rembrandt he later parodied, and Lichtenstein edited, cropped, simplified and tightened the literal idiocies of *True Love* into one of the most durable approaches to "good" painting in the annals of modern art. And on the West Coast, there's been Joan Brown, whose work may prove how quickly what was once perceived as "bad" is critically assimilated and is now seen as charming and inventive.

Of the Pop artists, Andy Warhol looms as the most totally, deliciously "bad": wrinkled canvas stretching, clogged silkscreens, illegible *Daily News* photos, repugnant or corny or limp subject matter, and crass color. Warhol, however, suffuses the dish he cooks up with an unerring sense of graphic chic, and it is the Warhol of the slick shoe drawings, greeting cards and cookbooks, rather than Andy the neo-Dadaist, who emerges as the "good" chef. (Like Jim Dine, who started out more or less "bad," and has gotten more defiantly "good" with unmistakably old-masterish licks, Warhol's recent work is laden with a deftness unexpected by, and perhaps unavailable to, the wave of "bad" painters thrashing in his wake.)

Finally, there is the precedent of Chicago—Ivan Albright begetting H. C. Westermann begetting The Hairy Who begetting every third artist to show

on Ontario Street: critic Peter Schjeldahl refers to the current "badding" of SoHo as "the Chicagoization of New York," and painter Frank Owen says wistfully that the Midwesterners have been "snookered again" (meaning The Big Apple has looked over and overlooked "bad," seen its market potential, and gone out and laid down its own pipeline instead of sending to Illinois for the methane of *malerisch*). Chicago's Imagism is, however, usually tightly rendered, where the new wave of New York "bad" is loosely, even wildly painted.

Jonathan Borofsky, "I Dreamed I Found a Red Ruby," 2 color lithograph, 76" × 39½"
© Gemini, G.E.L. 1982 Los Angeles

There is one thing which Schnabel, Garet, Rivers, Warhol and the Imagists have in common, and that is that their underlying purpose—to make "effective" modern art that looks like it was made by an artist with special talents—belies the look of the "bad," and vice versa. The undeniable purpose (attended by such giveaways as the art's participation in a sophisticated gallery system, slick kromecote announcements, and the artist's having one or two degrees from an art school or university art department) most often turns a putative obsession into a strategy. What is supposed to look like a van Goghian, "I can't help it, in my emotional state I couldn't paint a cypress tree any other way even if I wanted to, and therein lies the power of my art," comes off more like the art director of *New York* magazine saying, "You know, instead of running a photograph, why don't we get one of those punkish magic-marker drawings to catch their eyes?" In principle, the adoption of the skin of the "bad" without actually being consumed by its guts is no more a hypocrisy than any other form of artifice in art. As "the willing suspension of disbelief" essential to our perceiving a bunch of actors prancing about on the stage as the court of Richard III is usually the result of the author's craft rather than his passion, it should be the visual artist's honorable prerogative to replicate dementia.

The big trouble with attempting to make significant painting via the "bad" is not that the "badness" is built rather than bled, but that it can at best only echo a real thing which exists outside not only the art world but sometimes art itself. Witness Henry Darger of Chicago, against whom "bad" artists like Fred Escher and Jedd Garet pale in comparison.

Darger died in 1973 at the age of 81, after a long and troubled life which included being sent to a home for feeble-minded boys and ending up washing dishes in a hospital. Discovered in the room in which he lived for 40 years were thousands of typewritten pages, single-spaced, and bound into 13 volumes, detailing *The Realms of the Unreal*, the saga of the seven "Vivian sisters" on a planet far from earth, their efforts to free thousands of child-slaves, and their sufferance of bondage, torture, even crucifixion at the hands of the "Glandelenians" and assorted other evil men. Recognized as a spiritual progenitor of the nastier aspects of Imagism, Darger's accompanying watercolors were given a posthumous exhibition at Chicago's Hyde Park Art Center, and chunks of his artistic estate were consigned to the dealer, Phyllis Kind, who has mounted two Darger shows. (Darger's pictures indicate about the same level of talent as his writing, that of a slightly precocious and wacko fifth grader—Darger's imaginative technique of working from actual newspaper and magazine imagery notwithstanding—and it's interesting to note that the literary world, apparently attaching less importance than the art world to the hipness of ineptitude, does not, to my knowledge, plan to publish the text.) Other examples abound: Lee Godie in Chicago, Elijah Pierce in Columbus, Ohio, and Ed Murphy (né Newell) and Lewis Palmer in California—*real* outside sen-

sibilities who would do the work they do, no matter what (to the sophisticated artist) the perceived unviability of semi-exhausted "good" painting.

It is too simplistic to designate art-world strategy the sole, or even dominant, driving force behind the present surfeit of "bad" painting. Hilton Kramer opened an emphatically favorable *New York Times* review of shows by Julian Schnabel and Malcolm Morley (a deftly painterly Photorealist gone loosely painterly Expressionist—whether that's "good" to "bad," I can't say) by noting:

> *At the heart of every genuine change in taste there is, I suppose, a keen feeling of loss, an existential ache—a sense that something absolutely essential to the life of art has been allowed to fall into a state of unendurable atrophy. It is to the immediate repair of this perceived void that taste at its profoundest level addresses itself.*

What has been allowed to atrophy is, of course, Expressionism. But there is a difference, say, between Nolde, with his attempt to reach a primal nerve, and David Salle, with his use of a recognizably debased source—i.e., pulp illustration. The reinfusion of gut, soul, pain, rage and plain ol' visual clout into an art form which, like painting, operates best with some esthetic distance (i.e., a screaming face painted in cadmium red light, with splatters, is not necessarily the best painterly equivalent of rage), and, if not esthetic distance, a genuineness, is not well served by a catalogue of disguises lifted from the art of the insane, the untutored and the jejeune, and coyly plopped down south of Houston Street, east of Michigan Avenue, or a block away from Ocean Front Walk.

When Richard Diebenkorn attempts another "good" painting, it succeeds or fails on simply how *good* (without the quotes) he paints it. Diebenkorn may by now be a bit academic, and it may be painters like Ron Gorchov or Elizabeth Murray who will manage to revitalize "good" painting by distilling and distancing elements of the "bad" and integrating them as positive components against the excesses of elegance, straightforwardness, *tours de force* and fetishism. It may even be that Murray and Gorchov are, underneath, conservatives and that some like Julian Schnabel (who is, on the basis of a wonderful red triptych called *Raped by a Zombie* in the Neumann Collection in Chicago, a very interesting painter) is rescuing painting from its doldrums. If he is, it will be for more permanent and less trendy, more thoughtful and less spleenish, and more fundamentally "good" and less superficially "bad" reasons, than the disingenuous dogma of the shadow Academy.

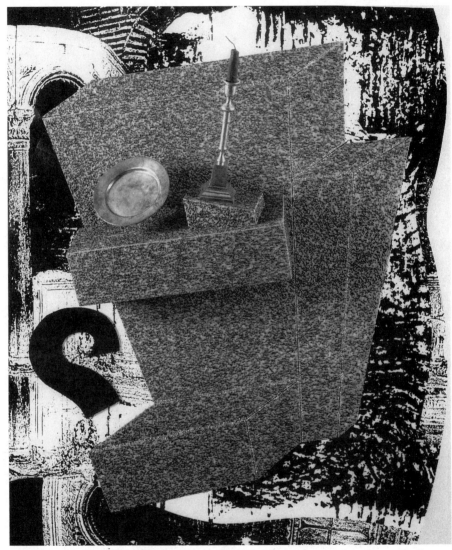

Jill Giegerich, *Untitled.* **1990 Resinite sandpaper, rubber, brass, photocopy, shellac on plywood. 59¾″(H) x 47⅛″(W) x 13½″(D)**

Courtesy of Fred Hoffman Gallery.

Determining Aesthetic Values

Henry Geldzahler

Curator, critic, and collector Henry Geldzahler grapples with the question of evaluating new and unfamiliar art—neoexpressionist painting, for example. Geldzahler's criteria for good art have nothing to do with modernism's insistence on purification and self-definition; nor do they involve overt analysis of politics, culture, and the media. He prescribes a firm grasp of art history and an understanding of oneself and one's times as necessary prerequisites for intelligent judgment. This general background makes it possible to judge the value of a specific work by its memorability, its ability to reveal new qualities over time, and the pleasure it gives day after day. For Geldzahler, quality in art is an experiential judgment and not based on *a priori* standards; one must employ one's own visual capacities.

Let me explain to you why I am addressing this subject. I was sitting in my office a few months ago and I received a call asking if I would give a lecture on a Sunday afternoon, because the lecture I had delivered in 1976 met with some success. I said, "Gee, I'll do that. It's months off, it'll never happen"—a very dangerous thing to say. I asked myself, "What is the question I am asked most often?" And that is, "What is Andy Warhol really like?" I couldn't possibly talk about that for two hours. So, barring, "What is Andy Warhol really like?" the question I am asked second most often is, "How can you tell if it's any good?"

Art historians taught me a long time ago that if you want to make a point forcefully, don't illustrate it. So what I will do is talk at a little distance; I'm going to try to enunciate some principles; I'm going to get bogged down in

Reprinted from Henry Geldzahler, "Determining Aesthetic Values," *Interview* (November 1982). (This is an edited transcript of a lecture delivered at the Yale University Art Gallery in January 1982.)

anecdote and autobiography, and at the end, I'm going to indicate that it's all anecdote and autobiography, and the principles have to be arrived at individually. I will try to tell you, not what I know about looking at pictures, but what I can verbalize. Some of this will sound very pedestrian and some of it might even sound insightful. I'm not going to make any distinction.

There are two prerequisites for having any sense of what is of value and quality in your own time. The first is a firm grasp of the history of art. The firmer the grasp you have and the better grounded you are in every conceivable period, the less shocked or thrown off base you're going to be by something that appears to be new but *isn't* or that is meretricious in any of a dozen ways. A grounding in the best art that's ever been done, hitting your head against the concrete wall of achievement, there's absolutely no substitute for it. It means living in or visiting metropolitan centers. You can not learn this from slides; slides are the history of images, not the history of art. The history of art is contained in works of art, which are unique. Such things as texture, condition, the presence of a work of art, its size (all slides are the same size), the scale of the work, the *presence*—the physicality of it on the one hand and the aura on the other—these things are transmitted only in a one-to-one relationship with the work itself.

The other prerequisite you must have in order to come to terms with contemporary art is a thorough sense of who *you* are in your own time. And to combine those two attributes in one person is not easy. The greatest poetry available to us at any given time, from the point of view of relevance, is probably the poetry written that day, because it speaks to our own condition most intimately and proceeds from common presuppositions. It might be very difficult to come to terms with it, it might even be difficult to find it. What magazine is it in? Who's going to point me in that direction?

But it is to the music of our time, the art of our time, that our greatest responsibility lies. Now in order to be a sensitive barometer of recent art, in taste and in experience, you've got to be pretty tough on yourself. You can't let yourself get away with too much psychological flimflam. The terror, the fear, the exaltation (in a drug culture, sometimes even the use of drugs; in a culture that's heavily psychoanalyzed, perhaps a dose of psychoanalysis)—there are all kinds of doors through which one has to go in order to have the "contemporary" experience, if you will, and this has been true of every period.

The best summing up of what in the contemporary art of any period that's so exciting is the Ezra Pound paraphrase of Confucius, *Make it new.* *Make* is to fashion. *It* is tradition, or the craft, the history. And *new* is. . . . Make it new, constantly make it new. If the artist makes it too new, then we're going to have to chase to catch up with it, or, it may be mere novelty. If the *it*, the craft, dominates to such an extent that it makes it difficult to see the contemporary content, then it might take a while longer to catch up. But make it new. I sometimes call it "Tickle the Sleeping Giant." The Giant is the history

of art, the canon that we've inherited. The Sleeping Giant is the Metropolitan Museum of Art collection; the *tickle* is the contemporary art section.

To make it new one must be in touch with a tradition while, at the same time, knowing exactly who you are and what your own time is about. Those are the beginnings, and they're not easy. They're the hard part. Now come a couple of rather more pleasant rules because they can be easily encapsulated.

How do you tell the value of contemporary art? One of the ways I've discovered is memorability. If you look and can remember, a month, a week, a day later, the way it's made, the way the forms fit, the color-message of the picture, then it's probably good. It's a little like leaving *Traviata* or *La Boheme* whistling the tunes. They're memorable. If a work calls itself to memory without your asking it, if it insists, if it comes back like a melody, then that's quite serious and you probably have to buy it. Memorability is very important. If you're impressed with a work of art on the spot, and it leaves you with nothing when you're gone, chances are it's not very good.

On the other side of the coin is what Clement Greenberg calls the *narrative* element in art and this principle holds true for the most abstract painting as well as the most representational. The work of art must continue to reveal new messages and images on subsequent viewings, and not exhaust itself in what I call the Big Bang, revealing everything to you the first time you see it and then having a lessened impact each time subsequent. The narrative, or the story, is how a picture reveals itself to you through time. The story is in *you*. It's an internal story and only you can judge it. A Kenneth Noland, for instance, has a rather simple geometric layout which could probably even be explained over the telephone to someone; and yet there's an awful lot about a Kenneth Noland that *can't* be explained over the telephone, an awful lot that grows on you on subsequent viewings.

Another helpful thing to remember, and this comes again from an intimate knowledge of the history of art, and also from a knowledge of your own time, is to recognize the cycles, the swing of the pendulum. It's no accident that taste in art changes. This happens on a rhythmic basis but not in a predictable way. One can't construct a *Farmer's Almanac* calendar to say that in the fourth decade of the 21st century we'll be back to the figure, or classicism, or something like that. But if you look back through the history of art, you begin to see the ways in which the cycle exists in time. Some cycles take in fifty years, others ten or fifteen years. If you understand the necessity and inevitability of these cycles, you won't be terribly surprised when something happens, yet it's foolish to predict, and critics who try to predict are, I think, in up to their eyeballs. Because it is only the genius, the artist in the studio, who is creating the new rules of his or her generation. And even *he* can't tell you what he's going to be doing three days from now. He (de Kooning, Pollock, or whomever), at the time he is creating, will, in spite of a grasp of his own intention, in spite of the fact that his hand and mind and eye are in perfect control, will surprise himself, will find that there is more happening on the canvas than

LAURENCE DREIBAND,
Eucalyptus Study 21. **15
inches square (framed).
Charcoal on Coventry Rag
Paper**
*Courtesy of Turner/Krull
Gallery, Los Angeles*

he knew he was putting in. There are more gestures, more references: he has ingested the history of art more thoroughly than he has realized. And for the critic to say, "It's time to return to the figure," or "It's time to do this," or "The next thing is going to be that," is completely off the wall, I think. Samuel Butler said that the history of art is the history of revivals. That's a rather sophisticated remark. It's not quite true—it borders on Oscar Wilde—but there is some truth to it.

The idea is not to anticipate the new, because we've just decided one can't do that. Instead, one should endeavor to recognize the inevitability of the new once it occurs. This is inevitability after the fact. The quicker you can do this, the more in touch you are with what's going on. To rear back and say, "No, no, this can't be art!" is something you have to live through a few times, until your skin is formed and your eyes are renewed in such a way that you can deal with it. But don't try to shorten that time, because it's fruitless. The art won't go away. Once it's there, it's up to you to catch up with it. It doesn't mean that everything that's touted as new is going to be first-rate, either. To anticipate is impossible. To be able to fit it into the history of art, recent and past, once you've seen it, is what I call Retrospective Inevitability.

There is another exercise if you want to judge the quality of a work of art. It's terribly expensive and very few of us can do it: buy the art and live with it. If you're not sure about something and it hangs in your bedroom or it's on the way to the kitchen and you see it every day, consciously or not, it will either disappear and you'll never see it again or it will impose itself on you. For about

fifteen years, I had a painting by Hans Hoffman in my bedroom. It was over the mantle and—I mean this literally—it was like getting fresh flowers every day. It had a continuing presence, a continuing growth and importance in the world of images that I carried around with me. Something we find people doing increasingly, is buying what they can afford—the decorative arts. Decorative art, the occasional piece—the vase, the ashtray, the doorknob, whatever it is that attracts your attention—if you're not sure about it and you're in a position to do so, buy it for ten or twenty dollars and leave it on the table. Your sense of quality in that area will speed up very quickly. Your ability to zero in on that which is cute and burns itself out quickly, or that which has what Clive Bell calls significant form, will be a very useful lesson.

The one thing you must never fear is, if a work of art gives you pleasure, that it must be soft, it must not be good. There is nothing wrong with pleasure. That a beautifully colored Rothko gives us more pleasure than one of the late dark ones doesn't automatically make the late ones better, although there's a lurking suspicion in our minds the more austere Rothko should be liked better. One thing you musn't do is fall for the artist's trick of saying, "Love me, love me, I need you." That's a kind of false pleasure. It's where the color becomes so lush and so soft, so *overdone*, that you realize the artist is crying out in his loneliness for some relationship with you, and there you have to spurn him or her.

The single-bang art work is the titillator. I also call it the one-joke work. Beware of the new that is new by virtue of only one characteristic. A Lowell Nesbitt painting of a Georgia O'Keeffe-like flower blown up to ten by eight feet—sure it's new; no one's done a Georgia O'Keeffe ten by eight feet before. But is that enough? Another example is the famous *Time* magazine invention of Op Art (which followed Pop Art), that never happened. It never existed. It was a question of visual titillation, an abstract version of the Christ portrait blinking at you as you cross the room.

Another big-bang aspect of a work of art can be the high-tech finish. No one's ever been as shiny as a Trova, but is that shininess enough? If you want to think in an art historical way, think about a Trova standing next to a sculpture by Oskar Schlemmer. In thinking about Schlemmer's complexity of forms, the Trova disappears.

Just now, at Grand Central Station, I saw an enormous billboard for a Kodak photograph; it was very exciting—a red farmhouse in the snow. I got a bang out of it. I thought to myself, "I'm giving this lecture, let me test this picture." I looked away and kept looking back. I found that, technologically, to be given the sense of an enhanced ability to see, that alone can give you an aesthetic chill: but it doesn't last. What can give you an aesthetic chill that lasts is the Flemish, the Van Eyck idea of reality, lending people the ability to see in sharp focus the distance, the middle ground and the foreground all at the same time. That, combined with the subject matter, with the quality of the paint, the way it's put down—all contributes to the greatness of Flemish paint-

ing. A huge and very beautifully photographed and reproduced shot of a farmhouse in the snow doesn't continue to reveal. It doesn't have a story in time. As a matter of fact, it rapidly wears itself out. An original is Dubuffet, for instance; it was both new subject matter at the time it was done, and presented in a way that was new formally. I don't know how Dubuffet looked when he first appeared in 1945; I would think rather shocking. But the thing that's so extraordinary is that there is no art that remains shocking for more than ten or twelve years. There is no shocking art that doesn't reduce itself either to triviality or to beauty. The apocalyptic wallpaper, which was the impression people had of Pollock, now becomes the rather lacelike, choreographic painting to which the history of art gives its imprimatur of high achievement. This makes some artists furious, because they would like to be a termagant, an angry interpreter for all eternity. Time has a way of calming things down.

Some of the most challenging hours I had as a student were in a connoisseurship course at Harvard with a man named Jacob Rosenberg. Jacob Rosenberg was the curator of prints at the Berlin Museum up to 1937, or however late Hitler allowed him to hold the position. He then went to England and from there came to Harvard. His two volume Rembrandt biography remains the finest. Rosenberg's connoisseurship course consisted of an hour of slides, five minute viewings of a Rubens drawing alongside a Rubens copy, a Rembrandt drawing and a "school of Rembrandt." You never knew which slide would be on which screen. After an hour of writing down your impressions, you spent the next two hours discussing what it was that led you to think the one was a Rembrandt, and the other the school of Rembrandt. It was one of the most useful exercises I've ever had. Rosenberg was able, in his Cuddles Slezak accent and manner (the jovial waiter in *Casablanca*), to speak about things like linear variety, and the many other categories that animate works of art, and that have to be present in every work for it to be first-rate. His writings on connoisseurship are indispensable, and I highly recommend them. It doesn't help when you're confronted with a new work to force yourself to think about rhythm and variety, because your mind quickly turns to mush that way. But as a way of rationalizing after the fact what it is that attracts you to something, these methods truly work.

The Fogg Art Museum at Harvard keeps a large collection of fakes. It's a fascinating subject, and it taught me a great deal about the complexity of esthetic values in great works of art. No matter how good a fake might be on the day it is made, it is quite easy to spot 25 years later because forgers always assume the presuppositions of their own time. Rembrandt is far more complicated than any faker can possibly recreate; therefore, an 18th century forgery of a Rembrandt and a 19th century forgery of a Rembrandt look very different, because one is done from the point of view of Boucher and Fragonard, and the other from the point of view of Delacroix. In other words, there's enough in Rembrandt to allow the copier to move around and find what it is that will

appeal to his generation. One doesn't do this consciously, but because it's the only thing one *can* do—see it in one's own time.

The truth is—and all of us know this—one gets so much more information in the blink of an eye than one can verbalize in hours and hours. You have to learn to trust that totally systemic way of looking. It may take weeks for the elements that make up a work to shake down to the point where they can be verbalized, to where you can be persuasive (first of all to yourself, and then to a neighbor) about what it is you like in a work of art. But there is no substitute for what we were talking about in the first place, which is the intimate knowledge of the history of art and the constant renewal of one's mind and eye through looking at works of art in the great museums.

A frequent question I am asked is "Can a sense of quality be transferred from one area to another?" I think it can. It's hard to talk about, but I have a wonderful example. I helped assemble the Woodward Family Collection in Washington, D.C.; they hired me in 1962, when Mrs. Woodward was 62 years old. She had a wonderful collection of 18th century French drawings and furniture. They wanted to collect American art to lend to embassies abroad. They knew there was something new going on; they didn't understand it, but they wanted to learn. I would bring them Rauschenbergs and Gottliebs and Stellas back in 1962 and 1963. And Mrs. Woodward was able to abstract something that had to do with consistency—with a feeling of authority in an important work of art—some series of intimations she was able to transfer from her impeccable knowledge of 18th century French furniture, that enabled her to say, yes, yes, yes, and occasionally, no. I was very impressed with her. That was the most vivid example I've seen of someone who was able to transfer a sense of quality.

Are critics a help? One of the most shocking things I hear is, "Did you see So-and-so got a wonderful review?" Reviews are written by reviewers. A reviewer is just you or me having an opinion; it can be more or less articulate. We don't live in a culture where our reviewers have the ability to stand on our shoulders and see further than we can. We're not talking about Baudelaire or Apollinaire, we're talking about somebody on the local paper who equally might be writing about fashion or movies. Here's a review of the first *La Boheme*, in 1894, written by a man named Carlo Bersezio, the foremost Turin critic of the time:

> *Just as it makes only a slight impression on the spirit of its listeners,* La Boheme *will leave only a slight trace in the history of opera. The composer would be wise to consider it a momentary mistake and continue boldly on the right path.*

Another reviewer was a man named Wolf, who wrote about a Degas exhibition: "Does Mr. Degas know *nothing* about drawing?"—which is something David Hockney likes to quote whenever he gets a bad review. "*Does Mr. Degas know nothing about drawing?*" So much for reviewers.

John Canaday (he preceded Hilton Kramer as a critic at *The New York Times*) wrote about my *New York Painting and Sculpture 1940–1970* show, the week before it opened, "Rumor has it that Henry Geldzahler's *New York Painting* show is the biggest booboo of the year." A critic who says "rumor has it" is somebody in a very special category. John Canaday used to fulminate in articles against curators and critics who actually know artists. He felt you should not know artists because that's going to prejudice you in some way. The critic should be Jovian, above in a helicopter, never on the ground, seeing things only from a great distance. I feel exactly the opposite. It's the artist who teaches you. When somebody said to me, "Why does Frank Stella have more space than any other artist in the *New York Painting and Sculpture* show?" I said, "Why shouldn't he? He's my best friend." That was a joke. But what it means, in part, is he's my best friend because he teaches me the most; he teaches me the most, therefore I respect him the most.

In the early 1960s, there was a New Zealand artist called Billy Apple. Billy Apple's real name is Barry Bates. He took the name Billy Apple because it was such a fascinating name. He came to New York in 1961. Pop Art was first shown at the Sidney Janis Gallery in early 1962. In the second or third month of '62, Billy Apple came to my office at the Metropolitan Museum and said, "Do you think Sidney Janis would like a painting about eight by ten feet of rows of 7-Up bottles?" I said, "Why? Do you think it's not worth making without knowing in advance whether Sidney Janis will like it? By the way, Andy Warhol has done the same thing with Coke bottles." "That's totally different," he said, "that's *Coke* bottles." He also once told me he turned down a studio in the same building as Jasper Johns because he didn't want Jasper "traipsing through his studio stealing his ideas." What could have happened to a genius of that quality I don't know, but I'll never forget him. I told that story to Frank Stella, at the time, in 1962, and Frank said, "There are no good ideas for paintings, there are only good paintings." The datum is the work of art.

The enormous luck I had in coming to New York in the summer of 1960 was in what George Kubler in his great book, *The Shape of Time,* calls "the happy entrance." I made a happy entrance. It was at a moment when the ground rules were changing. Just when it looked like abstract art was going to go on forever, when it looked like de Kooning was going to dominate forever, Frank Stella was laying down new rules and Helen Frankenthaler was putting color down in a new way and Andy Warhol and Roy Lichtenstein were opening other horizons. If I'd come in three or four years earlier I'd have identified myself with the older generation and I would have been as shocked by the new as anybody else. As it was, I came in with no prejudices, as a *tabula rasa*, a blackboard ready to be written on. It was a happy entrance because the guys with the chalk happened to be making good images and inventing new rules. That's also in the Kubler book: if you think of the history of art in terms of game theory, then it's extremely exciting to be in a place where the old game is exhausted—you can't make any moves because they've all been made

before—and a genius comes along, clears the board and says, "Now we're going to play the game *this* way." That's what happened in 1959–60. It took fifteen or eighteen years to exhaust that game.

The first audience for art is clearly the artist who creates it. Then it's his intimate friends and the other artists who are near him. It usually takes two or three years for the work to trickle out of the studio into the public arena. With Pop Art it took about a year and a half, and that was with the high-geared engine that is the New York City art world and the international art world training full view. Virtually the whole thing happened under the television cameras. It's quite amazing. When I first met the various Pop artists in the summer of 1960 they didn't know each other. I was able to introduce Lichtenstein to Rosenquist; Warhol didn't know Wesselman. It was a very exciting moment. And within a year and a half there was a symposium at the Museum of Modern Art and I was defending Pop Art, a young curator from the Metropolitan Museum going down to the Modern. That's when I knew something was wrong—when the Museum of Modern Art set up a symposium to try to tear down this new Pop Art, which Hilton Kramer and Dore Ashton and Peter Selz all said had no merit. I said, "Look, it's definitely art. Time will judge whether it's good art or not. There's no point in going crazy over it." The real anger was in Peter Selz because Peter is a German art historian who wrote a good book on German Expressionism. Peter's point in the late Fifties was, "We must return to humanism. We must have the new content of the agony of today in the works of art." The next thing would be no more abstraction. You have to remember that in '55, '56, '57, it looked like Pollock and de Kooning and Kline were going to dominate forever, that we were in a tunnel and there was no way out. The second generation Abstract Expressionists were the only answer. For Jasper Johns and Rauschenberg, Frank Stella and Helen Frankenthaler to come up with *their* option, and the Pop Artists with the other, was very disorienting to a good fellow like Peter Selz who wanted something else. He wanted Leon Golub and the new humanism to triumph.

It turned out that Peter was right. We *did* need a new figurative painting. But it was what he hated most in the world. It looked like a celebration of what was most banal and second-rate in America: the poster, the billboard, television. Jim Rosenquist, Lichtenstein. Horrors! We did have new figuration, but it was as antihumanist as the abstraction was. That new humanism was on the way but it only arrived recently.

In both Germany and Italy in the late Sixties and Seventies a figurative movement has been building. In Italy the artists who are best known and are beginning to have shows in New York galleries are Clemente, Cucchi, Chia and Palladino. The Germans include Lupertz, Penck and Baselitz. They're fascinating artists and they've taken a long time to get to New York.

This relates to the quality of the subject once again. These are the artists I've been seeing in the last couple of years who have challenged me most, who have made it most difficult for me to continue saying the same things I've been

saying about today's art. It has changed the ground we stand on. And this is the most you can ask from new art, that it force you to rethink your presuppositions. The idea that America, which has dominated the visual arts since the 1940s, should have a reverse river flowing from Germany and Italy (particularly those two countries), were against the grain of the preconceptions we were living with from the Forties through the Seventies. It's quite helpful, even salubrious, to be brought up short that way. These are artists you're going to be hearing more about. Robert Hughes in *Time* magazine fulminated against them a few months ago with such anger and passion and with such an excellently honed scalpel, I think it's possible he might turn around and embrace them in a year or two. In order to have put them down so exquisitely, he must really have thought about them. And the odd thing about the art you hate is sometimes you can begin to love it.

What I find so exciting about the Italians and Germans is that it's as if their art skips over the war generation, back to their grandfathers. It's as if these German Expressionists are continuing what Nolde and Schiele and others were doing in the Twenties and Thirties before Hitler came along. It's as if they are the conscience of their age, wiping out the 40 years they hate. The same is true with the Italians who look to the metaphysical paintings of the Teens and Twenties—not only de Chirico, but di Pisis and Carra and Savinio.

It is often the artists themselves who reveal to us what we've been missing. A famous example is Mendelssohn, who revived Johann Sebastian Bach because he needed him. Mendelssohn was inspired by Bach. The *St. Matthew Passion* wasn't played from 1750, when Bach died, until 1829, when Mendelssohn conducted it exactly one hundred years after it was written. Mendelssohn needed it to justify *Elijah* and *St. Paul*, his great oratorios. And it was Cezanne who was partly responsible for bringing us to Poussin again. Artists are extremely good at pointing us in a fertile direction. Sometimes the new is not really new at all, but the old seen in a new way.

Ellsworth Kelly, who couldn't be more of an artist in a different tradition, helped me to see the German Expressionists in a new way, and prepare me for what was coming. I was never a Max Beckmann fan, but one night a few years ago, Ellsworth sat me down with a 300 page drawing catalog of Beckmann and we looked at every single drawing. I was looking at Max Beckmann through Ellsworth Kelly's eyes. He lent me his eyes for the evening, truly. And in a way it prepared me for these German artists—these new Expressionists.

I think we're in the throes of writing a new game. These German and Italian artists have their equivalent in New York—Julian Schnabel and David Salle, both of whom are showing at Mary Boone and Leo Castelli. They are young artists, and each is bringing a sense of complexity and texture out of the Western tradition of figurative painting and are putting it back into their work in new ways. They look a little vulgar, a little off-putting now, in a way that is challenging. I know I started off with Julian Schnabel with the same resistance I had for Frank Stella's Black paintings: I said, "Uh-uh, uh-uh. I know a lot

about art, and one of them is that you can't break plates or paint on velvet." It turns out you *can*.

One of the reasons I left the Metropolitan Museum after 17 years was that I wasn't in touch with the art of the Seventies as I had been with the art of the Sixties. I didn't feel that the art that was being made was something I vibrated with in a very elemental way. As a matter of fact, I realized after I put up my *New York Painting and Sculpture 1940–1970* show that an epoch was over. While Olitski and Motherwell and others continued to paint wonderful paintings in the Seventies, their styles had been posited earlier. I wasn't quite in sync with what the Minimalists were doing, or the earth artists or the various other movements of the Seventies. And I wasn't going to be the curator of 20th century art at the Met who went around bad-mouthing American art. So when Ed Koch asked me to move over to city government, I knew it was time to do something else. When asked by the news media how it felt to be entering politics after 18 years in the ivory tower of the Metropolitan Museum, I replied that after 18 years in politics, it felt good to be entering government.

Imagine, then, my gratitude to a young curator named Diego Cortez when he assembled a show in 1981 at P. S. 1 in Queens, called *New York/New Wave*. He's a good twelve years younger than I am, and he's a good twelve years older than the artists he's shown. Diego's real name is James Curtis; he's an Episcopalian boy from Illinois who couldn't get anywhere in New York as James Curtis, so he changed his name and doors swung open: that's a 1980's success story. I purchased several works out of his show, and now have hanging in my apartment paintings (and sculpture) by many of these young artists. I'm using my test of How do you live with them? The answer is they jolt me; every time I see them I get a shock. It's a shock of newness, a shock of quality, but also one of recognition. I don't say that they are the greatest artists who ever lived, but they have plugged me into a contemporary ethos I wasn't aware of.

We are living in an exciting and formative period. I call this a Golden Age. Let's not make the mistake of missing it.

Honor, Power, and the Love of Women

Craig Owens

Critic Craig Owens regards neoexpressionist painting not as spontaneous expression but as self-conscious utilization of the codified techniques of expression necessary in order to gain acceptance in the art market. Rather than expressing a commitment to negating the authority of dominant cultural institutions, neoexpressionism functions as an escape from social and economic realities. Rejecting the modernist belief in science and technology, it is characterized as a retreat to fantasy rather than an examination of what Owens believes is the proper subject matter of contemporary art: power, authority, and domination.

In 1911, just as the Expressionist movement was gaining momentum in German-speaking countries, Freud speculated that the origin of the creative impulse lies in frustration, a sense that reality is impervious to desire:

> The artist is originally a man [and we will soon discover why, for Freud, the role of artist is invariably masculine] who turns away from reality because he cannot come to terms with the demand for the renunciaion of instinctual satisfaction as it is first made, and who then in phantasy-life allows full play to his erotic and ambitious wishes. But he finds a way of return from this world of phantasy back to reality; with his special gifts he moulds his phantasies into a new kind of real-

Reprinted from Craig Owens, "Honor, Power and the Love of Women," Art in America (January 1983).

This text is a revised version of a speech delivered on September 22, 1982 to the Society for Contemporary Art, the Art Institute of Chicago. I would like to thank Courtney Donnell for inviting me to address that audience. I would also like to thank Barbara Kruger, without whose work and conversation parts of this discussion would not have been possible. C. O.

ity, and men [the spectator posited here is also masculine] concede them a justifi-cation as valuable reflections of actual life. Thus by a certain path he actually becomes the hero, king, creator, favourite he desired to be, without pursuing the circuitous course of creating real alterations in the outer world.[1]

When he assigns art a compensatory role, Freud appears merely to repeat the basic error of Western art theory (Hegel: "The necessity of the esthetically beautiful [derives from] the deficiencies of immediate reality").[2] Why must art always be defined as an *alternative* to reality? Sometimes art is a *recognition* of reality, a mode of apprehending and of representing it. And why do we tend to neglect the fact that works of art always exist as *part of* the material world? Thus, Freud's treatment of the artist could easily be indicted for complicity with philosophical esthetics. Such an indictment, however, would have to overlook what is truly original here: Freud—like the Expres-sonists—situates art not in relation to reality, but in relation to *desire*. Even more importantly, he locates it in relation not only to the artist's desire, but to the spectator's desire as well. The work of art is the token of an intersubjective relation between artist and spectator; the investigation of this relation is the task of a properly psychoanalytic esthetics.[3]

However, the desire that Freud attributes to the artist and the source of the pleasure he attributes to the spectator are by no means unproblematic. Both are motivated, he proposes, by a (masculine) desire to be a hero. The artist's hopes of royalty and of mastery were explicitly stated in 1911 ("hero, king, creator, favourite"). Six years later, when he reiterates this definition in the *Introductory Lectures on Psychoanalysis*, Freud will have more to say about the spectator's pleasure; in Lecture 23 he writes, "[The artist] makes it possible for other people once more to derive consolation and alleviation from their own sources of pleasure in their unconscious which have become inacces-sible to them." That is, the spectator recognizes the desire of the artist repre-sented in the work as his own (repressed) desire, and the lifting of repression is invariably accompanied by a sensation of pleasure. Esthetic pleasure, then, is essentially narcissistic: it arises from the viewer's identification of his own desire with the desire of the other (in this case, of the artist). (Elsewhere, Freud writes of the spectator of *Hamlet*: "The precondition of enjoyment is that the spectator should himself be a neurotic.")[4]

Since the desire to be a hero is shared by artist and spectator alike, it is tempting to regard it as innate and immutable—to posit a universal human desire for mastery. There is, however, an alternative to this essentialist read-ing; for it is Freud who has taught us (through Lacan) that desire is a *social* product, that it comes into the world because of our relations with others. What is the source of the artist's desire, then, if not the sense of frustration that Freud locates at the origin of the work of art, his sense of powerlessness to achieve in reality what he desires in his fantasy? His desire to be a hero, then—"to feel and to act and to arrange things according to his desires"[5]—

arises only because he believes he *lacks* this power. (Lacan: Desire is lack.) And when this lack is represented within works of art, it will tend to be confirmed, that is, posited as (the) truth. Such works will also tend to reinforce the spectator's sense of his own impotence, *his* inability to create real alterations in the world.

We are all familiar with the popular diagnosis of Hitler as a frustrated artist (*verhinderter Künstler*): had he been able to sublimate in art his desire for power, the world might have been spared much anguish. Recently, this conceit has "inspired" a number of art works, most ostentatiously, Hans-Jürgen Syberberg's epic film *Our Hitler*, in which the führer is represented as history's greatest *filmmaker*.[6] (As I have argued elsewhere, Syberberg's work has much in common with that of the German "Neo-Expressionists.")[7] Such works estheticize, and thereby neutralize, the machinations of power; they also invert Freud's formula. For in the passage cited above, art is treated not as a sublimation of, but as a *realization* of desire; thus, the twenty-third lecture on psychoanalysis concludes: "[The artist] has thus achieved *through* his phantasy what previously he had achieved only *in* his phantasy—honour, power, and the love of women."

Sandro Chia's *The Idleness of Sisyphus* (1981) appears to confirm Freud's speculations on the artist. Not only does the painter's recourse to classical myth testify to his withdrawal from reality into a realm of subjective fantasy (the language of depth psychology is also the language of myth); what is more, Chia clearly identifies his own activity with that of a classical *hero*—Sisyphus, the Corinthian *king* condemned to eternal repetition. For it is not difficult to recognize in Chia's protagonist, as he struggles with a mass of inert, recalcitrant material, a displaced representation of the heroic male artist—a role Chia himself has rather pretentiously assumed, at least in interviews and public appearances.

Remember Sisyphus's crime and punishment: for (twice) rebelling against Death, he was sentenced eternally to push a giant boulder up the side of a mountain, only to have it roll back down again as he approached the summit, to the great amusement of the gods. Thus, if the Sisyphus myth can be said to represent Chia's own desire for royalty and for mastery, it also represents the sphere of perpetual frustration in which that desire is operative.

In Albert Camus's *The Myth of Sisyphus*, an extended philosophical argument against suicide composed in 1940 (that is, in the same year that France surrendered to Germany), Sisyphus is treated as the perfect embodiment of the modern (i.e., Existentialist) hero, who confronts without flinching the absurdity of his existence. Yet Camus's recourse to classical myth works to transform his hero's inability to change the world from a historical into a metaphysical condition, the origins of which remain shrouded in mystery. In the same way, Chia's invocation of Sisyphus projects frustration as a permanent state. In both Camus and Chia, then, myth objectifies psychology, while psy-

chology validates myth; both exist, however, in relation to an evacuated historical dimension.

This reading of Chia's painting is complicated, however, by the fact that his Sisyphus is a comic rather than tragic figure. Camus interpreted Sisyphus as an image of hope beyond hopelessness, of comfort and security in desolation. Such pathos is totally absent from Chia's treatment of the same myth; with his silly grin, business suit and diminutive fedora, his Sisyphus combines the physiognomy of the clown with that of the petty bureaucrat. Thus, Chia does not defend his hero but ridicules his blind obedience; the artist sides not with the suffering of the victim, but with the laughter of the gods.

Chia appears to ridicule the artist-hero in the same breath that he proclaims his resurrection. Here, we encounter the fundamental ambivalence that sustains the current revival of large-scale figurative easel painting, its perpetual oscillation between mutually incompatible attitudes or theories. Interpreted as irony, this ambivalence is sometimes summoned as evidence to support the thesis that painters like Chia are engaged in a genuinely critical activity; thus, *The Idleness of Sisyphus* has been interpreted as a "Dada cartoon designed to subvert the conventional mythic image."[8] Maybe I am taking Chia's painting too seriously, then; it is, after all, only a joke. Perhaps—*but at whose expense?* (Freud: Jokes are historically a contract of *mastery* at the expense of a third person.)[9]

In *The Idleness of Sisyphus* Chia debunks the (modernist) belief in progress in art—a belief which he and his colleagues emphatically repudiate. It must be stressed, however, that Chia is not critical but merely contemptuous of the ideology of progress; thus, he simply substitutes repetition (Sisyphus) for progress. If the social program of modernity can be defined, following Max Weber, as the progressive disenchantment of the world by instrumental reason, cultural modernism was also a demystification—a progressive laying bare of esthetic codes and conventions. In *The Idleness of Sisyphus*, however, Chia counters modernist *de*mystification with an antimodernist *re*mystification. Progress is exploded as (a) myth; Chia's painting is a joke, then, at the modernist painter's expense.

But because he identifies himself with Sisyphus, Chia seems to be indulging in *self*-mockery as well. Either way, *The Idleness of Sisyphus* testifies to the painter's ambivalence about his own activity, to a lack of conviction in painting—a lack Chia shares with most artists of his generation. (This is what links him with painting's supposed "deconstructors"—Salle, Lawson, et al.) And once we have acknowledged the prevalence of this attitude, how long can we continue to account for Chia and his colleagues' extraordinary prosperity— for these artists have indeed won "honour, power, wealth, fame . . ."—simply by positing some insatiable "hunger for pictures"?[10] Must we not speak instead of a more fundamental *contempt for painting*—a contempt which is shared by artists and audience alike?

The Idleness of Sisyphus alerts us, then, to what is at stake in the current revival of so-called Expressionist painting and its widespread institutional and critical acceptance. (Chia's painting was immediately acquired by the Museum of Modern Art; this is not only a measure of his success, but also an indication that the institutions—and the critics—that support this kind of work must be named as its collaborators.) Artists like Chia construct their works as pastiches derived, more often than not, from the "heroic" period of modernism. Chia favors Boccioni's dynamic Futurist line in particular, but he plunders a wide range of antimodernist sources as well—late Chagall, reactionary Italian painting of the '30s. The modern and the antimodern exist side by side in his work; as a result, they are reduced to absolute equivalence.

In Chia's work, then, quotation functions not as respectful *hommage*, but as an agent of mutilation. What Russian formalist critic Boris Tomashevsky wrote of the epigone seems applicable to the pasticheur as well:

> *The epigones repeat a worn-out combination of processes and, as original and revolutionary as it once was, this combination becomes stereotypical and traditional. Thus the epigones kill, sometimes for a long time, the aptitude of their contemporaries to sense the esthetic force of the examples they imitate; they discredit their masters.*[11]

Chia, Cucchi, Clemente, Mariani, Baselitz, Lüpertz, Middendorf, Fetting, Penck, Kiefer, Schnabel . . . —these and other artists are engaged *not* (as is frequently claimed by critics who find mirrored in this art their own frustration with the radical art of the present) in the recovery and reinvestment of tradition, but rather in declaring its bankruptcy—specifically, the bankruptcy of the modernist tradition. Everywhere we turn today the radical impulse that motivated modernism—its commitment to transgression—is treated as the object of parody and insult. What we are witnessing, then, is the wholesale liquidation of the entire modernist legacy.

Expressionism was an attack on convention (this is what characterizes it as a modernist movement), specifically, on those conventions which subject unconscious impulses to the laws of form and thereby rationalize them, transform them into images. (Here, convention plays a role roughly analogous to the censorship which the ego exercises over the unconscious.) Prior to Expressionism, human passions might be represented by, but could have no immediate presence or reality within, works of art. The Expressionists, however, abandoned the simulation of emotion in favor of its seismographic registration. They were determined to register unconscious affects—trauma, shock—without disguise through the medium of art; with Freud, they fully appreciated the *disruptive* potential of desire. Whatever we may think of this project today— whether we find its claims to spontaneity and immediacy hopelessly naive, or whether we believe that the Expressionists actually tapped a prelinguistic reserve of libidinal impulses—we should not overlook its radical ambition.[12]

In "Neo-Expressionism," however—but this is why this designation must be rejected—Expressionism is reduced to convention, to a standard repertoire of abstract, strictly codified signs for expression. Everything is bracketed in quotation marks; as a result, what was (supposedly) spontaneous congeals into a signifier: "spontaneity," "immediacy." (Think of Schnabel's "violent" brushwork.) The pseudo-Expressionists retreat to the pre-Expressionist simulation of passion; they create illusions of spontaneity and immediacy, or rather expose the spontaneity and immediacy sought by the Expressionists as illusions, as a construct of preexisting forms.

In all discourse, quotation represents authority. Modernism—Expressionism included—represents a challenge to authority, specifically to the authority vested in dominant cultural modes and conventions. Today, however, modernism has itself become a dominant cultural mode, as the quotation of modernist conventions in pseudo-Expressionism testifies. Transgression has become the norm in a society that stages its own scandals (Abscam). Thus, the contemporary artist is trapped in a double bind: if the modernist imperative is obeyed, then the norm is simultaneously upheld; if the modernist imperative is rejected, it is simultaneously confirmed.

In other words, today the modernist imperative to transgression can be neither embraced nor rejected. Caught in this untenable situation, the pseudo-Expressonists substitute an abstract revenge against modernism for its radical impulse. Modernist strategies are used against themselves: thus, the antiauthoritarian stance of the modernist artist is attacked as authoritarian, and anyone who argues for the continuing necessity of antiauthoritarian critique thereby opens him or herself to charges of authoritarianism. [13]

What we are witnessing, then, is the emergence of a new—or renewed—authoritarianism masquerading as antiauthoritarian. Today, acquiescence to authority is proclaimed as a radical act (Donald Kuspit on David Salle). [14] The celebration of "traditional values"—the hallmark of authoritarian discourse—becomes the agenda of a supposedly politically motivated art (Syberberg, Anselm Kiefer, but also Gilbert & George). More often than not, however, the pseudo-Expressionist artist claims to have withdrawn from any conscious political engagement, and this estheticist isolationism is celebrated as a return to the "essence" of art. (This is the basis for Achille Bonito Oliva's championing of the Italian "trans-avant-garde.")

Authoritarianism proclaimed as antiauthoritarian, antiauthoritarian critique stigmatized as authoritarian: this is one manifestation of what Jean Baudrillard diagnoses as a generalized cultural *implosion*. [15] Everything reverses into its opposite; opposites reveal mirrored identities. The imploded state of pseudo-Expressionist art would seem, therefore, to *preclude* irony. For irony is essentially a *negative* trope calculated to expose false consciousness; the coexistence, in pseudo-Expressionist work, of mutually incompatible attitudes suggests instead the *loss* of the capacity for negation, which Lacan

locates at the origin of the schizophrenic breakdown.[16] Schizophrenic discourse is paralogical; it does not recognize the law of contradiction. Thus, the schizophrenic will be obliged *to say the opposite of what he means in order to mean the opposite of what he says.*[17]

Although most of the major symptoms of schizophrenia are to be found in pseudo-Expressionist painting—hebephrenia, catatonia, ambivalence—I am not proposing that we diagnose contemporary artists, on the basis of their work, as schizophrenics. Nor would I proclaim schizophrenia, as some have, as a new emancipatory principle.[18] Still, my argument is more than descriptive; it seems to me that contemporary artists *simulate* schizophrenia as a mimetic defense against increasingly contradictory demands—on the one hand, to be as innovative and original as possible; on the other, to conform to established norms and conventions.

What we see reflected, then, in supposedly "revivalist" painting is the widespread antimodernist sentiment that everywhere appears to have gripped the contemporary imagination. This sentiment is hardly limited to art, but manifests itself at every level of intellectual, cultural, and political life at present. Antimodernism is primarily a disaffection with the terms and conditions of *social* modernity, specifically, with the modernist belief in science and technology as the key to the liberation of humankind from necessity. Fears of ecological catastrophe, and of the increasing penetration of industrialization into previously exempt spheres of human activity, give rise to a blanket rejection of the ideology of progress. Responsibility for the crisis in social modernity is, however, often displaced onto its cultural program—especially the visual arts. Thus, the antiauthoritarian stance of the modernist artist—in particular, the Expressionist valorization of human desire—is often blamed for the much-discussed "crisis of authority" in advanced industrial nations.[19]

Antimodernism is one manifestation of what Belgian politial economist Ernest Mandel identifies as the "neo-fatalist" ideology specific to late capitalist society—a belief that science and technology have coalesced into an autonomous power of invincible force. In his book *Late Capitalism*, Mandel traces its effects in detail:

> *To the captive individual, whose entire life is subordinated to the laws of the market—not only (as in the 19th century) in the sphere of production, but also in the spheres of consumption, recreation, culture, art, education and personal relations, it appears impossible to break out of the social prison. "Every-day experience" reinforces the neo-fatalist ideology of the immutable nature of the late capitalist social order. All that is left is the dream of escape—through sex and drugs, which are in their turn promptly industrialized.*[20]

Sex, drugs, rock and roll—there is, as we know, another traditional means of escape (although this function has largely been assumed by the mass

media): Art. And it is this route—blocked by the avant-garde's ambition to intervene, whether directly or indirectly, in the historical process—that pseudo-Expressionist artists are attempting to force open once again. But in offering the spectator an escape from increasing economic and social pressures, they reinforce the neofatalist ideology of late capitalism. Theirs is an "official" art which provides an apology for the existing social order; collaboration with power replaces the oppositional stance of the modernist artist.

Have we not finally uncovered the source of the sense of frustration that Freud located at the origin of the work of art—namely, a belief in the opacity and omnipotence of the social process? It is not surprising, then, that the current "revival" of figurative modes of expression should be sustained everywhere by artists' desires to be heroes. The desire for mastery is nowhere more apparent than in that rapidly proliferating genre of art works that can only be called the "artificial masterpiece." *Artificial*, because genuine masterpiece status can accrue to a work of art only after the fact; *masterpiece*, because such works, whether executed by men or women, are motivated by a masculine desire for mastery, specifically, a desire to triumph over time.

When the historical conditions surrounding a work's production and reception by the artist's contemporaries have been superseded, and yet the work appears to continue to speak to us in the present *as if it had been made in the present*, we elevate the work to the status of a classic.[21] What this view of the work of art represses is the successive reappropriation and reinterpretation of works of art by each successive generation. A classic certainly did not appear to be a classic at the time of its first appearance, and it is naive to assume that it meant the same thing to the artist's contemporaries as it does to us. Nevertheless, the survival of works of art gives rise to the illusion that timeless metaphysical truths express themselves through them.

The artificial masterpiece inverts this situation: it speaks in the present as if it had been made in the past. As such, it testifies primarily to our impatience, our demand for instant gratification and, most importantly, the spectator's desire to see (his sense of) his own identity confirmed by the work of art. The extraordinary speed with which the pseudo-Expressionists have risen to prominence indicates that their work, rather than creating new expectations, merely conforms to existing ones; when "the fulfilled expectation becomes the norm of the product," however, we have entered the territory of *kitsch.*[22]

Throughout the history of art, style has been one of the most effective indices to the existence of a timeless truth in the work of art. Thus, Carlo Maria Mariani resurrects 19th-century Neoclassicism—a style which, in its own time, was calculated to provide an ascendent bourgeoisie with an idealized image of its own class aspirations and past struggles—an image transposed, however, from the plane of history to that of myth.[23] Mariani's Neo-Neoclassicism indicates that the academic project of sublimating history into

form and universality—a project that was abandoned by the earliest modernists—has returned.

Although it may appear to occupy the opposite end of the stylistic spectrum, A. R. Penck's cultivated neoprimitivist technique performs exactly the same function. Penck's work derives directly from American painting of the 1940s—specifically, from the Abstract Expressionist's early involvement with myth and primitive symbolism (early Gottlieb, Pollock, etc.). These artists were interested in such emblematic imagery primarily as a bearer of cultural information; Penck, however, uses it to express a heroic affinity with the precultural—with the barbaric, the wild, the uncultivated. It also gives his work the appearance of having been around since the beginning of time.[24]

Artificial masterpieces are also manufactured today through the revival of outmoded artistic materials and production procedures, thereby denying the fundamental historicity of those materials and techniques.[25] Although the entire revival of easel painting must be evaluated in these terms, Francesco Clemente's resurrection of fresco is a particularly blatant denial of history, as are Jorg Immendorff's, Markus Lüpertz's and, now, Chia's return to monumental, cast-bronze sculpture. Other artists resuscitate discarded iconographic conventions: Louis Cane, for example, paints Annunciations. Here, Catholic subject matter indicates a desire for catholicity; but it also reads as a reference to Cane's recent "conversion" from modernist abstraction to antimodernist figuration.

Perhaps the most transparent strategy for simulating a masterpiece is that of antiquing the canvas itself. Thus, Gérard Garouste's neo-Baroque allegories—which, the artist insists, "stage the battle of the forces of order and disorder, of the rational and the irrational"—are dimly perceived through what appear to be layers of yellowed varnish. But Ansel Kiefer also "antiques" his canvases. Not only has he returned to landscape painting; he also attempts, through the implicit equation of the barren fields he depicts with the burnt and scarred surfaces of his own canvases, to impart to his paintings something of the desolation and exhaustion of the earth itself. (What is more, Kiefer attributes this desolation to mythical rather than historical forces. His "Waterloo" paintings bear a legend from Victor Hugo: "The earth still trembles/from the footsteps of giants.") Thus, Kiefer's art insists that it is only the faithful reflection of (its own) shattered depletion.

In the 1970s, as is well known, several writers—Richard Sennett and Christopher Lasch among them—diagnosed the collective Narcissism that appeared to have infected an entire society. It is tempting, on the basis of the phenomena discussed above, to describe our own decade as Sisyphean, referring, of course, to the widespread "compulsion to repeat" in which we appear to be deadlocked. It is, however, precisely this tendency to treat contemporary reality in mythological terms that is at issue here. When the critic diagnoses a collective neurosis, does he not also betray his own desire for

(intellectual) mastery? In the eighth chapter of *Civilization and Its Discontents* Freud addressed the question of intellectual mastery, significantly, in the context of a discussion of the possibility of psychoanalyzing entire societies: "And as regards the therapeutic application of our knowledge," Freud writes, "what would be the use of the most correct analysis of social neurosis, since no one possesses authority to impose such a therapy on the group?"

Yet everywhere we turn today we encounter therapeutic programs for the amelioration of our collective "illness"—nowhere more blatantly than in the authoritarian call for a return to traditional values which, we are told, will resolve the crisis of authority in advanced industrial nations. Perhaps, then, it is to the issue of mastery—of power, authority, domination—that both art and criticism must turn if we are to emerge from our current impasse.

Notes

1. Sigmund Freud, "Formulations Regarding the Two Principles in Mental Functioning," *General Psychological Theory*, ed. Philip Rieff, New York, 1963, pp. 26–7, my italics.

2. On art as supplement, see Jacques Derrida. "The *Parergon*" *October* 9 (Summer 1979), 3–41, as well as my afterword, "Detachment/from the *parergon*," 42–9.

3. Psychoanalytic discussions of the work of art's relation to its spectator occur mainly in film theory and criticism; see in particular the work of Christian Metz (*The Imaginary Signifier*) and Stephen Heath (*Questions of Cinema*).

4. Freud, "Psychopathic Characters on the Stage," *Standard Edition*, vol. 7, p. 308.

5. Ibid., p. 305. The entire passage reads as follows: "The spectator is a person who experiences too little, who feels that he is a 'poor wretch to whom nothing of importance can happen,' who has long been obliged to damp down, or rather displace, his ambition to stand in his own person at the hub of world affairs; he longs to feel and to act and to arrange things according to his desires—in short, to be a hero."

6. On *Our Hitler*, see Fredric Jameson, "In the Destructive Element Immerse," *October* 17 (Summer 1981), 99–118, and Thomas Elsaesser, "Myth as the phantasmagoria of History . . . ," *New German Critique* 24–5 (Fall/Winter 1981–82), 108–54. I disagree with Elsaesser's defense of Syberberg's practice, but I am indebted to his insights on the modern functions of myth.

7. Bayreuth '82," *A.i.A.*, Sept. '82, p. 135.

8. Michael Krugman, "Sandro Chia at Sperone Westwater Fischer," *A.i.A.*, Oct. '81, p. 144.

9. See Freud, *Jokes and Their Relation to the Unconscious*. This particular formulation of Freud's thesis is from Jane Weinstock, "She Who Laughs First Laughs Last," *Camera Obscura* 5, p. 107.

10. This is the title of Wolfgang Max Faust's recent book on contemporary German painting (*Hunger nach Bildern*).

11. Quoted in Hans Robert Jauss, *Toward an Aesthetic of Reception*, Minneapolis, '82, p. 197.

12. See Theodor Adorno's discussion of Schoenberg's Expressionism in *Philosophy of Modern Music*, New York, 1980, esp. pp. 38–9.

13. This is the thrust of attacks launched recently by Peter Schjeldahl, who has increasingly been gravitating towards a Neoconservative position, against myself and other writers—ironically, from the pages of the *Village Voice*, supposedly the last bastion of '60s-style radicalism.

14. "Salle, then, offers us an explicitly conformist art—an art in perfect harmony with its world. . . . Its attempt at maximalizing its resources is nothing but an acceptance of—submission to—the totality of its world." It is not that I disagree with Kuspit's description of Salle's

enterprise: rather, I find no cause for celebration. "David Salle at Boone and Castelli," *Art in America*, Summer '82, p. 142.

15. Jean Baudrillard, *L'Echange symbolique et la mort*, Paris, 1975, passim. For an English text, see Baudrillard's "The Beaubourg Effect," *October* 20 (Spring 1982).

16. See in particular Lacan's "On a question preliminary to any possible treatment of psychosis" in *Ecrits: A Selection*, New York, 1977.

17. This formulation is Gregory Bateson's. See Anthony Wilden, *System and Structure*, London, 1972, pp. 56–62.

18. Gilles Deleuze and Félix Guattari, for example. See their *Anti-Oedipus*, New York, 1977.

19. This is the argument of Neoconservative Daniel Bell in *The Cultural Contradictions of Capitalism*, New York, 1976, esp. pp. 85–119. For a rebuttal, see Jürgen Habermas, "Modernity versus Postmodernity," *New German Critique* 22 (Winter 1981), 3–14.

20. Ernest Mandel, *Late Capitalism*, London, Verso, 1978, p. 502. Mandel, of course, is indebted here to Lukács's *History and Class Consciousness*.

21. Jauss, pp. 28–32.

22. This definition is Wolfgang Iser's. Quoted in Jauss, p. 197.

23. Elsaesser, pp. 132–33.

24. Thus, Penck tends to project violence as part of some essential "human nature." But we can treat violence as innate only at the risk of overlooking its specific *social* determinants: its origins in frustration provoked by an opaque, omnipotent social process.

25. On the historicity of artistic materials and production techniques, see Benjamin Buchloh, "Michael Asher and the Conclusion of Modernist Sculpture," *Performance, Text(e)s & Documents*, ed. C. Pontbriand, Montreal, 1981, pp. 55–65.

Appropriated Sexuality

Mira Schor

Artist and critic Mira Schor looks at the ways in which the misogynous imagery in David Salle's paintings is explained away by male critics. Salle's mastery at appropriating and manipulating imagery deflects serious examination of the overt desecration of the female body which the paintings depict. Theories about visual cliches and deconstruction, as well as Salle's market success, blind critics to the obvious content of the paintings.

Whoever despises the clitoris despises the penis
Whoever despises the penis despises the cunt
Whoever despises the cunt despises the life of the child.[1]

—MURIEL RUKEYSER

Rapists make better artists.[2]

—CAROLYN DONAHUE/DAVID SALLE/JOAN WALLACE

A woman lies on her back, holding her knees to her stomach. She has no face, she is only a cunt, buttocks, and a foot, toes tensed as if to indicate pain, or sexual excitement, or both. A patterned cloth shape is superimposed over her, and paint tipped pegs protrude from the wooden picture plane above her. Thus she is dominated by phallic representations.

This image of woman in David Salle's *The Disappearance of the Booming Voice* (1984) may be appropriated from mass-media pornography, but more immediately it is based on a photograph taken by Salle himself. Salle has said that "what's compelling about pornography is knowing that someone did it. It's not just seeing what you're presented with but knowing that someone set it up for you to see,"[3] and that "the great thing about pornography is that something has been photographed."[4] Salle has even suggested that photography was invented for the enhancement of pornography.

Reprinted from Mira Schor, "Appropriated Sexuality," *M/E/A/N/I/N/G* #1 (December 1986).

But, cries Robert Pincus-Witten, "clearly your works must be liberated from the false charges of pornography."[5] This sentiment permeates almost all the vast critical literature on Salle. The issue of pornography is forever raised and laid to rest. But the issue of misogyny is left untouched. Yet it is the pervasive misogyny of Salle's depiction of woman that is so persistently refuted and excused in favor of a "wider possibility of discussion"[6] for "in literature of twentieth-century art the sexist bias, itself unmentionable, is covered up and approved by the insistence on . . . other meanings."[7] Salle's depiction of woman is discussed in terms of the deconstruction of the meaning of imagery, and in terms of art historical references to chiaroscuro, Leonardo, modernism, postmodernism, post-structuralism, Goya and Jasper Johns, Derrida and Lacan, you name it, anything but the obvious. The explicit misogyny of Salle's images of woman is matched by the implicit misogyny of its acceptance by many critics. This complicity is clearly stated by Pincus-Witten: "We're commodifying the object and we're mythifying the makers . . . I've certainly participated in that mechanism because I believe in the mechanism."[8]

The "mechanism" and RPW's belief in it are evident in his earliest interviews with Salle, "up close and personal." He visits Salle's studio in 1979 and meets "a dark 26 year old, impatient and perplexing."[9] "The real content of Salle's painting is irony, or paradox, or parody."[10] *Flesh into Word* (1979), reproduced alongside this text, contains several images of women. The painting is framed on the left by a kneeling nude, seen from behind, near a telephone, and on the right by a headless, upside down nude. A central, more heavily drawn female contains within her a pleasing, bosomy sketched-in nude. The central figure is scowling and smoking; a small plane flies into her brain. Thus the private plane (canvas plane/paintbrush/penis) of the male artist zeroes in on the only female in his painting who seems to be trying to think and to question his authority.

RPW returns months later, now apparently writing for Harlequin romances. "Complex David Salle—lean of face, tense, dark hair on a sharp cartilagenous profile—the unflinching gaze of the contact-lensed. A cigar-smoker (by way of affectation?) and a just audible William Buckley-like speech pattern."[11] The macho positioning is completed by the specification of locale: "the Salle studio is in that row of buildings in which Stanford White—shot by Harry Thaw—died."[12] Thus the vicarious glamor of a notorious murder committed over the naked body of a woman is rubbed on to Salle (and perhaps on to his hopeful accomplice, RPW).

RPW off-handedly describes the left half of *Autopsy* (1981), Salle's notorious photo of a naked woman sitting, cross-legged, sad and stiff, on a rumpled bed, a dunce cap on her head and smaller ones on her breasts. In *Autopsy*, the naked woman is juxtaposed with an abstract pattern of blue, black and white blocks. This type of juxtaposition of representation with abstraction, as well as any juxtaposition of "appropriated" images, seems to be enough to allow for the deflection of scrutiny away from the sexual content to other, apparently

more intellectually valid, concerns, specifically "the uncertain status of imagery, the problems of representation that infect every art."[13]

Challenged in public forums to explain the meaning of *Autopsy* and other like images, Salle has stated tersely that it is about "irony." Indeed his work is seen by his supporters as an eloquent representation of the nihilistic relativism which can result from an ironic stance and which is one of the hallmarks of current "avant-garde" art.

For Thomas Lawson, who does see Salle's representations of woman as at best "cursory and off-hand," at worst "brutal and disfigured,"[14] Salle represents nevertheless one of the hopes for the survival of painting, painting as the "last exit" before the despair of "an age of skepticism" in which "the practice of art is inevitably crippled by suspension of belief."[15]

This school of art accepts and revels in the loss of belief in painting except as a strategic device. The images of painting are representations of representations, not of a suspect "reality." Belief in any meaning for an image in this age of reproduction is dismissed as naive.

However if all images are equivalent, as the constant juxtaposition of females nudes with abstract marks, bits of furniture, and characters from Disney cartoons in Salle's work indicates, then why are male nudes not given equivalent treatment, not just drawn occasionally from the back, but literally drawn and quartered as female nudes are? If images have been rendered essentially meaningless from endless repetition in the mass media, what is the motivation for the one choice that Salle has clearly made, which is to mistreat only the female nude? Salle does not mistreat the male nude therefore he is sensitive enough to the meaning of some imagery.

Much is made by critics of the refusal of the paintings to render their meaning. Lawson writes of the work that its "obscurity that is its source of strength."[16] "Meaning is intimated but tantalizingly withheld." Donald Kuspit writes of a "strangely dry coitus of visual cliches."[17] In withholding their meaning, the paintings are like Woman, the mysterious Other. In withholding his meaning, the artist is an impotent sadist.

The source of this anger is to be found in the intertwined associations among painting, woman, meaning, and death, which form the core of Salle's work. These are clearly expressed in his 1979 manifesto "The Paintings are Dead:"

> 1. *The Paintings are dead in the sense that to intuit the meaning of something incompletely, but with an idea of what it might mean or involve to know completely, is a kind of premonition. The paintings in their opacity, signal an ultimate clarification. Death is "tragic" because it closes off possibilities of further meaning; art is similarly tragic because it prefigures itself as an ended event of meaning. The paintings do this by appearing to participate in meaninglessness.*[18]

For "the Paintings" and "art" one can read "woman" who can only seem to be "known," then returns to the self-enclosed "opacity" of her sex. The

meaning "intuited" is that, in the words of Simone de Beauvoir, "to have been conceived and then born an infant is the curse that hangs over [man's] destiny, the impurity that contaminates his being. And, too, it is the announcement of his death."[19] The opacity of the Mother, the calm enclosure of the promise of his own death seems to incite man to fantasies of rape of woman, and of art.

It is significant that the illustration to Salle's manifesto is an installation shot of the dunce cap pictures. It is also significant that in response to the seemingly obvious offensive nature of this image (*Autopsy*), Kuspit writes that "to put dunce caps on the breasts as well as the head of a woman, and to paint her with a mechanically rendered pattern . . . is to stimulate, not critically provoke—to muse, not reveal."[20] This brings to mind *Cane* (1983), in which a woman, hung upside down in one of the traditional poses of Christian martyrdom, is impaled by a real rubber-tipped cane resting in a glass of water on a ledge. The cane represents the phallus of the artist, as well as being an art historical notation, as the painting and the woman are screwed; as befits a "strangely dry coitus" she may die of peritonitis but she won't get pregnant.

Salle uses woman as a metaphor for death; woman has become a vehicle for the difficulty of painting. Painting, with the potential sensuality implicit in its medium, has become a metaphor for woman, and, also, a vehicle for the subjugation of woman/death. In *Face in the Column* (1983) a naked woman is pressed down by a hand which cannot be her own, by a slice of orange, and by a black band of shadow that straps her down to the ground or bed. A drawing of a woman sitting on a toilet is superimposed so that her ass is directly over the larger woman's face, a further reminder of her disgusting physicality. A white profile of Abraham Lincoln acts as a representative representation of honest male activity distanced from the physical functions of woman, for, to quote Salle, "the ass is the opposite end of the person, so to speak, the most ignoble part of the person and the face is the most noble, the site of all that specificity."[21] As the *butt* of the ironist, woman is "trapped and submerged in time and matter, blind, contingent, limited and unfree."[22]

Carter Ratcliff comes close to grappling with Salle's treatment of women, admitting that "to glamorize cruelty is the pornographer's tactic."[23] *But* "Salle's images of nude women" are "not exactly pornographic. He brings some of his nudes to the verge of gynecological objectivity."[24] Perhaps Ratcliff means veterinary gynecology because I have only seen dogs take poses remotely as contorted as the one a naked woman is forced into in a 1983 Salle watercolor: flat on her back, her thighs spread apart, her legs up. Footless, armless, helpless, she serves as the base for a set table in a pleasantly appointed room. In *Midday* (1984) a woman is on the floor of a similarly decorated room. Flat on her back, legs up, she holds up her hands as if to help her focus on, or protect herself from, the actively painted face of a man floating above her.

To Ratcliff, Salle is "like a self-conscious pornographer, one capable of embarrassment."[25] A repentant rapist then, who can be excused from culpability. However, Ratcliff continues, "to see his paintings is to *empathize with his*

intentions, which is to deploy images in configurations that *permit them to be possessed"*[26] [my emphasis]. It is crucial to emphasize that this form of possession implies a male spectator and is condoned by the male art critic. Linda Nochlin writes that "certain conventions of eroticism are so deeply engrained that one scarcely bothers to think of them: one is that the very term 'erotic art' is understood to imply 'erotic for men.' "[27] The hierarchy of erotic art is clear: "the male image is one of power, possession and domination, the female one of submission, passivity and availability."[28] Carol Duncan stresses the violence with which "the male confronts the female nude as an adversary whose independent existence as a physical or a spiritual being must be assimilated to male needs, converted to abstractions, enfeebled, or destroyed."[29]

Salle's reduction "of woman to so much animal flesh, a headless body"[30] seems, in part, to be a response to radical avant-garde feminism that he was exposed to while a student at the California Institute of the Arts in the early 70s. The Feminist Art Program at CalArts, created and led by Judy Chicago and Miriam Schapiro, which I was part of, aimed at channeling reconsidered personal experiences into subject matter for art. Personal content, often of a sexual nature, found its way into figuration. Analyses and quotes (i.e. "appropriation") of mass media representations of woman influenced art work. "Layering"—a technique favored by Salle—was a buzz word of radical feminist art and discourse, as a basic metaphor for female sexuality. The Feminist Art Program received national attention and was the subject of excitement, envy, and curiosity at CalArts. Even students, male and female, who were hostile to the Program, could not ignore its existence or remain unchallenged by its aims.

The history of this period at CalArts has been blurred, for instance in the curating of the CalArts Ten Year Alumni Show (1981), which excluded most women and any of the former Feminist Program students. In Craig Owens' review of that show, he mourned the resurgence of painting by artists nurtured in the supposed post-studio Eden of CalArts. His point may be well taken on the nature of the sell-out by certain artists, but he does not probe beneath the given composition of the show to see that the Feminist Program, excluded from the retrospective, was truly radical and subversive in daring to question male hegemony of art and art history, whereas post-studio work at CalArts often simply continued an affectless commentary on art history.

Salle's lack of belief in the meaning of imagery is in striking and significant contrast to much work by women artists. From Paula Moderson-Becker, Florine Stettheimer, and Frida Kahlo to Eva Hesse, Louise Bourgeois, Nancy Spero, and countless other artists working today, women artists have shown a vitality that shuns strategy and stylistics in order to honestly depict the image of the core of their being. A comparison of two artists' statements speaks to this difference in belief, and, parenthetically, of motivation:

> *I am interested in solving an unknown factor of art, an unknown factor of life. It can't be divorced as an idea or composition or form. I don't believe art can be*

based on that. . . . In fact my idea now is to counteract everything I've ever learnt or even been taught about those things—to find something inevitable that is my life, my thoughts, my feelings.[31]

I am interested in infiltration, usurpation, beating people at their own game (meaning scheme). I am interested in making people suffer, not through some external plagues, but simply because of who they are (how they know).[32]

Salle's abuse of the female nude is a political strategy that feeds on the backlash against feminism increasingly evident in the national political atmosphere. The current rise of the right in this country puts issues pertaining to female organs and the women's freedom or loss of choice at the top of their list of priorities. It is not surprising that in such an atmosphere Salle's theater of mastery of humiliated female *Fleisch* (the title of a Salle painting) is so acceptable despite its badboy shock value.

As the black leather trappings of the Nazi SS have become trivially eroticized, so too it is possible for some critics to openly succumb to the cult of the artist as magical misogynist. Michael Kruger describes a day in the country with Salle:

And then he did something that left me completely perplexed . . . without removing the cigar from his mouth, *David concentrated his attention on the center, where he placed the gigantic figure of a woman, naked, her thighs spread apart. And he did all of this in such a convincing matter-of-factness that the obsceneness of the gesture with which he had drawn so quickly in the snow only struck me as my view began to melt. . . . The most obvious explanation . . . was that David was using a symbolic action to liberate the instrumentalized body from the constraints of the economy, to return it to nature. So there was this splendid body before us, several hundred meters across, and there were the skiers, their tiny bodies wrapped in the most incredible disguises, registering naked shock. . . . The route back down the valley obliged them to desecrate the figure.*[33] *[my emphasis]*

Woman apparently cannot win, either she *is* nature, or must be *returned to it,* in order to be *desecrated,* in a scene that rivals the imaginings of Ian Fleming—a giant cunt, a scenic mountain full of skiers, and the heroic male artist, James Bond/David Salle, a cigar/pacifier in his mouth, poker-faced no doubt. One can only wonder what the reaction of the critic and the skiers might have been if the artist had drawn a giant male figure with erect penis positioned so as to invite castration.

Recent attention has been focused on Paul Outerbridge's photographs of oppressed looking female nudes posed with the standard trappings of fetishism and sado-masochism, on Balthus' pedophilic portrayals of little girls who just happen to have their skirts flipped up around their waist. This attention represents an effort to give art historical validation to present styles and content. A pertinent example of this art historical bolstering, and one that is revealing as to the sources of his misogyny, is Salle's choice of "appropriation" in *Black Bra*

(1983) in which a real, large, black brassiere hangs off a peg attached to a large image of a Cezanne-like bowl of apples.

As Meyer Schapiro's "The Apples of Cezanne: An Essay on the Meaning of Still-life" illuminates, still lifes provided Cezanne with a method of self-control, a "self-chastening process."[34] "I paint still-lifes. Models frighten me. The sluts are always watching to catch you off your guard. You've got to be on the defensive all the time and the motif vanishes."[35] Indeed, Cezanne's early paintings of nudes are anxious, uncontrolled, and violent, as the thick, gloppy brush marks demonstrate. Through painting careful arrangements of "perfectly submissive things" that have "latent erotic sense,"[36] Cezanne achieves self-possession, possession of the object of desire, and control of his medium. Needless to say, the comparison between Salle and Cezanne invited by Salle's appropriation of the apples goes no further than the original misogyny. Cezanne was able to arrive at a restructured vision of erotic struggle in which the original violence is transcended and the link between sexuality and death is addressed beyond the target of female flesh. In short, Cezanne grew up.

But, by his quoting of Cezanne, Salle only links himself to the master's subjugation of the uncontrollable forces of sexuality and death incarnated by man in woman. By positing the art work as being about the self-consciousness of the artist in relation to art history he deflects the perception of its content for what it is—misogyny, narcissism, impotence. To condemn that content is to betray misunderstanding of the whole purpose, which seems to be a continuation of a male conversation which is centuries old, to which women are irrelevant except as depersonalized projections of man's fears and fantasies, and in which even a man's failure is always more important than a woman's success. In Laura Mulvey's formulation "the function of woman in forming the patriarchal unconscious is two-fold, she first symbolizes the castration threat by her real absence of a penis and second thereby raises her child into the symbolic. Once this has been achieved, her meaning in the process is at an end, it does not last into the world of law and language except as a memory which oscillates between memory of maternal plenitude and memory of lack."[37]

If, in a painting as in a dream, all the elements can be seen to represent the artist's psyche, then Salle is the upside-down nude impaled as well as the rubber-tipped Cane. The identification with martyrdom indicates that the artist is subjugating the woman in himself. In subjugating woman who, historically, is linked with painting as muse, model, and embodiment of sensuality, he is suppressing the painter in himself. Perhaps he is conquering fears about his virility, for "the victim of rape is not inclined to question the virility of her assailant."[38]

To some extent this essay was suggested by a male artist who explained to me that Salle's work was not misogynist but was a coded message to other men of his own impotence. Well, like the little girl in the old cartoon, "I say it's spinach, and I say the hell with it." Whatever the message is—be it homo-eroticism, self-hatred, suicidal fantasy—the "desecration" of woman is Salle's expressive vehicle, his "code."

The painting *What Is the Reason for Your Visit to Germany* (1984), which could also be titled "Bend Over Baby, While I Quote Jasper Johns," seems a temporary summation of Salle's constant themes. In one panel a naked woman bends over, her breasts dangling as she performs for the artist and the spectator. The word "fromage" is written across the center of the panel, at the very least indicating the condescending relationship of photographer to child, "say Cheese," certainly a reference to "Cheesecake," may be a derogatory reference to the very smell of her sex. A companion panel of a lead covered saxophone provides a phallic bulge and a competitive allusion to an older master. Over the woman is drawn, twice, the image of Lee Harvey Oswald being shot; once, so that the physical resemblance to Salle himself is immediately apparent, and then again as his head explodes into paint.

We see in this one painting a conflation of Salle's humiliation of woman, his glamorization and martyrdom of the assassin/artist, as he links woman, death, and paint.

A vicarious suicide, David Salle savages woman rather than savage himself. This is considered appropriate sexuality, and this is a source of his market value.

> *I researched and wrote the first draft of this essay in the spring of 1984. The Art Index entries under SALLE, DAVID were then, and are now, composed almost totally of supportive presentations and exegeses of his position. Articles critical of him are few and timid in their scope. There are none that are critical from a clearly feminist point of view. My article could be endlessly updated to include analyses of recent writings on Salle, but the balance of opinion is unchanged.*
>
> *Some have questioned my use of the word "cunt" to describe female genitalia. I do so advisedly. It is the word that best describes what Salle paints, and it is a word that he himself does not shun.*
>
> *I have limited my focus to Salle's depiction of women and to the treatment of that depiction by critics, that is to say I have scrutinized only his subject matter. I have not addressed myself to issues of quality or style. If the question is asked "is David Salle a 'good' artist?," I can answer that I feel he is very good at what he does, which is the manipulation and juxtaposition of appropriated images and styles. It is crucial to offer a critique of his imagery because he is so effective in his presentation of it, because he is a critical and a financial success, and because his work and his career have epitomized a system of art practices and theories that dominate this decade.*
>
> *October 1986*

References

1. Muriel Rukeyser, *The Collected Poems of Muriel Rukeyser*, (New York: MacGraw-Hill, 1982), p. 484.
2. Carolyn Donahue/David Salle/Joan Wallace, "The Fallacy of Universals," *Effects—Semblance and Mediation*, Number 1, Summer 1983, p. 4. (It was impossible to ascertain to whom this quote should be correctly attributed, thus all three names.)
3. David Salle, *Bomb*, Fall 1985, No. XIII, p. 24.

4. David Salle, *Arts Magazine*, November 1985, p. 80.

5. Robert Pincus-Witten, *Arts Magazine*, November 1985, p. 80.

6. Sherrie Levine, "David Salle," *Flash Art*, Summer 1981, no. 103, p. 34.

7. Carol Duncan, "Virility and Domination in Early Twentieth-Century Vanguard Painting," *Feminism and Art History—Questioning the Litany*, ed. Norma Broude and Mary D. Garrard (New York: Harper & Row, 1982), p. 308. Reprinted in Richard Hertz and Norman Klein, *Twentieth Century Art Theory* (Englewood Cliffs, NJ: Prentice Hall, 1990).

8. Pincus-Witten, op. cit., p. 81.

9. Pincus-Witten, "Entries: Big History, Little History," *Arts Magazine*, April 1980, p. 183.

10. Ibid.

11. Pincus-Witten, "David Salle: Holiday Glassware," *Arts Magazine*, April 1982, p. 58.

12. Ibid.

13. Donald Kuspit, "Reviews: David Salle," *Art in America*, Summer 1982, p. 142.

14. Thomas Lawson, *ArtForum*, May 1981, p. 71.

15. Lawson, "Last Exit: Painting," *ArtForum*, October 1981, p. 45. Reprinted in this volume.

16. Lawson, May 1981, p. 71.

17. Kuspit, Summer 1982, p. 142.

18. David Salle, "The Paintings are Dead," *Cover*, Vol. 1, no. 1, May 1979.

19. Simone de Beauvoir, *The Second Sex*, trans. H. M. Parshley (New York: Bantam Books, 1961), p. 136.

20. Kuspit, p. 142.

21. Salle, *Bomb*, Fall 1985, p. 20.

22. D. C. Muecke, *The Critical Idiom #13—Irony and the Ironic* (London and New York: Methuen & Co. Ltd., 1970), p. 48.

23. Carter Ratcliff, "David Salle and the New York School," *David Salle* (Rotterdam: Museum Boymans-van Boeuningen, 1983), p. 36.

24. Ibid, p. 36.

25. Ibid.

26. Ibid.

27. Linda Nochlin, "Eroticism and Female Imagery in Nineteenth-Century Art," *Woman as Sex Object: Studies in Erotic Art 1730–1970*, ed. Thomas Hess and Linda Nochlin (Newsweek: 1972), p. 9.

28. Nochlin, p. 14.

29. Carol Duncan, "The Esthetics of Power in Modern Erotic Art," *Heresies 1 Feminism, Art and Political* (New York: January 1977), p. 46.

30. Carol Duncan, "Virility and Domination in Early Twentieth-Century Vanguard Painting," op. cit., p. 296.

31. Eva Hesse, quoted by Cindy Nemser, "Interview with Eva Hesse," *ArtForum*, no. 9, 1970, p. 59.

32. David Salle, "The Paintings are Dead," *Cover*, op. cit.

33. Michael Kruger, *David Salle* (Hamburg: Ascan Crone, 1983), p. 8.

34. Meyer Schapiro, *Modern Art—19th and 20th Centuries—Selected Papers* (New York: Georges Braziller, 1978), p. 33.

35. Ibid., p. 30.

36. Ibid., p. 30.

37. Laura Mulvey, "Visual Pleasure and Narrative," reprinted from *Screen 16*, no. 3 (August 1975) in *Art After Modernism: Rethinking Representation*, ed. by Brian Wallis (Boston: David R. Godine, 1984), p. 361.

38. Harold Rosenberg, *Discovering the Present—Three Decades in Art, Culture and Politics* (Chicago and London: The University of Chicago Press, 1973), p. 46.

Sabina Ott, *Sub Rosa #1.* **1992 48″ x 26″ Oil and encaustic on panel**

Courtesy of the artist.

Last Exit: Painting

Thomas Lawson

Modernism's pretentious desire for eternal values is viewed by critic and painter Thomas Lawson as symbolic of its surrender to the social structure it had originally sought to subvert. Neither modernism's ahistorical stance nor a fashionable and calculated neoexpressionism are adequate strategies for the radical artist. Lawson advocates critical subversion, deconstruction on canvas of the illusions of real life as represented in the mass media. Painting is the perfect vehicle for raising "troubling doubt" about the ideas and methods of the media precisely because it is situated at the center and not the periphery of the art marketplace.

The paintings have to be dead; that is, from life but not a part of it, in order to show how a painting can be said to have anything to do with life in the first place. —DAVID SALLE, *Cover*, May 1979

\mathbf{I}t all boils down to a question of faith. Young artists concerned with pictures and picture-making, rather than sculpture and the lively arts, are faced now with a bewildering choice. They can continue to believe in the traditional institutions of culture, most conveniently identified with easel painting, and in effect register a blind contentment with the way things are. They can dabble in "pluralism," that last holdout of an exhausted modernism, choosing from an assortment of attractive labels—Narrative Art, Pattern and Decoration, New Image, New Wave, Naive Nouveau, Energism—the style most suited to their own, self-referential purposes. Or, more frankly engaged in exploiting the last manneristic twitches of modernism, they can resuscitate the idea of abstract

Reprinted from Thomas Lawson, "Last Exit: Painting." *Artforum* (October 1981).

painting. Or, taking a more critical stance, they can invest their faith in the subversive potential of those radical manifestations of modernist art labelled Minimalism and Conceptualism. But what if these, too, appear hopelessly compromised, mired in the predictability of their conventions, subject to an academicism or a sentimentality every bit as regressive as that adhering to the idea of Fine Art?

Such is the confused situation today, and everyone seems to be getting rather shrill about it. At one extreme, Rene Ricard, writing in *Artforum* on Julian Schnabel, has offered petulant self-advertisement in the name of a reactionary expressionism, an endless celebration of the author's importance as a champion of the debasement of art to kitsch, fearful that anything more demanding might be no fun. The writing was mostly frivolous, but noisy, and must be considered a serious apologia for a certain anti-intellectual elite. On the other hand the periodical *October* has been publishing swinge-ing jeremiads condemning, at least by implication, all art produced since the late '60s, save what the editors consider to be permissible, which is to say that art owes a clear and demonstrable debt to the handful of Minimal and Conceptual artists they lionize as the true guardians of the faith. From a position of high moral superiority these elitists of another sort, intellectual but antiesthetic, condemn the practice of "incorrect" art altogether, as an irredeemably bourgeois activity that remains largely beneath their notice. Both approaches, of the esthete and the moralist, leave distinctions blurred, and art itself is conveniently relegated to an insignificant position as back-ground material serving only to peg the display of self or of theory. From both sides we receive the same hopeless message: that there is no point in continuing to make art since it can only exist insulated from the real world or as an irresponsible bauble. This is only a partial truth. It would be more accurate, although a good deal more complicated, to argue that while there may be no point in continuing to make certain kinds of art, art as a mode of cultural discourse has not yet been rendered completely irrelevant.

> *Today . . . modern art is beginning to lose its powers of negation. For some years now its rejections have been ritual repetitions: rebellion has turned into proce-dure, criticism into rhetoric, transgression into ceremony. Negation is no longer creative. I am not saying that we are living the end of art: we are living the end of the <u>idea of modern art</u>.*
>
> —OCTAVIO PAZ,
> *Children of the Mire: Modern Poetry from Romanticism to the Avant-Garde*

Despite the brouhaha, the numerous painting revivals of the latter part of the '70s, from New Abstraction to Pattern and Decoration, proved to be little more than the last gasps of a long overworked idiom, modernist painting. (The diversionary tactics of so many bemused critics hid this truth

under a blanket eventually labelled "pluralism," but as the decade closed that blanket became more and more of a shroud.) These revivals were embalmed and laid to rest in Barbara Rose's poignantly inappropriately titled show "American Painting: The Eighties." The exhibit, presented in 1979, made the situation abundantly clear, and for that we should be thankful. Painter after painter included there had done his or her best to reinvest the basic tenets of modernist painting with some spark of life, while staying firmly within the safe bounds of dogma. The result was predictably depressing, a funereal procession of tired cliches paraded as if still fresh: a corpse made up to look forever young.

While it was still a creative force modernism worked by taking a programmatic, adversary stance toward the dominant culture. It raged against order, and particularly bourgeois order. To this end it developed a rhetoric of immediacy, eschewing not only the mimetic tradition of Western art, but also the esthetic distance implied by the structure of representation—the distance necessarily built into anything that is to be understood as a picture of something else, a distance that sanctions the idea of art as a discursive practice. With modernism, art became declarative, we moved into the era of the manifesto and the artist's statement, justifications which brook no dissent.

Modernism's insistence on immediacy and the foreclosure of distance inevitably resulted in a denial of history, in an ever greater emphasis on not just the present, but the presence of the artist. Expressive symbolism gave way to self-expression; art history developed into autobiography. Vanguard art became a practice concerned only with itself, its own rules and procedures. The most startling result was the liberation of technique; the least useful result was the pursuit of novelty. As the modernist idea became debased, its deliberate sparseness worn through overuse, the acting-out of impulse, rather than the reflective discipline of the imagination, became the measure of satisfaction and value. As a result the modernist insistence on an essential meaninglessness at the center of artistic practice came actually to mean less and less. From being a statement of existential despair it degenerated into an empty, self-pitying, but sensationalist, mannerism. From being concerned with nothingness, it became nothing. The repudiation of mimesis, and the escalating demands for impact, for new experience beyond traditional limits, inevitably loosened the connections between artistic discourse and everyday life. Art became an abstraction, something of meaning only to its practitioners. On the whole modernist artists acted as though alienated from bourgeois society—it was the only posture that gave their work a significance transcending its own interiority. But for the most part this remained only a posture, rarely developing into a deeper commitment to social change. In a manner that foretold the final decline of the moral authority of modernism, radically individualist artists all too often found

comfortable niches in the society they professed to despise, becoming little more than anxious apologists for the system.

Of course there had been one important moment that saw a possibility for a more truly revolutionary activity, and that was in Moscow in the years immediately following the Russian Revolution. This period not only pushed modernism to its logical expression in abstraction, but turned that abstraction away from the personal toward a more significant critique of production. Developing implications nascent in the work of Cézanne and the Cubists, it concentrated on the basic ingredients, ideological and material, involved in the production of art. This moment, abandoned by the artists themselves (only partly because of political pressures) in favor of a totally reactionary antimodernism, saw the first stirrings of a seed that, when later conjoined with the very different, but equally radical, activity of Marcel Duchamp, came to fruition just as the modernist hegemony seemed unassailable—demonstrating that it was not.

That fruition has been called Minimalism, and the Minimalist artists subverted modernist theory, at that time most ably articulated by the followers of Clement Greenberg, simply by taking it literally. If modernist art sought to concern itself with its own structures, then the Minimalists would have objects made that could refer to nothing but their own making. This absurdist extremism worked by dramatizing the situation, which in turn reinjected a sense of distance, and a critical discourse was once again possible. (It is no accident that it was this generation of artists—Donald Judd, Robert Morris, Robert Smithson, Art & Language, Joseph Kosuth, and Mel Bochner—who reintroduced the idea that an artist might be more than a sensitive person with talent, might in fact be both intelligent and articulate, might have something to say.)

All the while, countless other artists continued as if the ground had not been opened up in front of them, even adopting some of the superficial characteristics of the very modes that were rendering their practice obsolete and moribund. Some, of course, continued to paint, and it was those whom Rose chose to celebrate in her exhibition. And if that show seemed to lack all conviction, Rose's catalogue essay more than compensated with the vehemence of its language. Defending a denatured modernism that had become so divorced from historical reality that it could pretend to celebrate "eternal values," she lashed into Minimalism and Conceptualism as though they were agents of the Anti-Christ. Which, for the true believer, they are.

Rose made it clear that procedure had indeed become ritual, and criticism mere rhetoric. Modernism has been totally coopted by its original antagonist, the bourgeoisie. From adversary to prop, from subversion to bastion of the status quo, it has become a mere sign of individual liberty and enterprise, freed entirely from the particular history that once gave it meaning. It is not just that its tactics and procedures have been borrowed by the propaganda industries—advertising, television, and the movies—it has become a part of

them, lending authority and authenticity to the corporate structures that insistently form so much of our daily lives.

> We need change, we need it fast
> Before rock's just part of the past
> 'Cause lately it all sounds the same to me
> Oh-oh . . .
> It's the end, the end of the 70's
> It's the end, the end of the century
> —The Ramones, from the song,
> "Do you remember Rock 'n' Roll Radio?" 1979

The end of the century. If modernist formalism seems finally discredited, hopelessly coopted by the social structures it purportedly sought to subvert, its bastard progeny continue to fill the galleries. We all want to see something new, but it is by no means clear that what we have been getting so far has any merit beyond a certain novelty. As Antonio Gramsci so presciently observed in his prison notebooks, a period lacking certainty is bedeviled by a plethora of morbid symptoms. Following the lead of architectural critics these symptoms have been hailed, rather carelessly, as "post-modern," with that term standing for a nostalgic desire to recover an undifferentiated past. According to this understanding any art that appropriates styles and imagery from other epochs, other cultures, qualifies as "post-modern." Ironically, the group that has been enjoying the most success, to date, as the exemplification of this notion is made up of pseudoexpressionists like Jonathan Borofsky, Luciano Castelli, Sandro Chia, Francesco Clemente, Enzo Cucchi, Rainer Fetting, Salomé, and Julian Schnabel. Despite the woolly thinking behind this usage, the claim does have some merit, but in the end the work of these artists must be considered part of a last, decadent flowering of the modernist spirit. The reasons for this initial success are quite straightforward. The work of these artists looks very different from the severe respectability of recent modernist production in New York, yet it is filled with images and procedures that are easily recognized as belonging to art, or at least to art history. As their champions are quick to point out, their work can be keyed, at least superficially, to a strain of activity that stretches from Conceptual art back to Dada. And on top of that they appear personal, idiosyncratic in a period during which lip service has been paid to the idea of individual liberty, even as that liberty is being systematically narrowed by the constraints of law and commerce.

These young painters ingratiate themselves by pretending to be in awe of history. Their enterprise is distinguished by an homage to the past, and in particular by a nostalgia for the early days of modernism. But what they give us is a pastiche of historical consciousness, an exercise in bad faith. (Even Borof-

sky's integrity becomes implicated here as a result of his relentless mystifica-
tion.) For by decontextualizing their sources and refusing to provide a new,
suitably critical frame for them, they dismiss the particularities of history in
favor of a generalizing mythology, and thus succumb to sentimentality.

Chia and Cucchi hanker after the excitements of neoprimitivism, espe-
cially as understood by the likes of Marc Chagall, nurturing a taste for assumed
naiveté. Castelli, Fetting, and Salomé hark back to the same period, favoring
instead the putative boldness of style and content of German Expressionism.
But whatever their sources, these artists want to make paintings that look
fresh, but not too alienating, so they take recognizable styles and make them
over, on a larger scale, with brighter color and more pizzazz. Their work may
look brash and simple, but it is meant to, and it is altogether too calculated to
be as anarchistic as they pretend.

Clemente and Schnabel are both more ambitious, seeking to accommo-
date a much broader range of references in their work. Both pick up on the
neoromantic, pseudosurreal aspects of fashionable French and Italian art of the
'30s and '40s, and make a great fuss about their wickedly outrageous taste in so
doing. But that is only a starting point, albeit one that, with its emphasis on
additive collage, sanctions an uncontrolled annexation of material. Renaissance
and Baroque painting, Indian miniatures, cheap religious artifacts, a certain
type of anything is fair game. And whatever is accepted becomes equivalent to
everything else, all distinctions are merged as styles, images, methods, and
materials proliferate in a torrent of stuff that is supposedly poetic, and thus
removed from mere criticism.

This wider cultural cannibalism is the topic of another essay; the
annexation of wide areas of modern art is problematic enough for my pur-
poses here. Concentrating on that alone we have a surfeit of evidence,
showing an historicism that pays court to a strain of 20th-century art that
can, superficially, be identified as antimodern. Superficially, because any
work produced in a certain period must share essential characteristics with
other work of the same period; antimodern, because I am talking about the
production of artists of the '30s and '40s who openly rebelled against the
mainstream of radical modernism. In other words, the sophisticated if often
rather mild-mannered art that was recently gathered together as part of the
Beaubourg's *Les Réalismes* exposition. The same material also served as an
introduction to the revisionist history presented at Westkunst. This was art
that was difficult only in the sense that a naughty child is difficult; that is,
art that misbehaved within a strictly defined and protected set of conven-
tions. Art that misbehaved to demonstrate the need for discipline. Art that
advocated a forced return to "eternal values," in both the esthetic and polit-
ical realms. Art that often declared itself nationalist, always traditionalist. It
is possible that recent work appropriating this art could have a critical
import. The work of the pseudoexpressionists does play on a sense of contra-
riness, consistently matching elements and attitudes that do not match, but

it goes no further. A *retardataire* mimeticism is presented with expression-ist immediacy. The work claims to be personal, but borrows devices and images from others. There is a camp acknowledgment that what was once considered bad art can now be fun: however, that acknowledgment is couched in self-important terms that for the most part steer clear of humor. Appropriation becomes ceremonial, an accommodation in which collage is understood not as a disruptive agent, a device to question perception—but as a machine to foster unlimited growth.

This marriage of early modernism and a fashionable antimodernism can be characterized as camp, and there is definitely a strain of Warholism about the work. It is cynical work with a marketing strategy, and therefore extremely fashion-conscious. It is work that relies on arch innuendo and tailored guest lists—a perfect example is provided by Clemente's series of frescoed portraits of a chic demimonde, although the Germans' concentration on gay subject matter works in an equivalent manner.

But to dismiss this work as belonging to camp is too easy, for something more sinister is at hand. The forced unification of opposites is a well-established rhetorical tactic for rendering discourse immune from criticism. The capacity to assimilate anything and everything offers the prospect of combining the greatest possible tolerance with the greatest possible unity, which becomes a repressive unity. With this art we are presented with what amounts to a caricature of dialectics, in which the telescoping of elements cuts off the development of meaning, creating instead fixed images—cliches—which we are expected to associate with the proper attitudes and institutions (high art fit for museums). With great cynicism this work stands the modernist enterprise on its head, removing the anxious perception of nothingness at the heart of modernist expression, and replacing it with the smug acknowledgment that if the art means nothing it will be all the more acceptable to those who seek only entertainment. Such a debased version of modernist practice is vigorously opposed to the very idea of critical analysis since it is simply a declaration of presence signifying only the ambition of the artist to be noticed.

> *Being in love is dangerous because you talk yourself into thinking you've never had it so good.* —DAVID SALLE, *ArtRite*, Winter 1976/77.

David Salle makes tremendously stylish paintings, paintings that will look good in the most elegant of rooms. His choice of color is brilliant—pale, stained fields, highlighted with bright, contrasting lines and areas of paint. A look of high fashion. And yet the images he presents this way are emotionally and intellectually disturbing. Often his subjects are naked women, presented as objects. Occasionally they are men. At best these representations of humanity are cursory, offhand; at worst they are brutal, disfigured. The images are

laid next to one another, or placed on top of one another. These juxtapositions prime us to understand the work metaphorically, as does the diptych format Salle favors, but in the end the metaphors refuse to gel. Meaning is intimated but tantalizingly withheld. It appears to be on the surface, but as soon as it is approached it disappears, provoking the viewer into a deeper examination of prejudices bound inextricably with the conventional representations that express them. Salle's work is seductive and obscure, and this obscurity is its source of strength, for when we attempt to bring light to the darkness, we illuminate much else as well. Salle follows a strategy of infiltration and sabotage, using established conventions against themselves in the hope of exposing cultural repression.

Salle occupies a central position in this polemic, for he appears to be balancing precariously between an empty formalism of the sort practiced by Clemente and Schnabel, and a critical subversion of such formalism. His work has long shared certain characteristics with the work of these artists, particularly in the deliberately problematic juxtaposition of heterogeneous styles and images. But whereas the worth of Clemente and Schnabel remains narcissistic at base, Salle's has always appeared more distant, a calculated infiltration aimed at deconstructing prevalent esthetic myths. Only now there seems to be a danger that the infiltration has become too complete; the seducer finds himself in love with his intended victim.

This infatuation has become more evident in the months following the so-called collaboration between Salle and Schnabel. This was a collaboration by fiat, a self-conscious gesture on the part of Schnabel (who had been given the painting in an exchange) in which he reversed the order of one of Salle's diptychs and partly covered one panel with a large, roughly painted portrait of Salle. The fabric of the original Salle was metaphorically ripped apart, literally wiped out, its meaning not so much altered as denied. The painting in fact became a Schnabel, a demonstration of the superior power of cannibalism over sabotage as a means of gaining control over one's subject. Lately Salle's paint has become thicker and more freely applied, some of the images clearly recognizable as taken from other art. In short, the ensembles seem less threatening.

Nevertheless, Salle's paintings remain significant pointers indicating the last exit for the radical artist. He makes paintings, but they are dead, inert representations of the impossibility of passion in a culture that has institutionalized self-expression. They take the most compelling sign for personal authenticity that our culture can provide, and attempt to stop it, to reveal its falseness. The paintings look real, but they are fake. They operate by stealth, insinuating a crippling doubt into the faith that supports and binds our ideological institutions.

Nothing is more unfitting for an intellectual resolved on practicing what was earlier called philosophy, than to wish . . . to be right. The very wish to be right,

down to its subtlest form of logical reflection, is an expression of that spirit of self-preservation which philosophy is precisely concerned to break down.
　　　　　—THEODOR ADORNO, *Minima Moralia*, 1951

I believe that most of the serious critics who are at all interested in the problem of defining that clumsy term "post-modernism" would agree with the gist of my argument so far, would agree that, in the current situation, not only is the viability of any particular medium suspect, but that esthetic experience itself has been rendered doubtful. But it is precisely here that we begin to drift apart in the face of the unreconcilable difference. Basically it is a conflict between a certain logical, even doctrinaire, purity and the impurity of real life; a disagreement over what to do about the gap between what ought to be and what is.

A recent and succinct statement of the idealist position is Douglas Crimp's essay "The End of Painting," which appeared in *October* 16 (Spring 1981). Crimp describes the ennervation of modernist painting in terms similar to those I have used, but then attempts to close the argument, by demonstrating "the end." For this purpose he chooses to isolate the work of Daniel Buren as exemplary of the Conceptualism that ten years ago sought to contest the myths of fine art. Crimp allows that Buren's work runs the risk of invisibility, that since it is intentionally meaningless in a formal sense, it might fail to operate on a critical level. And indeed it is a problem that the work needs an explanatory text, a handbook of the issues raised, a guide to one's approach. But that is the least of it, for what Crimp fails to acknowledge is that Buren's strategy has, by this time, degenerated into little more than an elegant device, naturalized by the forces it sought to undermine. Worse than looking like decor, the photographic record of his activity makes his work now look very much like the art he despises, recalling as it does the kind of *decollage* popular in Paris in the '50s. So Buren actually finds himself in a quandary similar to that faced by Salle, but since he deliberately reduced his means so severely in the beginning, he now has less to work with, and so has less hope of escaping either failure or cooptation. As a result of this inevitable impasse a good deal of Conceptual art has lost its conviction, and thus its ability to provoke thought.

One simply does not believe repeated warnings that the end is nigh, particularly when those issuing the warnings are comfortably settling down as institutions in their own right. Much activity that was once considered potentially subversive, mostly because it held out the promise of an art that could not be made into a commodity, is now as thoroughly academic as painting and sculpture, as a visit to any art school in North America will quickly reveal. And not only academic, but marketable, with "documentation" serving as the token of exchange, substituting for the real thing in a cynical duplication of the larger capitalist marketplace.

In recognition of this state of affairs Sherrie Levine has decided to simply represent the idea of creativity, re-presenting someone else's work as her own in an attempt to sabotage a system that places value on the privileged production of individual talent. In doing so she finalizes Crimp's argument more conclusively than Buren, but that finality is unrealistic. It is also desperate. She articulates the realization that, given a certain set of constraints, those imposed by an understanding of the current situation as much as those imposed by a desire to appear "correct" in a theoretical and political sense, there is nothing to be done, that creative activity is rendered impossible. And so, like any dispossessed victim she simply steals what she needs. Levine's appropriations are the underside of Schnabel's misappropriations, and the two find themselves in a perverse lockstep. The extremity of her position doubles back on her, infecting her work with an almost romantic poignancy as resistant to interpretation as the frank romanticism of her nemesis.

So what is a radical artist to do in the current situation if he or she wants to avoid instant cooptation or enforced inactivity? A clue, paradoxically, is to be found in one of Crimp's passages on Buren: "It is fundamental to Buren's work that it act in complicity with those very institutions that it seeks to make visible as the necessary conditions of the art work's intelligibility. That is the reason not only that his work appears in museums and galleries, but that it poses as painting." It is painting itself, that last refuge of the mythology of individuality, which can be seized to deconstruct the illusions of the present. For since painting is intimately concerned with illusion, what better vehicle for subversion?

> *Cultivated philistines are in the habit of requiring that a work of art "give" them*
> *something. They no longer take umbrage at works that are radical, but fall back*
> *on the shamelessly modest assertion that they do not understand.*
> —THEODOR ADORNO, *Minima Moralia*

Given the accuracy of Adorno's observation it is clearly necessary to use trickery to pry open that understanding, for the main problem today is to open the channels of critical discourse to a healthy skepticism. Established avenues of protest, the disturbances that are the usual remedies of the disenfranchised and the disenchanted are no longer effective. They are too easily neutralized or bought off by an official "inquiry." But by resorting to subterfuge, using an unsuspecting vehicle as camouflage, the radical artist can manipulate the viewer's faith to dislodge his or her certainty. The intention of that artist must therefore be to unsettle conventional thought from within, to cast doubt on the normalized perception of the "natural," by destabilizing the means used to represent it, even in the knowledge that this, too, must ultimately lead to certain defeat. For in the end some action must be taken, however hopeless, however temporary. The alternative is the irresponsible acquiescence of despairing apathy.

To an unprecedented degree the perception of the "natural" is mediated these days. We know real life as it is represented on film or tape. We are all implicated in an unfolding spectacle of fulfillment, rendered passive by inordinate display and multiplicity of choice, made numb with variety: a spectacle that provides the illusion of contentment while slowly creating a debilitating sense of alienation. The camera, in all its manifestations, is our god, dispensing what we mistakenly take to be truth. The photograph *is* the modern world. We are given little choice: accept the picture and live as shadow, as insubstantial as the image on a television screen, or feel left out, dissatisfied, but unable to do anything about it. We know about the appearance of everything, but from a great distance. And yet even as photography holds reality distant from us, it also makes it seem more immediate, by enabling us to "catch the moment." Right now a truly conscious practice is one concerned above all with the implications of that paradox. Such a practice might be called "post-modern" in a strict etymological sense because it is interested in continuing modernism's adversary stance, interested in the possibilities of immediate action, yet aware of the closure that that immediacy has imposed, in time, on genuine discourse. It is art that reintroduces the idea of esthetic distance as a thing of value, as something that will allow that discourse to open. It is art that pays attention to the workings of received ideas and methods, and in particular to those of the dominant media, in the hope of demonstrating the rigid, if often hidden, ideology that gives shape to our experience.

The most obvious procedure for this art that plumbs the dark secrets of the photographic question, the public trace of a submerged memory, would be to make use of the photographic media themselves, isolating pieces of information, repeating them, changing their scale, altering or highlighting color, and in so doing revealing the hidden structures of desire that persuade our thoughts. And indeed, it has been this kind of practice, the practice of such artists as Dara Birnbaum, Barbara Bloom, Richard Prince, and Cindy Sherman, working with video, film, and fashion photography, that has received the most considered attention from critics like Crimp and Craig Owens. And yet despite the success of this approach, it remains, in the end, too straightforwardly declarative. What ambiguity there exists in the work is a given of its own inner workings and can do little to stimulate the growth of a really troubling doubt. The representation remains safe, and the work too easily dismissed as yet another avant-garde art strategy, commentary too easily recognized.

More compelling, because more perverse, is the idea of tackling the problem with what appears to be the least suitable vehicle available, painting. It is perfect camouflage, and it must be remembered that Picasso considered Cubism and camouflage to be one and the same, a device of misrepresentation, a deconstructive tool designed to undermine the certainty of appearances. The appropriation of painting as a subversive method

allows one to place critical esthetic activity at the center of the marketplace, where it can cause the most trouble. For as too many Conceptual artists discovered, art made on the peripheries of the market remains marginal. To reopen debate, get people thinking, one must be there, and one must be heard. One of the most important of Duchamp's lessons was that the artist who wishes to create a critical disturbance in the calm waters of acceptable, unthinking taste, must act in as perverse a way as possible, even to the point of seeming to endanger his or her own position. And it seems at this point, when there is a growing lack of faith in the ability of artists to continue as anything more than plagiaristic stylists, that a recognition of this state of affairs can only be adequately expressed through the medium that requires the greatest amount of faith.

For it is this question of faith that is central. We are living in an age of skepticism and as a result the practice of art is inevitably crippled by the suspension of belief. The artist can continue as though this were not true, in the naive hope that it will all work out in the end. But given the situation, a more considered position implies the adoption of an ironic mode. However, one of the most troubling results of the cooptation of modernism by mainstream bourgeois culture is that to a certain degree irony has also been subsumed. A vaguely ironic, slightly sarcastic response to the world has now become a cliched, unthinking one. From being a method that could shatter conventional ideas, it has become a convention for establishing complicity. From being a way of coming to terms with lack of faith, it has become a screen for bad faith. In this latter sense popular movies and television shows are ironic, newscasters are ironic, Julian Schnabel is ironic. Which is to say that irony is no longer easily identified as a liberating mode, but is at times a repressive one, and in art one that is all too often synonymous with camp. The complexity of this situation demands a complex response. We are inundated with information, to the point where it becomes meaningless to us. We can shrug it off, make a joke, confess bewilderment. But our very liberty is at stake, and we are bamboozled into not paying attention.

The most challenging contemporary work using photography and photographic imagery remains illustrative. There is an indication of what might be considered, but no more; our understanding of the reverberations of the camera's picture-making is not advanced in a cohesive and compound form. Important issues are singled out, but they remain singular, strangely disconnected.

Radical artists now are faced with a choice—despair, or the last exit: painting. The discursive nature of painting is persuasively useful, due to its characteristic of being a never-ending web of representations. It does often share the irony implicit in any conscious endeavor these days, but can transcend it, to represent it. Many artists have decided to present work that can be classified as painting, or as related to painting, but that must be seen as

something other: a desperate gesture, an uneasy attempt to address the many contradictions of current art production by focusing on the heart of the problem—that continuing debate between the "moderns" and the "post-moderns" that is so often couched in terms of the life and death of painting.

John Baldessari, *Street Scene (with White) Instrusions / Single Leaf (Yellow).* 1992
Color photographs, acrylic; photocopy on Gandhi Ashram paper, acrylic wash; oil
enamel on rubber 100⅞″ x 34¼″

Courtesy of Margo Leavin Gallery, Los Angeles. © *Douglas M. Parker.*

Third Wave: Art and the Commodification of Theory

Sylvere Lotringer

Critic and theorist Sylvere Lotringer examines the reception of European neoexpressionism in the United States in the early eighties. Criticized by critics as "false spirituality" and as a misguided attempt "to turn back history" by utilizing painting and expression, Lotringer suggests that the real motivation for the attacks was the desire to maintain New York's cultural supremacy. Subsequent American art focused on "critical examination" and deconstruction of the media and on carrying out ideological critiques. Lotringer suggests that in fact what was produced was the "mirage of a critique" and that the appropriation of French theory became an excuse and justification for "smart art," leading to art's "ultimate disappearance."

No Wave

They all came in the late afternoon, mostly in groups of four or five, unlike the usual customers of this rather shady area of New York City where people linger alone, dropping in and out of adult bookstores or seedy sex shows. But this was a young, loud, leather-clad crowd, and they knew exactly where they were going. Others were already there talking excitedly on the sidewalk, or sprawled on cars parked along the street, sipping a Coke.

I was living just six blocks away at the time, sharing a loft with Diego Cortez, curator of the "No Wave Show" at P. S. 1, and Austrian artist Stefan Eins, who had just started the graffiti-art gallery Fashion Moda in the Bronx. The run-down building in which we all eventually gathered, a former massage

Reprinted from Sylvere Lotringer, "Third Wave: Art and the Commodification of Theory" *Flash Art* (May/June 1991).

parlor on 41st Street and 7th Avenue, crystallized the surrounding squalor in the brash statement of a new sensibility. It was littered with art.

This art, if art at all, was a far cry from the understated immaterial artifacts SoHo artists had been making for nearly two decades after Joseph Kosuth, upping the ante, extended Marcel Duchamp's refusal of "reticular painting" into a series of analytical propositions. Still the hundreds of pieces, mostly unsigned—among them Jean-Michel Basquiat's, Rammelzee's and Futura 2000's—displayed on the stairs, in the halls, down from the basement up to the fourth floor of the building, presented the same kind of raw and collaged art that, for the last two or three years, had sprouted all over West Broadway, at the heart of the close-knit New York art community: posters of guns and knives and cocks and chains and dollar bills with inflammatory political statements about sex, money, and terrorism. In SoHo it all looked rather childish and uncouth, also a little disquieting. Lucy Lippard remarked in the Fall 1980 issue of *ArtForum*, "I'm getting sick of all the guns and skulls and racist/sexist slurs," however noticing that this art was "a sort of reverse Magrittean situation in which the image carries all the weight no matter how fragile it may be." The first reappropriation of the decade didn't come from recycled high-art (neo-conceptualism), it happened in the street, eventually bringing the street back into the gallery.

It didn't take much "semiotic" proficiency (the term had just begun to gain some currency) to recognize under the neoDada aesthetics of shock-anarchism and naivety the studied signifiers of a new code staking the claim for a frustrated generation of young New York artists. Barred from established channels or institutions, they had found in the garbage culture of the Lower East Side and the intense night life of the Mudd Club, among new wave bands and punk accoutrements, their own programmatic identity.

The Estate of the Art

"We are interested in taking up situations that activate people outside the art world," proclaimed Colab, the loose assembly of young artists who had organized the "Times Square Show"—as well as other theme shows dealing with money and real estate. These shows were daring and euphoric events, effectively activating people outside the art world. Few realized that it was the beginning of the end.

Less than three years later, SoHo was turned into a luxury compound, irremediably scattering the New York art community all over the metropolitan area. "The Times Square Show," wrote Lippard, "was about artists banding together as pseudo-terrorists and identifying with the denizens of this chosen locale, envying them and imitating them at the same time colonizing them . . ." The "New Times Square Project" currently on display is less romantic, and far more conceptual. After consultation with Jean Baudrillard, it was decided that the original flavor of the neighborhood would be preserved,

offering a tour of *Times Square* set up complete with quaint shooting galleries, staged prostitution and a permanent display of Robert Mapplethorpe's photographs.

In October 1982, Thomas Lawson praised a young gallery owner, Mary Boone, for "deconstructing" capitalist manipulation with her "sophisticated strategy of seduction and refusal. A glass street front recalls the spectacle of department store windows beckoning passerbys to enter, while the gray baffle wall behind . . . denies easy entry." Semiotics, the great equalizer, had entered the art market. Dealers were becoming artists in their own rights; possibly the only ones.

Waves of War

In the early months of 1980, two powerful waves of neoexpressionist painting, first Italian with Chia, Clemente, and Cucchi; then German with Salomé, Middendorf, and Fetting, reached the American shore. Established New York critics who had dismissed with a sleight of hand the "shock and shlock" and trashy consumerism of No Wave artists, suddenly woke up to a major cultural threat: "The first world-historical art to come along since Pop art and minimalism."

The reaction was violent and immediate. Policing the arts, defending the pure strain of New York postminimalism against cosmopolitan threats and internal infiltration can be a taxing job, one that requires the prosecutor's axe and ruthless dialectics. But someone had to do it, and preferably more than one. The invasion had to be stopped, the disease eradicated by all means at hand.

This so-called neoexpressionism, Thomas Lawson unleashed, is actually a reactionary expressionism, "a retardataire mimeticism presented with expressionist immediacy." Uncivilized and unsublimated, he added, their art is only difficult "in the sense that a naughty child is difficult; that is, art that misbehaved within a strictly defined and protected set of conventions." In a topsy-turvy paranoid fashion the neoexpressionists' apparent spontaneity was denounced as social control; their desire as repression; their anarchism as conformity; their taste for popular culture as bourgeois appropriation. Childlike and false, inflated and bastardized, foreign, malevolent, "at once scandalous and servile" (Hal Foster), neo-expressionism was declared anti-modern, a mere *pastiche* of historical consciousness.

At the core of this well-orchestrated onslaught on neoexpressionism was the notion of *expressivity*, which Donald Kuspit in "Art as Damaged Goods" disparagingly opposed to the laconic expression of the best American avant-garde.[1] In "The New Expressionism," Kuspit wrote, comparing it to their more genuine forerunners, "we have the corruption of the spiritual will-to-power into an *expressive* will-to-power. Expression for the sake of expression is pursued, rather than expression to make spirituality manifest." Exposing emo-

tion, releasing instinctive feelings or uninhibited sexuality, he claimed, has ceased to be rebellious or liberating: "The revelation of desire becomes subtle repression of it, a way of controlling it . . . in the name of authority."

Paradoxically the American critic happened to be pretty close here to the—rather unpopular—position Michel Foucault had just adopted in his *History of Sexuality*. Breaking away from Reich, Marcuse and the neo-Freudian analyses of the Frankfurt School in terms of repression, the French philosopher asserted to the contrary that the expression of truth, the positive articulation of one's innermost desires, had indeed become an instrument of control and conformity. Neither Foucault nor Gilles Deleuze and Félix Guattari, the authors of *Anti-Oedipus*, which equated the fluxes of capitalism with the schizophrenic process, would have found anything objectionable in Kuspit's idea that "the unconscious today has become almost a fiefdom of the popular culture"—although they certainly would have asked what kind of unconscious it was that produced such a subjugation. The idea that the unconscious may not be one and eternal—as Freud maintained, and after him Jacques Lacan—but "representative" or "productive" according to specific collective configurations, didn't come to Kuspit's mind; nor did he realize, when he polemically equated anarchism with venture capitalism—"capitalism taking risks and so demonstrating the continued dynamics of the system"—that it was precisely the point raised by these continental thinkers who advocated turning capitalism against itself, but from within.

"With It and Against It" was the title of an article published in 1981 which eloquently argued in favor of the recent German expressionist revival. Its author, Wolfgang Max Faust, an art historian from Berlin, crystallized in this slogan the complex strategy developed by these neo-Nietzschean French theorists and otherwise implemented by the new revolutionary movements in Europe: with capitalism—which can no longer be resisted through traditional class struggles—but against it. Far from being a messianic utopia, revolution had to be generated in the present through a constant reappropriation and displacement of the energy of the capital. When Kuspit, therefore, reproached neoexpressionists for their lack of patience and their unwillingness to make a "serious and careful planning" for the revolution to come, what he was doing in effect was reiterating the classic Leninist demand for an orderly political (or artistic) avantgarde that would curb present desires for a fulfillment "only the future can bring."

It was thus paradoxically via Germany, but also Italy, that these elements of "postmodern" French theory, as it was erroneously called—postmodernism, a term originally introduced in architecture as a reaction to an international modernist style, was in fact packaged in the USA—first found their way into the American cultural debate.

In America, with its typical cultural amnesia, the euphoria of the 60s had quickly evaporated, leaving behind a renewed work ethic and a toothless brand of academic Marxism also current among most New York art critics. The

entire anti-institutional movement in Europe had, on the contrary, extended into the late 70s a "productively anarchic" activist culture. It is this collective ferment's fall-out on Italian art that Achille Bonito Oliva presented to New York already in 1979.[2]

That these theories—as well as, in a delicious pell-mell, Barthes, Derrida, Lacan, Kristeva—would have come from France, and not from Italy or Germany, is also something that American critics couldn't account for.

Ferdinand de Saussure's original intuition that language is a systematic grouping of signs in society was actually supported by three centuries of French political centralism, linguistic control and abstract rationality. This well-tuned instrument of cultural hegemony proved capable of integrating all other nonlinguistic systems into a language-based semiotic theory. (Neither Italy nor Germany ever managed to fuse their regional diversity into a unified state).

The emphasis on cultural specificity, the contention that repression isn't exerted from above but generated at every single level of society through micro-powers and disciplines, obviously ran counter to the French structuralist-semiotic emphasis on codes and systems, but also to proponents of conceptual art which strived to arrive at "universally meaningful statements in which the importance of individual and regional character was reduced, whether it related to the history of art or the history of a given nation" (Faust).

Neoexpressionist art in effect initiated the first theoretical debate of the 80s, although it was never recognized as such at the time, so muddled was it by considerations of national identities, shifting styles and allegiances, or crude cultural prejudice. Whether expressed in terms of "false spirituality" (Donald Kuspit's Spenglerian thesis of cultural decline)[3] or as a social symptom negating artistic innovation (Benjamin Buchloh's Marxist thesis of prefascist regression), or as a denial of the rhetorical nature of subjective expression (Hal Foster's decoding of Roland Barthes through Lacanian theory), in each case the message was loud and clear: it was an unconditional refusal of this "newly promoted art of local sentiments and archaic forms . . . [which] constitutes a disavowal not only of radical art but also of radicality *through art*" (Hal Foster)—meaning: the New York avantgarde.

Finally brushing aside all pretence, Kuspit concluded: this new expressionism is nothing but "a European attempt to take the sceptre of advanced art back"—and here is the telling admission— *"even to the extent of wanting to produce a spiritually significant not* simply aesthetically or stylistically original *art."* In other words, even if the new foreign art happened to be significant, it should be blasted anyway because it threatens New York's cultural supremacy.

Hardly two years later Kuspit abruptly changed allegiance, embracing neoexpressionism with the same dialectical subtlety he had previously demonstrated in condemning it. By then, the threat was no longer coming from

Europe, but from within. Its name was soulless abstraction in the arts. Critical intelligence. Appropriationism.

Moving to the public place, to the "real world" of consumerism, advertisement and corporate media productions—the outside world of money and real estate—American art instantly unleashed the powerful forces of mature capitalism waiting at the gates of the art world, sending signs spiralling beyond figuration and prices blazing on the art market.

Contrary to appearances, the 80s were dominated by issues dictated from the outside: first, the two waves of German and Italian art, and then the third wave of French theory. Paradoxically enough, New York art managed to regain a precarious ascendency over European art by casting its lot with this last continental wave.

Neoconceptual artists, Hal Foster suggested, manipulate social signs instead of producing art objects. Hence their interest in semiotics, especially in Roland Barthes' early—still neo-Marxist—definition of myth-making as a reduction of singular expressions by the bourgeois code. To expose this theft Barthes suggested producing another myth, but this time genuinely artificial, powerful enough to reveal for what it is the alleged naturality of the ideological appropriation. Ideally this second construct, "critical" of the first, would simultaneously restore the defaced original to its pristine state.

Reappropriationists claimed to be in a position to "demystify" the media and consumer society by taking away their most cherished icons: logos, ads, consumer items, etc. But if the myth is a disease of the code, an ideological "virus" turning the original content into a meaningful mummy, is it really possible to exorcize the fascination of the code—the black hole of the media— simply by exposing it "critically"?

It is easy to understand why American artists adopted with enthusiasm this semiotic strategy: it merely confirmed the viability of an ideological critique—and thus of an artistic avantgarde—extending their preoccupations to the realm of social signs. The persistent misreading of Jean Baudrillard's *Simulations* stems from there.[4]

That art as "a form of market criticism" was something new, as Gary Indiana suggested, is undeniable, but was that "smart art" smart enough about what a work of art is to evade the machinery of capital and the commodification of the market?

"The media is naturally interested in art that reflects it, no matter how critically," estimated Ann Hoy, a New York curator. Proponents of the art market, consequently, had no problem promoting the neoconceptualist brand of radicality. In reality both speculate on the codes instead of fetishizing the art object. Both keep decoding the fetish effect, with a surplus value of criticality on the side of the art, and a surplus value of capital on the side of the art market. They are virtually the same.

For all its elitism, the old artworld had managed to remain at a safe distance from the marketplace, even if the meaning of their art wasn't located

outside of that process. Their intelligence may not have been critical in the same fashion, but it didn't need to be since their art wasn't ambiguously market oriented. Stripping art from everything external, they refused to be locked in a position of "subversive complicity;" if critical intelligence is so keen on setting up "suave entrapments" with media fetishism, why not preclude complicity altogether by really upping the ante, like Gran Fury's posters glamorizing images that remain unacceptable to the media—gay couples or lesbian couples or interracial heterosexual kissing in a Benetton fashion ad?

New York critics dismissed neoexpressionist's mythological propensity as another symptom of "alienation from history" but what are media signs and consumer codes if not the very myths and symbols of late capitalist societies? America's only mythology—which is all pervasive—is the media. The only difference between so-called "progressive" (American) and "regressive" (European) reappropriations then is that German or Italian icons still have content—communal, historical, cosmological—whereas American representations squarely belong to the commodity-form, a pure orgy and semiurgy of signs, all the more seductive for their empty formality.

Opposing a myth, or commenting upon it is to become part of the myth—fulfilling its secret prophecy. The critical stance towards mass culture and consumer society is a mirage of critique, the way critical artwork is a mirage of work. Both are an intrinsic part of the mythical logic of the media.

Just looking at the scores of neoconceptualists now doing work in that manner, their range and versatility appear truly stunning. Jenny Holzer's electronic message machines absorbing the media form to flash tongue-in-cheek quotations and slogans; Barbara Kruger's sharp manipulation of media-rhetoric through exhortation and verbal commands; Richard Prince's signboard jokes and reframed or "remade" images deconstructing advertising mythology; Sarah Charlesworth's photo-safarist tracking down desire and naturality in media imagery; Louise Lawler's recontextualization of artworks through photographic displacement; Cindy Sherman's dramatic manipulation of media-made self-image; Robert Longo's monumental logo sculptures ironically exhibiting corporate power; Jeff Koons, Haim Steinbach and Robert Gober's display of consumer products, decorative objects or entire domestic settings in suspended states, etc.—this endless proliferation of muted or mutating critical stances aestheticizing commodity or commodifying aesthetics, has generated an intense soul searching among art critics reduced to appreciating the mythical distance between intent and integration as these artists achieve astounding success in the art market and among the media they portend to subvert. The procession of neoconceptual clones follows the rule Lévi-Strauss defines in his *Mythologiques*: losing power, myths turn into novels, and then into cheap serials.

The radical stance exhibited by "smart art" artists is not just self-serving, it is structurally ambiguous. Less than a critique of the code, it is its best

expression. Operating within the structures of the capitalist media, appropria-
tionists can't effectively question them. Their radical posture has outlived its
function. There's already a tendency among second generation appropriation-
ists to drop their critical stance altogether and just present an opaque replica-
tion of the bourgeoise decor and decorum—which is being instantly hailed as a
daring political statement.

In retrospect, Kuspit's nostalgic warning that the damage done by
"media melodrama" would be irreparable, and "the high aim of modernism
forever dissipated in the irresistible thrust and challenge of consumerism," is
accurate. The reappropriationists were reappropriated. The balance sheet,
however, is not entirely negative if we keep in mind that the real project of
critical intelligence may well have been not political or critical, as they
assumed, but semiotic. Manipulating media signs, neoconceptualists in effect
managed to close the gap between art and consumerism. (A recent hearing by
a New York State panel explored the possibility that the art market be regu-
lated like "a sort of commodities market.")

In *Recodings*, Hal Foster asserted somewhat rhetorically that his analysis
had become superfluous, the new conceptualists having now taken over the
task of reflecting critically upon the neoexpressionists' language.[5] That was an
interesting remark, which could suggest that the boundary between cultural
critique and artistic "deconstruction" was becoming blurred. But what did it
mean exactly? That the art of "selfless intelligence," in a Hegelian fashion, was
about to supersede cultural critique—or that it had effectively subjected its
own project to the imperative of "reflection"?

In 1980, Craig Owens located the allegorical impulse of postmodernist
art in reading and exegesis.[6] Doubling another text or another image, alle-
gory replaces the original expression of the work with a meaning of its own.
Like the critic or theorist, the allegorical artist is seen as an "interpreter,"
but the commentary he/she provides doesn't come after the fact, it consti-
tutes an integral part of the work. But there lies the possibility of perver-
sion: that instead of taking place within the work of art, the commentary
would merely be appended to it. While acknowledging the danger, Owens
never considered it seriously as another structural possibility inherent to
this type of work; instead he kept dismissing it as an accusation coming from
the outside, a mere formalist reaction to the allegorical challenge. Ironically
enough, in his effort to define allegory as a "dangerous supplement" already
at work in the original, Owens ended up reiterating the very logic of sup-
pression he accused Western art theory of having performed on allegorical
art (like Western philosophy on writing). The reduction, as it happened,
didn't come from the outside, but from within: it didn't pitch allegorical
artists against their modernist adversary, but resulted from their uneasy alli-
ance with "postmodern" theory—thereby perverting the very paradigm
Owens had been trying to uphold.

Sherrie Levine's mimetic strategy will help us understand how this para-digmatic perversion came about. The allegorical impulse, Owens suggested, has "always already" been present in culture in a fragmentary and imperfect fashion. Richard Prince's "remade" commercial pictures, for instance, still belonged to that tradition. But what were we to make of Levine's mechanical replications? For all their simplicity, her straightforward "rephotography" of modernist icons—unlike Pierre Menard's laborious rewrite of Quixote—defi-nitely upped the ante, presenting a real challenge to both art and criticism. Pure simulacrum pushing the allegorical project to the limit, it exemplified the paradox of contemporary art which, as Baudrillard has it, keeps creating "a profusion of images where there's literally nothing to be seen." The further paradox of Levine's work is that, having no body of its own, just the tentative trace of its critical indexation, it kept eluding traditional evaluation while beg-ging for outside commentary to insure its precarious existence. The comple-tion of the allegorical project coincides with its artistic exhaustion and its assumption by reflective discourse. In effect theory was not only added *post facto* to the work, but was literally substituted for it.

French theory swept over America at a time when a New World Order of art was being born through the convulsions of pluralism, the immersion in popular culture and the lures of the art market. Never before had the art com-munity been so porous to the outside. Reacting critically to pre-existing mate-rial instead of creating one's own could hardly be taken for a sign of strength. Still, there was something assertive and humorous, even impertinent in the early attempts to recycle, repossess and overpower cultural fetishes or con-sumer signs or products. Appropriating, Nietzsche wrote, means to impose form, to create forms by exploiting circumstances. Reappropriationists exploited circumstances. They elaborated a distinct art form out of the fiction of a critical consciousness, but few managed to transcend the ascetic—and aes-thetic—limitations of a selfless intelligence which merely allowed for strangled effusions, uneasy denials or demagogical exhortations. For a Cindy Sherman constantly recreating herself through protean imagery, how many manneristic postures enlisted theory as a marketable ploy for all too thin "radical" strategies?

Artists, Sherrie Levine admitted, resorted to theory to insure their credi-bility, or, like Barbara Kruger, to ward off embarrassing enquiry. Asked if join-ing the Mary Boone gallery constituted a "symbolic gesture," Barbara Kruger instantly rushed for cover: "Most probably," she replied, paraphrasing the master, "as the passages of the supposedly real seem to be mediated through the symbolic . . . I know," she added more candidly, "that for many women and men, the making present of that which had been unseen and unspoken can have a tremendous generative impact. . . ."[7]

The reliance of "smart art" on French theory is a symptom of—and not a cure for—the current aimlessness perceptible in the arts. Paradoxically enough, theory ended up acting as a stop-gap to independent reflection.

Like art, art criticism became parasitic to theory (Collins and Milazzo's turgid presentation of "The Last Laugh: Humor, Irony, Self-Mockery and Derision" at the Massimo Audiello gallery in January 1990 should definitely be anthologized), and art magazines a baroque appendage to the academic institution.

The neo-geo's claim to incorporate Baudrillard's "simulation" in an artwork was another case in point. Originating in the code, "simulation" has no original and cannot be represented in an object, let alone in the traditional painterly mode. Ideally Peter Halley's idea of representing the code itself as a model of "cells and conduits" could have been "the last laugh," a tongue-in-cheek exercise in theoretical travesty, but in taking Baudrillard's thought at face value, the neo-geo's rushed to occupy the space (of art) he had purposely left vacant at the cost of a monumental misreading.

The fact that Baudrillard's theory was misinterpreted and "simulation" taken literally (from the title) wasn't in itself objectionable. After all, "deconstruction" in America had little to do with Derrida's intricate strategy of reversal of displacement. Artists should be allowed to misread theory creatively. What was more disquieting was the "simulations" frustrated claim in paternity. Baudrillard's flat dismissal (at Columbia University) of his self-proclaimed "school" definitely put an end to the uncanny family romance.

The neoconceptualist's relation to theory, on the other hand, may not be as parasitic or vampiristic as it is generally assumed to be if we are ready to acknowledge that its actual project was not political or critical or even aesthetic, but semiotic.

The Saussurian utopia of a general semiology, of which language would only be a part and not the model, was quickly defaced in the hands of French linguistic and post-structuralist theorists who tightly tied down signs to language and textuality to literature. For all their reification of French theory, it can be claimed that reappropriationists actually saved semiotics from linguistic fetishization. Using words as images, manipulating objects as signs, decoding social systems through distinct visual and verbal strategies, they actually opened up dizzying prospects for the old science (or the new art) of signs.

For Baudrillard, contemporary art has lost its autonomous status and function to become just another value-sign. Conversely any value-sign could now be apprehended as art. Far from protecting it from the pressure of the market, the "dematerialization of the art object" actually paved the way for its rematerialization throughout a society become entirely "transaestheticized."[8]

Paradoxically it's not when theory was invoked most explicity—by the neo-geos—that it proved to be the more operative. A case could be made that reappropriationists, finally, were the only authentic simulationists inasmuch as they actively participated in art's ultimate disappearance. The "xerox degree of art," in any case, brought us closer to media hyperreality and to the axiomatics

of the market, forcing us to think anew the present status and possible future of art.

References

1. Donald Kuspit, "The New (?) Expressionism: Art as Damaged Goods." *Artforum*, November 1981.
2. Achille Bonito Oliva, *The Italian Transavantgarde*. Milano: Giancarlo Politi, 1980.
3. Donald Kuspit, "Flak from the 'Radicals': The American Case against Current German Painting." In: *Expressions: New Art from Germany*, the St. Louis Art Museum, 1983.
4. Jean Baudrillard, *Simulations*, transl. Paul Foss and Paul Patton. New York: Semiotext(e), 1983.
5. Hal Foster, *Recodings*, Seattle: Bay Press, 1985.
6. Craig Owens, "The Allegorical Impulse: Toward a Theory of Postmodernism." *October*, No. 12 & 13, Spring/Summer 1980.
7. "Barbara Kruger," An interview with Anders Stephanson. *Flash Art*, October 1987.
8. Jean Baudrillard, *La Transparence du Mal*. Paris: Gallée, 1990.

Alexis Smith, *Rocky Road.* **1990 Mixed media collage. Two panels: each 64″ x 23″ x 3″**

Courtesy of Margo Leavin Gallery, Los Angeles. © *Douglas M. Parker.*

Art and Media Culture

Lisa Phillips

Curator Lisa Phillips argues that the power of mass communications systems, in particular the power of television, has surpassed visual art's power to communicate; this change has brought about "a complete transformation" of the function of art. Phillips reviews the historical influence of the "Image World" on art, in particular the art of the 1960s, and distinguishes artists who "institutionalized dissent" from artists who believed that they could be an alternative to media culture, analyzing its "hidden agendas." In the 1980s, artists brought up on television and the mass media sought to question the ideas of uniqueness, authorship, and originality; however, their success and celebrity status raised the question of just how critical such an art could be.

Everything is destined to reappear as simulation. Landscapes as photography, women as the sexual scenario, thoughts as writing, terrorism as fashion and the media, events as television. Things seem only to exist by virtue of this strange destiny. You wonder whether the world itself isn't just here to serve as advertising copy in some other world.
 —JEAN BAUDRILLARD[1]

Today we can speak of an Image World—a specific media culture of teletransmissions, channels, feedback, playback, and interface that has produced a televisual environment. TV is the ultimate object for our new era—the perfect "static vehicle."[2] Cinema was the first of such vehicles to bring us sounds with moving pictures, the sensation of speed, and condensation of time. Now the TV monitor is assuming every function—everything will take place on the smooth, operational surface of the control screen without our ever having to

Reprinted from Lisa Phillips, "Image World—Art and Media Culture." © 1989 Whitney Museum of American Art.

move. We can shop through it, do our banking, select a date, meet new friends, tour faraway places, get a degree. The speed of transmission has replaced the velocity of vehicular, physical transport. The intensive time of instantaneity has replaced the extensive time of history. Philosopher Paul Virilio has even predicted that our destiny is "to become film" by becoming teleactors—circulated on the screen without ever circulating. And soon, with the aid of fiber optics, we will receive information and images directly on our retinas, our bodies becoming the screens.[3]

Mass reproduction of the image and its dissemination through the media has changed the nature of contemporary life. In a century that has seen the intrusion of saturation advertising, glossy magazines, movie spectaculars, and TV, our collective sense of reality owes as much to the media as it does to the direct observation of events and natural phenomena. The media has also changed the nature of modern art. As image makers, artists have had to confront the fact that this new visual mass communication system has in some way surpassed art's power to communicate. Over the past thirty years, they have come to terms with the mass media's increasing authority and dominance through a variety of responses—from celebration to critique, analysis to activism, commentary to intervention. The ascendancy of this new visual order has raised a host of critical issues that many artists have felt obliged to confront: Who controls the manufacture of images? Who is being addressed? What are the media's strategies of seduction? Has the media collapsed time and history into a succession of instants? What are the effects of image overload, fragmentation, repetition, standardization, dislocation? Is the photograph still a carrier of factuality? Where is the site of the real? Is understanding "reality" a function of representation? All of these questions have directed attention away from aesthetics to the nature of representation itself as the principal problem of our age. Since much of experience is mediated by images, the issue of how meaning is constructed through them has become central. Artists have also had to recognize that as our relationship to the visual world has changed so has the role we assign to art. This awareness has precipitated nothing less than a complete transformation of the function of art and the conventional guideposts used to define it.

Historical Threshold

The effects of the Image World were beginning to make themselves felt in art during the first decades of the century, when a convergence of recent technical discoveries—electrical wiring, movie projection, portable cameras, and the automobile ushered in the new age with a vertiginous rate of change. When, in 1912–13, Braque and Picasso incorporated bits of newspaper into their Cubist collages, the range of acceptable materials and iconography for art was considerably widened to include elements of mass culture. In 1914, Marcel Duchamp pushed the issue further, selecting

objects and images from the real world and re-presenting them as "ready-made" art. Duchamp was actively interested in commercial imagery throughout his career. In an early example of rectified readymade, *Apolinère Enameled* (1916–17), Duchamp used an actual advertisement for Sapolin, a popular brand of paint. He altered the lettering slightly— [S]APOLIN[ÈRE]—and added the reflection of the girl's hair in the mirror. Some of his other artworks included a fake check and a wanted poster featuring his own face. Duchamp was the first to appropriate consumer objects and images as readymade art, recognizing that in a reproductive world uniqueness and singularity were diminishing, and framing and context determined meaning. By relocating these objects in an art context, he conveyed a new message that defined art within the framework of commodity fetishism.

Berlin Dadaists John Heartfield, Raoul Hausmann, Hannah Höch, and George Grosz composed their agitprop works entirely of images cut from newspapers and magazines. They developed the concept of photomontage to express their political views in a compelling, filmic way. The practice of photomontage was common in Soviet art of the twenties, as it was at the Bauhaus. In the early twenties, Bauhaus artists established their well-known interdisciplinary program, which accorded graphic design and photography equal status with the so-called high arts of painting and sculpture. These artists, along with the Surrealists and Constructivists, extended the practices of collage and montage into mass forms of communication: photography, film, architecture, fashion, and theater. Salvador Dali, for instance, ready and willing to work with the mass media, art-directed segments of Hollywood movies, appeared in commercial advertisements, designed furniture, and created *Dali's Dream House* in the amusement area of the 1939 World's Fair in New York. A figure who straddled high and low art, he achieved celebrity for his eccentric and flamboyant personal style; his flawless painting technique and bizarre imagination epitomized certain popular myths of the artist as crazy, excessive, and extreme, but brilliant.

In 1939, Clement Greenberg wrote his prophetic essay "Avant-garde and Kitsch" to clarify the difference between high and low art, their social origins and effects. Both emerged in the nineteenth century, he pointed out, for different ideological purposes: high (authentic) culture to serve the rich and cultivated, kitsch—a synthetic art, a simulacrum of culture—to satisfy the new urbanized masses enjoying increased leisure time. Greenberg noted that kitsch, because it was mechanically produced, quickly became "an integral part of our productive system in a way in which true culture could never be," and that "[its] enormous profits are a source of temptation to the avant-garde itself."[4] Sensing the power of kitsch, he warned that it could contaminate high art. Even in 1939, therefore, some foresaw the breakdown of traditional distinctions between high and low culture.

Conditions in America following World War II conspired to produce irreversible social change. Mass-manufactured advertising images ran rampant as

consumer spending increased. The hyperbole of postwar American advertising and packaging was invasive as we became image junkies addicted to visual consumption. "Image" alone counted—everything was in the "look."[5] With the advent of television we had direct access to a continual flow of visual information. "The individual," George Trow observed, "became a point on a grid of 200 million."[6]

Soon painting too took the screen as a new model. In 1962, Robert Rauschenberg and Andy Warhol independently began to silkscreen photographic images directly onto the surfaces of their canvases. Colliding and abundant fragments of real life from magazines, movies, and tabloids were not attached and glued but transferred mechanically—"received" on the surface of the "flatbed picture plane."[7]

The photo-silkscreen on canvas was a new hybrid form—part photograph, part painting, part print. It overturned the prejudice against photography as painting's poor relation. In these works and in many others by Pop artists, the photograph became the origin of the image. The appearance of this new technical-mechanical means not only modified art's forms but also art's very concept, destabilizing the aesthetic object and official taste. As British Pop artist Eduardo Paolozzi commented, "The unreality of the image generated by entirely mechanical means *is commensurate with* the new reality with which we have lived for half a century but which has yet to make serious inroads on the established reality of art."[8]

In the fifties, Rauschenberg had begun to activate the grounds of his paintings with newsprint; he then emphasized these found images through the transfer and silkscreen processes. He loaded his canvases with image shards, letting the world in with an inclusive Whitmanesque spirit of democracy. His scrapyard of images produces a buzz—a kind of visual interference on the pictorial surface that alludes to the space of the billboard, dashboard, and projection screen.[9]

Warhol went a step further: he internalized the very methods of the media, incorporating its processes into the construction and *conception* of his work. He emphasized the depersonalization of the media, its dependence on stereotypes and repetition and its fascination with surface. He fetishized the whole structure of mechanical reproduction; "I'd like to be a machine, wouldn't you?," he said. The image, for Warhol, became fact, signifying that it signifies nothing. He recognized that repetition had emptied images of meaning; they had become commodities—objects whose only value was exchange value.

To many, Warhol's attitude represented a rejection of the deepest values of modern art. He worked not like an artist but an art director, manipulating images and making the kind of design decisions he had made as a commercial artist. And his repeated imagery—of commercial products, of Jacqueline Kennedy in mourning, of Marilyn Monroe's press photo—collapsed the antago-

nism between the unique and the reproduced, the original and the copy, an antagonism on which the integrity of high culture had always depended.

All of the Pop artists came under fire when Sidney Janis introduced the movement in 1962 with his "New Realists" exhibition. Warhol's cohorts James Rosenquist, Roy Lichtenstein, and Tom Wesselmann all drew their imagery and techniques from mass culture, painting a new landscape of promiscuous signs and consumer products that formed a collective portrait of America and its utopian vision of prosperity. Lichtenstein's *Image Duplicator* of the following year can be regarded as an apt symbol for the enchantment of the age with mechanical reproduction and manufactured images. Critics objected to Pop's fascination with materialism and brazen affirmation of commercial values. Hilton Kramer insisted that the social effects of Pop Art were indistinguishable from those of advertising art, "reconciling us to the world of commodities, banalities, and vulgarities."[10] Others, like Irving Sandler, mistrusted Pop's commercial success and the exposure it received in slick magazines because "it rendered the advertising ethos respectable."[11] The ambiguity of Pop's position and its voyeuristic detachment still provoke discussion today. During a recent symposium on Warhol held at the DIA Art Foundation, a debate broke out over the imputed meaning of Warhol's selection of a photograph of Imelda Marcos for the cover of *Interview* magazine.[12] Did Warhol think she was a real star, or was he mocking stars and the possibility of exploiting them, or criticizing their exploitation?

One of the clearly political works of the period was James Rosenquist's *F-111* (1965), considered the apotheosis of Pop. While Warhol had been designing shoe ads and store displays in the fifties, Rosenquist was earning his living as a billboard painter. High above Times Square, he grew intimate with abstract patches of Kirk Douglas and Lynn Fontanne. He later drew on this experience and applied billboard techniques to his paintings—collapsed compositions of close-ups, body parts, disjointed fragments. *F-111*, his first environmental work, was a wrap-around picture spread that directly commented on the sinister nature of military technology. Its sale in 1965 to Robert Scull for the then astonishing sum of $60,000 received front-page coverage in *The New York Times*.[13]

Pop Art not only made capital visible but exposed art as an industry. Resistance to the dominant culture eroded as avant-garde and kitsch crossed into each other's territories. In the early 1940s, Theodor Adorno and Max Horkheimer had already prophesied an age of universal publicity, when all aspects of Western society would be absorbed within the mass media.[14] With Pop, the prophecy was fulfilled. Maintaining a position outside the system no longer seemed germane as critical works were embraced by the very forces they criticized. Dissent was institutionalized and art moved into the center of the status quo.

The Apparatus

Other groups of artists held to their faith in an oppositional art that could offer an alternative to media culture. Fluxus, an international group of artists, recognized Pop's strategic acuity in anticipating cultural transformation, but found Pop's glibness, ambivalence, and lack of critical intervention objectionable. Fluxus artists used mass-culture forms—film, TV, postage stamps, newspapers, and commercial products—as vehicles for their art, referring directly to Dada and the Duchamp-Cage tradition in their anti-art, anti-taste stance. Unlike Pop artists, however, they took a counter-cultural position toward the commodity status of the art object and targeted the mass media as the most nefarious ideological prop. Pushing the limits of acceptability, they infused their works with political and sexual innuendos.[15] Compared to Pop Art, Fluxus remained deliberately marginal, peripheral, and never took a mainstream, mass-marketing approach. Fluxart was often ephemeral, made casually of inexpensive materials; and poetry, film, sound, movement, and photography played as significant a role as the objects. Some works, among them Nam June Paik's video sculpture, opened up whole new avenues for artists to explore. Other works, though prescient, were never realized, such as George Maciunas' visionary plan for a multimedia *Flux Amusement Center* in SoHo with film wallpaper (1968). The Fluxus artists' disavowal of expertise, glamour, quality, and even sometimes the object itself directly anticipated Conceptual Art, which came to the fore in the late sixties.

The photographic image *as fact* assumed a central place in Conceptual Art. In 1965, Joseph Kosuth made *One and Three Photographs*, a three-part work consisting of a rather dull, prosaic, yet factual photograph of a lone tree on a barren hill, a copy of it (hence, a copy of a copy), and a photographically enlarged dictionary definition of the word "photograph." In putting the three together, he simultaneously provoked questions about originality and uniqueness and about the conventions through which representation is produced. Quoting Wittgenstein, he said, "the meaning is the use."[16]

John Baldessari burned his paintings at the end of the sixties in a ritualistic display of renunciation of the handmade object. He came to this renunciation after working on a series of photographic emulsions on canvas which ironically eliminated all signals that indicated "art." Mechanically made like Kosuth's, the works had a detached, alienated air that informed rather than formed. In these early works, Baldessari used photographs that contradicted the conventions of good photography combined with wry sardonic captions— for example, *"An Artist Is Not Merely the Slavish Announcer of a Series of Facts"* (1966–68). Despite, or perhaps because of, this contravention, he helped establish photography (and language) as independent vehicles for representation. He subsequently adopted a film storyboard format, developing purposefully disjointed and melodramatic narratives through the use of movie

stills and images lifted right off the TV screen—all designed to avoid or submerge aesthetic decisions.

Conceptual Art established a new imperative for artists: that what must be investigated is "the apparatus the artist is threaded through."[17] Art had to be seen as part of a network of social relations constructed within a fluid interchange of cultural codes. Representation is an apparatus of power, realized in specific contexts that allow it to signify rather than to be constituted solely within the absolute domain of the individual imagination. Therefore, a work's "aesthetic qualities" and "autonomy" were no longer valued; it was the *framing* of the work that would reveal the social nature of artistic activity and the contingency of art's meaning.

Artists began actively seeking more diverse public forums and contexts in order to re-position the conditions of art's distribution and reception. Billboards, books, the magazine page, TV spots, and rock clubs became sites for works that created friction between the controlled public context and the intervention of an independent outside voice. Canadian artist Ian Wilson took out an "ad" of his printed name in the June 16, 1968, Sunday *New York Times*, and Dan Graham embarked on a series of works that used the magazine page to reflect on the nature of advertising. For a museum exhibition, Joseph Kosuth placed ads in dozens of magazines around the world, each containing a translated section heading from *Roget's Thesaurus*. Kosuth, Daniel Buren, and Les Levine rented billboard space for their art.[18] Most of these works were temporal, functioning as disruptions within the flow of editorial and advertising matter, while reflecting on the codification of language and image systems. The process of getting art out into the world, of changing art's frame and context, enabled artists to broaden their audience as they mediated between the privileged domain of culture and the commercial realm of the mass media.

By 1970, artists of different persuasions were moved to experiment with the media. Bruce Nauman, Richard Serra, Vito Acconci, and Keith Sonnier, to name a few, extended their interests to media forms by making films and tapes. Serra's tape *Television Delivers People* (1973) . . . and Sonnier's video installation *Channel Mix* (1973) are evidence of the compulsion to address media issues even by process-oriented sculptors. This was a period of widespread institutional critique—and a shared belief in art's ability to dismantle myths and analyze institutional strategies by using their forms as a means of criticism. Marxist theory, as employed by the Frankfurt School, structuralism, and post-structuralism became favored methodologies by which to examine art and its history. The mass media, one of the most powerful institutions, came under heavy scrutiny. Artists now had access to the technology of the media, and they appropriated its language and forms—its art direction, its cool, "factual" distance—in order to make its codes and hidden devices visible. Hans Haacke epitomized a clear, unequivocal political approach. Using the visual format of corporate advertising campaigns, as in *The Right to*

Life (1979), he added his own subversive copy to expose the deceit and hidden agendas behind the anonymous, impersonal facade of the corporate public image. In this case, below the Breck Girl's radiant, innocent face we are told that pregnant female workers at American Cyanamid (Breck's parent company) are exposed to toxins that endanger their unborn children; they are given the choice of moving into lower paying jobs or having themselves sterilized.

An Uneasy Alliance

In the 1970s, a new generation was coming of age. Many of these young artists were working in the studios of the California Institute of the Arts, founded in 1961 by Walt Disney.[19] This was a TV, rock-and-roll generation, bred on popular culture, and it took images very seriously. The artists were media literate, both addicted to and aware of the media's agendas of celebrity making, violence-mongering, and sensationalism.

These artists had been trained to critically question their relationship to social institutions. But, unlike their predecessors and more like Pop artists, many became increasingly cynical about the real possibility of maintaining an oppositional position toward these institutions. What made it difficult was art's increasing public acceptance and absorption into the mainstream of American life. Artists who attempted to make anti-object art that would resist commodification found it necessary to seek some kind of institutional support from museums and alternative spaces in order to have an audience (and often their works were reclaimed by the market). No matter how artists tried, it proved almost impossible to resist institutional forces. The tradition of the avant-garde as it had always been known came to an end. The only way for artists to engage it was as an image, a representation.[20]

The conceptual point of convergence for the emerging generation of artists was the recognition that there can be no reality outside of representation, since we can only know about things through the forms that articulate them. According to Douglas Crimp, who introduced some of these artists in the landmark "Pictures" exhibition at Artists Space in 1977: "To an ever greater extent our experience is governed by pictures, pictures in newspapers and magazines, on television and in the cinema. Next to these pictures firsthand experience begins to retreat, to seem more and more trivial. While it once seemed that pictures had the function of interpreting reality, it now seems that they have usurped it. It therefore becomes imperative to understand the picture itself, not in order to uncover a lost reality but to determine how a picture becomes a signifying structure of its own accord."[21] Pictures, once signs of the real, had been transformed into real objects by TV, advertising, photography, and the cinema.[22]

The premise that representation constructs reality has direct implications for theories of subjectivity. It means that gender roles and identity can be seen

as the "effects" of representation.[23] This became a natural line of inquiry, particularly for artists involved with feminist issues. In a group of early collages, Sherrie Levine extracted images of female models from fashion spreads and advertisements and used them as the "background" material for silhouette portraits of George Washington and Abraham Lincoln. These mass-media depictions of women are literally inscribed and contained within the broader symbolic realm of mythological heroes and great male leaders. In her *Untitled Film Stills* (1977–80), Cindy Sherman takes active control of her own image as she directs herself acting out a series of canned film stereotypes for the camera. She inverts the logic of commodification by exposing self-expression as a limitless replication of existing models (in this case, models defined by masculine desire). In another serial work from the late 1970s, Sarah Charlesworth photocopied the front pages of the *International Herald Tribune* for one month and then blocked out the texts, so that only the masthead, layout, and photo reproductions remained. The sequence of images as well as their sizes and relationship to each other on the page create a new story. The altered pages at first seem to reveal nonsensical, surrealistic conjunctions of images. But seen as an aggregate they show how the news is presented, who and what is deemed important, and the astonishing paucity of female representation. Deprived of its textual content, the autonomous system of the newspaper page becomes apparent.

Not only do found materials and their re-framing show how social reality and representation "subject" us, but the process again raises the issues of uniqueness, authorship, and originality, which had always been the defining characteristics of art and greatness. Like the myth of individual creativity, the original and the unique were now seen to be effects of a social fiction of mastery, control, and empowerment. This fiction is made patently manifest in the rephotography of Richard Prince and Sherrie Levine, for instance, where found reproductions were re-presented with little alteration. Only the image's context was changed—but that was enough to make its social codes and their peculiar unreality apparent.

By the end of the 1970s, it was increasingly clear that the deconstructive method had become dry and pedantic. American artists' direct experience of the media's special effects, their awareness of how the media affects our lives, set them off on a fantastic voyage through the media system—its unreality, artifice, immateriality, and replication. Art entered the spectacular realm, further exploiting the very strategies that made the media so powerful. The works grew dramatically in scale, the surfaces became glossier and more colorful, the imagery more grandiose, and the compositions more graphically arresting. And aesthetics reentered the art discourse, but with the revised notion of beauty—alienated and weird—offered by the media's spellbinding seductions. The younger generation, at home with this language, nevertheless approached it with a mixture of love and hatred, respect and fear, dependence and resentment.

Pictures of ambivalent and alienated desires emerged. Robert Longo's *Men in the Cities* series (1979–82) is a good example. In these monumental, larger-than-life drawings, conceived by Longo but executed by a commercial illustrator, men and women strike poses that alternately allude to pleasure or pain. The aesthetic was similarly ambiguous in its relation to the media. Was it distanced and critical in its alienated imagery or was it complicit—simply mimicking the media's techniques?

What made the situation confusing was that some artists seemed to combine the crowd-pleasing strategies of entertainment with the spirit of critical investigation.[24] This new politicized style quickly attracted media attention and was offered as an innovative and stimulating commodity. Artists were enlisted as members of the "research and development" team of commercial culture.[25] Not only was the "look" of art adopted by commerce, but in the eighties the concept of the avant-garde itself was used as a marketing strategy, most often by concentrating on the artist as personality. Companies such as Cutty Sark, Rose's Lime Juice, Absolut Vodka, Amaretto, and The Gap have featured endorsements by artists ranging from Philip Glass to Ed Ruscha. Over the past few years, the art and entertainment press have repeatedly featured artists, critics, and curators in fashion and life-style spreads as the latest chic commodity. Some artists, however, were quick to discover a newfound power in this development and began to reclaim public spaces usually occupied by the media for their own political messages. Bus shelters (Dennis Adams), electronic signage (Jenny Holzer), flyposters (Barbara Kruger, the Guerrilla Girls), and advertising placards (Gran Fury) are just some of the sites that artists have invaded, interrupting the expected channels of information with compelling visuals and independent voices.

The fame and success artists have acquired in the last decade have presented a dilemma. After analyzing and commenting on signs borrowed from the media, they now must encounter their own media image and consider the role they play in the construction of consent. Suddenly their position is unclear: are artists using media strategies in order to expose them or to expose themselves? Even when theoretical justification is vigorously offered, it is often quickly overshadowed by personal publicity and celebrity attention.

Jeff Koons is the hyperrealization of the contradictions of our age. After selecting sentimental chatchkes, images, and collectibles from pop culture, Koons has them sumptuously executed by expert craftsmen in stainless steel, porcelain, or polychromed wood and enlarged to near human scale. These images of American juvenilia—from TV, film stills, advertisements, and rock music—are themselves the sculptural embodiment of cinematic spectacle. Added to the effect of the works is Koons' carefully conceived PR campaign for his public persona: he has taken control of his own image in the media, packaging himself through a series of elaborately staged, airbrushed "advertisements" that feature the artist in a variety of situations. These situations—artist with

buxom babes, artist at the head of the class, artist as animal trainer—success-fully mock the ultraperfect world of advertising, where images of sex and power are used to dominate and control.

But no matter how sharply focused, such messages are far from clear. One is left with a sense of unreality and incredulity; aware of how images are deployed by the media, we are still held captive by their force and entranced by their narcotic magic. Even if at times it seems that the artist's involvement with media images has become an institution—a new academy of sorts which, by definition, has played itself out—the seductions and manipulations of the media remain so compelling and powerful that artists continue to reformulate them. With hindsight, the activities of this thirty-year period will be seen not as a passing phase but as the beginning of an epic scenario.

Notes

1. Jean Baudrillard, *America*, transl. Chris Turner (London: Verso, 1988), p. 32.
2. See Paul Virilio, "The Last Vehicle," in *Looking Back on the End of the World*, ed. Dietmar Kamper and Christoph Wulf, transl. David Antal (New York: Semiotext[e], 1989), pp. 107–19.
3. Ibid, pp. 115–16.
4. Clement Greenberg, "Avant-garde and Kitsch" (1939), in *Art and Culture* (Boston: Beacon Press, 1961), p. 11.
5. See Susan Sontag, "The Image World," in *On Photography* (New York: Delta Books, 1977), pp. 153–80.
6. George Trow, *Within the Context of No Context* (Boston: Little, Brown and Company, 1981), p. 9.
7. Leo Steinberg, "Other Criteria," in *Other Criteria* (New York: Oxford University Press, 1972), pp. 85–91. Steinberg used this term to describe a reorientation of the painted surface, a shift from a vertical to a horizontal picture plane. In his view, this shift corresponded to a shift of subject matter from nature to culture, the space of representation changing from an ana-logue of visual experience to one of operational processes.
8. Quoted in Paul Taylor, ed., *Post-Pop Art* (Cambridge, Massachusetts: The MIT Press, 1989), p. 103.
9. For further description, see Steinberg, "Other Criteria," pp. 85–88.
10. Quoted in Peter Selz, ed., "A Symposium on Pop Art," *Arts Magazine*, 37 (April 1963), p. 36.
11. From Sandler's 1962 review of the Janis show, quoted in Dick Hebdige, "In Poor Taste," in Taylor, *Post-Pop Art*, p. 93.
12. Gary Garrels, ed., *The Work of Andy Warhol* (Seattle: Bay Press, 1989), pp. 131–33.
13. See Judith Goldman, *James Rosenquist* (New York: Penguin Books, 1985), p. 43.
14. Theodor W. Adorno and Max Horkheimer, "The Culture Industry: Enlightenment Is Mass Deception," in *Dialectic of Enlightenment*, transl. J. Cumming (New York: The Seaburg Press, 1972), pp. 120–67.
15. See Jon Hendricks, *Fluxus Codex* (Detroit: The Gilbert and Lila Silverman Fluxus Collection, 1988), p. 21–29.
16. Joseph Kosuth, "Art after Philosophy" (1969), in Ursula Meyer, *Conceptual Art* (New York: E. P. Dutton & Co., 1972), p. 158.
17. Robert Smithson, quoted in Craig Owens, "From Work to Frame, or Is There Life after 'The Death of the Author?' " in *Implosion*, exhibition catalogue (Stockholm: Moderna Museet, 1988), p. 207.

18. For a more complete discussion of these conceptual projects, see Mary Anne Staniszewski, "Conceptual Supplement," *Flash Art*, no. 143 (November–December 1988), pp. 88–97.

19. Among the graduates were David Salle, Matt Mullican, Troy Brauntuch, Sherrie Levine, Allan McCollum, Jack Goldstein, Barbara Bloom, and Larry Johnson. John Baldessari, an original faculty member, taught for eighteen years and was a guiding force at Cal Arts, along with conceptualists Douglas Huebler and Michael Asher.

20. See Hal Foster, "Between Modernism and the Media," in *Recodings: Art, Spectacle, Cultural Politics* (Port Townsend, Washington: Bay Press, 1985), p. 35.

21. Douglas Crimp, *Pictures*, exhibition catalogue (New York: Artists Space, 1977), p. 3.

22. This comingling of art and commerce spawned a new type of exhibition in the late seventies and early eighties—exhibitions that incorporated materials from the mass media (food packaging, anonymous photographs, commercial advertisements). "It's a Gender Show" (1981), by the artists' collaborative Group Material, Barbara Kruger's "Pictures and Promises: A Display of Advertisings, Slogans and Interventions" (1981) at the Kitchen, and exhibitions organized individually by Marvin Heiferman and Carol Squiers at P. S. 1 testified to the global penetration of the mass media and naturally drew critical fire from purists. See Carol Squiers, "The Monopoly of Appearances," *Flash Art*, no. 132 (February–March 1987), pp. 98–100.

23. For further discussion, see Kate Linker, "When a Rose Only Appears to Be a Rose: Feminism and Representation," in *Implosion*, pp. 189–98.

24. See David Robbins, "Art After Entertainment," *Art Issues*, no. 2 (February 1989), pp. 8–13; no. 3 (April 1989), pp. 17–20.

25. See Richard Bolton, "Enlightened Self-Interest," *Afterimage*, 16 (February 1989), pp. 12–18.

European Sensibility Today

Donald Kuspit

While resisting the temptation to assume that all European art shares "a common ground of sensibility," critic and philosopher Donald Kuspit suggests that European artists do in fact have a pessimism and "sense of weariness" which informs their art. For European artists, "reality is inherently untrustworthy" and their relationship to the past "available for manipulative reflection." Rather than regarding the past as "finished and over," European artists view the horrors of the twentieth century as continuing to provide significant content to contemporary psycho-social awareness and its reformulation in contemporary art.

Is it possible to find a common ground of sensibility for contemporary European art? Isn't it foolhardy to attempt to find unity in what is so obviously disparate? Doesn't it blur important differences between the artists, and isn't it epistemologically naive, even absurd, to suppose that there must be an underlying 'cause' or 'mood' they have in common? Hasn't the very notion of a hidden universality become suspect—become an empty transcendence, an ignorant assumption of substratum less innocent than it looks, for it does enormous damage to particular existences and fosters incredible misunderstandings of them? Discontinuity, not continuity, is the rule of understanding today; the assumption of uncontradictory relationships is the big intellectual lie. A century's epistemological warnings against weaving different existential threads in one intellectual rope should make us wary of any construction of sensibility. Yet lurking within all the differences, stylistic as well as materialistic, generational as well as national, it seems to me there is a situation-bound emotional approach that makes for a certain unconscious communality among European artists, that makes the conscious individuality of each seem less absolute.

Reprinted from Donald Kuspit, "European Sensibility Today," *New Art International* (1990).

There is a certain common intuition, hardly whispered, among contemporary European artists, whatever their separate histories.

Today, the way to an understanding of Europe is through America (and vice versa), and the way to an understanding of European sensibility is no different. Each is implicitly the background for the other, through socio-historical circumstance, including not only their mutuality within that peculiarly metamorphic transcendent substance called 'Western Civilisation,' but more particularly because they are major partners in 'information exchange,' each always looking over its shoulder at the other in what has become the quintessential activity of the Information Age. There is no way of being contemporary or current—carried along by the current—without being aware of what is happening elsewhere, especially in some other place that is implicitly assumed to be as important as one's own, if not secretly envied for being more important (or expected to be). Europeans have envied post-war American art, beginning with Pollock's trend-setting all-over paintings of the late 40s, and continuing through the 60s, with its fast-paced, highly innovative production (ranging from Pop art and Minimalism through Earth art and Conceptual art), and finally into the 70s, when a highly diversified, so-called pluralistic art scene (largely but not exclusively orientated to such social issues as feminism and the Vietnam War) was created. But at the beginning of the 1980s, with the *New Spirit in Painting* exhibition in London, and various other European, mostly German, international exhibitions, which retrospectively seem to have come hard on the heels of each other, Americans have envied (even hated) Europeans for their art's dynamic growth, and especially for its orientation towards memory. More precisely, its power of phylogenetic recapitulation to achieve a new ontogenesis, its desire and ability to delve into both the recent past of American art and the more distant past of its own art history, assimilating both into a new expressive (if not uniformly Expressionistic) art, was recognised as pace-setting. Indeed, it was a major articulation of the Post-Modern condition, perhaps in a profounder way than Post-Modern American architecture. European historicism has come to seem very contemporary, and signals the fact that the present is no longer orientated towards a future—no longer as all-meaningful as it once seemed, for a variety of psycho-social reasons (not least of which is the collapse of belief in the Utopian promise of modernity)—but towards the past, discovered to be unexpectedly rich in possibilities. These can be realised by 'poetically' subsuming and synthesising the old modes of production and interest, to create a fresh sense of individuality and novelty. American forward-lookingness/future-orientation, as it has been called, has been replaced by European backward-lookingness, or respect for the past (which of course always seems to have more dignity, to be more civilised, than the present).

From an American point of view, Europe has always emphasised, or rather meant, oldness, while America was the brave new world, the place of the infinitely expanding horizon of the future. Europe is the place of memory,

masked and civilised by the *politesse* of art, but still peculiarly raw—perhaps, as today's European artists seem to imply, more raw than the American wilderness, from which much American art implicitly took its inspiration. The Europeans know the past is not the dead horizon it appears at first glance to be. Paradoxically, the modes of civilisation—including artistic styles and interests—now seem fresher than nature. This is perhaps why the tide of art has become predominantly European, for Europe has always known how to live with ruins, how to work with and through the past, whose ghost often seems more living than one's body. America has assimilated European art information, just as Europe has assimilated American art information. Each keeps close watch on the other. But the European artist's response to information in general is essentially different from the American artist's response. The American tends to take it as an end in itself, as a structure in itself.

Information and facts are implicitly regarded as one and the same and, as the American typically says, the facts speak for themselves. The problem is to get to them. This remains so even with the widespread recognition of the relativity of fact. The facts are relative, but they must be the case, once a case has been made for them. They supposedly contain their meaning in themselves. Moreover, the facts of the past are not related to with any depth by the Americans. They are not reworked, but sentimentalised, in Disneyland style. One cannot imagine an American artist seriously alluding to the American Indian heritage or Melville's dramatic vision of life in the way that Kiefer alludes to Hermann, the barbaric Germanic chief who defeated the Romans, or to Wagner's mytho-operatic vision. To carry this further, for the American, the bacon-strips of information-fact are allowed to fry in their own fat. They are then consumed for their own supposedly inherent tastiness. In contrast, the Europeans, to continue the all-American metaphor, tend to fry the information facts in the grease of memory. This gives them an altogether different sense of the taste of the facts, that is, of so-called reality. And this is where the difference between contemporary European and contemporary American sensibility comes in seriously: they have a different sense of reality. (André Breton already said that the sense of reality was the issue of modern art). One can say, no doubt all too simply, that America, for all the difficulties of its current socioeconomic situation, for all the pressure of predatory world-wide competition with it, remains optimistic, perhaps cautiously optimistic, but nonetheless forward-looking.

In Europe, for all its post-war prosperity and success, there is an ingrained pessimism, a kind of subliminal negativism, a certain sense of weariness and *déjà vu*, which informs the art. There it is often masked by black humour altogether beyond irony—and/or spiritual (reconstructionist/therapeutic) ambitions. There is evidence of both in Polke, Clemente, Dokoupil, Kounellis, the Poiriers, even Beuys, to mention only what seem the most exemplary cases. There is sometimes a pursuit of the mystique of 'memorableness' as an end in itself, to counteract the weight of historical facts. (I think this

is the case in artists as different as Paladino and Kapoor, although it does not exhaust the understanding of their art.) And there is often a kind of insidious theatrical nihilism, nihilism in the garb of contemporary everydayness—a sense of the hollowness of things conveyed through the hollowness of representation, a kind of apathy of representation, an alienated representation (as in Richter and Armleder), which is nihilism at its most nostalgic and narcissistic.

The key point here is that contemporary European artists have a different sense of reality than American artists. The European artists have internalised the modern idea of the relativity of reality with a vengeance. It suits their sensibility perfectly. Reality for them is inherently untrustworthy; for so history has been, notoriously. More particularly, contemporary reality is invariably understood in relation to past history. (The European instinctively feels there is no other way to grasp it, while the American tends to experience the present as a thing unto itself.) This necessarily changes the sense of both present and past reality. The future is less obviously real in contemporary Europe than in America, or rather, its reality is always tainted by the shadow of the past and the suspiciousness of the present. This is why I would say that the most general quality of contemporary European art—if one wants to make a sweeping generalisation—is lack of forthrightness, calculated equivocation, ambivalence of feeling and ambiguity of meaning, pursued as ends in themselves, rather than as the unfortunate fallout of circumstances. In this, contemporary European art shows how much it retains—has learned the lesson of— the so-called 'obscure' side of early European Modernism, or attempts to reinstate it, perhaps unwittingly. In any case, there is a new obscurity—not obscurantism—for all the Post-Modern sense of the past as 'clear information.' This new obscurity, with its feelings of intimacy and inevitability, is inseparable from endemic European pessimism, with its overtones of cynical self-enlightenment.

A paradox emerges from the contrast of the European and American sensibilities. If, as Baudrillard has said, the hyperreal is 'the generation by models of a real without origin or reality,' or the establishment of a state of simulation, then we can say that the American world, and by extension American art, is more hyperreal than the European world. This is exactly because America believes in facts, in the form of information, that is, in hyperreal form. Facts are generated and administered by information systems, that is, models of fact. In Europe, facts are inseparable from memories; the past is unsystematic, or else the ruins of various systems. It is never as intact and closed as a system (of information). We are really badly informed about the past, and it is poorly administered. (Indeed, the past often seems more open, and more available for manipulative reflection, than the present. The rewriting of history is usually more complex and evocative than predicting the future.) Thus, futility is built into the past, whereas in America, security is built into the past as much as into the future and present, because they are presented in information form, that is, as part of a system of simulated time, which is the American substitute

for history and memory. There is no sense of inherent conflict between past, present, and future in America, but rather a sense of continuous development from one to the other. The equivocations of European art—sometimes brittle, sometimes poignant—reflect the conflict between the conditions of time. It is finally the different sense of time that is responsible for the different sense of reality in European and American art. European art today has a more haunted look than American art, indicating a different relationship with the past.

The preoccupation with both its substance and form is pervasive today, but the attitude to it—one might say the ideology of the past—is drastically different. Where American artists—such as those who simulate abstract paintings and the neo-Duchampian specialists in commodity objects (is their hyper-reality or simulated reality simply an old irony in the Emperor's new artistic clothes?)—appropriate the past as a *fait accompli,* regarding it as a finished fact, the European artists are themselves appropriated by the past, which never stops unfolding and tightening its hold on the present. Their contemporaneity ends up belonging to the past, which shows not only the power of its hold on them, but the inseparability of their sensibility from it. It is not simply that Europe had to recover from World War II to repair its sense of autonomous identity, but that it had to recover sufficiently free to reflect on the recent past as part of its destiny, and to experience the past as an inalienable part of its identity. It had to recover a primitive sense of being possessed by an irreducible past to make new art. In America, identity and destiny seem much more predetermined, despite the fact that America has less of a (controlling) past than Europe. It is just because Europe unconsciously remains controlled by its past—and self-consciously knows it—that it has once again become the place where the possibility of profound, daring psycho-social awareness remains most alive, as is evident in its new expressive art.

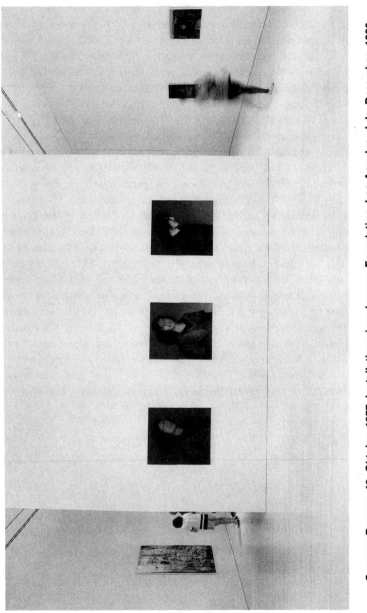

GERHARD RICHTER, *18. Oktober 1977.* Installation view, Lannan Foundation, Los Angeles, July–December, 1990. 15 paintings related to the Baader-Meinhof gang.

Courtesy of the Lannan Foundation.

Death and the Painter

Peter Schjeldahl

Painter Gerhard Richter's photo realist paintings of the Baader-Meinhof group's demise are viewed by critic Peter Schjeldahl as expressing "the anguish of the aesthetic in the face of political violence." Both a test of the powers of the medium of painting and a fragmentary study of violence, the suite of paintings exudes a "depressive density" brought on by the collision of "irresistible estheticism and immovable moralism." Richter's paintings question the pleasures and impact of paint as compared with photography and question the future of "the embalmed corpse" of abstract painting.

Gerhard Richter's 15 wonderfully painted but modest, mostly smallish grisaille oils on subjects related to the West German terrorist Red Army Faction (RAF), known in the 1970s as the Baader-Meinhof group or gang, seem a deliberately stunning event, meant to rasp political and esthetic nerve ends. These drastically mournful pictures display visual, intellectual and moral ambiguities likely to prove inexhaustibly provocative. Some European intellectuals have accused Richter of exploiting a grisly cause célèbre—the deaths in their prison cells in Stuttgart in 1977, probably by suicide, of Andreas Baader, Gudrun Ensslin and Jan-Carl Raspe (Ulrike Meinhof hanged herself in prison a year and a half earlier)—in a spirit of mere estheticism. I think it more accurate to say that Richter has expressed the anguish of the esthetic in the face of political violence. He thereby riskily complicates his always abstruse approach to painting—for nearly three decades a bewildering alternation of abstract, photo-realist and conceptual motifs in styles simultaneously spectacular and astringent, virtuosic and dry. The Red Army Faction suite provides an occasion for speculating on Richter's enterprise, which feels ever more central to the equivocal nature and embattled meaning of painting in present history.

Reprinted from Peter Schjeldahl, "Death and the Painter," *Art in America* (April 1990).

All the pictures are based on police and news photographs. Two show the setting of the 1972 capture of Baader, Raspe and another Red Army Faction member, Holger Meins (who would die in prison from effects of a hunger strike): a banal modern building with a toylike armored personnel carrier in front of it. Three are sights in a cell: a wall of books, a record player and a blurred general interior in which, one notices, a body is hanging (it is Ensslin). Two show the sprawled body of Baader, shot dead. One, the largest, is a panorama of the three terrorists' funeral cortege: three coffins glowing wanly white in crepuscular surroundings whose details were all but obliterated when Richter smeared the entire painted surface horizontally. That leaves seven close-up pictures of Meinhof and Ensslin: a posed portrait of Meinhof as a girl, three sequential shots of Ensslin after her capture (she catches sight of the camera, she grins, she turns away) and three posthumous views of Meinhof's head in profile with an oddly elegant line around her neck that happens to be the welt left by her hanging. These last three paintings are among the most shocking representations I have ever seen, but exactly what is represented— and why and to what end—isn't easy to say. Or perhaps it is just hard to confront, involving as it may some guilty, thrilled, gnarled secrets of esthetic predilections in the vicinity of death.

"Death is the perfect subject for photography," the superb photojournalist James Hamilton once told me. He said it matter-of-factly, from practical experience, and seemed to mean little more than that death solves most of a reportorial photographer's problems in advance. No need to worry about timing, for instance. More than that, isn't a corpse already something like a photograph—in a perishable emulsion? The photographer reproduces it. Every latitude of choice in taking the picture—such as the camera's angle and its physical distance from the corpse, dramatizing specific attitudes of life toward death—has an absolute and eloquent definition, if realized with any intelligence. (A viewer may be emotionally shattered precisely by the picture's *inhuman* poise.) Painting cannot do this. It is a medium of fiction, for one thing, in which the death of David's Marat, say, or of Manet's matador is convincing only as death acted on a stage can be convincing. Beyond that, there is the fundamentally erotic way in which painting engages the imagination. It is a *lived* medium, enmeshed in active time: a time of making recovered in the time of viewing. The livingness of paint, infused with touch, abolishes psychological and, in a way, even physical distance, becoming symbiotic with our sense of our own flesh. Only a cerebralizing, graphic medium—and photography is the graphic triumphant—can be satisfyingly thanatotic.

What can we say, then, of a painter's decision to reproduce in oils the photograph of a corpse? We can say that it is perverse, going against the grains of both photography and painting. We can say that a disruptive willfulness is demonstrated. "Perversity," a pejorative sometimes applied in defiant praise, implies less a bad action than a questionable motive, someone doing something—even something unremarkable in itself—for an abnormal, wayward rea-

son. Why would a masterful painter devote the supple capacities of his medium to the slavish representation of banal and gruesome photos? Why, from another angle, would someone seriously concerned with the political drama documented in those photos address it in the synthetic, perhaps unavoidably glamorizing medium of painting rather than in an analytical essay, for instance? I don't think these questions admit of rational answers. The discomfort they express cannot be resolved, because it is the very point of the artist's act: a crisis in the common order of mediums and the proper order of their intentions, the normal relation of pictorial means and ends. The crisis is registered as a disorienting sense of sheer arbitrariness, a toxic confusion apt to make one yearn for explanations that will either exclude the "perverse" act from consideration (such being the reflex of conservative institutions) or reassuringly normalize it after the fact (the reflex of liberal institutions charged with absorbing avant-gardes). A third, scarcely bearable option is to entertain the thought that "perversity"—self-contradiction, self-defeat—is a fundamental condition not only of given conventional orders but of the socialized human activities—including painting, including politics—to which the conventional orders give masks of reason. I think that Richter's Red Army Faction paintings offer no alternative to just such radical pessimism.

The overall title Richter gives these paintings—"18. Oktober 1977"—memorializes a wild day in German history, when terrorist efforts to win freedom for Baader, Ensslin and Raspe (serving life sentences in Stammheim Prison for the bombing murders of four American servicemen in 1972) met with failure. The prisoners died shortly after receiving news that an assault by West German commandos in Mogadishu, Somalia, had ended a plane hijacking by Arab allies of the Red Army Faction. Later, RAF kidnappers who had held industrialist Hanns Martin Schleyer since Sept. 5, demanding release of the prisoners, money and safe passage out of the country, killed him.

The RAF still exists—claiming credit for the murder of a Frankfurt banker just last December—but the events of Oct. 18, 1977, climaxed a seven-year period (beginning when journalist Meinhof, in her first criminal act, organized an escape by Baader from jail in Berlin) marked by waves of bombing, shooting and bank robbery and by judicial and police countermeasures that brutalized and at times all but paralyzed West German society. Most evidence in the prison deaths of Meinhof, Baader, Ensslin and Raspe, including the question of motive, argues against theories of official murder, but neither can the theories be disproved. The Baader-Meinhof legacy remains a sulfurous issue between political leftists and rightists in Germany. Richter's RAF paintings need to be seen in that traumatic context, which gives an inflammatory content to images already intrinsically harrowing.

I am thinking of the two pictures of Baader lying in an "uncomfortable" posture (that's how it registers, connoting violence) with his head flung back to expose his throat in a way that feels "vulnerable" (as if anything bad could

happen to him now). But mainly I am thinking of the three views of the dead Meinhof, in which the throat is similarly unguarded and one's sense of transgressing as a viewer, intruding upon a terrible intimacy that the subject is helpless to protect, is compounded by a fascination with the charm of this particular victim. I find these pictures desperately grim, and also lingeringly sensual. Taken as an overall shape, Meinhof's head and neck are distinctly phallic. What does this mean? Maybe nothing in itself. But there it is, and the process of association and reflection thus begun must be followed to an end. The process amounts to a test of painting's capacity to grapple with a shocking reality made coldly, alienatingly spectacular by photography, or at least to grapple with the alienation.

Looking at the three pictures of Meinhof dead, one's eye will likely go straight to the dark band around the throat, inevitably reminiscent of the velvet "choker" worn by Manet's *Olympia*—an association that, again, may *mean* nothing, while persisting as grit for the mind to worry on. No gratifying reverie is apt to be pursued before these ghastly views that are probably morgue-slab shots taken some time after death, because already a certain gauntness about the features hints at decay. But the delicacy of the paintings' execution can't help but stimulate. The color amazes, for one thing. The range of white, gray and black conveys the look of a blurry photograph and also, somewhat, of a decrepit television image, but strictly by means of chiaroscuro, the modulated retention of light in limpid oil glazes. The face emerges from a glossy black ground by way of extraordinarily deft modelings in sooty gray, and the white of the flesh has a unique radiance, at once pale and livid, like a weak glare through fog at night. The effect is one of bad light in bad air, a dank and perhaps foul atmosphere. But it pleases, as any subtilization of vision is bound to please.

The ashy glow of all 15 Red Army Faction paintings is like a brightness perceived by eyes that have grown accustomed to darkness, making them a strange sight in a well-lit museum room. Ross Bleckner is a contemporary painter who has used something like this effect to lyrical, "spiritual" ends. There is nothing spiritual about the way Richter uses it. (A closer parallel is that of Vija Celmins' astonishing small oils of imaginary starscapes, shiny and dense and as impacted as uranium.) The look of the work in installation estranges partly but not only on account of an awkward, miscellaneous-looking disparity of shape and size among the canvases. Peering into the pictures (all of them, but especially the smeared ones of the arrest scene, the bookcase, the hanging and the funeral), you are taken out of the room's space and light without being led anywhere, instead being given something like a representation of failing eyesight: straining to see and seeing only so much. Viewed glancingly or from afar, the pictures are clenched and obdurate, seemingly heavy enough to crack the floor if they fell. The upshot for feeling, with cognizance of the work's subject matter, isn't so much sad as beyond sadness, evoking a numbness per-

haps of grief and perhaps of rage. The work is relentlessly depressive, with a weary, Saturnian gravity. It is a dead zone, a singularity devouring every genial flicker of mind and heart.

Taken as an ensemble—certainly, by present viewers perhaps little familiar with a news story remarkably unnoted in the U.S., even at the time—the 15 paintings add up to no discernible narrative, though they suggest fragments of one: scattered bits and pieces of a massive tale, like sentences and paragraphs torn from a long novel. Two pictures tell us, for instance, that a prisoner could read books and listen to music, which seems pretty measly narrative freight for about 14 percent of the whole suite. Or does the narrator, Richter, hereby make a point of the narrow grounds—love of books, love of music—upon which he can identify with this prisoner, who was Baader? (Alternatively, the record player could be what Alfred Hitchcock called a "Maguffin," an innocent-seeming object with sinister narrative significance: authorities said that Baader hid a gun in it.) Nearly half the fragments cluster around two female characters, Meinhof and Ensslin, and constitute a dominant subplot, making an incidental, personalized poignance the strongest emotion of the series. We see a lovely girl in the sort of picture that is framed and set out by doting parents. We witness in mechanical and avid sequence—click click click—a young woman's volatility. We view a woman dead three times—with very slight variations that may bespeak either three separate photographs (with different lenses?) or different treatments of one photograph—as if not believing her motionlessness, and thus anticipating some change, some communication, some life. There is a mystery here mixed up with a hapless urge to get to the bottom of it, to know something that will not let itself be known, something that flinches from the grasp of knowledge. What were Meinhof and Ensslin besides terrorists who became victims of violence? (Of *whose* violence? It doesn't matter to them now.) Maybe if one pored enough over pictures of Meinhof and Ensslin, as Richter says he did over hundreds of photos relating to Baader-Heinhof before beginning the series, one could possess the truth of an overarching tragedy. Then again, maybe not.

The Red Army Faction suite may usefully be seen to continue this artist's career-long response, often commented on by his critics, to Andy Warhol's major photo-based paintings of 1962–65 (notably, in this case, the "Disasters," those serenely obscene icons of abject and anonymous deaths). As much as any other painter of the last quarter-century, Richter has reoriented the art of painting to a post-Warhol situation, defined by imperious, omnipresent influences of mechanical imagery. With his seductive photo-realist landscapes and still lifes and even, as we shall see, his painterly abstractions, no less than in his media-derived pictures, Richter has deepened and sharpened the implications of Warhol's own epochal "perversity": a crassly motivated transformation of painting (as painting was understood in its formal conventions and fashion-

able uses at the end of the era of Abstract Expressionism) into a parasitic growth on a world totally mediated by photographic products.

Back in the '60s, Warhol's art seemed to have a radical, death-of-painting import. Since then we have grasped the conservative side of his manipulations: preserving and exalting painting's capacity to have and to give transcending presence, all the more piquantly when invaded by mechanical forms and mass-cultural subjects. Warhol proved that painting, while humiliated by the media as a craft of communication, was still invincible on its own turf, which might be termed *communion*. Richter has rigorously observed the Warholian stalemate between radical negation (painting as an arbitrary bag of tricks) and conservative affirmation (painting as an irresistible mirror of consciousness). Richter's teeming output has exfoliated from this point without advance or retreat, as if all of it issued from a single, stuck moment in time. He goes beyond Warhol mainly in the degree of his moral seriousness, an unmitigated confrontation of the dark side both of painting and of the consciousness that painting reflects.

All of Richter's work is marked, for me, by a desiccated, practically freeze-dried pathos, an emotion so intrinsically powerful that it can survive, as it must in his dispassionate hands, any extreme of attenuation. I find a long-ago echo of that pathos in Edgar Allan Poe's remark that the most poetic of all subjects is a young woman who dies. I think that for Richter painting is a young woman, dying. It is necessary that he love her for her death to have meaning, and it is necessary that she die for his love to be immortalized. In this metaphor, the esthetic *is* the erotic, precisely configured. The emotion involved is at once morbid and tender. It is male. At times thematically explicit—in works ranging from a 1966 painting (from a photo taken while the subject was still alive) of a murdered prostitute named Helga Matura to the pictures of Meinhof and Ensslin—the displacement informs his attitude toward the ever-loved, ever-perishing flesh of painting itself.

The attitude implies a "perversity" too deep to be idiosyncratic or even personal, a fundamental conflict of the desire to know (you must kill a thing in order to know it, said D. H. Lawrence) and the desire to be at one with. This conflict comes to maximum pitch in the paintings of Meinhof dead, which oppose the perfect knowledge promised by photographs (of death, preeminently) with the perfect enjoyment tacit in the caressing of paint (life without end). With less intensity, the conflict plays throughout the Ensslin and Meinhof pictures in dramatic suggestions of possible male roles toward the women, each figured in a different sort of gaze: perhaps gazes of father, lover, friend, cohort and mourner (and perhaps intruding photographer, and perhaps murderer). In any and all cases, no relief is permitted from a world in which tenderness of spirit does not vouchsafe immunity from horror.

Is the esthetic, as an exclusive mode of experiencing and valuing existence, an original sin that guarantees horror sooner or later? Richter may suggest as

much in his focus on a Western urban terrorist group, a para-artistic phenomenon of political action that is senseless by any rational political measure. In interviews, Richter has declared his aversion to ideologically based violence, while also praising the RAF's quality of "hope." Hope for what? Richter is no more clear on this than the Baader-Meinhof members were, but both his moral aspiration and theirs, though opposed in politics, seem strongly marked by the yearning for purity of will, the scorn for worldly compromise and the iconoclastic suspicion of merely symbolic expression that are extreme traditions of Northern European Protestant thought. (Ensslin, perhaps not incidentally, was an Evangelical pastor's daughter.) I see an agony of conscience in the misted and dragged grisaille with which Richter, under the ironic cover of simply mimicking out-of-focus photography, seems physically to assault the very drive toward the vision—the voyeurism—that brought the images into existence in the first place. Such image-shy compunction seems distinctively Northern European, in contrast to unabashed Warholian image-intoxication. (The same transatlantic contrast holds for styles of political extremism, as in a comparison of Baader-Meinhof's austerity with the virtual Warholism of the most famous contemporaneous American terrorist group: the Symbionese Liberation Army, which sent to the press its flabbergasting, iconic photograph of kidnapped media heiress Patty Hearst with a machine gun in the archetypal pose of the Heroic Guerrilla.) Richter's distinctive tone—a depressive density resulting from a head-on collision of irresistible estheticism and immovable moralism, fire of the voyeur and ice of the puritan—may baffle American viewers, who tend to be relatively untroubled by pleasures of the imagination. But that tone well merits an effort of empathy, because it so trenchantly reveals the powerful and dubious character of painting in our shared civilization.

Richter's two-track career of abstract and photo-realist painting represents, to me, a dance of attraction and repulsion with the mythic force of the medium. The dance seems partly deliberate and partly unconscious. Richter's conscious project of manipulating styles on the brink of exhaustion suggests a strategic insight into the ongoing crisis of painting between the devil of photography and media and the deep blue sea of merely archaic, genteel craft. He stays answerable to and for both orders of value, embracing neither and renouncing neither. The unconscious element, which I have introduced as the metaphor of the young woman who dies, isn't unconscious through any frailty of Richter's, but because it subsists at a primordial psychological level. This is a level that lets us speak of "myth" as something real. In Richter's case, the myth of Western painting—queen of the visual arts—is reinforced by the very strength of his resourceful efforts to bracket and subdue it. (Such unintended upshots, or sudden shifts in the polarity of an intended action, are calling cards of the unconscious.) It remains to be seen how Richter's divided responses to painting's crisis, his abstraction and his photo-realism, function both apart and together to uncontrolled ends.

Richter's abstractions, which he has produced in vast quantities since the mid-1970s, deliver an initial visual impact as sensational, and as little encouraging to analysis, as the outer-space special effects in a George Lucas movie. They spur a sharp but shallow excitement, a species more of admiration than of sublimity. Upon further viewing, at the stage where one's eye gropes for a picture's formal order, the paintings disappoint, as the gorgeous unity of their first impression disintegrates into a mélange of jejune painterly effects—the result, as it happens, of techniques heavily reliant on chance. (Richter makes the abstractions, with their incredible complexities of visual incident, very quickly and simply, mainly by smudging and dragging paint across the surface with boards.) The beautiful paintings are lifeless. When first acquainted with Richter's art, in the early '80s, I decided that the rather strenuous point must be a parody of Abstract Expressionism, mocking the painterly poetics of existential sincerity and "action" with firework displays of perfectly irresponsible, arbitrary marks. I thereby missed the grave intelligence and the oddly energized despair of works that actually addressed abstraction in a state *already* mocked and all but reified—abstraction in the condition that was announced by, for instance, a series of Warhol paintings that is too often overlooked, the lovely, lethal "Flowers" of 1965. (Warhol said at the time that these were his last paintings, a heroically cogent position that, being no puritan, he didn't hesitate to shrug off later.) The impeccably frontal, reductive "Flowers" fulfilled the critical conditions of formalist abstraction of the period even while injecting them with the formaldehyde of photographic representation, annihilating their lingering romance of sincere expression. It is from that point, with the embalmed corpse of abstraction as a representation of itself, that Richter begins—and begins again, and has continued to begin in a stuttering impasse between an irretrievable past and an unreachable future. Hence the sensation of mournful vertigo that is my typical response when I am gazing at a Richter abstraction.

I now detect behind the animated lifelessness of Richter's abstract paintings, both in and beyond a disappointment patiently suffered, a lover's devotion to continuing abstraction by the only means possible after an epochal collapse of faith in its meaningful coherence. Or, rather, I detect a devotion to continuing abstraction by one of only *two* means possible, the other being Richter's decidedly lively brand of photo-realist landscape and still life. (By "photo-realist" I mean any painting whose primary esthetic effect entails the palpable intervention of a camera.) For a capital instance of shifting polarities, consider the deadness of the paint in Richter's lyrical-looking abstractions and then the sensuousness of the paint in his descriptive-looking countrysides, skulls and candles. There is no mystery about the contrast, a matter of quasi-mechanical technique versus handwork with a brush, but its effect amounts to a reversal of the expected, proper pleasures of the two modes: Richter's abstractions please as representation (of a genre of painting) and his representations please as abstraction (painting for its own sake under cover of subject

matter). Consulting my experience of contemporary art generally, I'm piqued to realize—as I would not have so vividly, but for Richter—what a characteristic phenomenon such literal duplicity of visual pleasure has become. It is a furtive adaptation of Eros, perhaps, in a culture beset with skepticism, such that we most readily (with the clearest conscience) satisfy our appetite for images with abstract designs and our appetite for painterly sublimity with paintings of photographic images. Richter is the present master of this epochal esthetic psychology, while perhaps also its captive.

In Edgar Allan Poe's astounding short story "Ligeia," a woman dies and returns to life only to keep dying and returning to life again and again, finally as another woman (the narrator's great love) altogether. It is a horror story. It is also an unbeatable allegory of male esthetic obsession, as a drama of irreconcilable drives toward the feminine: to have and to know, the respective actions of desire and fear. Like Poe, Richter temperamentally gravitates to the pole of knowledge and "ratiocination" (Poe's favorite activity), as witness the rigorous overdetermination of his styles, and is then drawn in symbolic episodes toward the pole of merging. I think it more than plausible to consider Richter's paintings of Meinhof and Ensslin as his "Ligeia." The terrorist muse, at once a cherishable woman and a frightening figure of fanatical purity, makes for a Ligeia-like unquiet corpse, turning the tables of desire and fear until they spin.

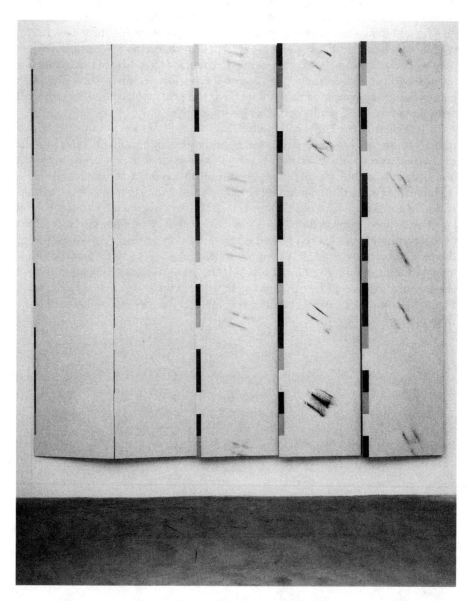

JEREMY GILBERT-ROLFE, *Open Warfare.* 1991 Oil on Linen 95″ x 95″ x 4″ (5 panels)

Courtesy of Ace Contemporary Exhibition, Los Angeles.

Bringing It All Back Home: Jeremy Gilbert-Rolfe's New Paintings

Colin Gardner

Using the work of Jeremy Gilbert-Rolfe as his example, critic Colin Gardner distinguishes abstract painting, which is a type of reduction, from non-representational painting, which is not reduced from anything and is unstable in its apparent completeness. Setting up dialectics of inside and outside, surface and depth, speeding up and slowing down, beginning and ending, the paintings offer "a sense of pleasurable play" which is constantly destabilized as the object is annihilated into "pure movement." Gilbert-Rolfe's paintings can be thought of as transgressive formalism creating a "decentered, non-subjective fluidity."

Less terrorized by the spectre of 'formalism,' historical criticism might have been less sterile; it would have understood that the specific study of forms does not in any way contradict the necessary principles of totality and History. On the contrary: the more a system is specifically defined in its forms, the more amenable it is to historical criticism. To parody a well-known saying, I shall say that a little formalism turns one away from History, but that a lot brings one back to it.

—ROLAND BARTHES[1]

There are no beautiful surfaces without a terrible depth.

—FRIEDRICH NIETZSCHE[2]

Reprinted from Colin Gardner, "Jeremy Gilbert-Rolfe: Bringing It All Back Home," *Artspace* (July/August 1992).

As a nonrepresentational painter working under the theoretical aegis of post-structuralism, Jeremy Gilbert-Rolfe occupies two seemingly contradictory positions. On one hand, his work slots neatly into an historicist tradition of abstraction, drawing upon the influence of Malevich, Mondrian, Barnett Newman and Robert Ryman, while on the other it indicts and resists an historicist reading. Similarly, his painting clearly evolves from a metaphysic of subjectivity and centeredness based on binary oppositions such as presence/absence, interior/exterior, identity/difference, yet it is also determined to transgress that hegemonic master narrative.

Clearly, like all *bona fide* deconstructions, Gilbert-Rolfe's work places itself within the confining "tradition"—impossible to escape in any case—all the better to dislocate it. By literally and metaphorically crossing and re-crossing the margins of modernist and Enlightenment practice, by perpetrating in effect a "double-cross," Gilbert-Rolfe updates and revises Roland Barthes' observation that a lot of formalism brings one back to history by bringing it back "in such a way as to deny the historical, or its sister concept the author, any final say in determining or imposing an ultimate or irreducible meaning onto the work."[3]

Such a transgressive formalism would have to be one that destabilizes the very notion of form, a formalism that upsets the distinction between this and that, here and there, center and outside, in effect a formalism through which the body thinks the world via deferral and difference. Apart from Jacques Derrida's notion of *différance*, the linguistic model for this position would be Emile Benveniste, who theorized the dependence of subjectivity and centeredness on discourse. Thus the pronoun "I" is perpetually interchangeable with, and thus mutually deferring to, the pronoun "you," in much the same way as here and there, this and that, work and frame are dependent on specific, potentially multiplicitous contexts: ". . . what does *I* refer to? To something very peculiar which is exclusively linguistic: *I* refers to the act of individual discourse in which it is pronounced, and by this it designates the speaker. It is a term that cannot be identified except in what we have called elsewhere an instance of discourse and that has only a momentary reference. The reality to which it refers is the reality of the discourse . . . and so it is literally true that the basis of subjectivity is in the exercise of language."[4]

Unlike an abstraction, which is a reduction from a signified that existed *prior* to it that is now significant for its *absence*, the nonrepresentational object or image *re*-presents nothing. It has no previous incarnation, no prior presence. One could therefore argue that nonrepresentation exists as pure *presence*, as the production of no thing, or the unseen. Moreover, because there is nothing to distill or edit down, the nonrepresentational "is an object which is complete by definition, and it is thus that it is subject to an endless deferral in the Derridean sense. It defers to other objects, both art objects and those to which we do not attach the high value we reserve for the eloquently useless, in being like them but not representing them, in differing from them and with

them."⁵ Insofar as it eschews a metaphysic of inside and outside—and therefore of lack—meaning in nonrepresentation is intrinsically anti-Lacanian. Meaning lies instead at the intersection of outsides, of durations and movements. It is thus a completeness that is inherently unstable. In this respect it is firmly aligned with the thinking of Jacques Derrida and Gilles Deleuze rather than a traditional, transcendental formalist such as Greenberg, where meaning refuses to tolerate exteriority. This combination of difference and deferral—the identity of "this" as opposed to "that," and the problem of "this-as-that"—has been a major concern throughout Gilbert-Rolfe's career. It raises questions such as: How do we enter and leave a painting? How is it possible to read it if "this" and "that" are in constant deferral? What constitutes the center and the margin? What is the relationship of the edge to the wall?

Since 1986, Gilbert-Rolfe has addressed these questions in an ongoing series called the "History and Seduction" paintings. Apart from an occasional red or blue painting which acts as a supplement to the series, the works are predominantly black ("history") or yellow ("seduction"), the most extreme contrasts of color which are not opposites. Painted on the side of the canvas as well as the ostensible "front," the works are presented as objects rather than two-dimensional, planar surfaces, and are simultaneously viewed obliquely as well as frontally. They are designed to set up a dialectic between inner and outer space, historicism and decenteredness in an attempt to move across and beyond such boundaries (and, by extension, dialectical thinking in general).

Third Note on the History of Difference (Train, Forest) 1988, for example, apart from invoking art history itself—Manet's tendency to paint his yellows on black, Malevich's *Black on Black*, Ad Reinhardt's black paintings—also invokes, through the denseness of black holes, a nullifaction, an anti-history. Yet this black is also serious, gloomy, light-absorbing, sucking the viewer into an abyss that also serves to center the eye in relation to the margin, the wall and neighboring works. In contrast, the yellow paintings stress the retinal effects of color in defining a surface rather than a depth. In *Seduction of the Complete* 1987, or *Seduction Painting/Role of Repetition* 1989, for example, drawing and composition, the contrast between solids and voids, are always in service to color, speeding up, slowing down, increasing and decreasing its disorienting retinal effects. Moreover, yellow is particularly difficult to focus, for it gives off an internal glow that seems to deny a clear interiority. It tends to blur distinctions between space and light, forcing our eye to remain on the surface of the canvas and to transform interior-exterior relationships into ones of mobile masses of space. We start to wonder where space begins and ends rather than what it actually *defines*.

In the "seduction" paintings therefore, the painterly surface now exists as an itinerant terrain or field, much like that produced in Impressionism, across which the eye can be led away, seduced toward an endlessly open, infinite margin. The eye's constant need to ground itself, to halt its nomadic drift into space by grabbing a thin strip of color at the margin, suggests that even the

edge can act as a median if the ostensible center is too boundless, too retinally unstable, to do the job. This constant push–pull and reversal/counter-reversal between center and edge, disequilibrium and sure-eyedness enacts a sense of pleasurable play, an erotics or *jouissance* in which anything is permitted. The painting, which began very much as a thing, an object, now, through vibrating color, sets up the notion of no thing, a no thing that is also a space. We thus have a built-in contradiction that lies at the root of nonrepresentation: although the surface underscores the physicality of the painting, the color destabilizes it as an object and forces it to defer to a space beyond which isn't necessarily there. The painting is thereby able to signify *this* (surface) as *that* (space) and *not that* (space beyond) simultaneously.

However, these early works in the series were forced to confront the fact that they were still completely circumscribed by the surrounding gallery wall. Its white space gave off a far greater sense of the infinite than the yellow painterly surface itself, so that the work tended to float like an object and become a self-contained "inside" vis-à-vis the wall's "outside." Gilbert-Rolfe's latest paintings are an attempt to blur this demarcation between painting and wall through, if anything, so extreme a formalism that the degree of deferral, and by extension, movement, is paradoxically increased. How is this done?

The new works consist of five, predominantly yellow vertical panels, butted obliquely against each other. The effect is of a series of stepped, angled surfaces, each exhibiting a single frontal plane and a painted left edge. The one exception is the extreme left panel, which slopes away toward the wall so that its left margin seems to merge with it. The wall is thereby directly implicated both as a plane and a space. No matter where we stand, it is impossible to see every surface frontally. If we look directly on the four right-hand panels, the extreme left surface is extremely oblique. If we stand in front of the latter, the four are oblique, with their left edges, if anything, more prominent than their ostensible "fronts." One wonders which reading is the correct one, which plane defers to which? The answer, of course, is that there is no one correct reading or position. Instead of presenting us with a rectangular whole centered on an invisible cone-of-vision, Gilbert-Rolfe forces us to eschew the hegemony of the eye in favor of the physical body. We have to literally walk along and with the work, to think less about *decoding* the painting and more about finding a way to *look at* it. The results are paradoxically very cinematic, much like a tracking shot in which the camera moves across the surface, constantly shifting position to retain a modicum of frontality.

How, then, do we (c)enter the work? This isn't obvious or easy. The central panel of five is not the center of a symmetry, because the left hand panel is positioned so obliquely. Similarly, the central gutter that divides the four right hand panels cannot be the center of the whole because of the supplementary nature of the fifth panel. Moreover, each left hand edge is painted in 19 colored chips of different widths, as if the artist couldn't make up his mind and started the painting five times. One might compare this effect with the single-

panel, *Tranquil and Impure Yellow* 1991. In this case, a yellow monochrome surface, interrupted at the left edge by alternating chips of white, develops increasing gradations of dark yellow from the center toward the right edge that culminate in a vertical strip of pale pink paint. The pink strip metaphorically and retinally transitions the right edge to the white wall, so that the wall itself, the ostensible "outside," becomes the beginning of another inside, yet also refers back to the left edge of the painting, with its white chips. This suggests a painting that *ends* more than once, then ends yet again, in a series of eternal returns.

However, if we move in closer to the surface of these works, certain, more stabilizing formal patterns start to become evident. In *Open Warfare* 1991, for example, each panel is painted in yellow on a different colored underpainting in a different-sized brush that matches the width of its own particular border chips. Stepping back to take in a macro-view, we now discover that the chips—which act as a form of drawing in that they help structure and compose the yellow-as-space—seem to follow a distinct and logical system, so that the formal and structural properties of the edge are brought significantly into the meaning properties of the center—and vice-versa. Thus the far left hand series of chips follows the vertical pattern of alpha, beta, gamma, black. In this case yellow, red, blue, black is followed by a new sequence that begins with the second color—thus, red, blue, yellow, black—followed by blue, yellow, red, black, etc., etc. These structural combinations also move horizontally across the painting, but when they reach the fifth panel, the sequence goes out of sync. It is as if this panel is the beginning of another painting entirely, so that we imagine the extreme right edge of the work expanding into an infinite number of other sequences, suggesting and endlessly deferring to other outsides. Thus, "all these things which are generated by this perfectly marvelous system doesn't actually generate things which are systematically straightforward."[6]

In *Simple Progression* 1991, this Derridean deferral is built into the formal properties of the work itself. A specific panel may be overpainted with a brush of a narrower width than its underpainting, allowing part of the color beneath to emerge as sketchy cross-hatchings. However, the sequence also defers to a gradual increase in brush widths, so that when we reach the fifth panel, the underpainting (red) is painted with a brush as big as the yellow brush, so that the red is completely obscured. The far right panel is thus a yellow monochrome mirroring the far left panel, but with a different brush width. Although the painting thereby seems to start again, to return to the beginning, the different surface texture suggests that it has really started a new series entirely. The painting expands within itself, reiterating and ultimately transcending its basic formal structure.

Just as we're beginning to understand the sequence of deferral and coming to grips with its slippage, the panels interrupt our sequencing and we're forced to revamp it again. Cinema once again offers a suitable paradigm. The

edge between panels closely resembles the filmic splice or edit, as if, in Godardian fashion, the narrative had started again and we were forced to relate a new, completely autonomous sequence to the one we had just seen. In this respect the reading is metonymic rather than metaphoric, a movement and duration of flow that overrides the simple dislocation of the cut. Deleuze, in an analysis of the pre-war French cinema of Marcel L'Herbier, Jean Vigo, Jean Epstein and Jean Grémillon has recognized a liquidity that is an apt parallel to this effect: "From this was to emerge an abstract art, in which pure movement was sometimes extracted from deformed objects by progressive abstraction, sometimes from geometrical elements in periodic transformation, a transformative group affecting the whole of space. . . . It is the French school which emancipates water, gives it its own finalities and makes them the form of that which has no organic consistency."[7]

This annihilation of the object into pure movement appears to ally Gilbert-Rolfe's project less with the material sign of Manet and the subsequent tradition of modernist abstraction than with a hedonistic colorist such as Matisse. Matisse, by reducing the body to a property of color inseparable from that of surface and ground, indeed inseparable from unpainted canvas, destroyed conventional beauty in favor of a far greater pleasure: that of the terror of infinite, retinal space. We are thus discussing, in effect, a theory of the sublime. Not the Burkean or Kantian sublime, which is separated from the beautiful, a sublime that gives a name to "whatever is in any sort terrible, or is conversant about terrible objects, or operates in a manner analogous to terror . . . that is . . . productive of the strongest emotion which the mind is capable of feeling."[8] Rather this is a Nietzschean, desublimated sublime that brings one back from the abyss, via ekstasis, disjuncture, outsideness—in short, the agency of art—to accept the meaninglessness of the everyday, of the formlessness of forms.

For Burke and Kant, the sublime was a way of thinking about excess as the key to a deeper kind of subjectivity. In this respect, it is inexorably centered in Enlightenment humanism. Gilbert-Rolfe's Nietzschean sublime, in contrast, is a decentered, non-subjective fluidity. It is a limitless, nomadic, discontinuous, uncertain, multiplicitous activity, unselfish, pleasurable, erotic. There are a couple of terms in rhetoric that describe the effect perfectly: *aposiopesis*—"a rhetorical device in which the speaker suddenly breaks off in the middle of a sentence, leaving the sense unfinished. The device usually suggests strong emotion that makes the speaker unwilling or unable to continue. The common threat 'get out, or else'— is an example."[9] Or: *anacoluthon*—"a grammatical term for a change of construction in a sentence that leaves the initial construction unfinished: 'Either you go—but we'll see.' "[10] In Gilbert-Rolfe's paintings, the sublime is a sign for an out-of-control, never-unified pleasurability in which disruption and the decentered canvas take on the form of a visual rhetoric.

Which brings us back, finally, to the frame, or *parergon*, as the delimitation of the work (*ergon*). As Derrida points out, "If art gives form by limiting, or even by framing, there can be a *parergon* of the beautiful, *parergon* of the column or *parergon* as column. But there cannot, it seems, be a *parergon* for the sublime. The colossal excludes the *parergon*. First of all because it is not a work, an *ergon*, and then because the infinite is presented in it and the infinite cannot be bordered."[11] The sublime is therefore in complete contradiction to the idea of the frame, yet a frame is necessary in the presentation of the unpresentable. "Derrida's point, in fact, is to show how the frame itself—even as it delineates an inside and an outside for each art work—permits, and even encourages, a complicated movement or passage across it both from inside-out and outside-in."[12] This constant criss-crossing of the frame or border, where the without-limits represents itself, is the movement of nonrepresentation and Gilbert-Rolfe's practice. "Here, when the danger to his will is greatest, *art* approaches as a saving sorceress, expert at healing. She alone knows how to turn these disgusting thoughts about the horror or absurdity of existence into representations with which one can live: these are the *sublime* as the artistic taming of the horrible and the *comic* as the artistic discharge of the disgust of the absurd."[13] Gilbert-Rolfe brings it all back home, with pleasure.

Notes

1. Roland Barthes, *Mythologies*, trans. Annette Lavers (New York: Hill and Wang, 1972), p. 112.
2. Friedrich Nietzsche, notebook fragment of 1869–70, cited in John Sallis, *Crossings: Nietzsche and the Space of Tragedy* (Chicago: University of Chicago Press, 1991), p. 37.
3. Jeremy Gilbert-Rolfe, "Abstract Painting and the Historical Object: Considerations on New Paintings by James Hayward," *Arts* Magazine, Vol. 61, No. 8 (April 1987), p. 31.
4. Emile Benveniste, *The Archaeology of Knowledge*, trans. A. M. Sheridan Smith, cited in Kaja Silverman, *The Subject of Semiotics* (Oxford: Oxford University Press, 1983), pp. 43–44.
5. Jeremy Gilbert-Rolfe, "The Current State of Nonrepresentation," *Visions* Art Quarterly, Vol. 3, No. 2 (Spring 1989), p. 3.
6. Jeremy Gilbert-Rolfe, conversation with the author, July 1991.
7. Gilles Deleuze, *Cinema 1: The Movement Image*, trans. Hugh Tomlinson and Barbara Habberjam (Minneapolis: University of Minnesota Press, 1986), p. 43.
8. Edmund Burke, *A Philosophical Enquiry into the Origin of Our Ideas of the Sublime and Beautiful*, 1757 (Oxford: Oxford University Press, 1990), p. 36.
9. Chris Baldick, ed., *The Concise Oxford Dictionary of Literary Terms* (Oxford: Oxford University Press, 1990), p. 15.
10. Ibid, p. 8.
11. Jacques Derrida, *The Truth in Painting*, trans. Geoff Bennington and Ian McLeod (Chicago: University of Chicago Press, 1987), pp. 127–128.
12. David Carroll, *Paraesthetics: Foucault, Lyotard, Derrida* (New York: Methuen, 1987), p. 136.
13. Friedrich Nietzsche, *The Birth of Tragedy*, cited in Sallis, p. 109.

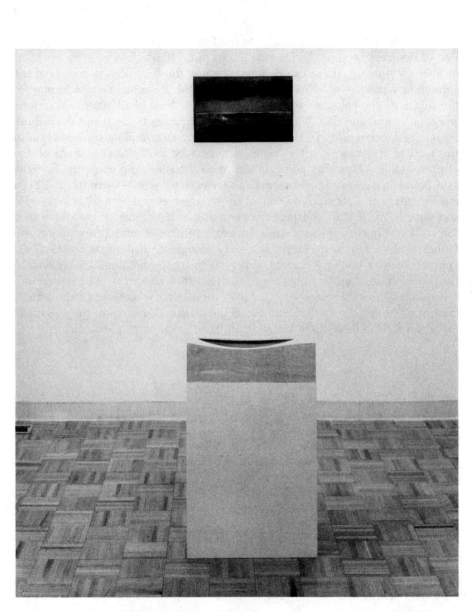

LINDA HUDSON-ROUSH, *Point of Origin.* 1989 Photographic transparency, mirror, hydrostone, wood pedestal, art acrylic paint. Photograph and mirror 12″ x 19″, mold on pedestal 31″ x 24½″ x 6½″.

Courtesy of the artist.

Seriousness and Difficulty in Contemporary Art and Criticism

Jeremy Gilbert-Rolfe

Painter and critic Jeremy Gilbert-Rolfe discusses the reasons that "the inno-
cent," the left wing and the right wing are resistant to seriousness in art and
art criticism. Because art plays with reality, art can be irresponsible and can
transgress rather than confirm popular formulas and cliches. While simplic-
ity can be a guarantee of commercial success, it promotes left wing "piety"
and is often a way of hiding ignorance. The best work resists interpretation
by reordering and changing simplistic categories of thought. Four strate-
gies for promoting "unreasonableness" include confusion, excess, nonsen-
sical, and "dumb beauty." Gilbert-Rolfe illustrates these strategies in the
work of four artists who are seriously willing to rethink contemporary inten-
tions, means, and methods.

In criticism one is often being serious about things which are by definition
not serious. Works, that is to say, which are seriously not serious and are diffi-
cult by not being difficult. Andy Warhol, for example, tried to fulfill both these
criteria. Whether he succeeded or failed is a serious and difficult question.

It's fair to ask, why is it serious and difficult? And the answer is, because
art itself is important to us for reasons which are—guess what—serious and
difficult.

Originally given first as part of a symposium at the High Museum in Atlanta, and then, in an
expanded form—to include art as well as its criticism—as a lecture at Sarah Lawrence College in
December 1990. Reprinted with permission of the author.

One way in which art is serious and difficult is that it raises questions which are unanswerable in more than one sense and all at the same time. It is simultaneously true that you can't actually prove that a work of art is good, which is to say, art resists the regimes of logic and science. Nor can you prove that it means what you say it means. And your idea of what it means might have to coexist in some way with a quite incompatible meaning which you will nonetheless not be able to deny—for example, Celine as liberator and Celine as fascist, and therefore in some sense perhaps not quite a *liberator*—and furthermore it may be the case that your interpretation of the work is entirely wrong but conceivably so influential as to color the way in which the work is seen even by succeeding generations, so that you may in fact both be the one to recognize the importance of the work and the person responsible for consigning it to infinite misreading.

So the work of art, as has been generally argued since the time when the slave-owning societies which gave us the word democracy also gave us aesthetics—the ancient Greeks in other words—is in a sense at the very least a kind of training ground for the very idea of difficulty, a kind of unserious zone where the serious might be properly considered as a form, and difficulty turned into a game. This is what used to be called the aesthetic dimension of everyday life. In our epoch we have come to think—or perhaps one should say the world labors under the delusion—that this dimension is far more important than was once realized. That contrary to the beliefs of Adam Smith and Karl Marx, it is not basic materials which count but luxury items. Late capitalism leaves heavy industry to the third world and concentrates instead on leading in the fields of fashion, popular music, high culture—areas of endeavor which don't produce things which people can actually use, like cars or ships or even televisions and portable radios.

It is here that one encounters an historical curiosity. For it turns out that, as it has become clearer that true power lies not with production but with counter-production, with the useless rather than the useful, with the sign rather than the thing, so, paradoxically, has it come to pass that people are less rather than more prepared to see the work of art itself as difficult or serious.

My friend John Johnston was once teaching a course in literature at Queens College in New York and at the end of the first meeting a student came up to him and asked if this was a class in which one would have to read books. Infinitely patient, he explained that since it was a literature class an encounter with books, with, indeed, works of both fiction and non-fiction, was both implicit and unavoidable. I retell this anecdote to illustrate my point. We have reached an historical moment where the innocent feel that it is reasonable to expect access to cultural production without effort, and specifically without engaging the peculiarities of the cultural form in question. Which in Johnston's case was and is the Book.

Possibly one could argue that people resist difficulty in criticism because what they seek in art is, precisely, relief from complexity. We are constantly

being told, and only historians disagree, that the world at large is becoming more complex. That there are no straightforward questions left. Every time we think we have our hands on one, it ceases to be straightforward and becomes instead replete with contradiction. It is utterly unacceptable for Iraq to invade Kuwait, and with relief we invoke the principle of national sovereignty as one of those constants by which we live our lives, like the right of free speech. But the problem immediately becomes complex when we reflect that America's primary ally in the region illegally occupies parts of all four of its neighbors' territories. Is it that total annexation is unthinkable but partial occupation is all right? Or is it that annexation is only bad when Iraq is doing the annexing? Clearly a serious and difficult question rather than a serious but simple choice.

The point is that no one is surprised by such difficulty or particularly resistant to it. Nor is such acquiescence in complexity restricted to the indisputably complex issue of the moral basis of the foreign policies of democracies. In Los Angeles County, where I live, there is a drought, with the result that the populace is being encouraged to conserve water, the result of which is going to be an increase in everybody's water bill. This is because saving water means that the water company sells less of it, and therefore must charge its customers more in order that its shareholders may persist in receiving their usual high rewards for doing nothing but having money to invest in other people's need for water. No one, so far as I know, has voiced irritation at this apparent violation of the sacred principle which has it that it is the free market which keeps prices down and that prudent consumption allows the individual to save.

So on every front, foreign and domestic, one finds tolerance for difficulty. Except, apparently, where art is concerned. Here the story is quite different. Despite all the reasons—some of which I've mentioned—for recognizing that art and its criticism are difficult whether one likes it or not, a general feeling persists to the effect that it shouldn't be. Or that it isn't really difficult at all, but is made difficult by critics in the same way that ordinary people, with good reason, often suspect that the law is itself straightforward but is made difficult by lawyers.

There are, I should propose, three constituencies opposed to difficulty and seriousness in art and art criticism. These are the innocent, the left wing, and the right wing. The innocent, represented by the student who asked if she would have to read books in a literature class, are the most obvious victims of the historical conditions which have led us to substitute the idea of the consumer for the idea of the citizen. The citizen had responsibilities, not least among them the obligation to think for himself and to acquire the means to do so. The consumer is a pig at the trough, a recipient of nutrition who does not pause to ask what place in the food chain may have been reserved for him by those who provide him with food. The woman who asked whether she'd have to read any books was asking for education without effort, and in that reflected the triumph of the idea of con-

sumption over that of struggle. Her argument didn't reach the point of asking whether, if she didn't read things for herself, and equip herself with the means to do so, she would pay a price for that. She was innocent of the need to think for herself, whence, perhaps, all intellectual difficulty derives, and wherein, as I've already implied, one consequently finds the primary argument *for* difficulty. Our answer to the resistance to difficulty enunciated by innocents, therefore, may be that art exists, not to destroy innocence, but to allow the innocent to find their own limits and in that both expand and protect themselves, or the selves that they then become.

Turning now to the left wing, permit me to say at the outset that I am myself left-wing when it comes to politics. The total failure of instituted socialism to produce material wealth in the third world and the Soviet Union notwithstanding, I continue to see nothing wrong with aspiring to a society based on fairness and respect for others as opposed to greed and narcissism. Nor am I persuaded that Marx's view of how history works has been superseded. A reliance on Marx's categories has, however, proved to be more or less totally useless when it comes to analyzing the work of art. Among the reason's why this should be so one would include the obvious truth that the work of art is an irresponsible phenomenon which is simply not reducible to its social origins. What this means is that the sort of things which Marxists tend to concentrate on don't answer the more pressing questions we're likely to ask of the work of art. Left-wing resistance to difficulty is founded in this truth, and is in consequence a resistance which tends to take the form of resisting difficulty by shrouding the analysis in another kind of convolution, the effect and goal of which is to attribute great significance to feeble and minor works which are nonetheless socially well intentioned while discrediting and short-changing complex and ambitious projects because they tend to be politically problematic.

The work of art is inherently irresponsible because it's open to the possibilities available to the signifier when the latter is freed from the constraints of the signified. The work of art, in other words, plays with reality because it is not reality. The first people to get excited about this property of the work of art were the French *Symbolistes*, who, as Penny Florence has explained, were interested how in the work of art anything can be put together with anything because everything that occurs in the work of art is occurring in the world of signs rather than of things, so that the work of art resembles the dream—a place of apparitions and appearances—rather than consciousness, which responds to and occupies, to the best of its ability, the real world, 'real' being a word which derives from the Latin word for thing. The work of art can make things do anything because it is made not of things but of signs, a point which Manet sought to emphasize by painting things as if they were as much flat as they were solids, emphasizing thereby that they are signs for things and not things themselves. One sign may relate to—share space with—any other sign as one thing may not coexist, in reality, with any other thing, so that the work

of art plays with the signifier in such a way as to create combinations which cannot, as I've suggested, be returned to a signified which makes sense in terms of a theory of meaning founded, as left-wing thought hypothetically always is, in an analysis of the real world, in, that is to say, the economics of the real. And thus it is that the left always ends up being frustrated by ambitious works of art, and accuses them of mystification, of being elitist. In fact those who made them never sought to mystify anything, in the sense of adding confusion to something which was in the first place uncomplicated, simple, and clear, but rather sought to pursue those possibilities inherent in signs but which had not yet seen the light of day. In a word, to add to the world's knowledge by stirring up the system upon which that knowledge depends. This, I am sad to say, is what the left-wing cannot stand—and by the left wing I mean the left wing that we actually have, not the one promised by Benjamin and Adorno—the idea that there is knowledge to be gained, generated, played with, that is more than a kind of ornamentation of the theory of production that they hold so dear, and mistakenly regard as a key to all that lives and breathes and to all that does not. As Baudrillard has shown, and as I hope I have now demonstrated, it is theories of counter-production which are called for by works of art, theories of irresponsibility rather than responsibility, of transgression rather than confirmation.

This is the sense in which the favorite works of the contemporary left are so arid, such trivial evasions of the difficult. The pieties of Jenny Holzer, expensively produced slogans offered as works of art, while directly comparable to the fatuous pieties of Mao Tse-Tung or the Ayatollah Khomeni, completely fail to generate anything like a new thought. What they do instead is exactly what the slogans of Maoists or of Islamic fundamentalists do, which is to pretend that difficult ideas can be reduced to simple formulations. It is the insistence that such rubbish is the best that culture can do which is so dangerous, the lunacy which has Jenny Holzer represent the United States at the Venice Biennale. That this could occur tells us that the worst has happened, that the thugs of limited imagination have taken over the administration of culture in the name, of course, of liberation, just like Mao and the Ayatollah. This is a ritual abolition of difficulty and therein lies its danger. The abolition of difficulty is what consumer culture is all about. It's not supposed to be what the left wing is all about.

And lest you think I am arguing here for an art of the amoral, let me say that if I am it is not for an amorality which remains at that level, which as it were preserves the work at a level which evades the moral indefinitely, but rather for an amorality which leads back to that morality which would oblige its audience to assume responsibility for itself, to be citizens instead of consumers. On this point I am inclined to quote from an essay by a thinker who is by no means of the left but who cannot thereby be subsumed by the right, George Steiner.

"Whatever enriches the adult imagination," says Steiner, "whatever complicates consciousness and thus corrodes the cliches of daily reflex, is a high moral act. Art is privileged, indeed obliged, to perform this act; it is the live current which splinters and regroups the frozen units of conventional feeling. That—not some modish pose of abdication, of otherworldliness—is the core of l'art pour l'art. This morality of enacted form is the centre and the justification of Madame Bovary."[1]

This quote from Steiner is from a collection called, appropriately enough, *On Difficulty and Other Essays*. It is of course precisely the kind of morality which Steiner invokes and describes which is evaded by the works which arouse enthusiasm on the left. It is a morality founded in difficulty rather than readymade answers, and its renunciation by the left underscores the extent to which the latter is now simply part of consumer culture. On the left as on the right, suppressing the difficult by advocating instead the most ridiculous simplicity is a guarantee of commercial success, which in academia means tenure and in the art world means that you get to sell your work. That these should be the goals and achievements of the left underscores one of the great truths of the Reagan era, namely that the powers that be have given cultural production to the left as a way of both keeping it quiet and simultaneously ensuring that it will become part of the Capitalist machine, willingly turning anti-capitalism into a growth industry which develops new markets pandering to tastes which already exist and beliefs that are already formed. In this sense, as we know, there is no difference between creating university departments which once never existed and which, once existing, cause us to wonder how we ever did without them, and products which invoke a similar response. How did we ever do without Women's Studies, Gay Studies, Afro-American Studies, or without computers, fax machines, and a telephone in the car? Small wonder that the language used to rationalize and justify the art favored by the commercial left should generally be so tortured; it exists to excuse the left's participation in all to which it was supposed to be opposed. And, most terrifying of all, the left doesn't know it. Drowning in sincerity, the commercial and academic left is the last bastion of unconsciousness, an unconsciousness which preserves itself by insisting that it alone possesses the key to consciousness. The left is the true heir of the Enlightenment, and what it has inherited is that mad belief in the mind as opposed to the body which led the Enlightenment astray and caused it to destroy itself, to never realize itself, and which now exists in such inadvertently parodic events as the career of Jenny Holzer—or Barbara Kruger, or Hans Haacke—or in such truly sad excesses as those acts of criticism that seek to persuade us that Leon Golub is an interesting painter or George Gissing an important novelist or Spike Lee, despite his many strengths, an inspired cinematographer. Whenever the left encounters anything truly interesting these days it shies away from it because it cannot immediately see itself *in* it. Thus do we now find narcissism where was once a methodology of liberation,

profound conservatism which believes itself to be anti-conservative because it is too sure of itself, too self-satisfied, too secure in its piety, in short, too conservative.

And so to the third variety of resistance to difficulty, that practiced by those who truly believe themselves to actually be conservative. If the innocent are, well, innocent, and the left is deluded in its belief that it can be opposed to the system even as it derives sustenance and power from the system, with which it really no longer has any quarrel at the level of the personal and the material, then those who actually call themselves conservative may be characterized, oxymoronically as it were, as both powerful and embittered. Like the left, conservatives oppose difficulty on the grounds they already have all the answers and that therefore what appears to be difficulty must in practice be willful obfuscation. Unlike the left, they are nowadays fully aware that, despite their immense power in the world, they are no longer in exclusive possession of power. The often heard complaint, advanced by aging curmudgeons like Allan Bloom and young fogeys like Michael Brenson, that the humanities' faculties of America's universities are increasingly coming to be dominated by leftists of the generation of the nineteen sixties—my generation—is true. What this means in practice is that the fans of Jenny Holzer have more power than they should. But it also means that you are not going to be taken seriously if you insist that culture fell apart with the invention of abstract painting or the importation of ideas from France. Which is to say, it also means that conservative thought has become exposed for the fraud that it always was. As we know, conservatives in America—and indeed elsewhere—have seldom been interested in conserving anything. What they're more typically interested in is egomania and instant gratification at any cost. Reagan was the great example of this, a man prepared to sell an entire country—this one—to the multinationals in the name of tradition, and so it is with conservative criticism, which is prepared to bowdlerize the entire history of modernism in order to preserve symbolically what cannot be preserved in practice, the hegemony of the white male.

My son, Cyrus Gilbert-Rolfe, made the point in a review of Bloom's book—*The Closing of the American Mind etc. etc. etc.*—that one big difference between young people of Bloom's generation and the young of today was that Bloom's generation got to talk about casual sex and the young today get to do it.[2] A remark which draws our attention to the extent to which conservatives are always infatuated by the symbolic, for while only getting to think about it Bloom's was a generation—perhaps the last one—which could seriously think about the world in exclusively male-centered terms. Bloom's crowd never actually got any, but they could actually imagine an exclusively male-oriented sexuality, if 'male-oriented' is quite the right way—puns and double entendres are beginning to proliferate in this sentence—to describe that particular fantasy. Of the three varieties of resistance to difficulty I have enumerated here the right wing one is the saddest and least serious precisely

because it seeks to destroy not only the present but the past. Earlier art and criticism were never so brutish and so straightforward as Hilton Kramer or Michael Brenson—Kramer's protege—would have us believe. If it had been it would never have survived, never have led to all that contradicts it but is indebted to it. I have made the point elsewhere that neoconservatism in politics is National Socialism without the working class component—a jingoistic, strike-free society ruled by an executive made up of politicians financed by giant corporations, like Nazi Germany but lacking the gruff beer-swilling aspect which guaranteed that the government would in fact make sure that the working class was well fed and well housed. In a similar sort of way, neoconservatism in art and its criticism is Modernism without the principle of change, a parody of the strained dialectic of a T. S. Eliot, and as such an intellectually trivial endeavor which, like Reaganism, implicitly imposes a total rupture, a radical break, between art as conservatives would now have it and the kind of art which an artist such as Eliot proposed, an art which sought to conserve its past through a sense of its discontinuity with that past. No one could take such nonsense seriously save those who were, implicitly, not serious.

To conclude, then, permit me to make a final point. I have suggested that resistance to difficulty in the work of art comes in three varieties: the innocent; the pious; the embittered. The point I should like to make is that while the innocent deserve our help, the left and the right deserve one another. There is, from the point of view of anyone actually interested in seriousness and difficulty, no significant difference between Andre Serrano and Jesse Helms. Indeed they need one another. Seriousness and difficulty, on the other hand, obviate both. They go elsewhere. So as to end on a note which addresses the needs of the innocent as well as obviating the cant of the pious and embittered, let me conclude by suggesting that what we want from art is something like what Jean Baudrillard says he gets from theory:

> "It is true that logic only leads to disenchantment. We can't avoid going a long way with negativity, with nihilism and all. But then don't you think a more exciting world opens up? Not a more reassuring world, but certainly more thrilling, a world where the name of the game remains secret. A world ruled by reversibility and indetermination. . . ."[3]

That is the world made by the work of art. Existing to disenchant the innocent, it offers reassurance to neither the left nor the right, but is instead thrilling. Its secret resides in its ultimate inexpressibility in any other form other than its own, its final untranslatability, its resistance to interpretation. Therein lies its difficulty, its irreducible seriousness. No wonder people resist it and the criticism it brings forth, it exists to destroy the world by endlessly reordering the names which give substance to things. And not content with reordering, it will even change those names or make them disappear, present-

ing us with that most threatening of all thrills, intelligible but nameless pleasure.

I come now to the second part of my lecture, in which I should like to discuss a handful of works which seem to provide some kind of thrill and which in my opinion pose a certain kind of worthwhile difficulty. It seems to me at least possible that one might reasonably propose that the thrill provided by the work of art is, quite often if not always, a thrill provided by one's sense of the work as something which is at once convincing and unreasonable. Unreasonable, that is, in the sense in which, at the beginning of this lecture, I suggested that the work of art is by definition a kind of thing or sign which resists the regime of the logical or the scientific.

I should want to insist, though, that the unreasonable can take a variety of forms, conceivably an infinite variety, so that to invoke the unreasonable is not to invoke one thing—which suggests that the unreasonable must be much more than merely the opposite of the reasonable, which in its tendency to totalize must always present itself as unitary and indivisible, but I leave that discussion to another day.

So I'm going to briefly discuss four instances of unreasonableness which are not different versions of one another and are also not meant to sum up, in their totality, all the varieties of the unreasonable which might collectively constitute art as a whole. These four instances are simply the four I want to talk about today, and the four which allow me to talk about what interests me most. These four possibilities are: The work of art as a kind of confusion; the work of art as a particular kind of deployment of excess; the work of art as something— which is to say, some sign—which produces and is produced by nonsensical relations; and the question of beauty.

To have a theory of the work of art as a confusion would be oxymoronic: confusion as coherence as it were. It would involve gathering contradictory meanings together in such a way as to cause them to undermine one another or place limits upon one another. Such a work would play with the idea of the complete explanation—the idea of discourse as totalizing. The confusion which characterized such works would then truly be oxymoronic, a structured confusion which led to a very clear sense of the way in which the work was not reducible to an idea of structure. It would instead be a work where confusion was caused by an extreme but at the same time incomplete fusing.

Writing about Mary Boochever's *Brilo* a couple of years ago . . . I said I thought it significant that it gave us a landscape image which is atmospheric (brown and gray, the colors of art before Impressionism and most Realism since: here a sign of the influence of Beuys) as an effect produced by a surface which is at once soft and brittle—wax. Malleability, waxiness, as a primary condition of the work's surface, then, while this malleability replaces and in fact reduces the malleability of the support, which is a cotton apron, reversing the customary relationship of a rigid skeleton or support to a comparatively softer painted surface. Painting a landscape on the apron, imposing a space on

a thing, turns the apron into a field containing both more spatiality than it possessed before (less thingness) and at the same time more substance (more thingness.) The provisionality, flimsiness—although you can't really call something as tough as an apron flimsy—of the original object is preserved at its extremities. The loop that goes over one's head and the strings which one ties around one's waist are left floppy. It reaches into the world, flops into the space which it now contains, in terms which unite it to its original self through those elements which, in its customary incarnation, connect it to the body.

It plays with the idea of the body, but at its center is an exterior space. Its interior is a reference to exteriority, to what contains the body and in contradistinction to which the body finds itself. As an effect produced by a waxy surface, the landscape space is also one whose atmosphere may be read as dense, impacted, and, in that, as itself an exterior. The concept of interiority is linked to a concept of the exterior at every point where one encounters it. This is a straightforward inversion of the body as it is encountered customarily when the body concerned is not one's own, i.e., as an exteriority which brings with it the assumption of an interior—which *depends* on our attributing interiority to it. These are the bodies which fill the space we see and, in so doing, to some extent reassure us that one's own body shares the exteriority they (as exteriorities themselves) occupy.

One is unavoidably involved in a discourse in beingness with such a work as *Brilo*, but it is by no means the kind of essentialist concept of being which characterized the art and art discourse of the nineteen-sixties. There is no sense here in which an interiority is supposedly being presented, rather there is instead an elaboration of the inevitability of the work's functioning through exterior reference which precludes our seeing any inside as something other than an outside (the interior is a landscape—an exterior—and the support is continuous with the work's extremities—its literal exterior.)

At the same time this is not a work reducible to the belief in an exteriority which confirmed the unitariness of an essentialist interior that was another version of the sixties' use, in American art, of phenomenological reduction—the belief enshrined in Frank Stella's (in retrospect dreamily Idealist) suggestion that, in his work, "what you see is what you get" (were that ever to be true, what kind of seeing would that be?) or Robert Morris' use of the idea of the *gestalt*. It is, rather, a work in which the idea of interiority is always present but, as such, is always deferred into a concept of exteriority. It is a deconstruction of the idea of interiority.

It is also a deconstruction of the (historicist) concept of usefulness, but this is probably less important. Who cares about such things other than those concerned to theorize the world through work, through religions founded on the image of production, and therefore with the moral, narrowly conceived of course, above all else? Be that as it may, the fact—to use the language of history conceived as a "science"—that *Brilo* is an artist's apron connects to the idea of work, where that work is the nonproductive production which is art.

Art is something people look at in their spare time, a production designed for moments of nonproduction. This is the sense in which the work of art is always a deconstruction of the conditions of production when viewed historically, *i.e.*, in terms of a science or poetics of production, and here one might want to consider for a moment the apron as a kind of social sign, here connected with art, *i.e.*, with the deconstruction of production through nonessential production (objects belonging to the space of leisure), but also, as an apron, signifying, on the one hand, the artisanal (carpenters and so forth, labor which is productive but not—compared to the incomes of commercially successful artists, stockbrokers, and Marxist professors—particularly lucrative, reminding one that except in art galleries and other parts of the luxury trade one never pays that much for the hand-made in industrial or post-industrial society), and on the other to the domestic, to labor which is fundamentally essential but which never enters the marketplace at all; to which, in other words, monetary value never, traditionally, gets attached at all except where servants are concerned, more or less the closest form of labor to actual slavery which the society continues to permit itself. As a social sign the apron functions to signify high value, marginalized value, no value. It is a kind of ultimate sign for apronness, and as such exhausts its identity as such a sign by exhausting all its meanings, collapsing them into one another.

Such a plethora of possibilities must detach it from any possibility of finding a final meaning within such a scheme. To describe it in these terms is to merely say it can be any thing, which tells us that this object is to be read in a different manner than Beuys' felt suit, which is directly autobiographical in its reference. *Brilo* is in this sense a further adjustment of the Readymade, a triumph of nonproduction presented through the retention of a reference to the conditions of its production (the opposite of Smithson's taking the earthmoving equipment away before declaring the *Spiral Jetty* finished) which simultaneously blocks access to the work through the concept of exemplary or representational labor, putting in its place the two zero degrees between which work and any religion derived from it takes place, the body, and the distance from the world which defines it, the world as distance, *as* landscape.

Turning now to the work as a deployment of excess, but not altogether losing sight of the idea of confusion as I do so, I should like to address the possibility of excess in terms of the rather special category of excess as repetition, and I shall do so through reference to a work by Roni Horn.

I say that a work such as *Pair Object III*, 1988, is structured, or otherwise dependent upon, excess, because it is in effect nothing less than an attempt—successful, I think—to make work in which the idea of presence and that of absence stand in a kind of supplementary relationship to one another, as opposed to a relationship of mutual exclusion.

This is unusual in the sense that much of the drama and controversy which constitutes and surrounds modern art has depended on theories which either seek to make the work entirely dependent upon an idea of presence, or

to demonstrate that the idea of the presence of the work is itself a fraudulent and misleading one and that works of art in fact depend on an identity and a set of associations—in short, an ontology—of quite another sort. Which is a way of saying that, in general, Art Theory has been a matter of either the formalism of the intrinsic or the formalism of the—historical or psychological—context.

Horn's piece is made of two identical pieces which, being forged bronze, cannot actually be exactly identical. Moreover, they can't be seen at the same time, but are rather exhibited together in separate rooms so that the relationship between them, graphically speaking, can only be known if one looks at neither and looks instead at the floor plan of the installation considered as a whole. Doing so will, inevitably, tell one only very little—although it certainly doesn't tell one nothing.

Far more important, however—far more useful—is the realization that the work demands to be read in terms of a drama provided by the opposition between the totally and insistently present and the remembered as an implied absence. The very physicality of sculpture underscores one aspect of its dependence, as a type of art, on one's experience of it as a heavy and impermeable mass, which is to say of its presence in one's space as another body, as a sign which is also inescapably a thing as well as a thing which is above all a sign. (I say it's above all a sign because it exists to be read or seen rather than to be used and in being used, to be overlooked in the sense that one overlooks the pen with which one writes.)

Writing about this work a couple of years ago, when it was first exhibited, I also made the point that it made great use of the idea of the oblique, and the oblique is always an *aspect* of the thing rather than its essence. So one may say that unlike the Minimalist works from which it is derived, Horn's sculpture is asymmetrical rather than symmetrical and that this property complements or reinforces its articulation through this idea of an excess of presence, of, that is to say, a presence which, through the presence of repetition (where what is repeated is known or felt but not seen), includes within its own presence the absent presence of its double—and where that absent presence is of course not really a double but is rather the rest of the piece. A shadow, as it were, which is not a reflection of the body but an integral part of the body while still in some sense extrinsic to it. In Horn's piece, this idea is taken further, so that the repeated element and the original element—the body and its shadow— have become interchangeable, each the origin of the other or neither the origin of the other, a division without origin, a repetition without development: one followed by one which altogether add up to one.

Turning now to my third example, the question of the work of art as a kind of sign system which functions through the production of nonsensical or unreasonable relationships, I draw your attention to a piece by Linda Roush. Even more than the pieces by Boochever and Horn to which I've just drawn your attention, this is a work which is likely to cause one to wonder just what it is one is looking at. Closer scrutiny reveals that it is a photograph of Mount

Ararat mounted on a transparent piece of plastic, and that the piece on the stand is a sculpture made out of a concavity rather than a positive shape. Mount Ararat is a mountain with two peaks, rather like a Roni Horn sculpture or the World Trade Center in New York—beloved by connoisseurs of espionage because Kim Philby went on a walking tour there and came back with a photograph of himself standing in front of it which was taken from the other side, the side of Soviet Armenia, a detail nobody noticed until it was too late—and which is also the place where Noah's Ark is supposed to have finally come to rest. So the indented sculpture, in effect, conflates three of the mountain's properties: the space between the peaks; the peaks themselves, where one is placed within the other and both are then inverted; and the idea of the vessel or container. It's one of those works which the people who write for the newspapers like to call enigmatic, which means they're a little too difficult for the writer in question to bother to figure out. I call it nonsensical because once you *have* figured it out—and it is presented in a way which makes its reading pretty clear to anyone who puts in the time, one looks *at* the mountain and *down into* the sculpture—one doesn't have a work which illustrates or puts to work an idea one already knows, as Holzer puts to work the idea of the advertising slogan or Haacke the idea of Courbet; but rather one which plays with the idea of the idea, or makes nonsense out of the idea of making sense, because once one has made sense of this work one is left with a piece which continues, in a sense, to make sense by not making sense. To say that it makes its own kind of sense is to trivialize it, for such a description begs the question of what kind of sense that is. Sense which belongs to no immediately recognizable category of sense-making is hardly simply another kind of sense, it is rather a very special kind, sense-making which plays with the idea of making sense, and in doing so renders the idea of making sense problematic and irresponsible rather than returning it to its customary status of responsible problem solving—sensible behavior, as we say.

It should be fairly clear by now that for me the work of art is that which arouses feeling, or causes discussion because it doesn't, in a way which either evades or obviates the usual parameters of anything one might describe as an argument. Without claiming to name the thrill provided by each of the three works I've just discussed, I can and have posited or gestured towards where it might be found in the defeat, through invocation, of the utilitarian in Boochever; in the infinite deferral of the idea of unity, and therefore of essence, in Horn; and in pursuit of a kind of sense which doesn't make sense in Roush.

Clearly these works have something in common even as they have nothing in common. They are all playful, for example, playing in turn with the very serious categories of the utilitarian, the unified, and the logical. And they are all playful in their insistence on being good to look at, where the latter may be defined as that which invokes pleasure rather than duty—which again places a chasm between them and work such as Haacke's or Holzer's.

As I've said pleasure is non-productive, in the sense that it provides relief from the tyranny of production, as the weekend provides relief from the working week. The work of art is work which is attached to that species of thought which has to do with not working, which is how and why the work of art is ultimately responsible for and to irresponsibility. And given that the irresponsibility of the art work is always turning into academies of irresponsibility, into official varieties of bad boyness, one might say that the work of art is actually always trying to find a way of being irresponsible to the very idea of irresponsibility itself, without, in so doing, returning to a trivial and banal notion of the responsible. (Which was the error performed by the generation which produced Holzer and Haacke and all their gray and serious friends who have expunged difficulty from art and whom one therefore finds it hard to take seriously.)

Which brings me to my fourth and final example and to the question of beauty. I take it for granted that beauty always eludes knowledge, in the sense that once we know it—in the analytic and narrow sense of the word—it has been taken over by a discourse alien to itself, has become codified, made into an adjunct of all that it itself is not, for it itself is very little if it isn't fascinating, capable of leading us astray from the straight and narrow path traced by clear and systematic thought. In other words beauty is that which gives pleasure as it transgresses against good sense, or better still, obviates it and renders it inoperative.

As such it cannot simply be human, and beautiful *people* are those who, in their symmetry, the clarity of their complexions, in short their perfection, are desirable precisely because their human attributes point to the inhuman. They are complete where ordinary mortals know themselves to be mortal because ordinary people know themselves to lack, to be missing something, to be less than perfect. Christian Haub's work also raises the question of the beautiful as dumb. Dumb in the sense that it needs no argument to present itself, is speechlessly eloquent that is to say, and dumb in the sense that it can be made out of things which we already know but is at the same time not reducible to that knowledge. It is not made out of good ideas so much as that it is made out of ideas which might in themselves be described as banal: good ideas are already complete, and certainly need no work of art to elaborate upon them—as Baudrillard has pointed out, a work of art made out of a good idea would by definition be either redundant or ornamental, which reminds us once again of Holzer or Haacke.

Haub plays with painting. In his work the surface doesn't replace what's behind it, it announces and complicates it. Where the work of art ends is problematized by the question of the role played by shadows which the objects cast. Whiteness itself is used to obscure whiteness. Composition becomes a matter of composing both the surface and what the surface itself composes. We are, as with Horn and the others, in a world of deferral rather than of essences.

And we are certainly in the world of the beautiful, where if it isn't beautiful it isn't anything at all. Here, the beautiful accompanies, or comes to us in the context of, a problematization of the language of painting, a language made up of opposites: surface and support; color and drawing; picture and frame; inside and outside. None of these oppositions survive Haub's attention without being thoroughly rethought, yet this is a rethinking which in no sense undermines painting but rather conserves it. So I'll conclude with what seems to me to be an obvious but at the same time important point. Seriousness and difficulty in art and criticism are resisted because they announce the necessity which we most urgently seek to ignore, the obligation to think the thoughts we already have in terms which will not merely bring a putatively new content to such thinking but will reorder the very terms in which that thinking thinks itself. I have refrained from quoting Derrida here but his shadow obviously falls over everything said by me this afternoon. Derrida has sought to rethink the language of philosophy by questioning the priorities in philosophical discourse of the idea of essence, the authorial voice, and the logical. The art and criticism of which I made fun at the beginning of my talk asks no serious or difficult questions about anything. The works I've briefly discussed at its end are wildly disparate in interest and intention but have in common an absolute will to rethink anything that could conceivably be done in another way than hitherto, and to rethink it in terms that haven't precisely been thought. That's what's serious and difficult about them, and that is what defines the thrill they provide. I said I shouldn't try to name it but I am prepared to come closer than before in saying where it is: it's in exploration rather than confirmation, in pleasurability rather than religion.

Notes

1. George Steiner, "Eros and Idiom," *On Difficulty and Other Essays*, Oxford: Oxford University Press, 1978, pp. 110–111.
2. Cyrus Gilbert-Rolfe, "Xyross," *Vivid Press*, I, 1, London 1989, 16.
3. Jean Baudrillard, "Forget Baudrillard," in *Forget Foucault*, New York: Semiotext(e), 1987, p. 71.

JORGE PARDO, *Cut Pinhole Camera.* **8½″ x 11″ Styrofoam, tape, photograph**

Photograph courtesy of Mike Adams.

The Boys in My Bedroom

Douglas Crimp

Reflecting on his earlier comparison of the appropriations of Robert Map-
plethorpe and Sherrie Levine, critic Douglas Crimp argues that he had not
properly considered the way in which "homophobia, in rendering us blind,
structures every aspect of our culture." Postmodern assaults on authorship,
universality, originality and on the institutional confinement of art must be
supplemented by an assault on homophobia, thereby giving postmodern
practice a distinctively political content.

In 1983, I was asked to contribute to the catalogue of an exhibition about the
postmodernist strategy of appropriation, organized by the Institute for Con-
temporary Art in Philadelphia—a museum now placed on probation by the
National Endowment for the Arts.[1] I chose as a negative example—an exam-
ple, that is, of old-fashioned *modernist* appropriation—the photography of
Robert Mapplethorpe. Here is part of what I wrote:

> *Mapplethorpe's photographs, whether portraits, nudes or still lifes (and it is not*
> *coincidental that they fall so neatly into these traditional artistic genres), appro-*
> *priate the stylistics of prewar studio photography. Their compositions, poses,*
> *lighting, and even their subjects* (mondain *personalities, glacial nudes, tulips)*
> *recall* Vanity Fair *and* Vogue *at that historical juncture when such artists as*
> *Edward Steichen and Man Ray contributed to those publications their intimate*
> *knowledge of international art photography. Mapplethorpe's abstraction and fet-*
> *ishization of objects thus refer, through the mediation of the fashion industry, to*
> *Edward Weston, while his abstraction of the* subject *refers to the neoclassical*
> *pretenses of George Platt Lynes.[2]*

Reprinted from Douglas Crimp "The Boys in My Bedroom," *Art in America* (February, 1990).

In contrast to Mapplethorpe's conventional borrowings, I posed the work of Sherrie Levine:

> When Levine wished to make reference to Edward Weston and to the photographic variant of the neoclassical nude, she did so by simply rephotographing Weston's pictures of his young son Neil—no combinations, no transformations, no additions, no synthesis. . . . In such an undisguised theft of already existing images, Levine lays no claim to conventional notions of artistic creativity. She makes use of the images, but not to constitute a style of her own. Her appropriations have only functional value for the particular historical discourses into which they are inserted. In the case of the Weston nudes, that discourse is the very one in which Mapplethorpe's photographs naively participate. In this respect, Levine's appropriation reflects on the strategy of appropriation itself— the appropriation by Weston of classical sculptural style; the appropriation by Mapplethorpe of Weston's style; the appropriation by the institutions of high art of both Weston and Mapplethorpe, indeed of photography in general; and finally, photography as a tool of appropriation.[3]

For several years I had hanging in my bedroom Levine's series of Weston's young male nudes. On a number of occasions, a certain kind of visitor to my bedroom would ask me, "Who's the kid in the photographs?" generally with the implication that I was into child pornography. Wanting to counter that implication, but unable easily to explain what those photographs meant to *me*, or at least what I *thought* they meant to me, I usually told a little white lie, saying only that they were photographs by a famous photographer of his son. I was thereby able to establish a credible reason for having the pictures without having to explain postmodernism to someone I figured—given the nature of these encounters—wouldn't be particularly interested anyway.

But some time later I was forced to recognize that these questions were not so naive as I'd assumed. The men in my bedroom were perfectly able to read—in Weston's posing, framing, and lighting the young Neil so as to render his body a classical sculpture—the long-established codes of homoeroticism. And in making the leap from those codes to the codes of kiddie porn, they were stating no more than what was enacted, in the fall of 1989, as the law governing federal funding of art in the United States. That law—proposed by right-wing senator Jesse Helms in response to certain of Mapplethorpe's photographs— directly equated homoeroticism with obscenity and with the sexual exploitation of children.[4] Of course, all of us know that neither Weston's nor Mapplethorpe's photographs would be declared obscene under the Supreme Court's *Miller v. California* ruling, to which the appropriations bill pretended to defer; but we also know that NEA grant applications do not come before a court of law.[5] For those considering whether to fund arts projects, it is the equation itself that would matter. As Jesse Helms himself so aptly said of his victory: " 'Old Helms will win every time' on cutting federal money for art projects with homosexual themes."[6] And indeed he will. As I hope everyone remembers, in 1987, when

gay men still constituted over 70% of all reported cases of AIDS in the United States, 94 senators voted for the Helms amendment to prevent safe sex information directed at us from being funded by Congress.[7]

Given these assaults on our sexuality and indeed on our lives, what are we to say now of the ways we first theorized postmodernism? To stay with the parochial debate with which I began, what does the strategy of appropriation matter now? My answer is that we only now know how it might really matter.

In October of 1989, the third annual conference of the Lesbian and Gay Studies Center at Yale began with violence unleased on the participants by the Yale and New Haven police forces.[8] The trouble started with the arrest of Bill Dobbs, a lawyer and member of Art Positive, a group within New York's AIDS Coalition to Unleash Power (ACT UP) that was formed in response to the Helms amendment. Dobbs was presumed to be responsible for putting up a series of what the police claimed were obscene posters around the sites of the conference. The 11 × 17 xerox posters—showing various images of and texts about sex appropriated from such sources as old sex education manuals, sexology texts, and pulp novels, and accompanied by the words "Sex Is" or "Just Sex"—were produced by the anonymous San Francisco collective Boy with Arms Akimbo, also formed to fight the Helms amendment. The collective's goal was to get as many people as possible involved in placing in public places imagery showing various cultural constructions of sexuality. Four thousand of the "Sex Is" posters were wheatpasted around San Francisco, and they also appeared in Sacramento, on various Bay Area college campuses, in Boston, New York, Tel Aviv, and Paris, as well as, of course, New Haven. For the month prior to the Yale lesbian and gay conference, the "Sex Is" xeroxes were shown in the city-sponsored San Francisco Arts Commission Gallery, situated across from San Francisco City Hall, in an exhibition titled "What's Wrong with this Picture? Artists Respond to Censorship."

But it is precisely the censorial intent of the Helms amendment, to which Boy with Arms Akimbo's pictures were intended to call attention at the Yale conference, that was effaced in the reporting of the events of that weekend. While charges against others arrested in the fracas were quickly dropped, those against Dobbs were not. And Yale president Benno Schmidt adopted an uncompromising stance.[9] Rather than apologize for the homophobic actions of his police, he sought to exonerate them through an "impartial" investigation, conducted as usual by the police themselves, to adjudicate the obscenity call and to consider possible police misconduct.[10] Moreover, Schmidt was quoted in the *New Haven Register* as saying that he thought at least one of the posters would be considered obscene using the Supreme Court's definition. The Court's caveat regarding "serious literary, artistic, political or scientific value" was simply disregarded by this so-called expert in First Amendment law, since the serious *political* value of Boy with Arms Akimbo's posters—that they constitute a form of political speech about Helms's equation of homoeroticism with obscenity—was never even admitted as an issue.

Boy with Arms Akimbo is only one example of how the postmodernist strategy of appropriation has been transformed through its shift from a grounding in art world discourse to a grounding in movement politics. Within the AIDS activist movement, and especially within ACT UP New York, a certain savvy about this narrow aspect of postmodernist theory has been especially enabling. The graphic work of the Silence = Death Project, Gran Fury, and many others, the video activism of DIVA TV (for Damned Interfering Video Activist Television) grows very directly out of propositions of postmodernist theory. Assaults on authorship have led to anonymous and collective production. Assaults on originality have given rise to dictums like "if it works, use it"; "if it's not yours, steal it." Assaults on the institutional confinement of art have resulted in seeking means of reaching affected and marginalized communities more directly.[11]

But finally, I want to say something about what was excluded from postmodernist theory, which made it considerably less enabling—excluded not only from the aesthetic theory I've been addressing, but also from more global theories. My own blindness in the Mapplethorpe/Levine comparison is symptomatic of a far greater blindness. My failure to take account of what those men in my bedroom insisted on seeing was a failure of theory generally to consider what we are now only beginning to be able to consider—what, in fact, was being variously considered at the Yale lesbian and gay studies conference: the dangerous, even murderous, ways in which homophobia structures every aspect of our culture. Sadly, it has taken the horror of AIDS and the virulent backlash against gays and lesbians that AIDS has unleased to teach us the gravity of this theoretical omission. What must be done now—if only as a way to begin rectifying our oversight—is to *name* homophobia, the very thing that Yale's President Schmidt so adamantly refused to do, the very thing that the entire membership of Congress refuses to do.

Returning once again to the comparison with which I began, but this time taking into consideration what the boys in my bedroom saw, the photographs by Mapplethorpe and Levine no longer seem definitional of postmodernism through their opposition. Appropriating Weston's photographs of Neil, Levine claimed them as her own. Seen thus in the possession of a woman, the nude pictures of the young boy no longer appear, through their deployment of a classical vocabulary, as universal aesthetic expression. Because Levine has "taken" the photographs, we recognize the contingency of gender in looking at them. Another consequence of that contingency is made explicit by Mapplethorpe. Appropriating Weston's style, Mapplethorpe puts in the place of Weston's child the fully sexualized adult male body. Gazing at that body, we can no longer overlook its eroticism. That is to say, we must abandon the formalism that attended *only* to the artwork's style. In both cases, then, we learn to experience Weston's modernist photographs not as universal images, but as images of the universal constituted by disavowing gender and

sexuality; and it is such deconstructions of modernism's claims to universality—as well as its formalism—that qualify as postmodernist practices.

What made Boy with Arms Akimbo's posters a provocation to the Yale police and its president was perhaps after all not their imputed obscenity, but rather their *variety*, their proliferation of different ways of showing *Sex Is . . . Just Sex*. Or rather, as Jesse Helms has made clear, difference, in our culture, *is* obscenity. And it is this with which postmodern theory must contend.

Notes

1. As punishment for having organized *Robert Mapplethorpe: The Perfect Moment* with funding approved by the National Endowment for the Arts, the ICA was subjected, through an amendment to a 1989 congressional appropriations measure, to a five-year probationary period during which its activities would be specifically scrutinized by the NEA.

2. Douglas Crimp, "Appropriating Appropriation," in *Image Scavengers: Photographer*, Philadelphia, Institute of Contemporary Art, 1982, p. 30.

3. *Ibid.*

4. The compromise language of the notorious Helms amendment to the NEA/NEH appropriations bill read: "None of the funds authorized to be appropriated for the National Endowment for the Arts or the National Endowment for the Humanities may be used to promote, disseminate, or produce materials which in the judgment of the National Endowment for the Arts or National Endowment for the Humanities may be considered obscene, including, but not limited to, depictions of sadomasochism, homo-eroticism, the sexual exploitation of children, or individuals engaged in sex acts and which, when taken as a whole, do not have serious literary, artistic, political or scientific value" (*Congressional Record—House*, October 2, 1989, p. H6407).

5. Moreover, in flagrant disregard of their own inclusion of the *Miller* language, the new law declared a sense of the Congress, clearly referring to photographs by Mapplethorpe and Andres Serrano, "that recently works have been funded which are without artistic value but which are criticized as pornographic and shocking by any standards" (*Congressional Record—House*, October 2, 1989, p. H6407). For an illuminating discussion of *Miller* in relation to the Right's attack on the NEA, see Carole S. Vance, "Misunderstanding Obscenity," *Art in America* 78, no. 5 (May 1990), pp. 39–45.

6. Maureen Dowd, "Jesse Helms Takes No-Lose Position on Art," *New York Times*, 28 July 1989, p. A1.

7. See my discussion of this other notorious Helms amendment in "How to Have Promiscuity in an Epidemic," in *AIDS: Cultural Analysis/Cultural Activism*, ed. Douglas Crimp, Cambridge, Massachusetts, MIT Press, 1988, esp. pp. 256–265.

8. The conference, titled "Outside/Inside," was held on the weekend of October 27–29, 1989. The police-instigated violence occurred on Friday evening, October 27.

9. As keynote speaker for the "Inside/Outside" conference, I wrote an open letter of protest to President Schmidt, reiterating the demands of the conferees that he forcefully condemn the violence perpetrated against us and publicly declare his support for our fight against homophobia. Perhaps needless to say, Schmidt saw fit to respond neither to my letter nor to the conferees' demands.

10. On November 30, the *New York Times* reported that "charges against Mr. Dobbs were eventually dropped," and that "two Yale police officers will be disciplined for using 'poor judgment.'" Thus, for what many of us experienced as extreme violence by both Yale and New Haven police against those of us protesting the initial arrests, the officers' disciplining will consist of a reprimand for one and three days without pay for the other. This accords perfectly with a number of recent cases in which the police have investigated their own abuses, as well as with a general failure to take attacks against gay men and lesbians seriously.

11. See Douglas Crimp and Adam Rolston, *AIDS Demo Graphics*, Seattle, Bay Press, 1990.

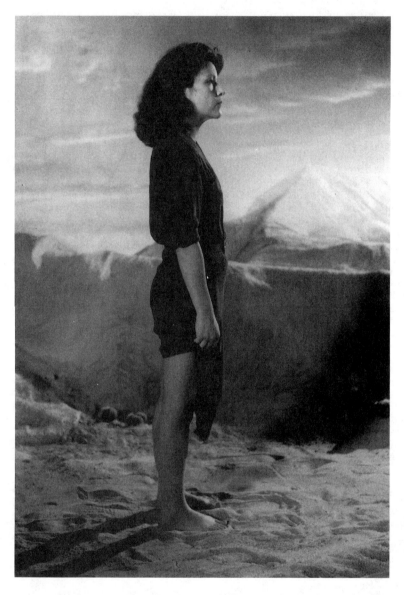

Patti Podesta, *Photo still from the video/film "A Short Conversation from the Grave with Joan Burroughs"* 1991

Courtesy of the artist. Photograph courtesy of Laura London.

Dismantling Modernism

Allan Sekula

Arguing that modernism proclaimed a bogus neutrality, photographer Allan
Sekula urges artists to become involved with the practical struggle to estab-
lish a more egalitarian society. Rather than engaging in media hype and
self-promotion, artists should conduct an intensive investigation of the
"authoritarian monologues of school and mass media."

Suppose we regard art as a mode of human communication, as a discourse
anchored in concrete social relations, rather than as a mystified, vaporous, and
ahistorical realm of purely affective expression and experience. Art, like
speech, is both symbolic exchange and material practice, involving the produc-
tion of both meaning and physical presence. Meaning, as an understanding of
that presence, emerges from an interpretive act. Interpretation is ideologically
constrained. Our readings of past culture are subject to the covert demands of
the historical present. Mystified interpretation universalizes the act of reading,
lifting it above history.

The meaning of an artwork ought to be regarded, then, as *contingent*,
rather than as immanent, universally given, or fixed. The Kantian separation of
cognitive and affective faculties, which provided the philosophical basis for
Romanticism, must likewise be critically superseded. This argument, then,
calls for a fundamental break with idealist aesthetics, a break with the notion of
genius both in its original form and in its debased neo-romantic appearance at
the center of the mythology of mass culture, where "genius" assumes the trap-
pings of a charismatic stardom.

I'm not suggesting that we ignore or suppress the creative, affective, and
expressive aspects of cultural activity, to do so would be to play into the hands

Excerpted from Allan Sekula, "Dismantling Modernism: Reinventing Documentary." Reprinted
from *The Massachusetts Review*, © 1979 The Massachusetts Review, Inc.

of the ongoing technocratic obliteration of human creativity. What I am argu-
ing is that we understand the extent to which art *redeems* a repressive social
order by offering a wholly imaginary transcendence, a false harmony, to docile
and isolated spectators. The cult of private experience, of the entirely affective
relation to culture demanded by a consumerist economy, serves to obliterate
momentarily, on weekends, knowledge of the fragmentation, boredom, and
routinization of labor, knowledge of the self as a commodity.

In capitalist society, artists are represented as possessing a privileged
subjectivity, gifted with an uncommon unity of self and labor. Artists are the
bearers of an autonomy that is systematically and covertly denied the economi-
cally objectified mass spectator, the wage-worker and the woman who works
without wages in the home. Even the apparatus of mass culture itself can be
bent to this elitist logic. "Artists" are the people who stare out, accusingly and
seductively, from billboards and magazine advertisements. A glamorous young
couple can be seen lounging in what looks like a Soho loft; they tell us of the
secret of white rum, effortlessly gleaned from Liza Minelli at an Andy Warhol
party. Richard Avedon is offered to us as an almost impossible ideal: bohemian
as well as his "own Guggenheim Foundation." Artist and patron coalesce in a
petit bourgeois dream fleshed-out in the realm of a self-valorizing mass cul-
ture. Further, the recent efforts to unequivocally elevate photography to the
status of high art by transforming the photographic print into a privileged com-
modity, and the photographer, regardless of working context, into an autono-
mous *auteur* with a capacity for genius, have the effect of restoring the "aura,"
to use Walter Benjamin's term, to a mass-communications technology. At the
same time, the camera hobbyist, the consumer of leisure technology, is invited
to participate in a delimited and therefore illusory and pathetic creativity, in
an advertising-induced fantasy of self-authorship fed by power over the image
machine, and through it, over its prey.

The crisis of contemporary art involves more than a lack of "unifying"
metacritical thought, nor can it be resolved by expensive "interdisciplinary"
organ transplants. The problems of art are refractions of a larger cultural and
ideological crisis, stemming from the declining legitimacy of the liberal capital-
ist worldview. Putting it bluntly, these crises are rooted in the materially dic-
tated inequalities of advanced capitalism and will only be resolved *practically*,
by the struggle for an authentic socialism.

Artists and writers who move toward an openly political cultural practice
need to educate themselves out of their own professional elitism and narrow-
ness of concern. A theoretical grasp of modernism and its pitfalls might be
useful in this regard. The problem of modernist closure, of an "immanent cri-
tique" which, failing to logically overcome the paradigm within which it
begins, ultimately reduces every practice to a formalism, is larger than any one
intellectual discipline and yet infects them all. Modernist practice is organized
professionally and shielded by a bogus ideology of neutrality. (Even academic

thuggeries like Dr. Milton Friedman's overtly instrumentalist "free market" economics employ the neutrality gambit.) In political-economic terms, modernism stems from the fundamental division of "mental" and "manual" labor under advanced capitalism. The former is further specialized and accorded certain privileges, as well as a managerial relation to the latter, which is fragmented and degraded. An ideology of separation, of petit bourgeois upward aspiration, induces the intellectual worker to view the "working class" with superiority, cynicism, contempt, and glimmers of fear. Artists, despite their romanticism and propensity for slumming, are no exception.

The ideological confusions of current art, euphemistically labeled a "healthy pluralism" by art promoters, stem from the collapsed authority of the modernist paradigm. "Pure" artistic modernism collapses because it is ultimately a self-annihilating project, narrowing the field of art's concerns with scientific rigor, dead-ending in alternating appeals to taste, science and metaphysics. Over the past five years, a rather cynical and self-referential mannerism, partially based on Pop art, has rolled out of this cul-de-sac. Some people call this phenomenon "post-modernism." (Already, a so-called "political art" has been used as an end-game modernist bludgeon, as a chic vanguardism, by artists who suffer from a very real isolation from larger social issues. This would be bad enough if it weren't for the fact that the art-promotional system converts everything it handles into "fashion," while dishing out a good quantity of liberal obfuscation.) These developments demonstrate that the only necessary rigor in a commodified cultural environment is that of incessant artistic self-promotion. Here elite culture becomes a parasitical "mannerist" representation of mass culture, a private-party sideshow, with its own photojournalism, gossip column reviews, promoters, celebrity pantheon, and narcissistic stellar-bound performers. The charisma of the art star is subject to an overdeveloped bureaucratism. Careers are "managed." Innovation is regularized, adjusted to the demands of the market. Modernism, per se (as well as the lingering ghost of bohemianism), is transformed into farce, into a professionalism based on academic appointments, periodic exposure, lofty real estate speculation in the former factory districts of decaying cities, massive state funding, jet travel, and increasingly ostentatious corporate patronage of the arts. This last development represents an attempt by monopoly capital to "humanize" its image for the middle-managerial and professional subclasses (the vicarious consumers of high culture, the museum audience) in the face of an escalating legitimation crisis. High art is rapidly becoming a specialized colony of the monopoly capitalist media.

Political domination, especially in the advanced capitalist countries and the more developed neo-colonies, depends on an exaggerated symbolic apparatus, on pedagogy and spectacle, on the authoritarian monologues of school and mass media. These are the main agents of working-class obedience and docility; these are the main promoters of phony consumer options, of "lifestyle," and increasingly, of political reaction, nihilism, and sadomasochism.

Any effective political art will have to be grounded in work *against* these institutions. We need a political economy, a sociology, and a nonformalist semiotics of media. We need to comprehend advertising as the fundamental discourse of capitalism, exposing the link between the language of manufactured needs and commodity fetishism. From this basis, a critical representational art, an art that points openly to the social world and to possibilities of concrete social transformation, could develop. But we will also have to work toward a redefined *pragmatics*, toward modes of address based on a dialogical pedagogy, and toward a different and significantly wider notion of audience, one that engages with ongoing progressive struggles against the established order. Without a coherent oppositional politics, though, an oppositional culture remains tentative and isolated. Obviously, a great deal needs to be done. . . .

THERESA PENDLEBURY, *Anopheles Mosquito.* 1992 Crochet Cotton 30″ x 40″

Courtesy of the artist.

Feminism and Postmodernism

Susan Rubin Suleiman

Greatly increased participation by women in experimental literary and visual artwork during the 1970s and 1980s raises the possibility of a distinctively feminist postmodern practice. Professor Susan Suleiman argues that following the example of Francois Lyotard, the postmodern condition can be viewed optimistically, as opening up possibilities for innovation. Feminism brings to the debates about postmodernism political commitment and an insistence that the meaning of texts or images are determined by interpretive context and are not inherent in the text or image. Nevertheless, serious questions remain just how oppositional any text or image can be, whether in the high or low end of the cultural arena.

Discourses on the Postmodern and the Emergence of Feminist Postmodernism

The absence of discussion of sexual difference in writings about postmodernism, as well as the fact that few women have engaged in the modernism-postmodernism debate, suggests that postmodernism may be yet another masculine invention engineered to exclude women.
> —CRAIG OWENS, "FEMINISTS and POSTMODERNISTS"

Typically male-dominated organizations open doors to women only after their power is on the wane.
> —ROZSIKA PARKER and GRISELDA POLLOCK, *FRAMING FEMINISM*

Contrary to what some recent commentators on postmodernism seem to think, there was life before François Lyotard. The term "postmodernism," designating a cultural sequel and/or challenge to modernism (however one defined that term) existed well before the publication of *La Condition postmoderne* (1979).[1] It is ironic that Lyotard's book, or rather its English translation, *The Postmodern Condition* (1981), should have become the required starting point for all current discussions of postmodernism by American and English critics, when Lyotard himself, in what I have called elsewhere a "rare instance of 'reverse importation' in the French-American theoretical marketplace," credited his use of the term to American critics, notably to Ihab Hassan.[2]

One would not be altogether wrong to see in this displacement, whereby the French philosopher "takes the place of" all his American predecessors, a sign of what Jameson diagnosed as the absence of historical consciousness in postmodern culture—as if the memory of those who discussed postmodernism in the 1980s did not extend beyond the confines of the decade itself; or perhaps, more ironically, to see in it a sign of the snob appeal of "genuine French imports" (or what are mistakenly thought to be such) in a certain sector of American intellectual life. But if this view would not be altogether wrong, it would not be altogether right either, for although Lyotard's book did not initiate the discourse on postmodernism, it did place it on a new theoretical and philosophical footing. Most notably, it articulated the links between French poststructuralist philosophy and postmodern cultural practices (including science and everyday life as well as the arts), so that the latter could be seen—at least in the ideal sketched by Lyotard—as an instantiation of the former.

All of the concepts Lyotard invoked to define the innovative aspects of postmodern knowledge—the crisis of legitimation and the refusal of "grand narratives," the choice of models of dissent and heterogeneity over models of consensus and systemic totality, the view of cultural practices as overlapping language games with constantly shifting rules and players—are concepts grounded in poststructuralist thought, as the latter was elaborated in France in the 1960s and 1970s by Lyotard, Derrida, Foucault, and others. *The Postmodern Condition* can thus be read as a poststructuralist manifesto or "manifesto of decentered subjectivities," expressing the optimism for the future that the manifesto genre requires. Although Lyotard is aware of the nightmarish possibilities offered by the "computerization of society" (his model of postmodern knowledge invokes and seeks to generalize the new technologies and conceptualizations—such as Mandelbrot's fractals—made possible by the computer), he emphasizes instead its potentialities as a positive dream. The dream is of a society in which knowledge would consist of language games that would be "non-zero-sum games," where there would be no losers or winners, only players in a constantly evolving process; where openness would be the rule, with information and data banks available to all; where instability and "temporary contracts" would lead neither to alienation nor to anarchy, but to "a poli-

tics that would respect both the desire for justice and the desire for the unknown" (p. 67).

In short, a utopian—or cautiously utopian, if such a thing is possible— version of Babel, a positive counterargument to the pessimistic views being elaborated, during the post-1968 decade, by Jean Baudrillard. Lyotard was seeing the same things as Baudrillard but interpreting them differently: what to Baudrillard appeared as the increasingly horrifying world of simulacra evacuating the real, indeed evacuating the very concept of a *difference* between the simulacrum and the real, appeared to Lyotard—at least potentially—as a world of increasing possibilities for innovation, brought about precisely by the breakdown of stable categories like "the real." Where Baudrillard saw the "postmodern condition" (a term he did not use) as the end of all possibility for (real) action, community, resistance, or change, Lyotard saw it as potentially a whole new game, whose possibilities remained open.[3]

That difference marked one of the stakes in what was soon to become, with the entry of Jürgen Habermas into the fray, the best known version of the "modernism-postmodernism debate."[4] Since then, the debate has shifted again: What is now in question is not so much whether postmodernism constitutes a totally new development or "break" in relation to modernism (most people, it seems to me, have now accepted that as a given, even if they don't agree on all the details of why and how), but rather the current significance and future direction of the new development as such.

What does all this have to do with women or feminism? And with the earlier American discourses about postmodernism, which I accused other recent commentators of ignoring and then proceeded to ignore myself? Obviously, this is not the place to undertake a full-scale history of discourses on the postmodern.[5] Suffice it to say that, like a number of other important "isms" (romanticism, modernism, classicism), postmodernism has functioned as both a formal/stylistic category and a broadly cultural category. From the start, the most provocative discussions have been those that linked the formal or stylistic to the broadly cultural. Irving Howe's 1959 essay, for example, "Mass Society and Postmodern Fiction," which is generally credited with first use of the term "postmodern" in its current sense, saw in the emergence of a new kind of American fiction (roughly, that of the beat generation) both a stylistic sequel to modernism—exemplified by Joyce, Mann, and Kafka, as well as Hemingway and Fitzgerald—and a cultural symptom of the transformations that had occurred in Western countries after World War II.[6] A similar argument, although adopting a different, more positive judgment on these transformations and on the literature that accompanies them, was made by Leslie Fiedler a few years later; it was also suggested, again in positive terms, by Robert Venturi and Denise Scott Brown around the same time regarding architecture, in the essay that was to become the basis for their famous (or infamous) manifesto of postmodern architecture, *Learning from Las Vegas*.[7]

A few years ago, I argued that as far as literature was concerned, it made no sense to try and establish clearcut formal differences between the "modernist" and the "postmodernist," for such an attempt invariably involved oversimplification and flattening out of both categories.[8] Although I would now want to change some of the premises of that earlier argument, I still believe that the effort to define postmodernism chiefly as a formal (or even as a formal and thematic) category and to place it as such in opposition to modernism is, even when successful, of limited interest.[9] If postmodernism practice in the arts has provoked controversy and debate, it is because of what it "does" (or does not do), not because of what it "is." In other words, it is an object "to be read," an intervention in the sense of an action or a statement requiring a response, rather than as an object of descriptive poetics, that postmodernism, whether in literature or in the other arts, strikes me as significant today.

This position, whether explicitly stated or not, seems to me to be shared by all those who are currently involved in the "postmodernism debate." Where is postmodernist practice going? Can it be political?—should it be? Does it offer possibilities for opposition, critique, resistance to dominant ideologies? Or is it irremediably compromised by its complicity with the market, with mass culture, capitalism, commercialism? Familiar questions, questions that have been asked in one form or another, at one time or another, about every avant-garde movement and experimental practice since Impressionism. Which does not make them less significant when asked about postmodernism, though it suggests that no definitive answers may be forthcoming.

And women? And feminism?

It should come as no surprise, knowing what we know about earlier avant-garde movements and their historians, to learn that the first writings about postmodernism made absolutely no mention of the work of women. One could argue that if early commentators like Irving Howe and Leslie Fiedler, whose prime examples of the postmodern were the Beats (Fiedler also included Pop art in the visual arts), did not mention women's work, it was because there was little or no such work around to be mentioned at the time. Restated in terms of my argument in Chapter 1, this would mean that the Beats and the Pop artists were male avant-gardes similar to Surrealism, excluding women during their most dynamic period. In fact, there were a few women active in both movements, if not at the very beginning, then close enough to it (Diane Di Prima among the Beats, Marisol among the Pop artists). Still, as in the case of Surrealism, one can ascribe the early critics' silence not only to ordinary sexism ("not seeing" women who are there), but also to a real scarcity of women's work in those movements.

Critics who started to write about postmodernism in the 1970s or 1980s had less of an excuse for excluding the work of women; for in what I take to be a genuinely *new* (*inédit*, as they say on bookcovers in Paris) historical development, women's participation in experimental literary and visual work during those two decades reached a level, both in terms of quantity and quality, that

could no longer be ignored. Some critics, of course, even among the most brilliant, managed to ignore it, as late as the mid-1980s; others, less brilliant, went so far as to theorize its absence. (A few years ago, I received a letter from a European doctoral student who asked whether I agreed with her professor that "women have not produced any postmodernist fiction," and if so, to what I attributed that lack. I replied that the lack may have been in the beholder rather than in the object.)

In the 1980s women's work began to be mentioned, and even featured, in academic discussions of postmodernism, especially in the visual arts. Rosalind Krauss's important article, "The Originality of the Avant-Garde: A Postmodernist Repetition" (1981), which made a strong, polemically "propostmodernist" case for the difference between postmodernism and its modernist or historical avant-garde predecessors (the difference residing, according to Krauss, in postmodernism's "radical questioning of the concept of origin . . . and originality"), cited as exemplary postmodernist works the photographs of Sherrie Levine; two years earlier, in the pages of the same journal, Douglas Crimp had argued for the innovativeness (originality?) of postmodernist "pictures" and cited, among other examples, the photographs of Levine and Cindy Sherman.[10]

To discuss the work of women as part of a new movement, trend, or cultural paradigm one is defending is undoubtedly a desirable thing. As Renato Poggioli showed, every avant-garde has its critical defenders and explicators;[11] their work, in turn, becomes a basis on which the movement, once it goes beyond its "scandalous" phase, is integrated into the standard literary and cultural histories. It is quite another thing, however, to take into account not only the existence of women's work, but also its (possibly) feminine or feminist specificity; and to raise, furthermore, the question of how the specificity, whether sexual or political, of women's work within a larger movement affects one's understanding of the movement itself.

In his 1983 essay "The Discourse of Others: Feminists and Postmodernism," Craig Owens made one of those conceptual leaps that later turn out to have initiated a whole new train of thought. Simply, what Owens did was to theorize the political implications of the intersection between the "feminist critique of patriarchy and the postmodernist critique of representation."[12] He was not the first to suggest the political potential of poststructuralism (which, in the preceding sentence and in Owen's argument, is virtually interchangeable with postmodernism); the ideological critique of the "unified bourgeois subject" and of classical representation had been a continuing theme in French poststructuralist writing from the late 1960s on and had been part of the political platform of *Tel Quel* in its most revolutionary period. Nor was the linking of the feminist critique of patriarchy with poststructuralism surprising, since French feminist theory had from the beginning acknowledged its link to deconstruction and even proclaimed it in its famous portmanteau word, *"phallogocentrism."* The novelty, indeed the pathbreaking quality of Owens's essay

was that it placed the feminist issue *at the center of the debate on postmodernism* (which was also, if one wishes, a debate on poststructuralism), as that debate was unfolding in the United States (and, with a bit of delay, in England) after the publication of Lyotard's *The Postmodern Condition*.[13]

On the other hand, Owens quite rightly criticized the major players in the debate for ignoring both the "insistent feminist voice" in postmodern culture and the whole issue of sexual difference in their discussions of postmodernist practices: thus even those critics who, like Crimp, Krauss, and Hal Foster (and Owens himself, in an earlier essay), discussed women's work as an important part of postmodernist art, could be faulted for ignoring the specifically feminist—or even "feminine"—meanings of that work (pp. 73–77). On the other hand, Owens suggested that if the feminist/critical aspect of postmodernist work *was* taken into account, there would result a new and more politically sharpened view of postmodernism itself—for feminism, after all, is not only a theory or an aesthetics, it is also a politics.

By linking feminist politics with postmodernist artistic practice, Owens provided the pro-postmodernists in the debate with a precious argument, whose advantages they were quick to grasp. Feminism provided for postmodernism a concrete political edge, or wedge, that could be used to counter the accusatory pessimism of a Baudrillard or a Jameson: for if there existed a genuinely *feminist* postmodernist practice, then postmodernism could no longer be seen only as the expression of a fragmented, exhausted culture steeped in nostalgia for a lost center. Indeed, such a view of postmodernism, with its sense of irremediable decline and loss, could now itself be shown to be implicated in the Western, patriarchal logic of the "grand narratives"—the very logic that feminism, and feminist postmodernism, contested. As Hal Foster, in an essay that I read as a response to and development of Owens's argument, eloquently noted: "Here, then we begin to see what is at stake in [the] so-called dispersal of the subject. For what is this subject that, threatened by loss, is so bemoaned? For some, for many, this may indeed be a great loss, a loss which leads to narcissistic laments and hysterical disavowals of the end of art, of culture, of the west. But for others, precisely for Others, it is no great loss at all."[14]

Andreas Huyssen, around the same time, was arguing that feminism and the women's movement, together with anti-imperialism, the ecology movement, and the growing awareness of "other cultures, non-European, non-Western cultures," had created a new "postmodernism of resistance" that would "satisfy the needs of the political *and* those of the aesthetic."[15] Most recently, following up on these arguments, Linda Hutcheon has spoken of the overlapping agendas between postmodernism and "ex-centrics": blacks, women, and other traditionally marginalized groups.[16]

In short, feminism brings to postmodernism the political guarantee postmodernism needs to feel respectable as an avant-garde practice. Postmodernism, in turn, brings feminism into a certain kind of "high theoreti-

cal" discourse on the frontiers of culture, traditionally an exclusively male domain.[17]

If this summary sounds cynical, the effect is only partly intended. There is, I believe, an element of mutual opportunism in the alliance of feminists and postmodernists, but it is not necessarily a bad thing. The opportunism operates not so much, or perhaps not at all, in the actual practice of feminist postmodernist artists, but rather in the public discourse about that practice: influential critics who write about the work of feminist postmodernists, especially in the realm of the visual arts, are both advancing their own reputations as "high theorists" and contributing to—or even creating—the market value of those artists' work, while other, less fashionable feminist work may go unnoticed. And once it becomes valuable on the market, the feminist postmodernist work may lose its critical edge.

This is not a new problem, as I have already suggested and will suggest again. In a world in which everything, even the discourse of high postmodernist theory, has an exchange value, should one reject the advantages of the feminist-postmodernist alliance for the sake of an ideal of aesthetic or intellectual purity? If every avant-garde has its public defenders and promoters, why not feminist postmodernism?

Oh dear, oh dear, now I do sound excessively cynical. Let me therefore quickly affirm that I take the theoretical arguments advanced by Owens, Foster, Huyssen, and Hutcheon in favor of the feminism-postmodernism alliance extremely seriously, and indeed subscribe to them (mostly); that I believe it is important to look for the critical and political possibilities of avant-garde practices in general, and of postmodernism in particular; and that I think women and feminists rightfully belong in the center of such discussions and practices—in the middle of the margin, as it were.[18] As I said earlier, with postmodernism we have arrived at a totally new situation for women artists: for the first time in the history of avant-gardes (or in history *tout court*), there exists a critical mass of outstanding, innovative work by women, both in the visual arts and in literature.[19] Simone de Beauvoir's complaint, in *The Second Sex*, that women artists lacked genius—that is, the audacity to take real risks and to carry "the weight of the world on their shoulders"—is no longer true, if it ever was. Today, thanks in part to the existence of predecessors like Beauvoir, there are women artists who possess genius in her sense—*and* who are aware at the same time that "genius," like every other abstract universal category, is determined by particulars: race, sex, nationality, religion, history. As Christine Brooke-Rose has recently noted, "genius" has the same Indo-European root as gender, genre, and genesis.[20]

Still, it would be unwise to celebrate postmodernism, even more so feminist postmodernism, without keeping one's ears open to dissenting voices, or without acknowledging things that don't "fit." Feminist postmodernism, like postmodernism in general, must confront anew some of the dilemmas that have plagued every successful avant-garde for the past century or more: the

dilemma of political effectiveness versus stylistic indirection and innovation, numbingly familiar to students of the 1930s; or the dilemma of the market and the avant-garde's relation to mass culture, which dominated, as Andreas Huyssen has shown, the "Greenberg and Adorno decades" after World War II. In addition, feminist postmodernism must confront the specific questions and challenges posed to it from within the feminist movement, notably as concerns the political status of the "decentered subject."

Not a short order, in sum. Enough to fill another whole book, in fact. But I shall fill only a few more pages, with thoughts and notes for future reflection and work, whether by me or others.

Opposition in Babel? The Political Status of Postmodern Intertextuality

Then I shall enter with my hypotheses and sweep the detritus of civilization.
—CHRISTINE BROOKE-ROSE, *AMALGAMEMNON*

The vital thing is to have an alternative so that people will realise that there's no such thing as a true story.
—JEANETTE WINTERSON, *BOATING FOR BEGINNERS*

The appropriation, misappropriation, montage, collage, hybridization, and general mixing-up of visual and verbal texts and discourses, from all periods of the past as well as from the multiple social and linguistic fields of the present, is probably the most characteristic feature of what can be called the "postmodern style." The question, as it has emerged in the debate on postmodernism, is: Does this style have a critical political meaning or effect, or is it—in Fredric Jameson's words—merely "blank parody," a "neutral practice" devoid of any critical impulse or historical consciousness?

Having extolled the virtues—including the political/critical virtues—of feminist irony and parody, I do not need to restate my own position. Nor is it necessary to reformulate the arguments over the political effects of "carnivalized" discourse. (Note that the affair of *The Satanic Verses* has confirmed the complicated status of carnival: what may appear as simply one more case of "authorized transgression," immediately recuperable or ignorable by the system, can, under certain circumstances, take on a life-threatening seriousness; which means that the political and ideological effects of carnival, or of the language games that correspond to it, can never be totally controlled or foreseen.) It will be useful, however, to consider the question again from a theoretical perspective, not as a prelude to a single interpretive reading.

What does it mean to talk about the political effect of a novel or painting or photograph? If one means that in a particular historical circumstance an artwork can be used for political ends, well and good: Picasso's "Guernica," exhibited in major European and American capitals between 1937 and 1939,

earned a lot of sympathy as well as material support for the Spanish Republic before coming to rest for a few decades in the Museum of Modern Art. If one means that the work elicits a political response, whether in the form of public commentaries or private reactions, including the production of other art works that build on it ("Guernica" is again a good example), that is also well and good.[21] What seems to me wrongheaded, or at the very least problematic, is talking about the political effect or meaning of a work—especially of a self-conscious, insistently intertextual, often multiply ironic work—as if that meaning were clear, immutable, and immanent to the "text," rather than determined by its interpretive context.

Political readings—indeed, all interpretations—tend to speak of works as if their meanings and effects were immanent; to convince someone else of the validity of one's reading, one has to claim, or at least imply, that it is the best reading, the reading most closely corresponding to the "work itself." When Jameson made his often-quoted claim that postmodern pastiche "is a neutral practice of . . . mimicry, without any of parody's ulterior motives, amputated of the satiric impulse, devoid of laughter and of any conviction that . . . some healthy linguistic normality still exists," implicit in the claim (which was used to support his general argument that postmodernism lacked authentic historical awareness) was the assumption that works of art determine their own meaning and reading. Linda Hutcheon, who strongly criticizes Jameson for not citing any examples, offers many examples of her own to show that postmodern parody does *not* lack the "satiric impulse" and is not apolitical or ahistorical. She is no doubt justified in her critique; but as the very act of citing counterexamples shows, she shares Jameson's assumption that political meanings reside in works, not in their readings.

I assumed the same thing, or acted as if I did, in my reading of, say, Carrington's *The Hearing Trumpet*. But precisely in the case of *The Hearing Trumpet* I also tried to suggest that how a work is read depends very much on who is reading it, when, and to what ends. My own reading, clearly situated in the late 1980s and almost unimaginable at the time the novel was written (the early 1950s), was determined by a particular set of ideological preoccupations, as well as by my appreciation of a certain kind of formally complex, humorous, feminist, postmodernist narrative fiction—a category I *constructed* and in which I placed the novel, not in which it necessarily or eternally belongs. It must be noted, furthermore, that my own reading, although individual, can be shown to be part of a collective discourse. As Stanley Fish and other theorists of "reader-oriented criticism" have argued, reading is a *shared* activity; every reading, no matter how personal or original (or "quirky") can be analyzed historically and ideologically as characteristic of a group, or what Fish has called an interpretive community.[22] To be part of an interpretive community, one does not need a membership card; it is a matter of having learned, in the classroom or through scholarly exchange, or through more informal modes of communication, certain shared ways of approaching a text: asking certain ques-

tions of it, and elaborating a language and an interpretive "strategy" for answering them.

Displacing the political effect from the work to its reading has the advantage of moving the debate from the question of what postmodernism "is" to the question of what it does—in a particular place, for a particular public (which can be a public of one, but as I have just suggested, every individual is part of a larger interpretive community) at a particular time. That displacement does not, however, alter the basic questions about the politics of intertextuality or of irony, or more generally about the relation between symbolic action and "real" action in the world. It merely . . . displaces them, from the work to its readings and readers.

Jameson, reading postmodernist intertextuality as an expression of advanced capitalism, "a field of stylistic and discursive heterogeneity without a norm," calls it "blank parody, a statue with blind eyeballs" (p. 65). But postmodernist intertextuality (is it the "same" one?) can also be thought of, for example in the British artist Mary Kelly's terms, as a sign of critical commitment to the contemporary world. According to Kelly, this commitment distinguished British postmodernist art of the 1970s and early 1980s from its American counterpart: whereas the Americans merely "purloined" previous images and "pilfered" the contemporary world's "cultural estate," the British were "exploring its boundaries, deconstructing its centre, proposing the decolonisation of its visual codes and of language itself."[23]

It is not clear from Kelly's comparison how one can distinguish, objectively, "mere pilfering" from political deconstruction and decolonization. Similarly, Jameson's recent attempt to distinguish the "ahistorical" postmodernism he deplores from its "homeopathic critique" in the works of E. L. Doctorow, works he admires and finds salutary, strikes me as dubitable at best.[24] So, for that matter, do all the other attempts that have been made to distinguish a "good" postmodernism (of resistance) from a "bad" postmodernism (what Lyotard calls the "anything goes" variety).[25]

It seems a good bet that almost any given work can be shown to belong to either of those categories, depending on how one reads it. Cindy Sherman's early work, the series of "Untitled Film Stills" from nonexistent Hollywood films, which the artist interprets as being "about the fakeness of role playing as well as contempt for the domineering 'male' audience who would read the images as sexy,"[26] and which some critics have read in those terms as a form of feminist ironic critique, have been read by other critics as works that play up to the "male gaze" for the usual profit: "the work seems a slicked-up version of the original, a new commodity. In fact, much of this work has proved quite salable, easy to show, easy to write about, easy to sell."[27] Even the "Third World" and "women of color," those brave new banners under which (together with feminism) the postmodernism of resistance has sought its political credentials, can be shown, if one is so inclined, to be caught up in the logic of the simulacrum and in the economics of multinational capitalism. In today's world,

one can argue, there are no more places *outside*; the "Third World" too is part of the society of the spectacle.

Perhaps it all comes down, in the end, to how one understands Christine Brooke-Rose's evocative phrase about "sweeping the detritus of civilization." Does (can?) the sweeper hope to *clear* the detritus, or is she merely making new patterns with it and thus adding to the heap? And if the latter, should the sweeper put away her broom?

Yet another twist: If postmodernist intertextuality can be read both ways, that fact itself is open to interpretation. For Linda Hutcheon, it proves that postmodernist works are ambivalent and contradictory, "doubly encoded," and that they therefore constitute not a "break" but a "challenge to culture from within."[28] For Craig Owens, it proves that postmodernism is the true art of deconstruction, for it recognizes the "unavoidable necessity of participating in the very activity that is being denounced precisely in order to denounce it."[29] But one could call this apology for postmodernism itself part of a strategy of "anything goes," with the added proviso: "as long as I recognize that I am not innocent." This was already, in an ethical and existential perspective, the strategy of Camus's "penitent judge" in *La Chute* (1956): Clamence is more than willing to admit his own guilt, as long as it allows him to denounce everyone else. But Clamence is not exactly an admirable character.

And so it goes—the twists may be unending.

Does that mean we should no longer play?

Martha Rosler, who calls her work "didactic" but not "hortatory," and whom critics consider a political postmodernist, worries that if the ironic work is not "derived from a process of politicization, although it claims a politics," it will simply end up in the art-critical establishment, where even feminist work—which *has* been affiliated with a politics—may become no more than "just a competing style of the sixties and seventies . . . outdated by fashion."[30] I recognize in Rosler's worry the outlines of two old but apparently inexhaustible arguments: can art which claims an oppositional edge take the risk of entering a museum? Can it afford to be negative and individualistic, rather than offering a positive, collective "alternative vision" of "how things might be different"? (p. 72).

Related to these arguments is the question of the symbolic versus the real. Meaghan Morris recently criticized the facile uses that apologists for postmodernism have made of the verb "appropriate": "It outrages humanist commitments, adds a little *frisson* of impropriety and risk by romanticizing as violation the intertextual *sine qua non* of all cultural activity, and semantically guarantees a politics to practitioners by installing predation as the universal rule of cultural exchange. . . . All energies become seizures and we all get a piece of the action."[31] Morris's critique is both humorous and apt: it *is* too easy to endow metaphorical appropriation with the power of real takeovers, and one *should* look for connections between "the politics of culture and the politics of politics" (p. 125). One should also, however, not belittle the value of symbolic

interventions in the field of the real. Is it necessary to belabor the fact that language is part of the world (the "real world") and plays a nonnegligible part in shaping both our perceptions of it and our actions in it?

And then there are those who believe only a certain kind of "real" can be political. Laura Kipnis, who identifies herself as a video artist and critic, dismisses all "first-world" writing that is not concerned with immediate political action—for example, French feminist theory—as an elitist luxury. "Real shifts in world power and economic distribution have little to do with *jouissance*, the pre-Oedipal, or fluids," she notes sarcastically.[32] (Sarcasm, as we know, is not to be confused with "blank" postmodern pastiche.) For Kipnis, if I read her right, the true postmodernist critique is an act of international terrorism in which "retaliation is taken, as has been announced, for 'American arrogance' "; and a truly new form of political struggle, which the West in its blindness has not recognized, is one "in which civilian tourists are held responsible for the actions of their governments" (p. 163).

This position, for all its hard-nosed charm, strikes me as too close for comfort to the murderous anti-intellectualism of commissars and other ayatollahs—or, since Kipnis is neither, to the traditional self-hatred of intellectuals who dream of getting their hands dirty.

Jeanette Winterson's *Boating for Beginners* is an outrageously blasphemous rewriting of the flood story from *Genesis*. It is also very funny. Has it escaped the censorious eyes of those who picket Scorsese's *Last Temptation of Christ* because it is "only a novel," by an author who is not a household name? Or because it is not "serious"? And yet, what could be more serious than the realization (if indeed it is true) that "there is no such thing as a true story"?

Postmodernism for postmodernism, politics for politics, I'd rather be an ironist than a terrorist.

To Market, To Market: Oppositional Art in Mass Culture

The whole world is constrained to pass through the filter of the culture industry. —MAX HORKHEIMER and THEODOR ADORNO,
 DIALECTIC OF ENLIGHTENMENT

Horkheimer and Adorno's pessimistic analysis of the power of the culture industry has become so much a part of contemporary intellectual discourse (to the point that it is almost itself a cliché, part of an anonymous "general wisdom") that one may wonder whether there is any new way to conceptualize the relation between authentic art and degraded entertainment, or between genuine thought and the manipulated thought-control of advertising and the mass media.[33] It is not that their argument hasn't been criticized for its elitism—it has been, by Andreas Huyssen among others. Futhermore, it can be criticized as a "grand narrative," explaining all of contemporary culture in terms of a

single paradigm: the culture industry, in their analysis, appears to be a mono-
lithic mechanism whose effects are omnipresent and inescapable.

Yet, the argument still has power it is hard to get around. One possible
conclusion to which their analysis leads has been stated by Thomas Crow, con-
cerning the deep logic of innovative art since the mid-nineteenth century: "the
avant-garde serves as a kind of research and development arm of the culture
industry."[34] According to Crow (whose rich and complex argument would be
worth following in detail), there exists a predictable pattern from Impression-
ism on, in which the avant-garde "appropriates" certain dynamic oppositional
practices from "below," from marginal groups or subcultures (here Crow dif-
fers significantly from Horkheimer and Adorno); these practices, transformed
into avant-garde invention, become, after a moment of productive tension
between the "high" and the "low" (or between the oppositional and the institu-
tional), simply a part of high art, but are eventually "recuperated" by the cul-
ture industry and returned to the lower zone of mass culture—in a form,
however, where the avant-garde invention is "drained of its original force and
integrity" (p. 258). This cycle, alternating between "moments of negation and
an ultimately overwhelming recuperative inertia" (p. 259), accounts for the
chronically problematic status of avant-garde art movements, which claim to
want to have a real effect in the world but are always, in the end,
"domesticated."

What hope is there for postmodernism, and specifically for feminist
postmodernism, as an oppositional avant-garde practice? Quite possibly, not
much—or not more than for previous avant-gardes. But that does not mean
that the attempt is not worth making. Rozsika Parker and Griselda Pollock
suggest that "feminism explores the pleasures of resistance, of deconstruction,
of discovery, of defining, of fragmenting, of redefining."[35] Is it possible that
such pleasures can be experienced by more than a privileged few and still
maintain their critical charge? I think it is significant that a number of politi-
cally motivated experimental women artists working today have found some
unexpected ways to *use* technologies associated with the culture industry.[36]
Jenny Holzer's use of electronic signs in airports and other public places—such
as the Spectacolor Board in Times Square, which flashed her message in huge
letters (part of a series titled "Truisms"): PRIVATE PROPERTY CREATED CRIME—
is one well-known example. Barbara Kruger, who has used billboards to dis-
play (and occasionally to transform into political posters) some of her photo-
graphs, usually shown in galleries and museums, has also used the Spectacolor
Board, to display the message: I AM NOT TRYING TO SELL YOU ANYTHING.[37]

In an interview in 1985, Holzer explained: "My work has been designed
to be stumbled across in the course of a person's daily life. I think it has the
most impact when someone is just walking along, not thinking about anything
in particular, and then finds these unusual statements either on a poster or on
a sign."[38] In the same interview, Holzer mentioned her discovery that "televi-
sion is not prohibitively expensive. . . . You can buy 30 seconds in the middle

of *Laverne & Shirley* for about seventy-five dollars, or you can enhance the *CBS Morning News* for a few hundred dollars. The audience is all of Connecticut and a little bit of New York and Massachusetts, which is enough people" (p. 297). Barbara Kruger, in turn, has stated that she works "with pictures and words because they have the ability to determine who we are, what we want to be, what we become."[39] While harboring no illusions about the alienating effects of television ("TV is an industry that manufactures blind eyes"), Kruger, like Holzer, seeks new ways to *use* it: for her, it is in the very "site of the stereotype," characteristic of TV representations, that "the rules of the game can be changed and subtle reformations can be enacted" (p. 304).

The hope expressed in such statements is that it is possible to find openings even in the monolithic mechanism of the culture industry; that it is possible for innovative, critical work to reach a large audience without passing through the "upward and downward" cycle analyzed by Crow, where what reaches the mass public is always already "evacuated cultural goods," deprived of force and integrity.

I am sure there must exist arguments to deflate this hope. But I will not look for them here.

Of Cyborgs and (Other) "Women": The Political Status of Decentered Subjects

What kind of politics could embrace partial, contradictory, permanently unclosed constructions of personal and collective selves and still be faithful, effective—and, ironically, socialist feminist?
 —DONNA HARAWAY, "A MANIFESTO FOR CYBORGS"

The question asked by Donna Haraway sums up, as well as any could, what is at stake in the feminist embrace, but also in the feminist suspicion, of postmodernism.[40] Haraway, proposing the technological cyborg as an "ironic political myth" to take the place of earlier, naturalistic myths of the goddess, celebrates the postmodernist model of "identity out of otherness and difference"; she proclaims herself antiessentialist, antinaturalist, antidualist, antimaternal, utopically "for a monstrous world without gender" (p. 100). All of this ironically, and politically to boot.

Next to such inventiveness, those feminists who want to hang on to a notion of feminine specificity may look (in Naomi Schor's ironic self-characterization) like "wallflowers at the carnival of plural sexualities."[41] But the differences between worshippers of the goddess and celebrants of the cyborg may themselves need to be put into question.

"If authenticity is relational, there can be no essence except as a political, cultural invention, a local tactic," writes James Clifford.[42] Which makes me think that sometimes it is politic to "be" a goddess, at other times a cyborg—

and at still other times, a laughing mother or an "alone-standing woman"[43] who sweeps the detritus of civilization.

Julia Kristeva's latest book, an exploration of what it means to be "foreign," recently reached the bestseller list in France—a country, Kristeva writes, which is both the best and the worst place to be an *étranger*. It is the worst, because the French consider everything that is not French "an unpardonable offense to universal taste";[44] it is the best, because (as Kristeva, being herself one, knows) in France a foreigner is a constant object of fascination, loved or hated, never ignored.

Of course it makes a difference (nor would Kristeva suggest otherwise) whether one feels loved or hated. It also makes a difference if one is actively persecuted for being "different." Still, for yet another ironic myth, I feel much drawn to her evocation of the "happy cosmopolitan," foreign not only to others but to him- or herself, harboring not an essence but a "pulverized origin." Such a person "transmutes into games what for some is a misfortune and for others an untouchable void" (p. 57). Which may not be a bad description of a feminist postmodernist.

As for politics, I don't hesitate to make my own ("appropriate" is the word) a message I recently found on a card sold at the Centre Georges Pompidou. The card is by Jamie Reid, the British artist whose work appeared on posters and jacket covers for the short-lived punk rock group the Sex Pistols. I bought it at the Paris opening of the exhibition on Situationism, a revolutionary movement of the 1960s that spurned museums (their chief spokesman was Guy Debord—he was not at the opening). Some of Reid's other work, ironic and anti-Thatcher, is shown in the exhibit.

The card is quite expensive, as cards go, and comes wrapped in cellophane; it is sold only in the museum. The picture on the cover shows Delacroix's *Liberty Leading the People,* against a background formed by four tilted modernist skyscrapers. The message reads (not exactly in this order): "Live in the Present. Learn from the Past. Look to the Future."

Notes

1. François Lyotard, *La Condition postmoderne: Rapport sur le savoir* (Paris: Editions de Minuit, 1979). English translation: *The Postmodern Condition: A Report on Knowledge*, trans. Geoff Bennington and Brian Massumi (Minneapolis: University of Minnesota Press, 1981); hereafter, page numbers are given in parentheses in the text.

2. Suleiman, "Naming and Difference: Reflections on 'Modernism *versus* Postmodernism' in Literature," in *Approaching Postmodernism*, ed. Douwe Fokkema and Hans Bertens (Amsterdam and Philadelphia: John Benjamins, 1986), p. 255. As I note in that essay, the first footnote in Lyotard's book cites Hassan's *The Dismemberment of Orpheus: Toward a Post Modern Literature* (New York: Oxford Univeristy Press, 1971) as a source for his use of the term "postmodern"; in the introduction, Lyotard justifies his choice of "postmodern" to characterize "the condition of knowledge in the most highly developed societies" by noting that "the word is in current use on the American continent among sociologists and critics" (*The Postmodern Condition*, p. xxiii).

Recent works on postmodernism that use Lyotard as an obligatory reference and make virtually no mention of any work before his on the subject include: *Universal Abandon? The Politics of Postmodernism*, ed. Andrew Ross (Minneapolis: University of Minnesota Press, 1988); *Postmodernism and Its Discontents*, ed. E. Ann Kaplan (London: Verso, 1988); "Modernity and Modernism, Postmodernity and Postmodernism," special issue of *Cultural Critique*, no. 5 (Winter 1986–87); "Postmodernism," special issue of *Social Text*, no. 18 (Winter 1987–88). This may be a specifically American, or Anglo-American, phenomenon; Richard Martin informs me that in Germany, where he teaches, Lyotard's book is known but Hassan's work remains the starting reference. I wish to thank Richard Martin, as well as Bernard Gendron, Ingeborg Hoesterey, and Mary Russo, for their careful reading and useful criticisms of this essay.

3. Lyotard situates himself explicitly in opposition to Baudrillard early on in *The Postmodern Condition*, when he notes that the "breaking up of the grand Narratives . . . leads to what some authors analyze in terms of the dissolution of the social bond and the disintegration of social aggregates into a mass of individual atoms thrown into the absurdity of Brownian motion. Nothing of the kind is happening: this point of view, it seems to me, is haunted by the paradisaic representation of a lost 'organic' society" (p. 15). Although he does not name Baudrillard in the text, Lyotard footnotes Baudrillard's 1978 book, *A l'ombre des majorités silencieuses*, as the one example of the analyses he is contesting here. Baudrillard's theory of the simulacrum, to which I referred, dates from 1975: *L'Echange symbolique et la mort* (Paris: Editions Gallimard). This theory is much indebted to Debord's theory of the "society of the spectacle," which dates from just before 1968 (Guy Debord, *La Société du spectacle* [Paris: Buchet-Chastel, 1967]). In 1988 Debord published a short commentary on his earlier book, which reiterates and reinforces his earlier pessimistic analyses. See his *Commentaries sur la société du spectacle* (Paris: Gérard Lebovici, 1988).

4. Habermas's contribution to the debate was the now famous essay, "Modernity—An Incomplete Project" (1981), reprinted in *The Anti-Aesthetic: Essays on Postmodern Culture*, ed. Hal Foster (Port Townsend, Wash.: Bay Press, 1983) pp. 3–15. Habermas criticized all those, including the French poststructuralists (whom he called "anti-modernist young conservatives"), who argued for a "break" with the "modernist" project of the Enlightenment. Habermas does not seem to have been responding here to Lyotard's book (the essay does not mention Lyotard), and he did not link postmodernism to poststructuralism. Lyotard, however, responded to Habermas in his 1982 essay "Réponse à la question: Qu'est-ce que le postmoderne?" which appears in English as an appendix to *Postmodern Condition*. It was after that essay that the version of the "modernism-postmodernism" debate associated with the names of Lyotard and Habermas reached full swing. There are other versions of the debate as well. For an American response specifically to this debate, see Richard Rorty, "Habermas and Lyotard on Postmodernity," in *Habermas and Modernity*, ed. Richard J. Bernstein (Cambridge, Mass.: MIT Press, 1985), pp. 161–175.

5. For a somewhat useful historical overview (as of about 1985), see Hans Bertens, "The Postmodern *Weltanschauung* and Its Relation with Modernism: An Introductory Survey," in *Approaching Postmodernism*, ed. Fokkema and Bertens, pp. 9–51. My essay in the same volume, "Naming and Difference," distinguishes various discourses on the postmodern in terms of their founding impulse: ideological, diagnostic, or classificatory.

6. Irving Howe, "Mass Society and Postmodern Fiction," in *The Decline of the New* (New York: Harcourt, Brace and World, 1970); first published in *Partisan Review* in 1959. The term "postmodernismo" was, it appears, already used in Spain by Federico de Onis in 1934; however, its meaning was quite different. See John Barth, "Postmodernism Revisited," *The Review of Contemporary Fiction*, 8, no. 3 (Fall 1988), 18.

7. Leslie Fiedler, "The New Mutants" (1965), reprinted in *Collected Essays*, vol. 2 (New York: Stein and Day, 1971), pp. 379–400; Robert Venturi, Denise Scott Brown, and Steven Izenour, *Learning from Las Vegas: The Forgotten Symbolism of Architectural Form*, revised edition (Cambridge, Mass.: MIT Press, 1988 [original ed. 1977]). In the Preface to the First Edition, Brown and Venturi cite their 1968 article "A Significance for A&P Parking Lots, or, Learning from Las Vegas," as the basis for the book.

8. Suleiman, "Naming and Difference."

9. The most successful effort of this kind so far is, I believe, Brian McHale's *Postmodernist Fiction* (New York and London: Methuen, 1987). Describing his work as an example of "descriptive poetics," McHales makes no attempt to link postmodernist fiction to contemporary cultural issues—indeed, he concludes that postmodernist fiction, like all significant literature, treats the "eternal themes" of love and death. Within its self-imposed formalist parameters, I find McHale's criterion for distinguishing modernist from postmodernist fiction (the former being dominated by epistemological issues, the latter by ontological ones) extremely interesting, and his detailed readings of postmodernist works in terms of the ontological criterion suggestive and persuasive.

10. Rosalind Krauss, "The Originality of the Avant-Garde: A Postmodernist Repetition," *October*, 18 (Fall 1981), 47–66; Douglas Crimp, "Pictures," *October*, 8 (Spring 1979), 75–88, both reprinted in *Art after Modernism: Rethinking Representation*, ed. Brian Wallis (New York and Boston: The New Museum of Contemporary Art and David R. Godine, 1984). Among literary critics, Brian McHale has included some discussion of the work of women, notably Angela Carter and Christine Brooke-Rose, in his *Postmodernist Fiction*, without, however, raising the question of sexual difference. Ihab Hassan, in the new Postface to the second edition of *The Dismemberment of Orpheus*, cites Brooke-Rose's name in some of his postmodernist lists (she was not cited in the first edition, 1971). The only general study of postmodernist writing to date that discusses women's work (along with that of other marginal groups) and also makes some attempt to take into account its political specificity is Linda Hutcheon's *A Poetics of Postmodernism: History, Theory, Fiction* (New York and London: Routledge, 1988).

11. Poggioli, *The Theory of the Avant-Garde* (Cambridge, MA: Harvard University Press, 1981), chaps. 5 and 8.

12. Craig Owens, "The Discourse of Others: Feminists and Postmodernism," in *The Anti-Aesthetic: Essays on Postmodern Culture*, ed. Hal Foster, (Port Townsend, Wash.: Bay Press, 1983), p. 59; hereafter, page numbers are given in parentheses in the text.

13. See n. 8 above. The most explicit linking of postmodernism and poststructuralism in the debate was made by Terry Eagleton, in his highly negative Marxist critique, "Capitalism, Modernism, and Postmodernism," *New Left Review*, 152 (1985), 60–73.

14. Hal Foster, "(Post)Modern Polemics," in *Recodings: Art, Spectacle, Cultural Politics* (Seattle: Bay Press, 1985), p. 136.

15. Andreas Huyssen, "Mapping the Postmodern," in *After the Great Divide: Modernism, Mass Culture, Postmodernism* (Bloomington: Indiana University Press, 1986), pp. 219–221.

16. Hutcheon, *A Poetics of Postmodernism*, chap. 4.

17. It is true, as Richard Martin reminds me, that some feminists are critical of this "high theoretical" discourse (or of any theoretical discourse closely associated with a male tradition) and would just as soon not participate in it. That raises a whole number of other questions regarding alliances and dialogue between men and women, which I will not attempt to deal with here. My own position on these questions should be clear enough by now; my favoring of dialogue and "complication" over separatist and binarist positions is explicitly argued in Chapters 4, 6, and 7.

18. The same argument can be made (as Linda Hutcheon's grouping together of "ex-centrics" and Huyssen's and Foster's use of the concept "Others" shows) for the alliance between postmodernism and "Third World" minorities or Afro-American writers, male and female. Many black American critics (Henry Louis Gates comes especially to mind) have recognized the similarity of concerns and of analytic concepts between feminist criticism and Afro-American criticism. The links between Afro-American writing and postmodernism have also been recognized, notably in the novels of Ishmael Reed. Black women writers, however, have rarely been called postmodernists, and even less feminist postmodernists. A case can be made for considering Toni Morrison and Ntozake Shange (among others) "black women feminist postmodernists." But the question of priorities (race or gender?) remains.

19. To be sure, there were a number of important women writers and artists associated with Anglo-American modernism and other earlier movements who were ignored or belittled by male critics, as recent feminist scholarship has shown. And as I argued in Chapter 1, there are significant historical and national differences that must be taken into account when discussing

the participation of women in avant-garde movements. My sense is, however, that none of the early movements had the *critical mass of outstanding, innovative work by women, both in the visual arts and in literature* (the phrase is worth restating and underlining) that exists today.

Is naming names necessary? Here, for the doubtful, is a partial list of outstanding English and American women artists working today, who can be (and at some time or other have been) called feminist postmodernists: In performance, Joanne Akalaitis, Laurie Anderson, Karen Finley, Suzanne Lacy, Meredith Monk, Carolee Schneemann; in film and video, Lizzie Borden, Cecilia Condit, Laura Mulvey, Sally Potter, Yvonne Rainer, Martha Rosler; in photography and visual arts, Jenny Holzer, Mary Kelly, Barbara Kruger, Sherrie Levine, Cindy Sherman, Nancy Spero; in fiction, Kathy Acker, Christine Brooke-Rose, Angela Carter, Rikki Ducornet, Emily Prager, Jeanette Winterson. (See also n. 18.) I thank Elinor Fuchs, Heidi Gilpin, and Judith Piper for sharing their expertise with me about women in postmodern performance. For more on contemporary women performers and visual artists, see the exhibition catalogue (which bears out my point about critical mass) *Making Their Mark: Women Artists Move into the Mainstream, 1970–1985* (New York: Abbeville Press, 1989).

20. Christine Brooke-Rose, "Illiterations," in *Breaking the Sequence: Women's Experimental Fiction*, ed. Ellen G. Friedman and Miriam Fuchs (Princeton: Princeton University Press, 1989), p. 59.

21. For an excellent collection of responses to "Guernica" and a clear exposition of its history as a "political" painting, see Ellen C. Oppler, ed., *Picasso's Guernica: Illustrations, Introductory Essay, Documents, Poetry, Criticism, Analysis* (New York: Norton, 1988).

22. Stanley Fish, *Is There a Text in This Class? The Authority of Interpretive Communities* (Cambridge, Mass.: Harvard University Press, 1980). For an overview of theories of reading, see my introductory essay, "Varieties of Audience-Oriented Criticism," in *The Reader in the Text*, ed. Suleiman and Crosman, pp. 3–45.

23. Mary Kelly, "Beyond the Purloined Image" (essay on a 1983 London exhibition with the same title, curated by Kelly), quoted in Rozsika Parker and Griselda Pollock, "Fifteen Years of Feminist Action: From Practical Strategies to Strategic Practices," in *Framing Feminism: Art and the Women's Movement, 1970–85* (London and New York: Pandora Press, 1987), p. 53. Aside from the excellent introductory essays by Parker and Pollock, this book offers a rich selection of written and visual work by women involved in various British feminist avant-garde art movements of the seventies and early eighties.

24. See Anders Stephanson, "Regarding Postmodernism—A Conversation with Fredric Jameson," in *Universal Abandon? The Politics of Postmodernism*, ed. Andrew Ross, pp. 3–30. Jameson suggests that Doctorow's works offer the possibility "to undo postmodernism homeopathically by the methods of postmodernism: to work at dissolving the pastiche by using all the instruments of pastiche itself, to reconquer some genuine historical sense by using the instruments of what I have called substitutes for history" (p. 17). The question Jameson does not answer (or raise) is: How does one tell the "fake" (homeopathic) postmodernist pastiche from the "real" one—which is itself a "fake," a substitute for history? The play of mirrors here may strike one as quite postmodernist . . .

25. François Lyotard, "Answering the Question: What Is Postmodernism?" trans. Régis Durand, in *The Postmodern Condition*, p. 77. Huyssen picks up the distinction in *Mapping the Postmodern*, p. 220. See also Foster, "(Post)Modern Polemics," in *Recodings*.

26. See Sherman's interview with Jeanne Siegel, in *Artwords 2: Discourse on the Early 80's*, ed. Siegel (Ann Arbor and London: UMI Research Press, 1988), p. 272.

27. Martha Rosler, "Notes on Quotes," *Wedge*, 2 (Fall 1982), 71. Rosler does not refer to anyone by name, but her critique appears clearly to be directed at the work of Kruger, Levine, and Sherman.

28. Hutcheon, *A Poetics of Postmodernism*, p. xiii and passim.

29. Craig Owens, "The Allegorical Impulse: Toward a Theory of Postmodernism," in *Art after Modernism*, ed. Brian Wallis, p. 235.

30. Rosler, "Notes on Quotes," pp. 72, 73; hereafter, page numbers are given in parentheses in the text. Rosler's characterization of her work as didactic but not hortatory is in an interview with Jane Weinstock, *October*, 17 (Summer 1981), 78.

31. Meaghan Morris, "Tooth and Claw: Tales of Survival and *Crocodile Dundee*," in *Universal Abandon?* ed. Andrew Ross, p. 123; hereafter, page numbers are given in parentheses in the text.

32. Laura Kipnis, "Feminism: The Political Conscience of Postmodernism?" in *Universal Abandon?* ed. Ross, p. 162; hereafter, page numbers are given in parentheses in the text.

33. Max Horkheimer and Theodor W. Adorno, "The Culture Industry: Enlightenment as Mass Deception," in *Dialectic of Enlightenment*, trans. John Cumming (New York: Continuum, 1982), pp. 120–167.

34. Thomas Crow, "Modernism and Mass Culture in the Visual Arts," in *Pollock and After*, ed. Francis Frascina (New York: Harper and Row, 1985), p. 257; hereafter, page numbers are given in parentheses in the text. I wish to thank Bernard Gendron for bringing this essay, in particular the remark I have quoted about the avant-garde and the culture industry, to my attention.

35. Rozsika Parker and Griselda Pollock, "Fifteen Years of Feminist Action: From Practical Strategies to Strategic Practices," in *Framing Feminism*, ed. Parker and Pollock, p. 54.

36. Women postmodernists are not the only ones to have practiced a kind of public intervention, of course; among men doing comparable things, Hans Haacke and Daniel Buren come to mind (though Buren's work questions more the politics of museums than the "politics of politics"). Nor is all of the political work by women exclusively feminist. These considerations do not invalidate any general point; rather, they enlarge it. For an interesting recent reflection on the critical possibilities of postmodernist art, which on several points intersects my own argument, see Abigail Solomon-Godeau, "Living with Contradictions: Critical Practices in the Age of Supply-Side Aesthetics," in *Universal Abandon?* ed. Ross, pp. 191–213.

37. Kruger refers to her use of billboards and the Times Square Spectacolor Board in her interview with Jeanne Siegel, "Barbara Kruger: Pictures and Words," in *Artwords 2*, ed. Siegel, pp. 299–311. In personal conversation with me, Kruger explained that she herself pays for all of the billboard and poster work; the abortion-march poster ("Your Body Is a Battleground,") is being made into postcards and T-shirts with proceeds going to Planned Parenthood. As Kruger is the first to point out, it is *because* she has a "name" in the artworld (she is represented by the highly visible, high-priced Mary Boone Gallery) that she is able to put up her billboards and posters. The idea that art should try to remain "pure," outside the circuits of the market, is, she stated, quite foreign to her—as, for that matter, is the idea of belonging to "the avant-garde," which she associates with elitism. I pointed out that the desire to bypass the elitist connotations of art and to intervene with her work in the real world is precisely what makes her work, in *my* terms, "avant-garde." She, I must report, remained skeptical. But then, she is also skeptical about being called "postmodernist." We finally agreed that if it is the artist's prerogative to reject all critical labels, it is the critic's or theorist's prerogative to invent them.

38. Holzer, interview with Jeanne Siegel, "Jenny Holzer's Language Games," in *Artwords 2*, ed. Siegel, p. 286; hereafter, page numbers are given in parentheses in the text.

39. Kruger, interview in *Artwords 2*, ed. Siegel, p. 303; hereafter, page numbers are given in parentheses in the text.

40. Donna Haraway, "A Manifesto for Cyborgs: Science, Technology, and Socialist Feminism in the 1980's," *Socialist Review*, 50 (1984), 75; hereafter, page numbers are given in parentheses in the text.

41. Naomi Schor, "Dreaming Dissymetry," in *Men in Feminism*, ed. Jardine and Smith, p. 109.

42. James Clifford, *The Predicament of Culture* (Cambridge, Mass: Harvard University Press, 1988), p. 12.

43. On the figure of the "alone-standing woman"—a fictional creation of Christine Brooke-Rose's—as an emblem of postmodernity, see my essay on Brooke-Rose's novel *Between: "Living Between, or the Lone(love)liness of the alleinstehende Frau*," *Review of Contemporary Fiction*, Fall 1989, 124–127.

44. Julia Kristeva, *Etrangers à nous-mêmes* (Paris: Fayard, 1988), p. 58; hereafter, page numbers are given in parentheses in the text.

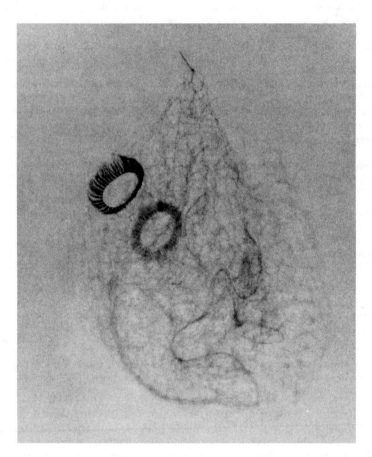

PAE WHITE, *Hornet.* 1991 Hairnet and eyelash, approximately 8″ square. Collection of Anders Tornberg

Courtesy of Shoshana Wayne Gallery, Santa Monica, CA.

Where's the Artist? Feminist Practice and Poststructural Theories of Authorship

Linda S. Klinger

The "death of the author" raises troubling questions for Professor Linda Klinger, who worries that such a doctrine may be just another strategy for silencing feminist practice. Discussing the work of Carolee Schneemann, Cindy Sherman and Clarissa Sligh, Klinger argues that the most effective feminist art presents itself both as the voice of "woman as artist" and of "woman as subject." Poststructuralist theories of the author "neutralize the full identity of women artists," while feminist art in the 1970s used collaboration and collective action as a way of strengthening the ego of the artist and increasing the political life of the work. Feminist theory must challenge the notion that artist and artwork are mere abstractions removed and isolated from concrete social realities.

I want to think about the active relationship between critical theory and women artists. Specifically, by looking at women artists as "authors," I'd like to consider in what ways recent critical theory cannot accommodate—literally "writes out"—feminist artistic practice. These reflections are based on my perception that poststructural critiques of authorship—formulated most succinctly by Roland Barthes[1] and Michel Foucault[2]—have deflected the trajectory of feminist cultural production by defusing feminist ideas that developed around the idea and person of the artist during the seventies. Such theories have contributed significantly to altering the framework for literary and visual criticism, yet they pose serious questions for a persuasive and *enduring* feminist pres-

Reprinted from Linda S. Klinger, "Where's the Artist? Feminist Practice and Poststructural Theories of Authorship," *Art Journal* (Summer 1991). Reprinted by permission of the College Art Association, Inc.

ence in the visual arts. The critique of authorship, widely introduced into America at a moment of political significance for feminism and art, may not completely erode a feminist position; it nonetheless carries enormous potential for stymieing the full participation of women artists in contemporary culture at the point where critical practice and artistic production meet.

This issue should greatly concern us, for now, after twenty years of hard labor, questions of identity, expression, and visual language provoke considerable anxiety, if not outright division, among feminists. Why, on the threshold of the nineties, are we left with nothing better than an uneasy truce with "postmodern culture"?[3] Typically, the discomfiture is described oppositionally, posed as the antagonism between theory—in which the terms of the critical discourse are stage-managed primarily by (white, male, Eurocentric) poststructuralist critics—and experience, between deconstruction and essentialism, poststructuralism and cultural feminism, and so on. This only substitutes rigid categorization for enormously complex positions and ensures that we maintain these categories as antipodal forces. What we really should examine are the dynamic points of contact between an aesthetic system and a political movement. Each arises from, and responds to, different historical circumstances; when they intersect, the identity of the woman artist has been refigured in troubling ways.

In pursuing this, we need to consider the many persons subsumed within the term "artist," as derived from its literary equivalent, "author." There is the flesh-and-blood woman, who has a psychological and sociological identity within a profession, the persona implied in the work, and of course the ideation or construct, Artist, manufactured by Western culture. Who of these is allowed "into" her work, and what role does she have there? These questions are directly broached within literary theory, where the domination of the authorial figure was established in Romantic aesthetics. The latter defined its critical activity on the assumption that art and the personality of its maker are correlated,[4] ultimately claiming primarily an aesthetic meaning for the work and, in effect, for its author. Early feminists, on the other hand, gave "authorship" and "author-ity" freer play, and introduced the artist into their work at many levels. To see what has happened to the woman artist over the course of the past twelve years or so, let's consider the following works. The first is a performance; the second and third are photographs; the last is a work in mixed media.

In Carolee Schneemann's "Interior Scroll," performed in August 1975, a long table is placed under two dimmed spotlights. A woman approaches the table carrying two sheets. She undresses, wraps herself in one sheet, spreads the other over the table; facing the audience, she drops the covering sheet and paints large strokes on herself that define the contours of her body and face. She reads a text from a book, then drops it, stands upright on the table. Extracting a scroll from her vagina, inch by inch, she reads from it:

> I met a happy man / a structuralist filmmaker
> —but don't call me that / it's something else I do—

he said we are fond of you / you are charming
but don't ask us / to look at your films
we cannot / there are certain films
we cannot look at / the personal clutter
the persistence of feelings / the hand-touch sensibility
the diaristic indulgence / the painterly mess
the dense gestalt / he said you can do as I do
take one clear process / follow its strictest
implications intellectually / establish a system of
permutations establish / their visual set . . .
my work has no meaning beyond / the logic of its systems
I have done away with / emotion, intuition, inspiration—
those aggrandized habits which / set artists apart from
ordinary people—those / unclear tendencies which
are inflicted upon viewers . . . / he said we can be friends
equally tho we are not artists / equally I said we cannot
be friends equally and we / cannot be artists equally.[5]

Two images by Cindy Sherman: a young woman looks away, into a bath-room mirror. She wears a blond wig and is wrapped in a towel; her head tilts back; she touches her throat tentatively, hesitant, transfixed by her reflection. The same woman, now in a dark wig and wearing a black dress, stands with her back to a bedroom mirror. She poses, eyes averted, one hand raised apprehen-sively to her face.

Clarissa Sligh's *Who She Was*: "She didn't know who she was but she knew she wasn't who you all said she was, she didn't know who she was but she knew she wasn't who you all said she was, she didn't know who she was but she knew she wasn't who you all said she was . . ." The words are repeated again and again, increasing in intensity until she screams with all her might, SHE DIDN'T KNOW WHO SHE WAS. The words cascaded down around her naked torso. Her hands are draped, still.

I interpret these works on two levels. Each was made at a different his-torical moment, three responses to a question that is implied but never asked directly: Who am I? The "I" at stake is clearly designated by gender, but her identity slides in and out of focus, depending on whether "she" is a woman whose knowledge and experience are bodily and innate, a "free-floating sign" continually reinvented by images, or a woman trapped by gender and race. Schneemann locates the roots of her performance in her investigations of the symbology of the female body and of goddess lore. "I assumed the carved figu-rines and incised female shapes of Paleolithic, Mesolithic artifacts were carved by women . . . that the experience and complexity of her personal body was the source of conceptualizing, of interacting with materials, of imagining the world and composing its images."[6] The performance becomes, in Schneemann's words, "the visual-mythic transmutation of self-knowledge," the source of which is clearly the artist's body, from which the scroll is "expressed."[7] Schneemann exposes her "self" intimately and literally; Sher-man, on the other hand, discloses "the fiction of the self."[8] Vamped, wigged,

and bemused, she is the woman in the photographs, constructed as "the feminine" by her representation through the stereotyping eye of the camera. Clarissa Sligh also looks for her identity outside an innate condition of being, although it is not a depersonalized fiction. In part, she attempts to create it by "reprocessing" her own memory and the "documents" of her past. Speaking of the larger body of her mixed-media works, she has written that they are "an attempt to represent the ever-present connection of what has already happened to a kind of continual present. I begin with the photograph, a creation of time and light. Against it I juxtapose other photographs, marks, or words. Using old family photographs, I reconstruct myself. I reshoot and reprint, write and rewrite. I attempt to connect to who I was. From this place, a direction flows for what I do."[9]

By making us aware of the question, these works implicitly engage the issue of women's subjecthood. But more particularly, these women have framed their position *as artists*; "woman as artist" and "woman as subject" are present as interrelated conditions. This is most apparent in Schneemann's text, where the (male) "happy structuralist" and the woman artist spar with each other, and against the romance of the Artist. The filmmaker's repudiation of "a dense gestalt," or "those aggrandized habits which set artists apart from ordinary people," is a claim to an overriding reality in systems—an ironic one at that, assuming that "ordinary people" do not experience emotion, intuition, and inspiration. He disconnects "person" from "artist" from "work," and so rejects the woman as an artist (even though he will "accept" her as friend). Schneemann's rebuff—"we cannot be friends equally and we cannot be artists equally"—confronts the issue of her identity and authorship head on, as does the performance itself. The woman and her work are presented as inseparable. Her identity inside and outside the piece is multivalenced: she speaks its words as their writer, performer, and as the protagonist of the narration.

In Sherman's photographs, the identity of the artist is subtly diffused. Two people are sealed in these hermetic spaces: someone invisible is presumed "outside" the frame, someone who triggers or "directs" the response of Sherman's character, the woman within our field of vision. But Sherman the photographer is coyly present too. As Rosalind Krauss suggests, the conceptual coherence in the photographs depends on our awareness of her as the artist.

> For the play of the stereotype in her work is a revelation of the artist herself as stereotypical. It functions as the refusal to understand the artist as a source of originality, a fount of subjective response, a condition of critical distance from a world which it confronts but of which it is not a part. The inwardness of the artist as a reserve of consciousness that is fundamentally different from the world of appearances is a basic premise of Western art. . . . If Sherman were photographing a model who was not herself, then her work would be a continuation of this notion of artist as a consciousness which is both anterior to the world and distinct from it, a consciousness that knows the world by judging it. In that case we would simply say that Sherman was constructing a critical parody of the forms of mass culture.[10]

For Sligh, the very process of making images imbues them with her presence, which becomes part of their content. The fact that she brings them into existence through hand and mind perpetually connects them to her being; the images are, conversely, the means by which she replenishes consciousness of herself.

> *As I combine elements of marks and photographs into one picture frame, simultaneous and successive time elements are brought into the present in one place, one moment, one event. As I construct the unsayable, the unspeakable, the unrepresentable through this reframing process, a healing occurs. The time of experience has taught me that every mark I make, every word I write is tied to every gesture I have ever made.*[11]

I am not suggesting that these works are specifically "about" the artist. Frequently present in much work by women, however, is the tendency to allow, or project, an awareness of self as an artist, as we find it here. To describe this as autobiographical also oversimplifies a complex historical point. It points instead to the dual legacy inherited from Abstract Expressionism and the early women-artists' movement in the formation of the woman artist's identity. The former fully embraced the notion of "painting as act" as comprising the "same metaphysical substance as the artist's existence";[12] the latter demanded an acute awareness of authorship beyond the rhetoric of metaphysical identity to consider her positioning within the politics and economics of a profession.

Can we afford, then, to ignore what we see in the procession of images before us? If we accept them as a developing chronicle of women as artists, something has intervened to alter a once-forceful persona. Where is the artist? Despite the empowerment implied by Sligh's statements, I take little comfort in what I perceive as an impasse, suggested by the work itself: a disembodied voice speaks in third person and past tense, displaced in time and place from a segmented, headless (and therefore mouthless) figure. Here "voice" is the remnant in a sequence in which we move from the physical and active presence of the artist, to an ambiguous persona that flickers, disguised, as the subject and object of a photograph, to a fragmented, passive form.

Some disturbing trends in the visual arts parallel the metaphoric disintegration of the woman artist in her work. In 1974 some hopefully noted "a number of developments indicating the increasing impact made by feminism" in the art world, a claim repeated in 1980.[13] But in 1987 Eleanor Heartney had to remeasure "the gender gap," just to be sure.[14] Her vaguely optimistic conclusion rings hollowly against the few statistical references in the article, which suggest that "women artists in general have a long way to go to achieve [professional] parity with men."[15] And recently, in an essay included in the catalogue of a major exhibition that celebrates the "fact" that women artists are "moving into the mainstream," Marcia Tucker describes the very premise of that exhibition as "highly problematic."[16]

Our present uncertainty regarding the whereabouts of the artist is all the more disquieting since the nominal acknowledgement of "difference" by "post-

modern culture" augured well for her. Indeed, the interests of feminism and postmodernism were specifically allied in an intricate and conceptually seductive essay by Craig Owens, published in 1983.[17] Exploring the "apparent crossing" of the feminist critique of patriarchy and the postmodernist critique of representation, he concludes that "women's insistence on difference and incommensurability may not only be compatible with, but also an instance of postmodern thought," contributing to "the discourse of the Other," which challenges the patriarchal hegemony of modernist thought, including aesthetics.[18]

The challenge has not been sustained, however. Owens himself points out that "if one of the most salient aspects of our postmodern culture is the presence of an insistent feminist voice (and I use the terms *presence* and *voice* advisedly),[19] theories of postmodernism have tended either to neglect or to repress that voice."[20] He does not question how or why that should be, though he alludes to it: "It is not always theory *per se* that women repudiate, nor simply . . . the priority men have granted to it, its rigid opposition to practical experience. Rather what they challenge is the distance it maintains between itself and its objects—a distance which objectifies and masters."[21]

But it is precisely this point that needs to be addressed, the mastery of description—language—over the phenomena it proposes to describe. The power of the "text" is intrinsic to the philosophical and critical underpinnings of "postmodern culture." And, although the greater part of contemporary art criticism claims otherwise, it is one of the ways poststructuralist theory intercepts the actively political thrust of feminist artistic practice. Not least, it confounds the presence of the artist herself, whose operations in their most radical forms once aimed to subvert the aesthetic objects that buttress patriarchal culture. The premises upon which postmodern critical practices are based simply do not accommodate the intricate sociology of feminist art, nor of the artist. Instead, they neutralize the full identity of women artists within the interplay of social, critical, and representational systems, privileging the image as a text. Conceptually postulating the artist as a critical trope, poststructuralist theories of authorship reify her as an abstraction, and return that abstraction to us as the subject of art.

The essays by Michel Foucault and Roland Barthes on the Author, written in the mid or late sixties, were not available in English until about a decade later, at a crucial moment for American feminism.[22] Their critique begins with an attack on the subject as defined by the traditions of Romantic aesthetics and liberal humanism, which claim the individual as the legitimizing source from which "meaning" proceeds.[23] The deconstruction of the subject in literary theory aimed to dislodge the *idea* of the Author, with all the attendant conditions of Author-ity,[24] as the center that controls the analysis of texts, in order to address writing as a discursive practice. Here Barthes's position is the more annihilating of the two; for him, "it is language which speaks, not the author."[25] Foucault retains the Author, but "stripped of its creative role." The Author is necessary only to the degree that it is a function of "the existence,

circulation, and operation of discourses" that govern the production of cul-
ture;[26] ultimately, however, it is subsumed within those discourses.[27]

An imagined rivalry between the Critic and the Author animates
Barthes's position; their dispute takes place over the bodies of historical
authors on the field of the text. "The image of literature to be found in ordinary
culture is tyranically centered on the author, his person, his life, his tastes, his
passions. . . . The *explanation* of a work is always sought in the man or woman
who produced it, as if it were always in the end, through the more or less
transparent allegory of the fiction, the voice of a single person, the *author*
'confiding' in us."[28] Barthes's conclusion indicates that the outcome ought to
redress, if not invert, the relationship of Author to Critic: "A text's unity lies
not in its origin but in its destination. . . . Classic criticism has never paid any
attention to the reader; for it, the writer is the only person in literature. We
are now beginning to let ourselves be fooled no longer. . . . We know that to
give writing its future, it is necessary to overthrow the myth: the birth of the
reader must be at the cost of the death of the Author."[29]

Speaking thus are individuals whose relationship to the question of
authorship developed from epistemological enquiry with a strong linguistic
bias. As Edward Said observes of Foucault and Derrida, "There is a fundamen-
tal uncertainty in their work as to what it is doing, theorizing over the problem
of textuality or . . . practicing an alternative textuality of their own."[30] Clearly
their work is sustained within academic circles devoted to the practice and
analysis of literature—by Readers, in other words, as well as Authors. From
this position, poststructuralist theory indeed offers a more sophisticated base
from which critical practices can be launched—one predicated on maintaining
the "text" as the primary locus of investigation, if not meaning per se. The
momentum of this enterprise is such that it refigures all modes of production
as forms of "textuality." The consequence, however, is another order of aes-
thetics perpetrated through its own discursive systems, one requiring that the
Author and Authorship be constructed and held in a vacuum, isolated from the
realms of education, law, economics, and gender that inflect individual iden-
tity and artistic production within society.[31]

Early feminist artistic practice and postmodern aesthetics collide at just
this point. The women-artists' movement also responded to the crisis within
traditional definitions of the author: an authentic position for the female sub-
ject is claimed in no uncertain terms in early feminist action and criticism, and
is implicit in the attempt to discern a female sensibility in art. But deeply
implicated in early feminist notions of the author are the political and institu-
tional conditions that also define authorship. In a sense it could not be other-
wise, since women had never enjoyed in the first place the privileges of
transcendent subjecthood and Author-ity now critiqued by poststructuralism.
Female "authorship" was enacted as an element in social procedure, and thus
demanded that closer attention be paid to the relations of power between indi-
viduals and institutions found within the production of art. This aspect of the
early feminist-artists' movement tends to be overlooked, probably because it is

not wholly articulated in theoretical discussion, and because it is obscured by a strongly utopian vision. The implicit recognition of artistic practice as an embodiment of these relationships at all levels is present, nonetheless, and can be inferred from feminist preoccupations with audience and in the strategies that aimed to redefine the artist at the level of practice.

Recognizing, for example, that "author-ity" is institutionalized as a matter of education, feminists attacked it at the roots. Alternative studio programs, notably the feminist art programs at California State University at Fresno and the California Institute of the Arts, soundly rejected the cultural myth of the artist as lone hero/genius by rejecting the studio training that supports such an identity. The aspiration was that making art might become a form of social transformation, and the artist an activist, in service of the re-formation of traditional cultural values; this could happen only by destroying the aura surrounding the " 'mystery of creation' and 'the artist's creative process.' "[32] Thus the ideal of community, shared labor, and open exchange was substituted in the teaching program, supported by collaborative methods developed in the contexts of consciousness raising and political action.[33]

Collaboration, or collective action, is a particularly informative model to examine for early feminist ideas regarding authorship. Pedagogically, it was a strategy used to strengthen the ego and self-awareness of the female artist; practically speaking, it became a method by which to expand resources and remaneuver the limits of process. It has particular implications for feminist authorship however, satisfying two correlated aspirations: first to demystify the persona of artist through the making of art, intensifying her presence as an active agent in the social processes of production; second, to charge the end product, whatever it might be, with a political life that extends beyond the "content" of the work. Decision making, judgment, communication—those responsibilities at the base of an ethical politics—are distributed and negotiated among a group as a means of producing art. Lucy Lippard's classic formulation speaks of the reintegration of the "aesthetic" and the "social self," the means of "expressing oneself as a member of a larger unity or comm/unity, so that in speaking for oneself one is also speaking for those who cannot speak."[34] I would emphasize that the mutual refiguration of artist and art depends crucially on a belief in agency, not as part of the "psychology of creation," which "transcends the world,"[35] but as the visible assertion of an intentionality that originates with the individual subject and intervenes with collective force.

According to this model, collaboration—at least the feminist aspirations for it—does not destabilize the identity of the artist; it reframes her in the Marxist terms of Walter Benjamin's cultural producer. Emphasizing production over product is essential, for it eliminates the distinctions between non-specialist (reader/writer/audience) and specialist (author/artist) and allows the feminist artist to discover another identity through her solidarity with a larger body, Benjamin's proletariat.[36] Most critically, it deflects attention from the aesthetics of the work, which, as Benjamin argued, are the obstacle to true intervention in oppressive cultural systems. The object is but the residue of

the process itself, that thing which has revised the identities of all who partici-pated in its production.

I have focused on collaboration, as it is both the hallmark of early femi-nist artistic practice and its legacy to the eighties: its efficacy and social logic are so persuasive that it has been absorbed rather nonchalantly into art prac-tice.[37] Yet even as this happens, the political force of collaboration has also been redirected, assimilated into the critical rhetoric of the decade. Feminists called attention to it as a strategy of disruption; critics began to associate its operative modes with a postmodern decentering of authorship, as a tactic that vexes the premium set on the uniqueness of the artist's hand, the expression of individual genius, or that erases completely the presence of the artist in the work.[38] This is a position now claimed by some collaborative groups, which I will not dispute. From a feminist perspective it makes little sense; moreover, I think it is self-deluding to believe that by denying the artist we encourage much more than a brand of aestheticism nicely complicit with the renewed gallery activity characteristic of the eighties.

The irony of the historical moment deserves some reflection. Women artists have been trapped between Abstract Expressionism and postmodern-ism, and largely excluded from each. Tellingly, the author is central to the operations of both. When critics breathed life into the Artist, whose "dialectic with the canvas" was tantamount to an epic encounter with the forces of God, nature, and his psychosexual conturbations, they aggrandized painting, the language used to describe it, and its status as a complement to national identity after World War II. For women artists, this rhetoric created a fair amount of confusion, if not outright ambivalence toward their professional and personal identity.[39] Postmodern criticism, which adapts the language of poststructural literary theory to visual production, inverts that rhetoric: the artist is voided and process is neutralized. The result is equivalent, however, leaving the work in the hands of another author who negotiates the "text." Perhaps it is overly cynical to say that when women artists obligingly evaporate "authorship" their work becomes more palatable. Shall we say, rather, that the denaturing strength of the literary topos assimilates their production into politically neu-tral territory; the work "works" because a critical language places it into an acceptable canon.

In an age when both God and the NEA have forsaken the profession, no artist should be begrudged her identity. So I return to familiar ground to remember that the early women-artists' movement was founded in the *politics* of authorship, and that the early proclivity of the movement was to challenge author and production as abstractions distanced from social reality—precisely what poststructuralism reinforces. In saying this, I am allowing a permeability to exist between many kinds of authors. Yet I believe that their elision occurs within the dynamics of production. Those committed as critics, historians, or artists to the goals of feminism need to pay attention to the levels at which, and circumstances under which, critical theory and artistic practice intersect, and with what consequences to those many identities. This is not a swipe at "the-

ory," but an argument for taking it seriously. If we heed one of the premises of our own "postmodern age," we must accept theory and criticism as discursive practices that mediate their subject. How one describes the author allows, or disavows, cultural production as the instrument for political action and social change.

Notes

Warmest thanks to Curt Bentzel, Ilene Lieberman, Tom Macavera, and Jon Rosenthal, who combined the very best traits of friends and intellectual sparring partners as I prepared this essay.

1. Roland Barthes, "The Death of the Author," in *Image, Music, Text*, trans. and ed. Stephen Heath (New York: Noonday Press, 1977), 142–48.
2. Michel Foucault, "What Is an Author," in *Language, Counter Memory, Practice: Selected Essays and Interviews*, ed. Donald Bouchard and trans. Donald Bouchard and Sherry Simon (Ithaca: Cornell University Press, 1977), 113–38.

 The essay by Nancy K. Miller, "Challenging the Subject: Authorship, Writing, and the Reader," in Teresa de Lauretis, ed., *Feminist Studies/Critical Studies* (Bloomington: Indiana University Press, 1986), 102–20, addresses similar concerns, though it came to my attention after my own position was formulated. Since she writes from the perspective of an historian and critic of literature, her paper, as well as de Lauretis's introduction in the same volume, are valuable complements to the critical work now undertaken by feminists in the visual arts.
3. See Linda Alcoff, "Cultural Feminism versus Post-Structuralism: The Identity Crisis in Feminist Theory," *Signs: Journal of Women in Culture and Society* 13 (1988): 405–36. See also Leslie Wahl Rabine's analysis of the historical and ideological sources of the conflict, offered in service of a reconciliation: "A Feminist Politics of Non-Identity," *Feminist Studies* 14 (1988): 11–31.
4. "One looks to an author of his work, another reads the author out of his work; and the third reads a work in order to find its author in it. The first type is primarily an investigation of literary causes. . . . The attempt is to isolate and explain the special quality of a work by reference to the special quality of the character, life lineage, and milieu of its author. The second type is biographical in aim . . . , the third, however, claims to be specifically aesthetic and appreciative in purpose; it regards aesthetic qualities as a projection of personal qualities, and in its extreme form, it looks upon the poem as a transparency opening directly into the soul of the author." M. H. Abrams, *The Mirror and the Lamp: Romantic Theory and the Critical Tradition* (New York: Oxford University Press, 1952), 227.
5. Paraphrased from Schneemann's description of her performance "Interior Scroll," in *High Performance* 6 (1979): 13. The text for "Interior Scroll" was from "Kitch's Last Meal" (supereight mm film, 1973–77).
6. Schneemann, "Interior Scroll," 12. See also Lucy Lippard, *Overlay* (New York: Pantheon, 1983), 66–67.
7. Schneemann, "Interior Scroll," 12.
8. Douglas Crimp, "The Photographic Activity of Postmodernism," *October* 15 (1980): 99; Cindy Sherman interviewed by Jeanne Siegel in Jeanne Siegel, *Artwords 2: Discourse on the Early 80s* (Ann Arbor: UMI Research Press, 1988), 269–82.
9. Unpublished statement by the artist, April 1988.
10. Rosalind Krauss, "A Note on Photography and the Simulachral," *October* 31 (1984): 59–62.
11. Unpublished statement by the artist, April 1988.
12. Harold Rosenberg, "The American Action Painters," in idem, *The Tradition of the New* (New York: McGraw-Hill, 1965), 27–28.
13. Lise Vogel, "Fine Arts and Feminism: The Awakening Consciousness," reprinted in *Feminist Art Criticism: An Anthology*, ed. Arlene Raven, Cassandra L. Langer, and Joanna Frueh (Ann Arbor: UMI Research Press, 1988), 24–25. See also Kay Larson, " 'For the First Time Women Are Leading and Not Following,' " *Artnews* 86 (1987): 64–72.
14. Eleanor Heartney, "How Wide Is the Gender Gap?" *Artnews* 86 (1987): 139–45.
15. Ibid., 145.

16. Marcia Tucker, "Women Artists Today: Revolution or Regression?" in Randy Rosen and Catherine C. Brawer, eds., *Making Their Mark: Women Artists Move into the Mainstream*, exh. cat. (New York: Abbeville Press, 1989), 197.

17. Craig Owens, "The Discourse of Others: Feminists and Postmodernism," in Hal Foster, ed., *The Anti-Aesthetic: Essays on Postmodern Culture* (Port Townsend, Wash.: Bay Press, 1983), 57–82.

18. Ibid., 61–62.

19. This qualifier is in deference to Derrida's theory of the sign, and of writing as the interplay of "presence and absence"; see Derrida, "Difference," in *Speech and Phenomena and Other Essays on Husserl's Theory of Signs*, trans. David B. Allison (Evanston: Northwestern University Press, 1973), 138.

20. Owens, "The Discourse of Others," 61.

21. Ibid., 63.

22. For a discussion of the historical and legal circumstances that produced the essays by Barthes and Foucault, see Molly Nesbit, "What Was an Author?" *Yale French Studies* 73 (1987): 229–57.

23. Derrida, Barthes, and Foucault do not occupy undifferentiated positions, although, within art criticism, the application of their thought has tended to result in a similar dissolution of the artistic figure. See Edward Said's cogent analysis of the divergence between Derrida and Foucault in "Criticism between Culture and System," *The World, the Text, and the Critic* (Cambridge: Harvard University Press, 1983), 178–225.

24. Edward Said, *Beginnings: Intention and Method* (New York: Basic Books, 1975), 83–84.

25. Barthes, "The Death of the Author," 114; compare Foucault, "What Is an Author?" 115–16.

26. Foucault, "What Is an Author?" 137–38.

27. Said, *Beginnings*, 186–88.

28. Barthes, "The Death of the Author," 143.

29. Ibid., 148.

30. Said, "Criticism between Culture and System," 185.

31. See further, Nesbit, "What Was an Author?" passim.

32. As stated, for example, by Arlene Raven, in "Feminist Education: A Vision of Community and Women's Culture," in Judy Loeb, ed., *Feminist Collage: Educating Women in the Visual Arts* (New York: Teachers College, Columbia University, 1979), 258.

33. See especially Raven, "Feminist Education"; also, Miriam Shapiro, "The Education of Women as Artists: Project Womanhouse," *Art Journal* 31 (1972): 268–70; and Paula Harper, "The First Feminist Art Program: A View from the 1980s," *Signs: Journal of Women in Culture and Society* 10 (1985): 762–81.

34. Lucy Lippard, "Sweeping Exchanges: The Contribution of Feminism to the Art of the 1970s," in idem, *Get the Message?* (New York: E. P. Dutton, 1984), 151, 153; Lucy Lippard and Candace Hill-Montgomery, "Working Women/Working Artists/Working Together," *Woman's Art Journal* 3 (1982): 19–20.

35. Rosenberg, "The American Action Painters," 29.

36. "A writer who does not teach other writers teaches nobody. The crucial point, therefore, is that a writer's production must have the character of a model: it must be able to instruct other writers in their production and, secondly, it must be able to place an improved apparatus at their disposal." Walter Benjamin, "The Author as Producer," in *Understanding Brecht*, trans. Anna Bostock (London: Verso, 1973), 98. Compare Lucy Lippard, "Notes towards an Activist Performance Art," in idem, *Get the Message?* 316–17.

37. See most recently Eleanor Heartney, "Combined Operations," *Art in America* 77 (1980): 140–47.

38. David Shapiro, "Art as Collaboration: Toward a Theory of Pluralist Aesthetics, 1950–80," in Cynthia Jaffee McCabe, *Artistic Collaboration in the Twentieth Century*, exh. cat. (Washington, D.C.: Smithsonian Institution Press, 1984), 53–61.

39. Anne Wagner, "Lee Krasner as L. K.," *Representations* 25 (1989): 42–57; compare Rozsika Parker and Griselda Pollock, *Old Mistresses: Women, Art, and Ideology* (New York: Pantheon, 1981), 145; and Griselda Pollock, "History and Position of the Contemporary Woman Artist," *Aspects* 28 (1984): n.p.

George Porcari, *That's Some Logic Yours* **(Third Panel).** **1992** **3½″ x 5″**
Courtesy of the artist.

Negotiating Difference(s) in Contemporary Art

Amelia Jones

Critic and professor Amelia Jones discusses cultural and sexual identity as unstable constructions. While difference often becomes deviance, leading to "containment and exclusion," difference can also be viewed as a "process of endless differentiations that result in continually shifting identities and identifications." The four artists discussed examine the authority of "mainstream, anglo-American culture" and the idea of the "natural" and the "normal" in order to subvert the repressive and mythical norm.

In recent years, this country's continually re-fabricated fantasy of a homogeneous "American" identity has been violently undermined. It has become increasingly clear that our socio-cultural character is, in fact, fragmented and heterogeneous—that it is not a singularly identifiable norm but a complex web of differences.[1] This expansive cultural diversity renders suspect any continued attempts to characterize an average American in fixed or unified terms. Though the media and a majority of politicians continue to perform this universalism, their vehement insistence on a normative American identity must be seen as evidence of the growing threat of these culturally diverse and increasingly vocal *others*. In fact, as more women, gays and lesbians, people of color, and constituents of other marginalized, oppressed, and otherwise disempowered groups fight to ensure that their concerns are taken seriously, the ideological biases subtending the "mythical norm" of American subjectiv-

A shorter version of this essay appeared in the catalogue, *The Politics of Difference: Artists Explore Issues of Identity* (Riverside: University Art Gallery, University of California, 1992), which accompanied an exhibition by the same name held at the University Art Gallery, January 12 to March 8, 1992. Reprinted with permission of the author.

ity—described by Audre Lorde as "white, thin, male, young, heterosexual, Christian, and financially secure"[2]—are being laid bare in their continued operations.

One of the pivotal strategies in these struggles of variously marginalized peoples to make their identities understood as viable and empowered alternatives to the mythical norm is the attempt to expose the operations of the *politics of difference*: the machinations by which any subject *different from* the norm is first stereotyped then devalued as *deviant*, a characterization which then justifies (in fact necessitates) the subject's containment and exclusion. Within the nefarious politics of racial difference, for example, big-city African-American males (who are *"other"* to the norm) are stereotyped as highly volatile urban cowboys wielding automatic rifles, poised to destroy "universal" (anglo) American family values. Innumerable other examples of the *continuation* of this exclusionary politics, as articulated in visual and discursive forms, can be cited: from the melodramatic image of the gay AIDS victim as a sore-infested cadaver—and so "rightly" ostracized from society, to the picture of welfare recipients kicking back as they drain the American government of taxpayers' pennies, to representations of rabid feminists deliberately aborting themselves monthly in a diabolical attempt to destroy the sanctity of the American family.

The crucial role of the politics of difference in establishing particularly *sexual* identity through representation (that is, in defining gender as a social category) was recognized and theorized at length by feminists in cultural studies and film theory in the 1970s and 1980s. Laura Mulvey's now infamous "Visual Pleasure and Narrative Cinema" (1975) and Stephen Heath's "Difference" (1978), both published in *Screen*, were two high-points in the politicized deployment of psychoanalytic theories of sexual difference to examine polarized gendered viewing and narrative relationships set up in classical Hollywood films—where women are represented as passive and sexualized "others" to positively valued, active male characters and to implicitly male spectators.[3] In the last decade, these psychoanalytically informed studies of the politics of sexual difference at work in films have been modified and applied to the visual arts. For example, the essays collected in the exhibition catalogue *Difference: On Representation and Sexuality* (1985) draw on the arguments staged in feminist film theory to examine how sexual identity is constructed and reinforced, or potentially critiqued through static visual images. In particular, Jacqueline Rose's essay extends Freudian theories of sexual identity, suggesting that "there can be no work on the image, no challenge to its powers of illusion and address, which does not simultaneously challenge the fact of sexual difference. . . ."[4] Arguing that visual representation itself hinges on codes of sexual difference, Rose implies that difference is exclusively (or at least primarily) sexual: that identity itself is a question of *sexual* difference as articulated through psychically embedded codes of male/

female identity formation that are played out in the social realm through representation.

However, more recently, this very focus on the *sexual* as primary category of difference has been challenged. Michael Warner, for example, has argued that the primacy assigned to sexual difference in structuring identity and in constructing norms of subjectivity through representation exemplifies Western culture's "totaliz[ing of] gender as an allegory of difference."[5] Warner recognizes that this bias, constitutive of modern, Western conceptions of individual identity, is informed by pervasively Freudian models that define sexual difference as constituting the core of subjectivity. This "heterosexist self-understanding" of identity lies at the heart of modern social organization, where gender is "assumed to be our only access to alterity"—that is, our only access to *difference* or *otherness* relative to the norm (201, 200).

No longer viewed as a more or less stable system of oppositions by which, primarily, the masculine is defined as superior to a fixed notion of femininity as *other*, difference is now being actively conceptualized as a *process* of endless differentiations that result in continually shifting identities and identifications. Within this more complex logic, a gay man—who may appear to be "simply" a financially secure, thin, attractive, anglo male (and privileged as such)—can be seen also to be marginalized in certain contexts as *not straight*. While oppressed by the discriminations and exclusions of hegemonic patriarchal social systems, an upper-middle class, straight, white female can also be seen as complicit in many ways with the dominant culture's systematic oppression of people of color, lesbians and gays, and members of the working class. An African-American man, disempowered in relation to anglo-dominated social, economic, and political structures, may in other contexts discriminate against African-American women.

Through this new understanding of difference as a process of differentiation (or of Derridean *différance*[6]), a more complex and subtle conception of identity is afforded. One person's identifications will continually shift and transmutate depending on his/her economic and social situation and interrelations with other groups: "the question of identification," as cultural theorist Homi Bhabha eloquently argues, "is never the affirmation of a pregiven identity, never a self-fulfilling prophecy—it is always the production of an 'image' of identity and the transformation of the self in assuming that image."[7] This model of difference(s) has been empowering for artists whose identities are alternative to the mythical norm of American subjectivity and who have thus had their work subordinated to and excluded from dominant cultural practices. As a process that operates on the level of representation, the politics of difference can be disrupted or subverted through visual practice, with the artist afforded the potential to manipulate or transform the image of a certain category of subjectivity ("chicano," "woman," "black," "queer," etc.) to subvert or undermine the repressive mythical norm.

Here, my goal is to give attention to a new generation of artists who expand on gender-based feminist theorizations of difference to counter the racist, sexist, and heterosexist logic of the mythical norm of American subjectivity through an examination of the politics of difference. These artists draw from the increasingly complex understanding of this politics outlined above: no longer viewed as a static, simply hierarchizing function, it is now recognized to operate as an active *process* of differentiation that continually reformulates new hierarchies based on more resistant permutations of the mythical norm.

This essay features the work of artists trained and actively working and/or exhibiting in Los Angeles (which I thus privilege inevitably as a site of multiplicity and cultural differences)—artists whose works aggressively address some of the questions raised by the politics of difference as it operates in our culture. Lauren Lesko, Philip Pirolo, Gary Simmons, Millie Wilson, like East coast artists such as Dave Hammons, Adrian Piper, and Jimmie Durham, take issue with the binary logic by which the idealized norm is valued in opposition to alternative identities, which are simultaneously marginalized as insufficient "others." Conceptualizing identity as a mobile series of identifications crossing over categories of gender, class, sexual orientation, and race, these artists critique the fixed stereotypes that have worked integrally within the politics of difference to justify their exclusion from social and political empowerment. They undermine and parody the stereotype or refuse its false unification by representing alternative identities in positive yet multiplicitous ways. Their work is materially and visually compatible (all of the artists create objects and installations that dialogue with the space of the gallery), and each practice introduces a possible range of visual and textual strategies for intervening in the prescriptive and monolithic construction of a normative American subject.

Lauren Lesko's work is characteristic of a strongly feminist critique of the politics of sexual difference that moves away from the binary deconstructions of 1980s feminist appropriation art—such as Barbara Kruger's appropriations of mass-media images of women and men, their manipulated, montaged surfaces disrupted by aggressively intervening texts ("Your Gaze Hits the Side of My Face" over an "ideal" sculpted female head, or "Surveillance is Your Busywork" across a man peering out at the viewer). Lesko constructs highly polished tableaux and sculptural objects that take issue with the hierarchical logic mapped out so forcefully in Kruger's work. Working through the psychoanalytic division of mind from body,[8] her installations operate to contest the very binary logic by which femininity is conceptualized as simply the *opposite of* masculinity.

In *Eyeful* (1991), for example, Lesko constructs a large "vanity" out of three images of little girls appropriated from early twentieth-century postcards, blown up to life-size (a literal "eyeful") and printed in negative. Coyly exposing their rearends, these thinly disguised erotic portraits of little girls typify the representation of the female subject, even from the earliest stages of

childhood, as a sexualized object of prurient masculine desire: the passive *other* to the active male norm.[9] Exposing the images in negative on large sheets of transparent film and then veiling them under a diaphanous layer of gauze, Lesco ironicizes the dual logic of the politics of difference, emphasizing the fact that, far from neutrally presenting some "inherent" aspect of female subjectivity, images of women commonly represent a nascently sexualized femininity defined through the desire of an implicitly masculine spectator. Femininity—in the post-Freudian west constituted via the heavily charged politics of difference—is a transparent, *negativized* function ("not masculine").

Here also, by presenting the images on a large scale wood frame with opulently gilded legs, Lesko forces the viewer to confront them in a narcissistic exchange of representational identities. And, finally, by *veiling* each of the three images, Lesko activates the psychoanalytic determination of femininity (coded in Freudian theory via the female genitalia) as metaphorically occluded or masked. Freud's model of sexual difference pivots around his model of castration and penis envy, where, in Freud's words, it is female "shame" over the woman's ostensible "sexual inferiority" that motivates her "concealment of genital deficiency." Lesko's piece perhaps more clearly aligns itself with the observations of feminist theorists who have argued that it is *not* female shame but, precisely, the *male fear of castration* in the Freudian model which requires the veiling of the female body to remove its threat of supposed "absence" or "lack" of a penis—to hide this threatening "absence" *from the man.*[10] Playing out this latter reading, *Eyeful* refuses the veiling its full masking function by allowing the images to read clearly through the fabric.

Lesko continues her critique of the cultural construction of sexual difference in *Femininity—Lecture XXXIII, Part II* (1991), a text piece silkscreened in gold paint over a fake wainscot of high-gloss white paint along a gallery wall. Taken from Freud's infamous essay on femininity from 1933, the text describes the female subject in the following terms: "It seems that women have made few contributions to the discoveries and inventions in the history of civilization. . . ." (It is in this same notorious essay that Freud definitively stages a rigidly binary model of sexual difference that is predicated on female "sexual inferiority" and "genital deficiency," arguing simultaneously that "Sexual life is dominated by the polarity of masculine-feminine. . . ." and, "There is only one libido . . . [and it is] masculine."[11]) By printing the text in reverse, Lesko emphasizes again the negative, inverted nature of femininity as constituted in relation to a positively defined masculine norm. At the same time, her use of the color gold raises the issue of the commodification of femininity—which takes place precisely through the representation of the female body as exchangeable object of desire.

Framing the text is *Part I* of this piece, with two gold tassels mounted on the wall at genital height, each above a semi-circular podium. The fetishized tassels speak again of commodification—of the *positive* value of male sexual identity, but also of the visually registered, degraded exchange value of the

topless stripper—both identities suggested through the protruding but limp bundles of gold fringe, oscillating signifiers of sexual difference (or *différance*) that read both as flaccid penises and as glittery "pasties" for a stripper's otherwise naked breasts. As masculine signifiers, the tassels gain their privileged status, signaled by the miniaturized "grandstand" or podium, through the very same politics of difference that devalues the feminine (the function of the stripper's platform being the revelation of her private parts to the men below).

In Lesko's elegant play on the fetishized sculptural object, *Hysteria* (1991), a gilded clitoris-shaped object sits regally on a creamy white mohair covered pedestal that is anthropomorphic and specifically phallic in shape. Here the feminine is represented explicitly as genital but is also positively valued through its "currency" as "pure gold." The object, its sexualized form taken from a hat mold, also takes on value through its presentation, which aligns it with the ostensibly pure "aura" of the art object on display in a museum. The construction of *gender* (sexual difference in its culturally represented forms) is overtly politicized in Lesko's work such that the veiled operations of the politics of sexual difference are exposed.

Millie Wilson is concerned with a form of female identity that is doubly marginalized in American culture: that of the homosexual woman, whose lack of sexual desire for the male subject threatens the very edifice of masculinity on which the politics of sexual difference is erected. Over the last decade, Wilson has developed a body of work that challenges the status of invisibility to which lesbian subjects have been relegated under western cultures dominated by normative, hetero-sexist definitions of "proper" subjectivity. "Working negativity with a vengeance," her work examines the systematizing logic of what she calls the "intertwined pathologizing of sexual deviance and race."[12] In her large scale installation project *FAUVE SEMBLANT: Peter (A Young English Girl)* of 1989, for example, Wilson produced a fake historiography, including photographs and textual documents for a lesbian author, "Peter," parodying the art historical system by which elaborate, fully intentional and heroically expressive identities are constituted retrospectively for artistic authors (almost exclusively constructed as straight, white, and male in histories of western art).

Wilson manipulates the socially constructed codes of non-normative sexual identities further in her most recent project, *The Museum of Lesbian Dreams*. Appropriating melodramatic psychoanalytic and/or pseudoscientific narratives characterizing the lesbian subject as perverted and maladjusted, Wilson, like Lesko, juxtaposes the discourses to carefully appropriated and fabricated objects that force the textual stereotypes to self-implode. *Easel/Mirrors* (1990), for example, opens out the clichéed tropes by which art history defines a heroic identity for the (straight, white, male) artist as immanent in his emotionally invested canvas. Thus, the wooden easel holds not this "subjectively" informed painting, but a mirror on which is etched a "first-person" dream narrative of a "Welshwoman" from 1928, as told second-hand by Havelock Ellis in his study of transvestitism. "Welshwoman" cross-dresses,

but only in her dream fantasy, where she describes standing in a gray tweed suit with her back to a mirror, desiring a nearby girl, and being forced to hold a "loathsome" violin that plays itself without a bow. Her dream literally interrupts the reflective viewing experience demanded by modernism, where the viewer intuits a "universal" meaning through looking at a painting as if she or he is reflected there in identification with the artist. Here this reflection is coyly promised yet partially withheld by the mirror, reflecting only the viewer's cropped torso and the text itself, which slides into a double register as the viewer approaches the piece. The act of reading, itself perhaps a metaphor for the desired attainment of a fixed "meaning" for the art object/lesbian subject, is made difficult—the lesbian narrative and the decapitated body of the viewer her/himself intervene. Another mirror mounted on the wall behind the easel reflects the viewer's disembodied face, splitting the viewing subject into incompatible parts. This second mirror also reflects the empty wooden backing and an untouched wooden palette tucked behind the mock canvas/mirror on the easel, refusing the modernist desire to intuit a "true" meaning of the painterly gesture as discerned in the depths of the canvas itself.

In *Odd Glove* (1990), also from *The Museum of Lesbian Dreams*, a mirror placed under a table shimmeringly reflects the word "well," which is printed in reversed vinyl type on the table's underside so that it reads "correctly" in its reflection (what is "well"? what is not? who decides?). A period lesbian novel, *The Well of Loneliness*, is also referenced, situating lesbianism with its own specific history of cultural representation. And laid nonchalantly on the table, a solitary blue glove—hand-sewn with scalloped trim—symbolizes the *disruptive* power of female to female sexual attraction for the desiring male psyche, as melodramatically narrativized in a text etched around the four brass-covered edges of the table: "he was afraid of her glove/because she had/a certain success/with the woman he wanted." Alone without its reversed mate ("odd glove" was a nineteenth-century euphemism for an unmarried woman), this glove rests provocatively self-sufficiently (or "well"), seemingly complete without its other.

Wilson's concerns are primarily with the exclusivist construction of authorial identities in modernist art history, and the pathologizing and suppression of the lesbian subject that continues in American culture at large. For Philip Pirolo the politics of difference takes on, literally, global proportions. He appropriates erotic paraphernalia generally associated with gay male subcultural practices, aestheticizing them such that the characterization of gay identity as deviant in relation to the heterosexist mythical norm is overturned. Thus, a leather-bound globe hangs limply in a jock-strap-like embrace of chains (in *Bondage Globe*, 1991), subverting the usual nexus of global power relations through an acerbic evocation of the commonly veiled operations of *a different* politics of domination. By displaying the "world" itself within the eroticizing clutches of sexual bondage (its symbolic trappings associated with a particular gay identity formation), Pirolo theatricalizes the usually hidden sce-

narios of male homosexual desire and exposes as well the regulatory codes of
sexual behavior through which power can operate on a micro-level. By impli-
cating and containing the globe in this erotics, Pirolo also reverses the usual,
normative hierarchy of social behaviors: while gay sexuality is commonly sup-
pressed and marginalized from ostensibly universal formulations of western
identity, here it commands global relations.

Pirolo's other globe pieces suggest further ways of reconceptualizing sup-
posedly "global" representations of identity, exposing the narrow ideological
bases of universalizing and prescriptive norms to subvert the western, heter-
osexist bias against gay subjectivity. In his recent *Sphere with Chrome Stand*
(the globe's surface an opaque, milky white) and *Fetish Globe* (a globe covered
in pink velvet), the sporadic patterns that we have come to identify so com-
pletely with geo-politically determined national identities are eliminated. The
smooth white surface of *Sphere* annihilates all images and boundaries to give
the only possible image of a truly "universal" global identity, while the lush
and tactile surface of the "fetishistic" pink velvet globe feminizes and sensual-
izes the usually rigorously and scientifically divided terrain. On tall wooden
pedestals, the two pieces are installed symmetrically across one end of the
gallery a few feet apart. With them, Pirolo transforms the functional and didac-
tic globe, whose impartiality as image/object we normally take for granted, into
pristine or seductively plush aesthetic objects: two balls (with *nothing* in
between).

Pirolo's *Velvet Orifice* and *Hanging Flag* (both of 1991) continue these
suggestive plays with global "identities." The red velvet puckers of the anal
orifice (or is it a glory hole?) penetrate the gallery wall, suggesting that a hid-
den erotic economy resides within the bowels of the art institution itself.
Hanging Flag asserts an aggressive critique of the increasingly reified, bigoted
meaning that the American flag has recently taken on as an empty and flatulent
symbol of our putatively secure identity as a (or the) global superpower.
Pirolo's flag is wadded up and stuffed indecorously into a series of cock rings,
which, like the glory hole and the leather bondage straps, have been mobilized
within a particular gay sexual economy as part of an empowering set of alterna-
tive self-constructions. The long wad hangs limply on its pole, impotently
unable to wave in the hot air of American patriotism.

Pirolo's flag piece is neatly paralleled by Gary Simmons' *Noose Flag*
(1991), a flag pole lined with ominously dangling nooses rather than the famil-
iar, sartorially unified red, white, and blue fabrics. Denying the flag its usual
function—its veiling of the unpleasant ramifications of the politics of differ-
ence—with *Noose Flag*, Simmons evokes the ignominious history of lynching
in the United States. The patriotic banner becomes an illustration of the racist,
homicidal depths to which claims of difference have gone to support the mythi-
cal norm of the American subject.

The menacing message of this ghostly vestige of our most contested
"monument" is given further edge in other recent pieces by Simmons. *Us/*

Them Robes (1991), for example, makes explicit the logic by which the in-group privileges its identity in opposition to a devalued "them." Signaled by the appearance of the robes themselves is the oppositional logic that supports the authority of mainstream, anglo-American culture—where whites are assumed to have superior intelligence and social behavior on the basis of their differentiation from a stereotyped conception of blacks as uneducated and socially primitive. Plush and "monogrammed" in gold with the words "Us" and "Them," the robes are the attributes of affluent yuppies. At the same time, they could also be boxing robes, symbolically allied with the dominant stereotype of African-American culture as primitively pugilist and antagonistic (the current tendency to view urban blacks as perpetrating a wholesale destruction of civilization through gang warfare exemplifies this particular "us" against "them" mentality). As dual signifiers of difference, the robes mark out the oscillating process of differentiation that facilitates the social oppression of blacks through the spurious logic of "separate but equal" ("us" and "them").

This logic of separate spheres is further critiqued in *Fuck Hollywood* (1991), leather shoes on shoe-shine stands in a row along the floor. Over each shoe is draped a shoe-shine cloth embroidered with a racially loaded icon of Hollywood prowess (Elvis, the white imitator of black soul; Al Jolson, who blackfaced in *The Jazz Singer;* D. W. Griffith, creator of the notoriously racist *Birth of a Nation,* etc.). Here Simmons emphasizes that the empowerment of anglo entertainers has come in large part from their arrogation of "hip," marginalized (and so "bohemian") African-American cultural developments such as jazz—a process of exploitation in which the very artistic sources mainstream culture has been responsible for marginalizing are swiftly incorporated into the "center," such that the cultural specificity of these sources is sucked away. The cloths also reference the *other* classes and races of people on whom the Hollywood powerbrokers depend for their privilege—"shoe-shine boys," particularly working class blacks excluded from the roles inhabited by the members of the in-group through the politics of difference.

Who is on the margins? Who is in the center? Why—if our cultural identity is being reconfigured as I have argued here—are the politics of difference still so active, repressive and exclusionary practices still so common?

The critical force of the work I've discussed here gives me the optimism to suggest that the ongoing operations of the politics of difference—the blatant persistence of exclusionary discursive models and institutional structures of racist, homophobic, classist, and sexist acts, representations, and attitudes in American culture—does not signal a regression to a pre-1960s acceptance of a repressive norm. Rather, these continuing operations can be viewed in a positive sense as evidence of the *success* of the ongoing critique of exclusionary ideologies of difference underlying normative definitions of American identity. As Russell Ferguson has recently argued, the "need to enforce values which are at the same time alleged to be 'natural' (for example, the "mythical norm"

of the straight white male) demonstrates the insecurity of a center which could at one time take its own power much more for granted. . . . No longer can whiteness, maleness or heterosexuality be taken as the ubiquitous paradigm, simultaneously center and boundary."[13]

The increasing hysteria of the political and intellectual right can in this light be viewed as a *reaction formation* against the very confusions of identity promulgated by the collapse of the mythical norm in actual lived experience in this country. The power of these artists' works, and their importance for us today, lies at least in part in their ability to expose the notion of a "unified" American subject as a regressive and increasingly inaccurate fantasy, and to play out and exacerbate the actual demographic dissolution of this mythical norm of American identity.

At the same time, we must be aware that these multiplicitous alternative identities, once written about, as here, are necessarily already incorporated into a new, if *different*, politics of difference—where difference is privileged rather than suppressed or mobilized in the services of discrimination. Artists and writers articulating and playing out non-normative identities must continually renegotiate their siting within this politics, continually questioning the recuperative inclusions of their alternative expressions and identities into a "mainstream" of privileged cultural practices such that the *other* doesn't simply become yet another mainstream with its own particular exclusions. Through this continual negotiation (which will involve the continual opening out of difference *as a process*), the very structures and strategies by which cultural histories and norms are constructed—through inevitable recourse to newly constructed centers, with their inevitable margins—can be contested and refigured.

Notes

1. The term "American" itself has operated to shore up the fantasy of "unified" identity. Posed as an open term, in practice it refers most often to citizens of the United States (most commonly understood to be the descendants of anglo-European settlers) and negates the existence of Native Americans, Canadians, Central and South Americans, etc.
2. Audre Lorde, "Age, Race, Class, and Sex: Women Redefining Difference," (1984), reprinted in *Out There: Marginalization and Contemporary Cultures*, ed. Russell Ferguson, Martha Gever, Trinh T. Minh-ha, Cornel West (New York: New Museum of Contemporary Art, and Cambridge and London: MIT Press, 1990), 282.
3. Laura Mulvey, "Visual Pleasure and Narrative Cinema," *Screen* 16, n. 3 (Autumn 1975), 6–18. Stephen Heath, "Difference," *Screen* 19, n. 3 (Autumn 1978), 50–112. In feminist theory, it is conventional to employ the terms "masculine" and "feminine" to describe culturally constructed gender identities; "male" and "female" would apply to the actual, biologically sexed subject.
4. Jacqueline Rose, "Sexuality in the Field of Vision," *Difference: On Representation and Sexuality* (New York: New Museum of Contemporary Art, 1985), 31.
5. Michael Warner, "Homo-Narcissism; or, Heterosexuality," *Engendering Men: The Question of Male Feminist Criticism*, ed. Joseph A. Boone and Michael Cadden (New York and London: Routledge, 1990), 201–202.

6. With *différance*, Derrida deliberately misspells the French word for difference (*"difference"*) to push the word away from signifying anything easily fixable. *Différance* indicates a complex web of interrelated concepts:

> *"différance* [is] the movement according to which language, or any code, any system of referral in general, is constituted 'historically' as a weave of differences"; it is a process involving both *difference (différence)* and *deferral (différer* meaning to temporize or delay). It suggests a continual play of differences: "Essentially and lawfully, every concept is inscribed in a chain or in a system within which it refers to the other, to other concepts, by means of the systematic play of differences." Most importantly, *différance* lets us "know" that there is no fixed norm or "master," but only a center that must continually be propped up, reinforced, and redefined to retain its centrality: "What we know . . . is that there has never been, never will be, a unique word, a master-name." Jacques Derrida, *"Différance"* (1968), tr. Alan Bass, *Critical Theory Since 1965*, ed. Hazard Adams and Leroy Searle (Tallahassee: Florida State University Press, 1986), 126, 123, 136.

It is this propping up that I am examining here as the politics of difference.

7. Homi Bhabha, "Remembering Fanon: Self, Psyche, and the Colonial Condition" (1986), reprinted in *Remaking History*, Dia Art Foundation Discussions in Contemporary Culture, Number 4, ed. Barbara Kruger and Phil Mariani (Seattle: Bay Press, 1989), 139. Teresa de Lauretis has also argued this point, praising Audre Lorde's formulation of this new understanding of subjectivity: "[n]either race nor gender nor homosexual difference alone can constitute individual identity as the basis for a theory and a politics of social change. What Lorde suggests is a more complex image of the psycho-socio-sexual subject. . . ." Teresa de Lauretis, "Sexual Indifference and Lesbian Representation," *Theatre Journal* 40, n. 2 (May 1988), 164; de Lauretis is drawing on the ideas Lorde discusses in her book, *Zami: A New Spelling of My Name* (Trumansburg, New York: The Crossing Press, 1982).

8. As Lesko herself has put it, "I'm a visual artist seduced by the language of aesthetics . . . representing my subjectivity in concrete form [and attempting to reintegrate] mind and body [by contesting] the psychoanalytic division of mind from body," from her statement given at Artists' Symposium for the exhibition "The Politics of Difference," University of California, Riverside, February 20, 1992.

9. These are the standardized terms of sexual difference outlined by Laura Mulvey in "Visual Pleasure and Narrative Cinema." Mulvey draws heavily on Freudian theory to define the dynamic of viewing that characterizes the classic Hollywood film where, she argues, the female characters in the film are represented as passive sexual objects for the active, scopophilic or fetishizing, male gaze. Many feminist theorists have critiqued Mulvey's theory for fixing too rigidly the viewer/viewed, subject/object, masculine/feminine positions of subjectivity; in a sense Lesko's work operates within this more recent critical dialogue, since it takes issue with the post-Freudian construction of difference along rigid poles of sexual identity.

10. Sigmund Freud, "Femininity" (1933), *The Standard Edition of the Complete Psychological Works of Sigmund Freud*, v. 22, tr. and ed. James Strachey (London: Hogarth Press, 1964), 132. Jacques Derrida promotes an alternative understanding of veiling in his reading of Nietzsche, *Spurs: Nietzsche's Styles* (1978), tr. Barbara Harlow (Chicago: University of Chicago Press, 1979). Here, Derrida suggests that the veiling of women "around the apotropaic anxiety" (her "lack" according to the male subject's notions of completion), is paralleled by the veiling of the penis itself (to make it *seem to be* the phallus, the necessarily hidden symbol of power in Western culture): "It is the oblongi—foliated point (a spur . . .) which derives its apotropaic power from the taut, resistant tissues, webs, sails and veils which are erected, furled and unfurled around it" (41).

11. Freud, "Femininity," 131, 132.

12. Millie Wilson, statement given at Artists' Symposium for the exhibition "The Politics of Difference," University of California, Riverside, February 20, 1992; and Wilson, "The Theoretical Closet," *all but the obvious*, catalogue (Los Angeles: Los Angeles Contemporary Exhibitions, 1990), 16.

13. Russell Ferguson, "Introduction: Invisible Center," in *Out There*, p. 10.

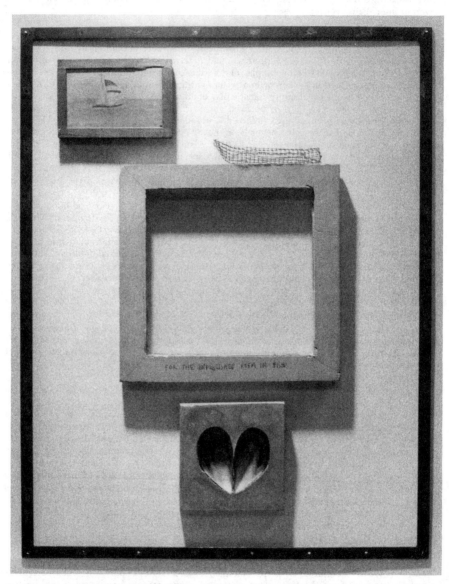

ALI ACEROL, *For the Unpublished Poem in Fish.* 1992 Mixed media: steel, wood, concrete. 3′ x 2′

Courtesy of the artist.

On the Question of
Teaching a Dentist to Shave

John Brumfield

Photographer John Brumfield addresses the responsibility of art programs to do more than merely assimilate students into the art subculture. Brumfield urges that in addition to teaching art mores and manners, instructors initiate serious critical examination of values beyond prevailing fashion—in particular the function of art in contemporary society and the processes for determining its meaning and truth.

Generally speaking, most art programs emphasize either commercial or fine art: there's lots of overlapping of course, but the range of current practice is pretty well defined within the extremes implied by those two categories. At one end of a hypothetical continuum you have the School of the Art Institute of Chicago, or the San Francisco Art Institute or CalArts—schools that are devoted almost exclusively to high art concerns, and, at the other pole, you have such institutions as Parsons, the Art Institute of Houston, the Rochester Institute of Technology, and even the Brooks Institute, A School of Photographic Arts and Sciences—high-tech training centers into which kids enroll, fresh out of high school, wanting to be Frank Frazetta or Calvin Klein, wanting to make $10,000 a minute or become the design head at General Motors or do a lot of slurp-flash album covers and be—if you will—the Queen of the Now. When they get to a place like that, a place whose curriculum and track record promises a legitimate shot at that kind of box office, what they are indeed taught is how to *do* that. The mechanicals, of course. And of course also, the

Excerpted from John Brumfield, "On the Question of Teaching a Dentist to Shave," *Afterimage* (November 1982).

post-puberty socialization required of all initiates entering a professional fraternity.

Classes are so structured that they are not exposed to much else. Certainly not to ideas. One learns when to use a blue marker and what to do with an airbrush and precisely how to handle a full range of filters and gels—all the latest techniques for making candies or cars or contraceptives more beautiful than real, how to improve on a model's drape or a president's underbite—for the core of the curriculum is based on the practical necessity of mastering a technology to perfection.

Isn't there a de facto philosophy of art buried here? Sure. But it's incidental to the more pervasive ideology of superficial professionalism; for these are, all of them, training camps to which come an apparently endless wave of recruits equipped, often enough, with little more than a shapeless ambition, and it is the function of the school to provide the appropriate shape. Given the society, that's an imperative of survival, the necessary *modus operandi* of access.

Nor should we be too quick to condemn, for it's awfully hard—speaking of the bitch and moan theory that Paul Berger alludes to—to find a place in our society where you don't have to go to bed with grimy hands. All of us are involved in something that is paid for by money that originates—that enters the market—elsewhere; the Sancta Sanctora of High Art are no exception. We are all familiar with the image from *The Americans*, the school of art captioned *Salt Lake City, Utah*, perhaps by implication itself a temple of salvation, surely of truth and beauty; but positioned as precisely as it is in Frank's carefully constructed sequence, the school is also a specifically stratified element of the socio-political hierarchy. It is embedded in the support system of prestige and privilege.

And it is specific. Like every other trade, professional, or business school, the fine arts programs of all western societies operate in response to a client-market base, for which the "art world," an essentially mediating superstructure, is, in this respect, an organically fluid service community. Functioning to signal, accommodate, and rationalize the expectations of the client class, the art world is the model against whose various sub-categories the fine arts institution judges itself. Thus the art curriculum of any given school is a mirror, not of the incremental nature of art, nor—as is popularly supposed—of the market, but rather of one or more administrator's perceptions of the dynamics of the current complex *in which* the market system finds itself. Essentially sociological, these need not be especially analytical perceptions. For the task is simply to see where one fits in the scheme of things. Within the dominant culture.

In this milieu an art of rigorous discourse, of exposition, of issues scrupulously examined, is simply unwelcome, and it is not surprising that in most art schools it is a commonplace that such art either cannot exist or must be propaganda. And insofar as our educations have been limited to fine arts curricula,

this seems likely to be the case. Because like dentists, we have been *professionally educated*. We are narrowly well-informed, acculturated, and appropriately superficial; and while our fine arts educations have failed—at every juncture—to address even the rudiments of intellectual discipline or critical integrity, they have, at all the better schools, provided us with an abundance of professionally acceptable response patterns. For a typical fine arts curriculum is comprised, usually, of about one-third of the craft content of the trade school to two-thirds catechism: critique "situations" in which the matriculating neophyte adopts a vocabulary and a rhetorical stance signifying the attainment of true seriousness. Indeed, what our students are really learning from the profoundly educational process that might be called the deep syntax of the art school is how to fit. How to fit. How to be an acceptable—preferably esteemed—member of a fringe mandarin elite: how to assimilate into the behavioral modalities modeled before them by their teachers great and small. How to fit. How to move, how to dress, how to talk, how to think, and of course how to make an image that is patently within the canons of the high art sub-culture. If the essential bourgeois illusion is freedom, the essential illusion of the artist is significant self-expression. Because the choices by which art is made are far more arbitrary than is commonly pretended. We conform. We no longer do street photography, carve in blue marble, paint religious subjects in cathedral settings, or model cowboys in red bronze because these are all passé—for a variety of reasons. They are tired, trite, out of touch, corny, irrelevant, limited, and dated; and so, of course, is the imagery of last year's *Artforum*. There is, as we all know, nothing so retrograde as being merely recent. One must be on the money.

That's why it's important to recognize that there's a lot of teaching going on that goes on underneath the surface, and that teaching is really about assimilation into a sub-cultural value system: about the techniques and modalities of fraternal acculturation, not how to examine, analyze, or even evaluate beyond the clearly cued parameters of prevailing fashion. And while I doubt that one M.F.A. in 20 (50) can outline a set of criteria leading to a definition of "good art" that is sensible to anyone not already conversant with the jargon, my more emphatic point is that the structure—the system—of contemporary art education, fine and applied, simply cannot tolerate the introduction of critical discourse on any but the most parochially academic levels of sophistication.

To seriously examine art making as a pre-eminently behavioral activity, to rigorously consider the relative significance of art as an ongoing aspect of intellectual history, or to ask that the visual arts compete, *for serious attention*, in the world of ideas—such expectations are unbearable.

For while we may indeed pay enormous lip service to the litany that art is the means by which culture perpetuates its deepest values and transmits its subtlest insights, we are so far from truly believing this that it plays no active part in our private or professional assessments, our critical literature, or even in those magazine and newspaper reviews through which we daily translate the

latest developments in art into the language of the presumably educated layman. Moreover, to ask what it is we know when we have ostensibly enjoyed the opportunity to draw upon the new insights and perceptions of a fresh work of art or, further, to ask what an image means, is often to do no more than be awkwardly embarrassing. For in most cases we really don't know. The work of art—by Joel Witkin, Bart Parker, or Patrick Nagatani—may indeed suggest, point, connote, or imply in all kinds of relatively specific directions, but as to what it actually signifies, most of us really can't say. We may talk about the high seriousness of art, and cluck proudly at the superiority of sensibility that its apprehension represents, but exactly how to bring that superiority out of the ideal world of the ineffable and into the arena of knowledge and communicable meaning so that it may have something of a truly visceral significance, that is a problem for which we have developed too few tools.

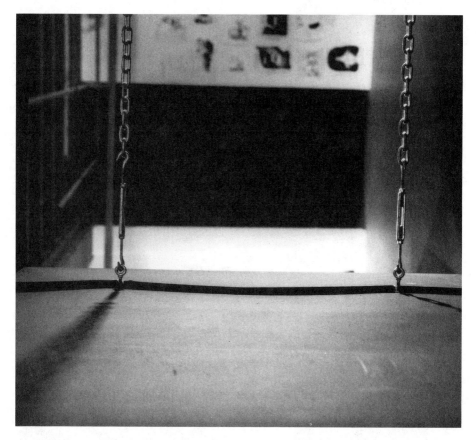

LIZ LARNER, *Chain Perspective (Reversed, Reflected, Extended).* 1992 (Detail from *Helter Skelter* at The Museum of Contemporary Art, Los Angeles.) Steel chain, steel columns, hardware, mirror, paint

Courtesy of Stuart Regen Gallery and 303 Gallery, Los Angeles.

Function of the Museum

Daniel Buren

In his influential work and writing, artist Daniel Buren has directed attention to the institutional framework within which artworks are displayed—a framework obscured by modernism's emphasis on the self-sufficiency of the artwork. The museum preserves art, reinforcing the idea of the masterpiece; the museum collects work, thereby making an economically motivated distinction between work which is and is not successful. The museum also serves as a refuge, isolating work and placing it in an idealistic and illusory removal from actual political and economic conditions.

Privileged place with a triple role:

1. *Aesthetic.* The Museum is the frame and effective support upon which the work is inscribed/composed. It is at once the centre in which the action takes place and the single (topographical and cultural) viewpoint for the work.
2. *Economic.* The Museum gives a sales value to what it exhibits, has privileged/selected. By preserving or extracting it from the commonplace, the Museum promotes the work socially, thereby assuring its exposure and consumption.
3. *Mystical.* The Museum/Gallery instantly promotes to "Art" status what it exhibits with conviction, i.e. habit, thus diverting in advance any attempt to question the foundations of art without taking into consideration the place from which the question is put. The Museum (the Gallery) constitutes the mystical body of Art.

This statement is an extract from a text written in October, 1970. It was to be the third part—"Le Donne"—of the text "Position—Proposition" published by the Museum of Mönchen-Gladbach in January 1971, the two others being "Standpoints" and "Critical Limits." This was first published by the Museum of Modern Art, Oxford, England for Buren's show, March 31–April 15, 1973. Reprinted by permission of the author.

It is clear that the above three points are only there to give a general idea of the Museum's role. It must be understood that these roles differ in intensity depending on the Museums (Galleries) considered, for sociopolitical reasons (relating to art or more generally to the system).[1]

I. Preservation

One of the initial (technical) functions of the Museum (or Gallery) is preservation. (Here a distinction can be made between the Museum and the Gallery although the distinction seems to be becoming less clear-cut: the former generally buys, preserves, collects, in order to exhibit; the latter does the same in view of resale.) This function of preservation perpetuates the idealistic nature of all art since it claims that art is (could be) eternal. This idea, among others, dominated the 19th century, when public museums were created approximately as they are still known today.

Painted things are generally attitudes, gestures, memories, copies, imitations, transpositions, dreams, symbols . . . set/fixed on the canvas arbitrarily for an indefinite period of time. To emphasize this illusion of eternity or timelessness, one has to preserve the work itself (physically fragile: canvas, stretcher, pigments etc.) from wear. The Museum was designed to assume this task, and by appropriate artificial means to preserve the work, as much as possible, from the effects of time—work which would otherwise perish far more rapidly. It was/is a way—another—of obviating the temporality/fragility of a work of art by artificially keeping it "alive," thereby granting it an appearance of immortality which serves remarkably well the discourse which the prevalent bourgeois ideology attaches to it. This takes place, it should be added, with the author's, i.e., the artist's delighted approval.

Moreover, this conservatory function of the Museum, which reached its highest point during the 19th century and with Romanticism, is still generally accepted today, adding yet another paralysing factor. In fact nothing is more readily preserved than a work of art. And this is why 20th century art is still so dependent on 19th century art since it has accepted, without a break, its system, its mechanisms and its function (including Cézanne and Duchamp) without revealing one of its main alibis, and furthermore accepting the exhibition framework as self-evident. We can once again declare that the Museum makes its "mark," imposes its "frame" (physical and moral) on everything that is exhibited in it, in a deep and indelible way. It does this all the more easily since *everything that the Museum shows is only considered and produced in view of being set in it.*

Every work of art already bears, implicitly or not, the trace of a gesture, an image, a portrait, a period, a history, an idea . . . and is subsequently preserved (as a souvenir) by the Museum.

II. Collection

The Museum not only preserves and therefore perpetuates, but also collects. The aesthetic role of the Museum is thus enhanced since it becomes the single viewpoint (cultural and visual) from which works can be considered, an enclosure where art is born and buried, crushed by the very frame which presents and constitutes it. Indeed, collecting makes simplifications possible and guarantees historical and psychological weight which reinforces the predominance of the support (Museum/Gallery) inasmuch as the latter is ignored. In fact, the Museum/Gallery has a history, a volume, a physical presence, a cultural weight quite as important as the support on which one paints, draws. (By extension, this naturally applies to any sculpted material, transported object or discourse inscribed in the Museum.) On another level, let us say social, collecting serves to display different works together, often very unalike, from different artists. This results in creating or opposing different "schools"/ "movements" thereby cancelling certain interesting questions lost in an exaggerated mass of answers. The collection can also be used to show a single artist's work, thus producing a "flattening" effect to which the work aspired anyway, having been exclusively conceived—willingly or not—in view of the final collection.

In summary, the collection in a Museum operates in two different but parallel ways, depending on whether one considers a group or a one-man show.[2]

A) In the case of a confrontation of works by different artists the Museum imposes an amalgam of unrelated things among which chosen works are emphasized. These chosen works are given an impact which is only due to their context—collection. Let it be clear that the collection we are speaking of and the selection it leads to are obviously economically motivated. The Museum collects the better to isolate. But this distinction is false as the collection forces into comparison things that are often incomparable, consequently producing a discourse which is warped from the start, and to which no one pays attention (cf. "Beware!" Introduction).

B) In collecting and presenting the work of a single artist (one-man show) the Museum stresses differences within a single body of work and insists (economically) on (presumed) successful works and (presumed) failures. As a result, such shows set off the "miraculous" aspect of "successful" works. And the latter therefore also give a better sales value to juxtaposed weaker works. This is the "flattening" effect we mentioned above, the aim of which is both cultural and commercial.

III. Refuge

The above considerations quite naturally lead to the idea, close to the truth, that the Museum acts as a refuge. And that without this refuge, no work can "exist." The Museum is an asylum. The work set in it is sheltered from the

weather and all sorts of dangers, and most of all protected from any kind of questioning. The Museum selects, collects and protects. All works of art are made in order to be selected, collected and protected (*among other things from other works which are, for whatever reason, excluded from the Museum*). If the work takes shelter in the Museum-refuge, it is because it finds there its comfort and its frame; a frame which one considers as natural, while it is merely historical. That is to say, a frame necessary to the works set in it (necessary to their very existence). This frame does not seem to worry artists who exhibit continually without ever considering the problem of the place in which they exhibit.

Whether the place in which the work is shown imprints and marks this work, whatever it may be, or whether the work itself is directly—consciously or not—produced for the Museum, any work presented in that framework, if it does not explicitly examine the influence of the framework upon itself, falls into the illusion of self-sufficiency—or idealism. This idealism (which could be compared to Art for Art's sake) shelters and prevents any kind of break.[3]

. . . . In fact every work of art inevitably possesses one or several extremely precise frames. The work is always limited in time as well as in space. By forgetting (purposefully) these essential facts one can pretend that there exists an immortal art, an eternal work. . . . And one can see how this concept and the mechanisms used to produce it—among other things the function of the Museum as we have very rapidly examined it—place the work of art once and for all above all classes and ideologies. The same idealism also points to the eternal and apolitical Man which the prevalent bourgeois ideology would like us to believe in and preserve.

The non-visibility or (deliberate) non-indication/revelation of the various supports of any work (the work's stretcher, the work's location, the work's frame, the work's stand, the work's price, the work's verso or back etc. . . .) are therefore neither fortuitous nor accidental as one would like us to think.

What we have here is a careful camouflage undertaken by the prevalent bourgeois ideology, assisted by the artists themselves. A camouflage which has until now made it possible to transform "the reality of the world into an image of the world, and History into Nature."

Notes

1. It must be quite clear that when we speak of "the Museum" we are also referring to all types of "galleries" in existence and all other places which claim to be cultural centres. A certain distinction between "museum" and "gallery" will be made below. However the impossibility of escaping the concept of cultural location must also be stressed.

2. We are here referring more particularly to contemporary art and its profusion of exhibitions.

3. A detailed demonstration of the various limits and frames which generally constitute a work of art—painting, sculpture, object, ready-made, concept . . .—has been removed for technical reasons from the original text. However this subject matter can be found in other texts already published, such as: "Critical Limits," Paris, October 1970; "Around and about," *Studio International*, June, 1971; "Beware," *Studio International*, March 1970; "Standpoints," *Studio International*, April, 1971; "Exposition d'une exposition," *Documenta V catalogue*.

The Event

Allan Kaprow

The first "Happenings" of Allan Kaprow, Claes Oldenburg, Robert Whitman and others in the late fifties and early sixties appropriated the action from Action Painting to engage in direct confrontation with an audience which, ideally, became participants. In his book *Assemblage, Environments and Happenings*, from which this excerpt is taken, Kaprow outlines the informal rules for bypassing theatrical conventions which guided his early work. He consciously broke down modernism's rigid distinction between art and life by deriving the sources for his performances from any place except the arts. His rules disengage theatrical notions of space, time, and audience through the decreased use of physical frames—a stage, an announcement, a gallery—and the increased use of mental frames or attitudes to distinguish performances from other events. Kaprow's experiments with what he subsequently called "lifelike art" paralleled those of artists such as Dick Higgins, Alison Knowles, George Maciunas, and Wolf Vostell.

It was repeatedly clear with each Happening that in spite of the unique imagery and vitality of its impulse, the traditional staging, if it did not suggest a "crude" version of the avant-garde Theater of the Absurd, at least smacked of night club acts, side shows, cock fights and bunkhouse skits. Audiences seemed to catch these probably unintended allusions and so took the Happenings for charming diversions, but hardly for art or even purposive activity. Night club acts can of course be more than merely diverting, but their structure or "grammar" is usually hackneyed and, as such, is detrimental to experimentation and change.

Unfortunately, the fact that there was a tough nut to crack in the Happenings seems to have struck very few of its practitioners. Even today, the

Excerpted from Allan Kaprow, *Assemblage, Environments and Happenings* (New York: Harry N. Abrams, 1966).

majority continues to popularize an art of "acts" which often is well-done enough but fulfills neither its implications nor strikes out in uncharted territory.

But for those who sensed what was at stake, the issues began to appear. It would take a number of years to work them out by trial and error, for there is sometimes, though not always, a great gap between theory and production. But gradually a number of rules-of-thumb could be listed:

(A) *The line between art and life should be kept as fluid, and perhaps indistinct, as possible.* The reciprocity between the man-made and the ready-made will be at its maximum potential this way. Something will always happen at this juncture, which, if it is not revelatory, will not be merely bad art—for no one can easily compare it with this or that accepted masterpiece. I would judge this a foundation upon which may be built the specific criteria of the Happenings.

(B) *Therefore, the source of themes, materials, actions, and the relationships between them are to be derived from any place or period* except *from the arts, their derivatives, and their milieu.* When innovations are taking place it often becomes necessary for those involved to treat their tasks with considerable severity. In order to keep their eyes fixed solely upon the essential problem, they will decide that there are certain "don'ts" which, as self-imposed rules, they will obey unswervingly. Arnold Schoenberg felt he had to abolish tonality in music composition and, for him at least, this was made possible by his evolving the twelve-tone series technique. Later on his more academic followers showed that it was very easy to write traditional harmonies with that technique. But still later, John Cage could permit a C major triad to exist next to the sound of a buzz saw, because by then the triad was thought of differently—not as a musical necessity but as a sound as interesting as any other sound. This sort of freedom to accept all kinds of subject matter will probably be possible in the Happenings of the future, but I think not for now. Artistic attachments are still so many window dressings, unconsciously held onto to legitimize an art that otherwise might go unrecognized.

Thus it is not that the known arts are "bad" that causes me to say "Don't get near them"; it is that they contain highly sophisticated habits. By avoiding the artistic modes there is the good chance that a new language will develop that has its own standards. The Happening is conceived as an art, certainly, but this is for lack of a better word, or one that would not cause endless discussion. I, personally, would not care if it were called a sport. But if it is going to be thought of in the context of art and artists, then let it be a distinct art which finds its way into the art category by realizing its species outside of "culture." A United States Marine Corps manual on jungle-fighting tactics, a tour of a laboratory where polyethylene kidneys are made, the daily traffic jams on the

Long Island Expressway, are more useful than Beethoven, Racine, or Michelangelo.

(C) *The performance of a Happening should take place over several widely spaced, sometimes moving and changing locales.* A single performance space tends toward the static and, more significantly, resembles conventional theater practice. It is also like painting, for safety's sake, only in the center of a canvas. Later on, when we are used to a fluid space as painting has been for almost a century, we can return to concentrated areas, because then they will not be considered exclusive. It is presently advantageous to experiment by gradually widening the distances between the events within a Happening. First along several points on a heavily trafficked avenue; then in several rooms and floors of an apartment house where some of the activities are out of touch with each other; then on more than one street; then in different but proximate cities; finally all around the globe. On the one hand, this will increase the tension between the parts, as a poet might by stretching the rhyme from two lines to ten. On the other, it permits the parts to exist more on their own, without the necessity of intensive coordination. Relationships cannot help being made and perceived in any human action, and here they may be of a new kind if tried-and-true methods are given up.

Even greater flexibility can be gotten by moving the locale itself. A Happening could be composed for a jetliner going from New York to Luxembourg with stopovers at Gander, Newfoundland, and Reykjavik, Iceland. Another Happening would take place up and down the elevators of five tall buildings in midtown Chicago.

The images in each situation can be quite disparate: a kitchen in Hoboken, a *pissoir* in Paris, a taxi garage in Leopoldville, and a bed in some small town in Turkey. Isolated points of contact may be maintained by telephone and letters, by a meeting on a highway, or by watching a certain television program at an appointed hour. Other parts of the work need only be related by theme, as when all locales perform an identical action which is disjoined in timing and space. But none of these planned ties are absolutely required, for preknowledge of the Happening's cluster of events by all participants will allow each one to make his own connections. This, however, is more the topic of form, and I shall speak further of this shortly.

(D) *Time, which follows closely on space considerations, should be variable and discontinuous.* It is only natural that if there are multiple spaces in which occurrences are scheduled, in sequence or even at random, time or "pacing" will acquire an order that is determined more by the character of movements within environments than by a fixed concept of regular development and conclusion. There need be no rhythmic coordination between the several parts of a Happening unless it is suggested by the event itself: such as when two persons must meet at a train departing at 5:47 P.M.

Above all, this is "real" or "experienced" time as distinct from conceptual time. If it conforms to the clock used in the Happening, as above, that is legitimate, but if it does not because a clock is not needed, that is equally legitimate. All of us know how, when we are busy, time accelerates, and how, conversely, when we are bored it can drag almost to a standstill. Real time is always connected with doing something, with an event of some kind, and so is bound up with things and spaces.

Imagine some evening when one has sat talking with friends, how as the conversation became reflective the pace slowed, pauses became longer, and the speakers "felt" not only heavier but their distances from one another increased proportionately, as though each were surrounded by great areas commensurate with the voyaging of his mind. Time retarded as space extended. Suddenly, from out on the street, through the open window a police car, siren whining, was heard speeding by, *its* space moving as the source of sound moved from somewhere to the right of the window to somewhere farther to the left. Yet it also came spilling into the slowly spreading vastness of the talkers' space, invading the transformed room, partly shattering it, sliding shockingly in and about its envelope, nearly displacing it. And as in those cases where sirens are only sounded at crowded street corners to warn pedestrians, the police car and its noise at once ceased and the capsule of time and space it had become vanished as abruptly as it made itself felt. Once more the protracted picking of one's way through the extended reaches of mind resumed as the group of friends continued speaking.

Feeling this, why shouldn't an artist program a Happening over the course of several days, months, or years, slipping it in and out of the performers' daily lives. There is nothing esoteric in such a proposition, and it may have the distinct advantage of bringing into focus those things one ordinarily does every day without paying attention—like brushing one's teeth.

On the other hand, leaving taste and preference aside and relying solely on chance operations, a completely unforeseen schedule of events could result, not merely in the preparation but in the actual performance; or a simultaneously performed single moment; or none at all. (As for the last, the act of finding this out would become, by default, the "Happening.")

But an endless activity could also be decided upon, which would apparently transcend palpable time—such as the slow decomposition of a mountain of sandstone. . . . In this spirit some artists are earnestly proposing a lifetime Happening equivalent to Clarence Schmidt's lifetime Environment.

The common function of these alternatives is to release an artist from conventional notions of a detached, closed arrangement of time-space. A picture, a piece of music, a poem, a drama, each confined within its respective frame, fixed number of measures, stanzas, and stages, however great they may be in their own right, simply will not allow for breaking the barrier between art and life. And this is what the objective is.

(E) *Happenings should be performed once only.* At least for the time being, this restriction hardly needs emphasis, since it is in most cases the only course possible. Whether due to chance, or to the lifespan of the materials (especially the perishable ones), or to the changeableness of the events, it is highly unlikely that a Happening of the type I am outlining could ever be repeated. Yet many of the Happenings have, in fact, been given four or five times, ostensibly to accommodate larger attendances, but this, I believe, was only a rationalization of the wish to hold on to theatrical customs. In my experience, I found the practice inadequate because I was always forced to do that which *could be repeated,* and had to discard countless situations which I felt were marvelous but performable only once. Aside from the fact that repetition is boring to a generation brought up on ideas of spontaneity and originality, to repeat a Happening at this time is to accede to a far more serious matter: compromise of the whole concept of Change. When the practical requirements of a situation serve only to kill what an artist has set out to do, then this is not a practical problem at all; one would be very practical to leave it for something else more liberating.

Nevertheless, there is a special instance of where more than one performance is entirely justified. This is the score or scenario which is designed to make every performance significantly different from the previous one. Superficially this has been true for the Happenings all along. Parts have been so roughly scored that there was bound to be some margin of imprecision from performance to performance. And, occasionally, sections of a work were left open for accidentals or improvisations. But since people are creatures of habit, performers always tended to fall into set patterns and stick to these no matter what leeway was given them in the original plan.

In the near future, plans may be developed which take their cue from games and athletics, where the regulations provide for a variety of moves that make the outcome always uncertain. A score might be written, so general in its instructions that it could be adapted to basic types of terrain such as oceans, woods, cities, farms; and to basic kinds of performers such as teenagers, old people, children, matrons, and so on, including insects, animals, and the weather. This could be printed and mail-ordered for use by anyone who wanted it. George Brecht has been interested in such possibilities for some time now. His sparse scores read like this:

DIRECTION

Arrange to observe a sign
indicating direction of travel.

- Travel in the indicated direction
- Travel in another direction

But so far they have been distributed to friends, who perform them at their discretion and without ceremony. Certainly they are aware of the philosophic allusions to Zen Buddhism, of the subtle wit and childlike simplicity of the activities indicated. Most of all, they are aware of the responsibility it places on the performer to make something of the situation or not.

This implication is the most radical potential in all of the work discussed here. Beyond a small group of initiates, there are few who could appreciate the moral dignity of such scores, and fewer still who could derive pleasure from going ahead and doing them without self-consciousness. In the case of those Happenings with more detailed instructions or more expanded action, the artist must be present at every moment, directing and participating, for the tradition is too young for the complete stranger to know what to do with such plans if he got them.

(F) *It follows that audiences should be eliminated entirely.* All the elements—people, space, the particular materials and character of the environment, time—can in this way be integrated. And the last shred of theatrical convention disappears. For anyone once involved in the painter's problem of unifying a field of divergent phenomena, a group of inactive people in the space of a Happening is just dead space. It is no different from a dead area of red paint on a canvas. Movements call up movements in response, whether on a canvas or in a Happening. A Happening with only an empathic response on the part of a seated audience is not a Happening but stage theater.

Then, on a human plane, to assemble people unprepared for an event and say that they are "participating" if apples are thrown at them or they are herded about is to ask very little of the whole notion of participation. Most of the time the response of such an audience is half-hearted or even reluctant, and sometimes the reaction is vicious and therefore destructive to the work (though I suspect that in numerous instances of violent reaction to such treatment it was caused by the latent sadism in the action, which they quite rightly resented). After a few years, in any case, "audience response" proves to be so predictably pure cliché that anyone serious about the problem should not tolerate it, any more than the painter should continue the use of dripped paint as a stamp of modernity when it has been adopted by every lampshade and Formica manufacturer in the country.

I think that it is a mark of mutual respect that all persons involved in a Happening be willing and committed participants who have a clear idea what they are to do. This is simply accomplished by writing out the scenario or score for all and discussing it thoroughly with them beforehand. In this respect it is not different from the preparations for a parade, a football match, a wedding, or religious service. It is not even different from a play. The one big difference is that while knowledge of the scheme is necessary, professional talent is not; the situations in a Happening are lifelike or, if they are unusual, are so rudimentary that professionalism is actually uncalled for. Actors are stage-trained

and bring over habits from their art that are hard to shake off; the same is true of any other kind of showman or trained athlete. The best participants have been persons not normally engaged in art or performance, but who are moved to take part in an activity that is at once meaningful to them in its ideas yet natural in its methods.

There is an exception, however, to restricting the Happening to participants only. When a work is performed on a busy avenue, passers-by will ordinarily stop and watch, just as they might watch the demolition of a building. These are not theater-goers and their attention is only temporarily caught in the course of their normal affairs. They might stay, perhaps become involved in some unexpected way, or they will more likely move on after a few minutes. Such persons are authentic parts of the environment.

A variant of this is the person who is engaged unwittingly with a performer in some planned action: a butcher will sell certain meats to a customer-performer without realizing that he is a part of a piece having to do with purchasing, cooking, and eating meat.

Finally, there is this additional exception to the rule. A Happening may be scored for *just watching*. Persons will do nothing else. They will watch things, each other, possibly actions not performed by themselves, such as a bus stopping to pick up commuters. This would not take place in a theater or arena, but anywhere else. It could be an extremely meditative occupation when done devotedly; just "cute" when done indifferently. In a more physical mood, the idea of called-for watching could be contrasted with periods of action. Both normal tendencies to observe and act would now be engaged in a responsible way. At those moments of relative quiet the observer would hardly be a passive member of an audience; he would be closer to the role of a Greek chorus, without its specific meaning necessarily, but with its required place in the overall scheme. At other moments the active and observing roles would be exchanged, so that by reciprocation the whole meaning of watching would be altered, away from something like spoon-feeding, toward something purposive, possibly intense. . . .

ANN HAMILTON, *The Capacity of Absorption.* **Installation at the Temporary Contemporary, The Museum of Contemporary Art, Los Angeles, December 13, 1988– February 26, 1989.**

Courtesy of Ann Hamilton, Louver Gallery, New York.

A Profusion of Substance

Buzz Spector

Presenting a brief history of the use of organic substances in recent art, artist and critic Buzz Spector highlights the excess and ecstasy in much of the work. From Beuys' transformations to Laib's "shamanistic discipline"; from Rona Pondick's excremental and phallic masses to Ann Hamilton's "reveries of pleasure," the work Spector describes disturbs simple rules or systems of order. The overwhelming profusion violates "both the social and the artistic order" and invites the spectator to experience startling visual and conceptual discontinuities.

I propose a feast for the eyes, sumptuous, multiplictious, and occasionally disgusting. This is a banquet of works of art that include milk, rice, bread, vegetables, piles of fat, carpets of pollen, sheets of wax or chocolate, shit, urine, blood, and assorted rots. Not all dishes lend themselves to this table; only those servings that are both excessive and incessantly replenished, for this profusion of substance asserts the commodiousness of contemporary appetites, both for pleasure and transgression.

A veritable buffet of organic substances has been appropriated into visual art practice of the past thirty years; most commonly in the context of temporary site-specific installations or performances, but also in painting, printmaking, drawing, and sculpture. Of course, the mediums of art have always included the stuff of the body and its sustenance—the gloss of egg tempera, adornments of all manner of shell or bone, the various berries of pigments—a fact that always implicitly connected the practice of art with the vitality of nature. For organic substances, whether in the condition of their occurrence in nature or refined by human hands, are the material that, after all, engenders and sustains life and ultimately marks its termination. (To speak of bread, for example, as a symbol of charity and community is simply to elaborate on the

Reprinted from Buzz Spector, "A Profusion of Substance," *Artforum* (October, 1989).

actual capability of this baked amalgamation of flour and water to sustain life.)
Consider then, in this context, Roland Barthes' encounter with a particularly
unsavory meal:

> One day I was invited to eat a couscous with rancid butter; the rancid butter was
> customary; in certain regions it is an integral part of the couscous code. How-
> ever, be it prejudice or unfamiliarity, or digestive intolerance, I don't like rancid-
> ity. What to do? Eat it, of course, so as not to offend my host, but gingerly, in
> order not to offend the conscience of my disgust (since for disgust per se one
> needs some stoicism).[1]

Barthes' distaste for his dinner is overcome by the pleasure of eating with the
group, a pleasure so great, in fact, that he chooses to prolong it by eating more
slowly than usual. And his experience suggests itself as a potential emblem for
our own, as we confront, with initial trepidation, the shock of the actual in
much of the art of our century.

Why, we may ask, have some contemporary artists begun to focus specif-
ically on the processes of *decay* in organic substances? How does the idea of
the organic—and its reckless abundance—affect the meaning of such sub-
stances in or as the artwork? What kinds of cultural models are posited or
challenged through the use of organic substances in art?

Legislation of the flow of vital substances is one of the oldest attributes of
human culture. The history of rules of diet, or procreation, and of sacrifice, is
exactly the history of communal definition, within which the regulation of sub-
stances ingested, ejaculated, and excreted by the individual body has reflected
both the explicit and implicit values of a given society. Western culture is indeli-
bly marked by such legislative practices and their ritualizations, from the
entombment of the Egyptian pharaohs with food for their journey into the after-
life, to the kosher laws of the Hebrews, to the Christian ceremony of the Eucha-
rist. And representations of the organic, in its delicious abundance or its
evocative decay, occupy the whole of the tradition of still-life painting.

The introduction of actual organic substances into Modern art practice,
however, begins, in a way, with those handfuls of horse manure and rotten
fruit and vegetables tossed by the audiences at various Dada events, or, more
specifically, the stuff hurled by those audience members who knew that such
gestures were what the performers intended to provoke. Of course, just a few
years before, Marcel Duchamp's biomechanical depictions, including *Passage
de la vierge à la mariée* (Passage from the virgin to the bride, 1912) and his
several versions of *Broyeuse de chocolat* (Chocolate grinder, 1913–14), sug-
gested equivalences between the inputs and outputs of machines and those of
human beings in their sexual conduct. (And indeed, one of the most transgres-
sive qualities of Duchamp's 1917 *Fountain* was the unmistakable assertion of
its prior function as a receptacle for human urine.)

With the great Surrealist exhibitions of the 1930s, organic materials
began regularly appearing in works of art, as a provocative literalization of

their makers' interests in biomorphism and dream imagery. Here again, Duchamp's design of the central hall of the *"Exposition Internationale du Surrealisme,"* at the Galerie Beaux–Arts in Paris, 1938, is well known for its 1,200 coal sacks hung from the ceiling and a simulated lily pond surrounded by actual ferns and weeds. Writing about the installation, William S. Rubin noted that next to the pond "stood a sumptuous double bed, above which hung [André] Masson's *Death of Ophelia*, echoing the implications of the pond and the empty bed."[2] In similar fashion, the live snails and heads of rotting lettuce in Salvador Dali's sculptural tableau *Rainy Taxi*, installed in that same exhibition, operated as figments of a dream; their biological actuality subsumed to the dictates of the well-dressed plaster mannequins also along for the ride.

But with the outbreak of World War II, the global carnage overshadowed the concerns of European vanguardism; the younger European and American artists of the 1940s and early '50s, dismissing the academicized mannerisms of the Surrealists, abandoned as well the radical conception of installation so favored by them. Thus Duchamp's maze of twine entangling the 1942 "First Papers of Surrealism" in New York resembled nothing so much as a festooning of cobwebs over a moribund display of artifacts.

It wasn't until the late '50s that a number of artists began once again to use organic materials—among other elements—in new methodologies of incorporation, exhibition, and performance. Works such as Robert Rauschenberg's "Combine Paintings" and the multifarious residues and the plastic-encased collections of discarded objects comprising Arman's "accumulations" not only invoked and reflected the contemporaneous critical and philosophical milieu of Sartrean Existentialism and Zen Buddhism (as filtered through D. T. Suzuki and John Cage), but also represented a calculated critique of the symbolic detachment of Abstract Expressionist painting and sculpture. However, it was Happenings, operating once again, like the works of the Dadaists, between the boundaries of visual art and theatrical experience, that transported the gestural rhetoric of Abstract Expressionism (with its implicit echo of Jackson Pollock's famous claim "I am nature") from the studio into real time and space.

In 1958, Allan Kaprow published a reflection on Pollock and the meaning of his art:

> *Pollock, as I see him, left us at the point where we must become preoccupied with and even dazzled by the space and objects of our everyday life. . . . Not satisfied with the suggestion through paint of our other senses, we shall utilize the specific substances of sight, sound, movements, people, odors, touch. Objects of every sort are materials for the new art: paint, chairs, food, electric and neon lights, smoke, water, old socks, dogs, movies, a thousand other things. . . .*[3]

Thus the woman who squeezed oranges and drank their juice in Kaprow's 1959 presentation of *18 Happenings in 6 Parts* acted "ceremoniously," according to

the script, but the table full of sliced rinds, as well as the air "suffused with the smell of the fruit,"[4] were equally part of the event.

Kaprow's material inventory seems to have been drawn from Rauschenberg's heterogenous assemblies of objects. In discussing how Rauschenberg's works function allegorically, Craig Owens describes them as "dumping ground[s]," and continues:

> By making works which read as sites, however, Rauschenberg also seems to be declaring the fragments embedded there to be beyond recuperation, redemption; this is where everything finally comes to rest. [His work] is thus also an emblem of mortality, of the inevitable dissolution and decay to which everything is subject.[5]

Similarly, Arman's arrays of categorically selected debris—including such stuff as rusty spoons, toy pistols, dolls' eyes, clocks, and squashed tubes of paint—become faintly horrific through their profusion of nearly identical elements. Identifying the equivalence between accumulation and destruction informing Arman's art, Jan van der Marck wrote:

> Precise accumulations are conservative; random accumulations connote discard and waste, the preliminaries of destruction. To waste, in contemporary army slang, is to destroy and kill. All Arman's works reflect the dialectic of possession and death. Dried flowers in a herbarium or butterflies under glass are the perfect real-life parallels.[6]

By the early 1960s, Hermann Nitsch began exploring with an explicit ferocity that dialectic between possession and death, staging performances in which the meat and viscera of animals, either already dead or sacrificed in the course of the event, were handled and strewn around the performing space. The blood that stains the sheets and vestments from Nitsch's ceremonies is shocking in its quantity; nevertheless the spattered gestures crossing the surfaces of his paintings, in their sweep, transparency, and simplicity, are oddly reminiscent of Pollock or Franz Kline; and their palette recalls Mark Rothko's fields of shimmering red, orange, or rust. Several of Nitsch's contemporaries, including Otto Mühl, Günter Brus, and Rudolf Schwarzkogler in Vienna, and Carolee Schneemann in New York, were combining erotic and sacrificial references in their activities. Mühl and Brus separately performed in public such taboo acts as shitting, eating their own shit, and vomiting, often as part of sexual tableaux with other male and female performers. Schwarzkogler's notorious acts of self-mutilation occurred within displays of artifacts of torture and murder. In Schneemann's 1964 performance *Meat Joy*, a troupe of naked and near-naked performers rubbed themselves and each other with blood and hunks of meat. All of these artists sought to synthesize the ritual aspects of action painting with the allegorical powers inherent in Pop art's cultural "slumming," through perform-

ances that celebrated, in a kind of ritual frenzy, the *actual*. Thomas McEvilley has described Nitsch's performances as essentially revivals of ancient Dionysian rituals, through which "the partaker abandoned his or her individual identity to enter the ego-darkened paths of the unconscious and emerged, having eaten and incorporated the god, redesignated as divine."[7] Nitsch's own statements of purpose subsume mention of antique predecessors, advancing instead claims of a contemporary metaphysics of ecstasy. In a speech in 1973 Nitsch identified among his intentions "to bring to our consciousness a joy in its own existence. Life is more than duty: it is bliss, excess, waste to the point of orgy."[8]

At the same time, refusing the pictorialization of commercial advertising motifs that informed American Pop's materialist critique, a number of European artists focused on the organic material itself as an analogy for the processes of history. In such work, messiness and dissolution not only bespeak the formal and philosophical ruptures in modern art, but evoke the fractures in human life, experience, and perception engendered by the horrors of World War II. Niki de Saint Phalle's notorious and exuberant "shot works" of 1960, in which she attached tomatoes and eggs to her plaster reliefs and invited spectators to join with her as she shot at them, recalled both Tristan Tzara's Dadaist "cerebral revolver shot" and the actual carnage of the battlefield. Swiss artist Daniel Spoerri exhibited his "snare-pictures," arrangements of found objects fixed in place and wall-mounted, in Milan in 1961. Spoerri's tableaux of just-finished meals, with their fishbones, bread crumbs, and shriveled curls of fat appearing on "tabletops" with dishes, utensils, and cigarette-filled ashtrays, connote a kind of personal archaeology reminiscent of Rauschenberg, but they are additionally unpalatable because the dried residue of these meals indicates an all too corporeal decay. In a 1961 installation called *Grocery Store*, in Copenhagen, Spoerri rubber-stamped various foodstuffs, canned, bottled, and fresh, as works of art. In his 1966 artists' book *An Anecdoted Topography of Chance*, Spoerri accepted as collaborators the rats who devoured two of the snare-pictures shown at Galleria Schwartz, and went on to note:

> *Taboos have as their objective the preservation of traditions and forms, an objective that I reject: at the Galerie Koepcke "Grocery Store," sandwich rolls, in which garbage and junk were mixed during the kneading, were baked and sold as "taboo catalogues."*[9]

In the work of Piero Manzoni, the artist himself becomes both exemplary producer *and* production. In a 1960 performance in Milan, Manzoni invited the public to eat boiled eggs that the artist had marked with his thumbprint. Later, he canned his own shit and offered it for sale, sold balloons filled with "artist's breath," and planned to offer vials of "artist's blood." Manzoni's retinue of bodily substances functioned as "traces" of being, through which he proposed the body itself as "a message." Manzoni also signed things—and people—into being as living works of art. Declarations of authenticity accompa-

nied Manzoni's bodily autographs of a number of his friends and associates, including Marcel Broodthaers.

Still a practicing poet at the time he was declared a living artwork, Broodthaers, influenced by Stéphane Mallarmé and La Fontaine, was fond of bestiaries. In his verse, anthropomorphic cockroaches, serpents, jellyfish, and mussels served as metaphors of human social conduct. The pun, in French, between *la moule* (mussel) and *le moule* (mold), figured importantly in one of Broodthaers' last poems, concerned with issues of self—versus social—definition. As Michael Compton puts it, the "mussel secretes the shell which shapes it. This mussel plainly creates itself and so is perfect, that is, authentic."[10] But in Broodthaers' terms, the development of bird-in-egg or mollusc-in-shell became punningly equivalent to the social myth of individual self-determination, in which many thousands of individuals· will cast themselves in, or adjust themselves to, the same mold. By the time he began his new career as a visual artist, in 1964, Broodthaers saw the art object in similar terms, with the value of the art idea debased through the materialism of its merchandising. Broodthaers' early objects often included empty egg and mussel shells, spilling out of cooking pots, covering tables or chairs, or glued to canvases and hung on the wall. His artistic appetite for "insincere" objects played off the substantial authenticity of his organic materials. As his interests shifted in the direction of a critique of the museum as a social institution, Broodthaers became less interested in the given multiplicity of his natural subject matter and more concerned with the commerce and classification systems of objects in the museum.

Broodthaers' mock museological collections found their bibliophilic counterpoint in the collective publications of the German-born Dieter Roth, who, after fleeing to Switzerland during the war, spent many years afterward in a kind of voluntary international exile. Roth issued several "editions" of his *"Literaturwurst"* between 1960 and '71. These minced pages from books and magazines mixed with lard, gelatin, and spices, and stuffed into sausage skins, have been called by Ann Goldstein "food for thought."[11] Roth's ongoing documentation and publication of his life-as-art would eventually become his *Collected Works,* but in the 1960s he was still experimenting with "etchings with chocolate and bananas, books with texts printed on plastic or foil, bags filled with glued, dyed cheese, lamb cutlets, etc., and self-portraits and sculpture made out of food."[12] The artist's subsequent prolific output of offset volumes, presenting his activity in the form of an ongoing digest of reproductions, thus engages viewers in a melancholic contemplation of decay as a metaphor for the irrecoverable distance between experience and memory.

A similar use of substance as autobiographical relic characterizes the work of Joseph Beuys. His legendary World War II plane crash in the Crimean snows, and ensuing rescue by Tartar tribesmen who swaddled his bruised body in fat and felt, dictated the reading of these same materials from the time they first appeared in Beuys' art, in 1960, suffusing these resonant creations with a mythopoetic reflection of recent German history. As Donald Kuspit

puts it, "material was never given neutrally for Beuys, but always invested with memorable, primitive significance."[13] In an essay concerning Beuys' pedagogical philosophy, Eric Michaud quotes the artist:

> Fat . . . was a great discovery for me. . . . I was able to influence it with heat or cold. . . . In this way I could transform the character of this fat from a chaotic and unsettled state to a very solid condition of form. In this way the fat underwent a movement from a very chaotic condition to a geometrical context as its end. I thus had three fields of power and, there, that was the idea of sculpture. It was power over a condition of chaos, over a condition of movement, and over a condition of form. In these three elements—form, movement, and chaos—was the indeterminate energy from which I derived my complete theory of sculpture, of the psychology of humanity as the power of will, the power of thought, and the power of feeling; and there I found it—the schema adequate to understanding all the problems of society.[14]

Connecting this "schema" to Beuys' idea of "*Gestaltung* (the putting into form) as an end," marking "the general process of thought, of man, and of human society: the passage from an indeterminate or 'chaotic' state of energy to a state that is determinate, or 'crystalline,' "[15] Michaud goes on to examine the problematic relationship between Beuys' idealized conception of "social sculpture"—within which the model body stands in for the body politic, and in which everyone can be an artist—and the estheticized politics of fascism. From such idealism, Michaud suggests, it is all too easy to equate difference with debasement or deviance.

On another front, criticizing Beuys' conflation of personal myth and artistic meaning, Benjamin H. D. Buchloh dismisses his "seemingly radical ahistoricism" by offering a series of morphological comparisons between works by Beuys and such contemporaries as Richard Serra, Robert Morris, and Carl Andre. But Buchloh fails adequately to distinguish Beuys' works in organic substances from the "mixture of heterogenous materials within the sculptural unit"[16] characteristic of Modernist sculpture. In other words, qualities of viscosity, hardness, or pliability mean something quite different when applied to grease, steel, or plastic, on the one hand, and honey, bone, or fat, on the other. However misguided Beuys' mystical presumptions may have been, the substantial usages in his work can't be properly understood without consideration of how they relate to the idea of the body *as such*.

Perhaps more than any other artist, Beuys paved the way for a multitude of elaborations on the conceptual energy of the organic, as his projects moved through a range of manipulations—from the small to the large and from the decayed to the fresh. In his 1965 performance *Wie man dem toten Hasen die Bilder erklärt* (How to explain pictures to a dead hare), for example, Beuys' "lecture" to the dead animal could only be heard by his human audience, despite the artist's sardonic claim that his explanation was directed to the hare because he didn't like explaining the pictures to people. By claiming both

animal and substance as symbols of the self, equating the hare's burrow with sculpture and the honey that covered Beuys' own head with the character of thought, Beuys' performative gesture "resurrected" both carcass and smeared fluid. But by the time of *Honey Pump*, 1977, the installation Beuys assembled for Documenta 6, the fresh honey coursing by the gallon through the plastic tubing could be seen as standing in for the blood in a model circulatory system. And the enormous scale of the installation encouraged a reading of the space it encompassed as analogous to a vast body, with visitors passing through its throbbing tubes and rumbling pump like so many individual cells. In whatever form or size, the operations of Beuysian nature are always transformational, asserting that the role of the artist is to enact "again and again, and in a variety of media, the movement from death to life."[17]

Whereas the evocation of ideal social formations persistently informed Beuys' manipulation of the organic, Jannis Kounellis, in early installations, introduced living plants, animals, and occasional human performers into the gallery in works and situations that served simultaneously as allegories of historical fragmentation and celebrations of the vitality of real life. His introduction of 12 live horses into a vanguard gallery space in 1969 offered visitors these animals as a kind of living equestrian statuary in a site where such statuary would be least expected. And in his installations that featured burlap sacks or open piles of beans, coffee, corn, peas, and rice, accompanied by bins of coal or piles of charred wood (simultaneously source and residue of fire) and small pieces of gold, Kounellis invoked the "progressive" chain of trade, of commerce—from the raw (beans) to the refined (charcoal) to the distribution (via horses) to a final, evaluative token (gold)—proffering a symbiology of the cycle of consumption on both a personal and a social level.

In a similar vein, Mario Merz employs the spiral form based on the Fibonacci sequence (1–1–2–3–5–8–13–21–) that, progressing to infinity, dictates the growth patterns of many organisms in nature, from pinecones and flower petals to the shell of the nautilus or the scales of an alligator's skin. Merz's installations, especially those involving heaps of fresh vegetables on progressively rising spiral tables, signify development and propagation, both in nature and in human consciousness. In these elegant homages to the human capacity to divine nature's logic, Merz also implicitly points to the limits of human understanding. Such works subtly posit that the role of the artist—and of art—may be, quite simply, to echo rather than imitate or mediate nature's given structures.

To submit oneself to the powers of the "given," then, rather than attempt to master it: this is the meaning that has underwritten the work of many contemporary artists who use the organic. In one of Wolfgang Laib's "Milkstones," from 1981, for example, the milk filling a shallow depression within a sheet of white marble promulgates a complex of symbolic associations. But the pale and empty stone is capable, in itself, of symbolizing milk, at least in terms of a chromatic resemblance. Filling it with an inorganic white liquid such as gesso

would also suggest milk. What does it matter that actual substance be present in, or as, the work of art? In an interview with Suzanne Pagé in 1986, Laib asserted: "All these [organic] materials are full of symbols—and still they exist in themselves—they are what they are. . . . These materials have incredible energies and power that I never could create."[18]

Yet there is prodigious human energy invested in the creation and presentation of these works. At the end of each day, someone must remove the clotted and dirty liquid from *Milkstone*, wash the slab clean, then refill it the next morning with fresh milk. Likewise, Laib's piles and squares of pollen must be regularly reseeded to cover the tracks of the night-feeding insects that regard these artworks as a most admirable repast. And simply to collect his pollen, Laib spends more than six months a year (from mid February through September) in meadows and forests near his home in rural southern Germany, collecting, one by one, the tiny granular deposits from hazelnuts, buttercups, dandelions, and pine trees. This painstaking annual harvest yields only "four, five, or six jars of three or four different kinds of pollen."[19] It is, perhaps, the invisibility of this intensive labor—for it can nowhere be read in the pieces as installed—that is the unspoken power of Laib's work. For if one conjures up an image of effort at all, it is that of a kind of shamanistic discipline, a ritualized gathering of vital substance as if for an offering or sacrifice.

Ironically, it is the specific materiality of Laib's work that deflects our attention from its means of production, its labors and services, to its immanence, its "absolute" availability. But there is another deflection in Laib's art, a diverting of use or function, whose willfulness suggests another organizing principle: that of the libertine diet of the Marquis de Sade. Laib's nourishing fluid or fecund power is poured but not consumed. Fresh milk gleams in its stone receptacle; once curdled, it is flushed away. The copious inundations of golden grains pollinate no blooms. There is no suckling or fertilization in these lavish displays, whose incipient degradation necessitates constant replenishment. The Sadean diet too, like Sadean sex, is mechanically efficient; any collapse into vulgar disorder is continually avoided. Time and again the players in Sade's erotic tableaux are admonished by one of their members to restructure their activities, so that their unbridled lusts are gratified within codes of transgression. In *Philosophy in the Bedroom*, 1793, Madame de Saint-Ange interrupts the proceedings by declaring: "If you please, let us put a little order in these revels; measure is required even in the depths of infamy and delirium."[20] In short, the pleasure of Sadean erotics can only be realized through its disciplined codes.

We understand the equivalence between acts of procreation and ingestion as one of penetration and incorporation. But the essential transgression of Sade is the diversion of sexual goals from conception to bliss. A similar diversion of diet and digestion from its life-sustaining function would be fatal, so Sade instead inverts these processes through his ecstatic coprophagy and profuse elaborations of menu. The staggering buffets of the libertines have the

"function of introducing pleasure (and not merely transgression) into the libertine world."[21]

Laib's installations embody an extraordinary plenitude. His systematic replenishings suspend decay. If, in the works of Spoerri, Roth, and Beuys, the organic and its potential dissolution bespeak both the powers and vulnerability of human life, Laib's work, with its constant, excessive reinfusions, posits the possibility of stopping time. It is precisely the convergence of vital substance and stopped time that allies this kind of work to the discursive space in Sade. Angela Carter describes the Sadean orgasm as a momentary "annihilation of the self," a self to which one returns all too quickly:

> *Orgasm has possessed the libertine; during the irreducible timelessness of the moment of orgasm, the hole in the world through which we fall, he has been as a god, but this state is as fearful as it is pleasurable and, besides, is lost as soon as it is attained.*[22]

The diabolical Sadean mixture of pleasure and pain is only briefly overcome, but in that moment something of life's terrible splendor is revealed. By rejecting the instrumentality of Sade's libertinism while accepting its union of sacred and profane, some artists seek to invoke the best of his vision. Here, the ecstatic experience is recuperated in sculptural terms.

In Rona Pondick's installations and sculptures, small rodlike masses, simultaneously excremental and phallic, are often situated upon luxurious cushions or beds. These feces-penises assume the status of repressed fantasies given concrete form, as Pondick provocatively applies the shape of an evacuation on the site of ejaculation. But Pondick's forms aren't actual feces. They are, in fact, made or cast from wax. *Mine*, 1987, is a knee-high ovoid of lumpy brown wax (the mass itself literally thrown together as Pondick tossed balls of softened wax from across the room to create it). The impacted mass resembles quite explicitly an outsized, gargantuan turd, and yet recalls the "dissociating reality" Barthes ascribes to Sade: "when written, shit does not have an odor; Sade can inundate his partners in it, we receive not the slightest whiff, only the abstract sign of something unpleasant."[23] Indeed, *Mine* would be less horrifically believable if made up of actual feces, since it could then only be understood as a construction of filth and not also as a model of impossible evacuation/penetration.

In a review of Pondick's 1988 installation *Beds*, at the Sculpture Center in New York, Kirby Gookin suggested that the structures of the arrangements within its three rooms were each "a parodic episode . . . which simultaneously venerates taboos and denigrates the sacred."[24] In the brightly lit first room, an arrangement of plush white nylon pillows resting on a block of wood resembled a bier, upon which—as if lying in state—rested a limp and turdlike form wrapped in slightly stained gauze. In the next, darker room, sheets of lead draped over three vaguely wedgelike rows of stacked sandbags sagged into the valleys between individual bags, as if pressed down by the weight of a body. On

the summit of one of the side rows, three brown wax turds became ejecta displayed as objects of veneration. One of the twin stacks of black satin pillows in the small third room concealed yet another fecal object. The narrow passage between these looming stacks was an inviting recess. As the visitor penetrated this plush softness, the waiting turd assigned the encounter a sodomitic quality.

Pondick's objects fluctuate between definitions, their irreconcilable material and formal references violating both the social and the artistic order. Recalling Georges Bataille's "intellectual scatology" through its unmistakable references to ejaculation and excretion, Pondick's art comes so dangerously close to nonart that one might literally wriggle in discomfort standing before it.

Similarly, the glass or wax castings from animal, and occasionally human, lungs in Maureen Connor's recent sculptures and installations seek to despoil the cool formality of the abstract steel forms in which they are situated. The welded steel armatures of Connor's series of "Lung Racks," 1988, resemble bottle-drying racks and clearly refer to Marcel Duchamp's famous readymade. But these contemporary appropriations are "assisted" by the simulated organs, sometimes wrapped by or stuffed into feminine undergarments, impaled on their protruding metal arms. The covert eroticism in Duchamp's original appropriation is rendered explicit through this juxtaposition. But equally important, the steel forms of *Lung Racks I* and *II* also resemble vaguely skeletal structures. This adds to the horror of the real-looking lumps of flesh with which they are studded. The organs of the body are epistemologically degraded by separation from it. This dead tissue also confirms the death of the absent body, but does not by its mere presence offer an explanation of the meaning of that death. Accident, murder, and sacrifice are indistinguishable as agencies behind the presence of Connor's glistening viscera, cast from actual organs in materials that convey the moisture, pliability, and sheen of their source. As such, they are convincingly abject, a pathetic residue of the formerly alive.

In *The Powers of Horror*, Julia Kristeva notes:

> It is thus not the lack of cleanliness or health that causes abjection but what disturbs identity, system, order. What does not respect borders, positions, rules. The in-between, the ambiguous, the composite. . . . Any crime, because it draws attention to the fragility of the law, is abject.[25]

Connor, like Pondick, rebuts her own sculptural syntax with her shocking references to the actual, the real. Hence, abjectness encroaches upon the abstracting distance of formal structure, invoking a Sadean concept of nature in which the only limit to both our pleasures and our terrors is the body.

Ann Hamilton's room-sized tableaux use immense quantities of natural residues, together with machines, furniture, and human performers. In a 1984 studio tableau entitled *Detour*, Hamilton positioned six performers in a variety of motionless confrontations with machines and materials, including a pile of feathers and a six-ton heap of gravel. Perhaps the most disturbing apparition was

a performer seated on the bench of a porch swing resting on the floor. Both human and swing were completely covered with burdocks. Visitors to the scene could see the twitches and movements of the performer breathing beneath the prickly burrs. In *the lids of unknown positions*, a 1985 installation at Twining Gallery, New York, Hamilton completely covered a 24-by-10-foot wall in mussel shells (reminiscent of Broodthaers), glued with lips outward. Hung on the wall with the shells was an old rusted lawn-roller. And two performers were engaged in troubling visual predicaments: one perched atop a lifeguard chair, head thrust through a hole in the ceiling; the second sat at a table, head apparently buried in a mound of sand piled on it. (The visitor's alarm at this apparent enactment of suffocation was tempered by the realization that some access to air must be hidden in the table.) The stoic unresponsiveness of Hamilton's performers to confinement, exposure, or displacement can easily be equated with the disciplined endurance of Sadean sexual partners.

In Hamilton's 1988–89 installation *The Capacity of Absorption*, at the Los Angeles Museum of Contemporary Art's Temporary Contemporary facility, visitors passed through three chambers covered, successively, in animal, vegetal, and mineral residues. The walls of the first room were draped with sheets of beeswax-coated paper; the second was festooned with fibrous clumps of pond algae; and the third was blackened by graphite powder, the "lead" of pencils. Water plowed through these spaces literally and figuratively: 150 wall-mounted glasses of water, each containing a tiny whirlpool, in the first; a long, narrow wooden table whose surface was covered by running water, in the second; and finally, in the third, an enormous rusted metal buoy (tied by a clumsily knotted cord to a performer in the second room) rested on a floor composed of thousands of lead typographic characters. As with Laib's work, the thoughtful visitor might grasp the prodigious labor entailed in this vast assembly, but for most of its audience, *the capacity of absorption* was a fantastic texture of systematically—and symbolically—connected effects, producing an absorbing reverie of (erotic) pleasures.

Yet seeded discreetly within the installation were moments of shocking transgression: a video image of an ear constantly inundated by pouring water; and a cardboard puppet, jerked by a machine, whose repetitive twitching suggested spasms of both ecstasy and pain, for example. Kenneth Baker has described Hamilton's work as "interrupt[ing] the thoughtless flow of everyday life with something so troubling or lyrical that it paralyzes mental habit."[26] Her art evokes a world that is always coming into form, but that is also fragmented and particular. Hamilton's profusion of substance reveals the morbid interiority of our idea of plenitude, evoking Michel Foucault's reference to Sade's "limitless presumption of appetite."

Before us lies the splendid and terrible array of the world, whose overwhelming variegation exceeds our physical capacities, if not our appetites, to know it. If that world is constantly in flux, the actual nature of its substance remains constant. No theory of symbolism will suffice that does not acknowledge these conditions of meaning. That all the artists discussed here seek to unite

symbol and substance does not imply, however, their alignment with such uto-
pian visions as that of the end of time. Timelessness is an instrumental fiction of
those who propose activity itself as our *raison d'être*. But with a claim upon
consciousness that is deeper than this, the art of the organic emerges out of the
most intensely experienced discontinuities between our words and our world.

Notes

1. Roland Barthes, *Sade, Fourier, Loyola,* London: Jonathan Cape, 1977, p. 77.
2. William S. Rubin, *Dada, Surrealism, and Their Heritage,* New York: Museum of Modern Art, 1968, p. 154.
3. Allan Kaprow, "The Legacy of Jackson Pollock," *Art News* 57 no. 8, October 1958, p. 57.
4. Kaprow, "18 Happenings in 6 Parts/the script," in Michael Kirby, ed., *Happenings,* New York: E. P. Dutton, 1965, p. 65.
5. Craig Owens, "The Allegorical Impulse: Toward a Theory of Postmodernism," in Brian Wallis, ed., *Art After Modernism: Rethinking Representation,* New York: New Museum of Contemporary Art, 1985, p. 226.
6. Jan van der Marck, "Arman: The Parisian Avant-Garde in New York," *Art in America* 61 no. 6, November–December 1973, p. 93.
7. Thomas McEvilley, "Art in the Dark," *Artforum* XXI no. 10, Summer 1983, p. 65.
8. Hermann Nitsch, "Speech at the premiere in Prinzendorf," in *Hermann Nitsch: das orgien mysterien theater,* exhibition catalogue, Eindhoven: Stedelijk Van Abbemuseum, 1983, p. 46.
9. Daniel Spoerri, *An Anecdoted Topography of Chance,* New York: Something Else Press, Inc., 1966, p. 182.
10. Michael Compton, "In Praise of the Subject," in *Marcel Broodthaers,* exhibition catalogue, Minneapolis: Walker Art Center, 1989, p. 24.
11. Ann Goldstein, "Dieter Roth," in *Dieter Roth,* exhibition catalogue, Chicago: Museum of Contemporary Art, 1984, p. 14.
12. Ibid., p. 11.
13. Donald Kuspit, "Joseph Beuys' Mission," in *Warhol/Beuys/Polke,* exhibition catalogue, Milwaukee: Milwaukee Art Museum, 1987, p. 55.
14. Interview with Joseph Beuys by Bernard Lamarche-Vadel, August 1979, cited in Eric Michaud, "The Ends of Art According to Beuys," *October* no. 45, Summer 1988, p. 39.
15. Michaud, p. 39.
16. Benjamin H. D. Buchloh, "Beuys: The Twilight of the Idol," *Artforum* XVIII no. 5, January 1980, p. 41.
17. Kuspit, p. 57.
18. "Interview of Wolfgang Laib by Suzanne Pagé," in *Wolfgang Laib,* exhibition catalogue, Paris: ARC, Musée d'Art Moderne de la Ville de Paris, 1986, p. 17.
19. Ibid., p. 18.
20. See *The Marquis de Sade: The Complete Justine, Philosophy in the Bedroom, and Other Writings,* ed. Richard Seaver and Austryn Wainhouse, New York: Grove Press, Inc., 1966, p. 240.
21. Barthes, p. 125.
22. Angela Carter, *The Sadeian Woman and the Ideology of Pornography,* New York: Pantheon Books, 1978, p. 150.
23. Barthes, p. 137.
24. Kirby Gookin, "Rona Pondick," exhibition review, *Artforum* XXVII no. 4, December 1988, p. 120.
25. Julia Kristeva, *The Powers of Horror: An Essay on Abjection,* New York: Columbia University Press, 1982, pp. 3–4.
26. Kenneth Baker, "dissections . . . they said it was an experiment," in *Five Artists: Phoebe Brunner, Dan Connally, Macduff Everton, Ann Hamilton, Cynthia Kelsey-Gordon,* exhibition catalogue, Santa Barbara, Ca.: Santa Barbara Museum of Art, 1988, p. 5.

MIKE KELLEY, *Empathy Displacement: Humanoid Morphology (2nd & 3rd Remove) #10.*
**1990 Acrylic on panel, found handmade doll in painted box. Part 1: 62⅛″ x 24¼″. Part
2: 4¾″ x 9⅛″ x 23″**

Courtesy of Rosamund Felsen Gallery, Los Angeles. © Douglas M. Parker.

No Man's Time

Eric Troncy

Critic and curator Eric Troncy describes his "No Man's Time" exhibition in France as "spectacle" in which some artists have starring roles and others merely walk-on roles; the emphasis is upon avoiding the definitive while at the same time "having a lot to say." Plunging the spectator into "relative mistrust" the exhibition is a series of "skirmishes" which have nothing to do with resistance but more with "an ensemble of common interests" and chance, coincidence and fashion. . . . In short, the exhibition revolves around a series of "nontheoretical facts" and the balance of temporary truth.

Dear Helena and Giancarlo,

You have asked me to talk to *Flash Art* about "No Man's Time" and clarify the concept. Since the very outset, "No Man's Time" has been based on no particular concept and is without any theoretical scheme. First and foremost, the show does not set out to prove or claim anything. It is neither an angle on the future nor a synthesis of the present. "No Man's Time" is a show and its three-month duration is not unlike a theater run. Perhaps "No Man's Time" is exactly what critic Guy Debord intended in *La societé du spectacle* (Spectacle society), but this is of scant importance. Without a hint of cynicism, it might be said that "spectacle" is the most fitting setting in which to present these works just as certain forms of art history prove an appropriate shelter for Felix Gonzalez-Torres's work. The use of spectacle does not mean that these pieces are "spectacular"—on the contrary, the pieces are all small-scale and decidedly modest. Intimidation through gigantism has no role to play in their history, the materials are simple and the construction or assembly processes are free from unnecessary perfectionism.

Reprinted from Eric Troncy, "No Man's Time," *Flash Art* (November/December, 1991). Translated from French by Christopher Martin.

As in a spectacle, "No Man's Time" includes various actors with different characters making for certain disparate scenes. Some of the actors have starring roles, others are extras, some are good guys and others not so good: what could be more normal? The same is true of all group shows, the only difference being that we have chosen to take this factor into account.

It should also be pointed out that certain pieces in the show are "played" just as a play in the theater would be. Pierre Joseph's "walk-ons" (a leper and a medieval warrior were to be found roaming the exhibition spaces on opening day), Philippe Parreno's *No More Reality* (a children's demonstration), *Madonna* and *Backdraft* by Karen Kilimnik (a scene from a concert with music by Madonna and a boy dancer) or Dominique Gonzalez-Foerster's *Son esprit vert fit autour d'elle un monde vert* (Her green spirit made a green world around her) (a portrait in three stages of a woman at large during the show's opening, wearing a green dress). The artists' desires to "bring the pieces to life" says so much more about them than any critical discourse.

Not for one moment do I believe in those big shows that make out that they have understood everything that is going to happen in the future: just look at Documenta which, except in the eyes of a few outdated gallerists, has all but forsaken any notion of risk-taking. Everybody knows that heroism is only ephemeral and incites a measure of modesty; the rockstars of the 1970s now work at supermarket check-outs. We went out of our way to avoid installing anything definitive: even the title of the show places it in interval territory. What struck me about the majority of the artists participating in "No Man's Time" was their relative disregard for the "work of art." If twentieth century art has proved to be a constant (and sometimes much-needed) attempt to force back the limits of what we consider art, I honestly believe that the artists in "No Man's Time" can do little or nothing. Where they are concerned, it is more a question of "doing it" and "doing it in exactly this way." The result is that "they're done." Johan Muyle, for instance, says of his own pieces that the only reason they appear on the art circuit is that, at the moment, it is the only place that they are "taken into hand." And everybody knows that Raymond Pettibon's drawings could just as well crop up in a magazine without any regard for "great art." Richard Agerbeek's drawings look more like posters that would be at home in a child's bedroom than paintings, and I have noticed that various collectors who have visited the show—and I mean the owners of great collections of minimal art—all want to get their hands on Richard's drawings. The show has obviously provided a great release from certain precious attitudes that so many people are wont to adapt.

Generally speaking, the pieces in the show are "loquacious" (in Louis René des Forêts' meaning of the word) and all have a lot to say. As a result, the show is overloaded with narration, stories crossing, cutting into, and colliding with each other, from the borrowing of available models in Gonzalez-Torres's work to the simple, supplementary fiction cobbled together *in extremis* of Karen Kilimnik's *Count Dracula, Lucy and Aimee Morgana Come to Nice,*

made with crates of Johan Muyle's works. Story telling is obviously the general intention. The fact that the narrative is immediately exhausted in a drawing (Agerbeek, Shaw) or in a fragmented ensemble (Ruppersberg, Gonzalez-Foerster) means that the pieces take on additional values as clues—fragments which enable the reconstruction of a crime.

Moreover, I have realized that cinema appears to be a more interesting referential reservoir than art: Karen Kilimnik's *In Bed with Madonna* and *Backdraft*, Angela Bulloch's *King of Comedy*, Godard in Allen Ruppersberg's *Gremlins 2* and Philippe Parreno's *Alf* and *Twin Peaks*.

The exhibition setting is not merely a whim on the part of the curator but simply an attempt to correspond the model of the show with that of the works. The labyrinth we constructed at the entrance to the show not only affords us an opportunity to start recounting the work of all the artists (thus wiping out the surprise element) but it also serves to disorient the spectator by plunging him into relative mistrust. What could be more irritating than having the visitors trudge by, hands behind their backs, reminding us, all too clearly, of the extent to which an exhibition is nothing more than a social show, a convention? It is a preoccupation shared by some of the artists, such as Pierre Joseph who conceived of three passages aimed at interfering with the spectators' route: an excessively small door, a round door through which spectators are obliged to pass, and a soft floor.

All the artists (with the exception of Raymond Pettibon) came to stay for about a month at the Villa which gave them the possibility to discuss together their various skirmishes and the running of the show. The works involved are not based on considerations such as resistence against the museum system and are scarcely concerned with the site or the space. Therefore we can abandon any notions of having inherited the quirks of the 1970s and turn our attention towards a maintained "pollution of the surroundings" producing successes and failures in equal measure.

"No Man's Time" is patently not aimed at highlighting the oeuvre of each artist concerned—it is not a publicity-oriented vehicle with commercial ends. Once again, it is a spectacle, a discussion, and while the protagonists may be enthralled by their subject matter, it may prove boring for some of the public. What "No Man's Time" is dealing with is an ensemble of common interests. As paradoxical as it might seem, one cannot really understand the work of Allen Ruppersberg without sharing his passion for "serial killers," a passion shared by Kilimnik, Joseph, Bulloch, and others. The same goes for the iconography drawn up by Pruitt • Early or Jim Shaw, and Raymond Pettibon is not merely dealing with the "rock aesthetic" but with "the aesthetics of that branch of music." It is not any old music just as it is not any old killer, but a "serial killer." Herein lies the difference.

This basically, is what the whole exhibition is based on. If we want to avoid talking in terms of theory, we should not, however, avoid talking about chance, coincidence, or fashion because it is a very precise choice. Theory can

say what it wants about a work of art and art critics can be very persuasive; sometimes the art milieu throws out some very good shows. There can be fifteen group shows with the same artists and each time there can be a plausible theory (i.e. Collins & Milazzo). With "No Man's Time," on the other hand, it would be very difficult to add or deduct anything from it because the scenario is built on a series of non-theoretical facts which, however, subscribe to a shared culture. Once put together, these given facts make for no "conclusion" but a kind of "justice" or "balance" of temporary truth. Of course, it is a lot more difficult than putting on a show of Charlton/Andre (who are, however, excellent artists).

During the discussions with the artists for "No Man's Time," the conversation tended more in the direction of Bret Easton Ellis's *American Psycho* than Greenberg or Krauss. The idea of "No Man's Time" was, logically, to get on the same level as Bret Easton Ellis. Without a hint of cynicism, it can be said that to theorize would be a mistake. It is not cynical or defeatist to say that theories are interchangeable and ultimately ephemeral. What we really set out to do was to escape from these "indefatigable people," these "old but tireless rogues" as discussed by Peter Handke in his *Essai sur la fatigue* (Essay on fatigue).

Best regards,

Eric Troncy

Diana Thater, *Dogs and Other Philosophers.* 1991 Video installation

Courtesy of the artist and The Dorothy Goldeen Gallery, Santa Monica, California.

The Audience Culture

Norman M. Klein

For modernism, the canonical distinction made between fine art and popular culture is that fine art is self-critical while popular culture is mere entertainment. Social scientist Norman Klein shows that such a simple distinction is too easy: popular culture has its own forms of self-criticism; for example, talk shows that reveal what goes on "behind the scenes." Klein suggests that the subject of both high and low art is frequently the audience itself. In the past decade, in particular, art has referred increasingly to the shared audience experience. Audience culture, influenced very strongly by changes in the delivery and distribution of art, literature, video, and film, provides the most fruitful perspective from which to think about the presumed differences between art and kitsch.

The frantic discomfort of guests on quiz shows has often been parodied on film, most recently in *Melvin and Howard*, where the life quest of Melvin's family is to win on a "Let's Make a Deal" format show. In the video art piece *Kiss the Girls and Make Them Cry*, Dara Birnbaum selected a less frantic format to play with, "Hollywood Squares." There are no housewives dressed as giant wedding cakes, or families going into bacchanalian frenzy at the sight of a dining room set. On "Hollywood Squares," the celebrities are the ones on trial.

All quiz shows attempt a certain Las Vegas urbanity. The tanned, omniscient narrator—the host—will regularly survey the greed of the contestants, and insult them benignly—a smirk, a one-liner, a deadpan "No kidding?" The audience laughs. But on "Hollywood Squares," this polyester urbanity is the entire show. Everyone is coolly observing everyone else's ignorance, the way that glamour compensates for limited knowledge. The show undercuts the

Written for this volume, printed with permission of the author.

celebrities, like a multiple-screen talk show. Meanwhile, the viewer is invited to feel part of this electronic courtliness, and to judge who is the quickest wit.

What then did Dara Birnbaum do with this half-hour of blinking, smirking and imping? She edited out moments where the celebrities respond to the audience, then proceeded to isolate ("alienate") them. She telescoped their faces in and out; she paused at awkward moments, and repeated them, until the viewer could catch the celebrities' discomfort—an awkward wave, the adolescent bluff, a wildly exaggerated grin.

To further alienate the image, she introduced a musical sound track a few minutes into the piece—a bouncy version of "Georgie Porgie, kiss the girls and make them cry." The printed lyrics were flashed on the screen—a technique used often in videotapes shown in an art context. They also resemble the ideograms on Russian poster art of the twenties, or the bouncing ball cartoon shorts that came out of the Fleischer Studios. The viewer is asked to focus on the women; they seem to handle the icy Kino eye more painfully than the men.

One could write a cultural history of the past 200 years on how mass culture has been incorporated into painting, architecture, literature. If we chose to add folk culture to such a history, we could add volumes more. There is always a dilemma in the way such histories might be written, however—or the way Dara Birnbaum's piece might be seen. To borrow an example from criticism, even with the Frankfurt School (or particularly Adorno and Horkheimer), the distinctions between high and low culture are laid out as firmly as lines on the spectrum; art that is not self-critical belongs to the culture industry; art that claims to be self-critical is generically fine art, though it may not be free of the coloration of mass culture. It is generally assumed that the critic who examines this "crossover" must be clear, first of all, about which is art and which is not. For a start, we can say (bizarre I admit): Tarzan is not Tolstoy; Dostoyevsky is not Agatha Christie, and so on. Along that chain, Dara Birnbaum is not MTV, the rapidly growing 24-hour music network.

I will not belabor the reasons why these canonical distinctions are so central to criticism of mass/fine art (and particularly to literary criticism). It is ironic to remember, however, that among English Romantics of the 1790s, or French Romantics of the 1830s, or the Russian avant-garde in the 1920s, these distinctions were far less important. There were even attempts at a populist culture, a bit like "democratic art," as some Americans called popular wood engraving in the nineteenth century. "Romanticism is liberalism in literature," Hugo wrote in 1827, and his alliances with liberal publishers, and mass publishing, from 1830 onward demonstrate in the most practical way possible what he meant.

There is also no need to belabor the recent shift away from canonical criticism; distinctions between the fine arts and mass culture are, again, loosening. Is this due to the shift in information systems—how culture is delivered? Shall we blame the computer or video for the change? (Or the steam-driven printing presses in 1836 in Paris for popular Romanticism spreading

itself thin?) Shall we simply assign the problem to the generic crises of postmodernism? I would prefer to avoid rethreading all of that. Clearly, the most practical question must be whether there is anything that canonical criticism has ignored, anything of the referent or the intention of mass/fine art. I will try to address that question, using Dara Birnbaum's video piece as model.

The referent in much of video art is the television audience itself— prayerfully before the tube, making friends with the colored dots. *Kiss the Girls and Make Them Cry* has as its signified the commonly shared experiences of watching television. Whether we watch the shows or not, we are already informed of the experience (much the way we laugh at the image in a political cartoon).

At approximately the same time that Birnbaum's piece came out, Music TV began. After only a few years, MTV has already changed the way popular music is promoted. Increasingly, record releases have to be accompanied by whimsically nostalgic films of the rock group, from two to five minutes in length. Not surprisingly, Birnbaum's work has been compared to MTV (possibly even pirated there). By canonical standards, this is a serious "crime"; her work must separate itself from mass culture, must be self-reflective, even in its form.

The forms do indeed resemble each other uncannily. The telescoping montages, the eerie disjunction of music and narrative, the choppy editing (designed as an alienation effect) are common to both. However, they vary in one important way: the MTV pieces are often nostalgic narratives. Like kodachrome photos from the thirties, they have an oddly dyed, denatured look, a neon effect. They are dusky bits of business from Bogart and Bette Davis, from the "hep" forties, from gang epics like *The Warriors*, from television detective shows, from car crashes in movies. They are nostalgia turned into candle wax, but let us be clear about the issue: The nostalgia is not for the thirties itself. They are not airbrushed tabloids about the streets of New York after VE Day; and let us not simply call them "surreal," the miracle catchall phrase which says that here is mass culture sophisticated enough to pass as self-reflective.

These nostalgic puffs of filmed music are dreaming of the stuffed red velvet of neighborhood movie houses in 1945, of the neighborhood sense of community, when dad and mom went to a double bill every Tuesday night because the theater was air-conditioned. The nostalgia is for the audience of 1945, not the political or physical reality of that year. Mass culture is endlessly signifying how audiences felt, xeroxes of xeroxes, if you will—but rarely addressing the political or social conditions directly.

Dara Birnbaum is using a different format in that respect. There is little attempt at narrative, although some of her work plays with advertising scenarios. Like Nam June Paik's work, the theme is the Kino eye itself—how it changes people's expressions; how it is present at all times, denaturing the figures. MTV seeks to block the Kino eye; Birnbaum emphasizes it.

If only the distinctions were always that clear. Can we identify MTV as a sort of anti-Aristotelian narrative? Where does that place us in the canonical scheme of things?

The MTV experiments with narratives do, in their own way, propose a modernism. For support, I would call on the essay about Superman by Umberto Eco, where the anti-Aristotelianism of cartoon strips is compared to Robbe-Grillet (with suitable filters in between: Eco is quite magnificent in this essay).[1]

We can compare Eco with the orthodox canon, for example Clement Greenberg in "Avant-Garde and Kitsch."[2] If we interpolate MTV into Greenberg's article, the canon suggests that Music TV is a feature of ersatz culture; it is kitsch, "using for raw material the debased and academized simulacra of genuine culture." MTV could not exist without "the availability close at hand of a fully matured cultural tradition, whose discoveries, acquisitions, and perfected self-consciousness kitsch can take advantage of for its own ends. It borrows from its devices, converts them into a system, and discards the rest."

Clearly MTV, like most mass culture, borrows mostly from its own genus—from Hollywood films, from the audience culture in rock concerts, network television, advertisements. The canon does not help us here. We are forced to equate this gaudy effluvium with devices from the fine arts, as a type of modernism. Instead, for the moment, let us try to step outside of the canon. We will imagine that a mass-produced modernism exists *parallel* to the fine arts, owing nothing substantial to "genuine culture." After all, to argue that Dara Birnbaum is "teaching" MTV its formulas is like the flea telling the horse which way to run.

What are our alternatives? We must imagine a mass-produced modernism that is also *without clearly defined* self-critical features. Mass culture as modernism resembles Barthes' description of the petit-bourgeois "unable to imagine the Other." The resistance to self-criticism can be summed up in the phrase: "It's only entertainment." Or, "I just enjoyed it, that's all."

But is there a generic form of self-criticism in the culture industry? There certainly is, though it does not resemble Brecht, Beckett or Duchamp (who were very sensitive to the self-critical features of popular entertainment). Self-criticism in mass culture appears nightly in shows like "Entertainment Tonight," a chirpy, "celebritized" version of what Russian Formalists called "the laws of production." And yet the ritual is quite fascinating, not to be tossed away without some review. These are shows "behind the scenes," about fashion models in "real life," about how special effects are made, about celebrities being frank. The talk show is a sub-industry. Increasingly, the guests do not talk about glamour or their sex lives, but about Vegas after hours. Or everyday folks are brought in to present their ant farms; Johnny chimes in once again about Nebraska. Tinsel town has gone professional, and the results are central to mass/fine art, but how in God's canon do we classify shows like that

(and by extension, work like Birnbaum's)? I would recommend using a term like "audience culture."

With that term in mind, we imagine a modernism that can be discussed as a *social history of audience culture* (too vast a subject for a short essay, of course). Considering how blurred the process of modernism has become (and always was?), the critical problem for mass/fine art is not one of canon; it is one of audience, certainly for video art. Shocks in the delivery and distribution of culture need to be intervened with in some way, reenacted (even special effects films like *Tron* review the process of intervention; we are not inventing a new subject). When surveying the range of video art, and commercial films that reenact the impact of television (cable, video games, computerized software), we find a world where "audience" has become the metaphor for both work and leisure. Perhaps "community" has been replaced by "audience," like the town meeting canceled for "Hollywood Squares." That may be why Spielberg finds such charm in re-invoking the magic of the old Saturday matinee, when the local movie theater was a sort of community (we think).

Birnbaum offers us the painful community of the matinee on television. Odd, isn't it? Years ago, Nam June Paik described video art as a statement on information overload. Well, we have gone beyond overload now. The bits are beginning to make sense. A few years ago, I interviewed "Star Trek" fans ("Trekkies," though they prefer the term "Trekkers"). There is an example of "audience" becoming community, when ten thousand gather at a conference to reenact the thrill of watching a television program. I asked one why she persisted as a Trekker. She answered: "The show and the TV ship are like a family to me." In comments like that lies the signified of video art—the referrent—not simply the sin of our ways, but the nature of our rituals.

In the most perverse sense, I suppose, audience culture can only have itself to refer to (is that self-reflective?). The shared moments in front of the screen have become their own narrative, their own "object"; they are a shared myth. We live in a world of fantasy literalism, where even postmodernist architecture can look suspiciously like tourism. We "reference" the past as facades, like a film set. Recently I went to the MGM lot, where I saw a studio set of a street in Greenwich Village I used to visit as a teenager. The bricks were hollow plaster, and very clean. The background was painted, the garbage pails neatly overstuffed. It was like a photo of a building, isolated from its historical context—except that I was walking in the photo.

In "Hollywood Squares," when the grids separating the celebrities light up, we are given an architectonic design of a public place. The stars wave, they squirm, they react professionally. Increasingly, from quiz shows to people on the street interviewed for the five o'clock news, "average" Americans react very professionally to the Kino eye; they wave, they squirm, they treat the host as an equal, they pause for emphasis, they know where the camera is. We have abstracted our public life.

Brecht distinguishes this as a culture of "distribution," rather than "communication." He was obsessed by the contrasts and politics of audience culture. In 1921, he sits in a movie house unable to concentrate; his mind is filled instead with visions of a woman thrashing a pig, of the Warschauer's consumptive maid living alone in silence in a dark flat. "And I no longer see where the great difference lies," he writes in his diary. "Far be it for me to feel pity, all I mean is how poor we are, ape-like and easily abused, wretched, hungry, submissive."[3] Consider Warschauer's maid today, gathering her fortitude in front of a quiz show.

July 1992

The debate over the canonical in art theory has taken a new turn since this essay was written in 1982. Much of the postmodern debate, as of 1982, centered around the role of the viewer (reception aesthetics) and of mass culture (as self-reflexive object, and as a symptom of the ideological corruptions within the arts). It has since become clear that mass culture has an even broader role; it is the industrialization of entertainment that has in turn become the industrialization of information, in the service of international business interests.

It is difficult, and naive, to speak now about the deconstruction of Baghdad during the Gulf War, or of Los Angeles during the Uprising of 1992. Both of these violent moments were dominated by media, as a replacement for government, and as instruments of war. The ghost of mass culture totes a gun now. The opacity of the postmodern era has ended. The audience culture has taken on a solidity today that is threatening our political institutions, and altering our cultural practices even more rapidly than one could have anticipated in 1982.

MTV is now a global code. The culture of erasure and forgetfulness has replaced the last remnants of a culture based on industrial objects. Even our heavy industries are computerized, "facsimiled," and xeroxed, from steel to oil. The video/computer screen has become the site of exchange, for banking and for community. However, the same problems as in 1982, as in audience culture, remain. We live in a world that is overstimulated, and desensitized at the same time—a world dominated by the narratives and politics of an audience-centered economy, particularly in the U.S.

The Hollywood Squares setting has come to resemble political conventions for president. The scale of audience culture has grown, and the risks have grown as well. As a result, all essays from the eighties on the meaning of audience reception become documents by 1992 for an age that has passed. We must study them as source material toward a more politically engaged, and much more economically threatened future, of great promise and great risk. The audience culture must find a way to re-enter the self and re-enter world politics. Art must locate a new confessional style, despite the invasion by mass media; as well as a public style, despite the loss of public spaces. In the mutual

erasure of public and private boundaries, the storyteller must find a new way to speak honestly to the audience.

Notes

1. Umberto Eco, "The Myth of Superman," *The Role of the Reader* (Bloomington: Indiana University Press, 1979), 116: "One could observe that, apart from the mythopoetic and commercial necessities which together force such a situation, a structural assessment of Superman stories reflects, even though at a low level, a series of diffuse persuasions in our culture about the problem of concepts of causality, temporality, and the irreversibility of events; and in fact a great deal of contemporary art, from Joyce to Robbe-Grillet, or a film such as *Last Year at Marienbad*, reflects paradoxical situations, whose models, nevertheless, exist in the epistemological discussions of our times."
2. Clement Greenberg, "Avant-Garde and Kitsch," (originally published in 1939), *Modern Culture and the Arts*, ed. Hall and Ulanov (New York: McGraw-Hill, 1967), 175–191.
3. Bertolt Brecht, *Diaries 1920–1922*, ed. Herta Ramthun, trans. and ann. John Willet (New York: St. Martin's Press, 1979), 148.

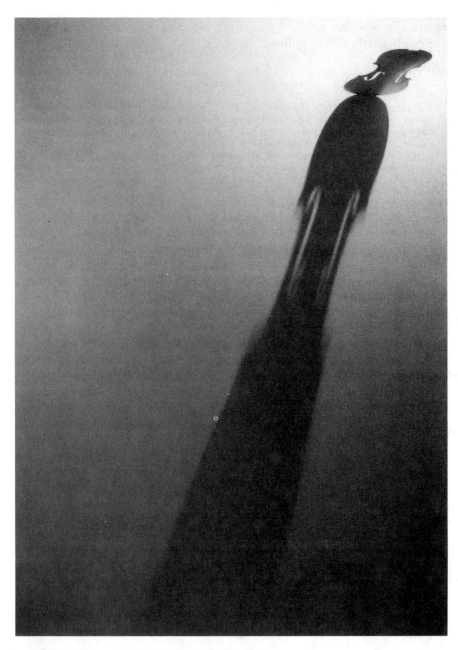

WENDY ADEST, *Duet* 1991 Violin part, light installation

Courtesy of the artist.

Commerce on the Edge

Jacki Apple

Rather than speaking about contemporary "performance art," artist and critic Jacki Apple argues that we should simply talk about "performance." Embraced and devoured by mass culture, the artists become performers and an important element in the production, presentation, and distribution of entertainment. "Performance has come of age; it is another pop genre."

It is common knowledge by now. The avant-garde has ceased to exist. It has become a nostalgic memory for its remaining survivors and former practitioners. A page in history for the generation that followed. A page turned at the turning point of a decade.

Performance Art once operated on the edge. But Performance Art, I argued several years ago, is not a generic term. It is historically bracketed, referring to a specific body of work defined by a particular ideology and methodology practiced from the late '60s to the mid '70s. Like Happenings of an earlier era, the label is not transferable. Vito Acconci, one of its more notable practitioners of the early '70s, recently referred to Performance Art as "belonging to a time, a time that made it possible." Performance Art was a romantic endeavor, a revolutionary art form that came out of a radical time. The times have changed.

In the '80s *performance* alone became a more appropriate, more accurate descriptive term for the intermedia event, the interdisciplinary spectacle. Non-specific and all encompassing, it could be applied to any aspect of the many-tentacled dance, theater, video, audio, cabaret, hi-tech, star-studded phenomenon of our time. Performance is the word of the decade, applied to every aspect of mass culture.

Reprinted from Jacki Apple, "Commerce on the Edge," *High Performance* (Issue 34, 1986).

Language collapses, disintegrates at the border, falls apart at the defining edge. Let's not confuse everyone by hanging on the "art" part. Art is no longer art, and performance is everyone's way of life.

Art is an endangered species, an American buffalo, a Siberian tiger hiding out in the Himalayas. Or is it the other way around? Art is everywhere, commonplace and ordinary, prolific as cockroaches. Art is advertising, entertainment, fashion, decoration and propaganda. Art is TV, and terrorism is "performance" at its most spectacular. As for life, life is a performance, an artifice, a simulacrum, sometimes a little flat, a little one-dimensional, a little slow compared to the mirror image on the screen.

It is a somewhat perverse irony that the philosophies and goals of two generations of artists—from the Happenings, Fluxus and Judson artists of the '60s to the '70s conceptualists and feminists—who espoused and attempted to practice the merger of art and life should bear such mutated progeny. How fitting that already Performance Art as a label has been reappropriated by the mass media to describe work so diametrically opposite to what the term originally signified. We weren't paying proper attention. Warhol was the true prophet of our time. It is not the boundaries between art and life that have been erased, but those between the art world and the entertainment industry, between art and the media, between life and TV.

The art world has finally been embraced by mass culture and devoured. No need to storm the palace. The inhabitants eagerly court, cavort and cohabit with the mass bourgeoisie. Their rewards include having their names and faces displayed alongside movie stars, athletes, politicians, evangelist preachers and TV news-casters in the glossy pages of the popular press who, in return, report with equal relish on their clothes, houses, cars, eating habits, sexual alliances and social activities. Art itself is a performance, the artist a performer, and the product merely another designer label commodity in the marketplace. If you have any doubts take a stroll through Soho, the K-Mart of art overstocked with bad over-priced reproductions!

The edge has been inverted. It lies at the center. The "cutting edge" is in the accountant's ledger. This discourse in performance is between the producer and the promoter. The terminology belongs to Broadway and Hollywood. The artist (now called the talent) is no longer an autonomous auteur. The artist is part of the system.

I recently came across a flashy day-glo red, silver, black and white promotional flyer from IPA (International Production Associates, Inc.), the newest power brokers in high art entertainment (sort of the CAA/Triad of arts management). The headline reads *Serious Art Sells*, underscored with "Smart art generation = untapped bonanza." The text talks about setting box office records with capacity audience turnouts of thousands in theaters, opera houses and culture palaces worldwide. It talks high percentages and even names numbers. The descriptions, such original lines as "Not to be missed," "Music with the

power of dynamite," and "A magic unique in world theater," not from the critical art press, but from *Time, Newsweek, The New York Times, Washington Post* and other major newspapers and magazines.

Who do these people represent? Stephen Sondheim, Baryshnikov, Bruce Springsteen? No. None other than Robert Wilson, ("Wilson comes home—it's about time!"), Philip Glass ("The world has become a Glass festival"), Molissa Fenley ("If dance were rock n' roll, she'd be Sting"), American Repertory Theater whose next season includes works by Wilson, Glass, Andrei Serban, Jo Anne Akalaitis and Laurie Anderson. Also represented is the Western Wind, a vocal sextet whose repertoire includes Italian madrigals, George Gershwin and Philip Glass; Le Cirque Imaginaire ("Rhymes with flair. A serendipitous blend of magic, acrobatics and vaudeville"), Japan's most famous butoh company Sankaijuki, and Laura Dean Dancers and Musicians ("visceral and immediate impact").

This is the jargon of the "Industry," the new vernacular of art à la show business, or as they put it in the flyer: "Serious Fun Worldwide" for an audience that "demands new culture now." We're talking big names and big bucks, fame and fortune. We're talking star talk and ticket prices for the well-heeled. This is the new establishment, the cutting edge at the center, art and performance in the Reagan era, the three M era—marketing, management and media. This is capitalism at work. This is America. No European-style reverence for high culture here. No European-style, socialist-tainted broad government support for the arts. Let's see if we can turn this thing into a profit-making business with a little wheeling and dealing Hollywood-style: package it and peddle it. This is our national cultural policy. This is performance today.

Location is so diverse that it no longer defines the content in any clearly indicative way. The location is a theater—be it little black box or large proscenium, Opera House or the Universal Amphitheater. The location is a club—from slightly sleazy, often short-lived storefronts to glitzy hi-tech discos. The location is the media—from local cable TV to PBS to MTV to *Saturday Night Live* to listener-sponsored public radio. The location is the national network of non-profit arts organizations and institutions (formerly known as artists' spaces). Performances no longer take place in "commercial" art galleries or museums (although a few occasionally still sponsor them under a performing and media arts program). Is context defined by the function of the space or by who foots the bill? On the new map everything is realigned. Even the old issues of intent and content, so relevant to identifying an activity as art in the '70s, have been voided and nullified by the '80s circumstances of production, presentation and distribution. The context is the art world or the entertainment world as a location for an idea. The two sides converge.

Consequently we are faced with the intent. Last year one of the directives on my students' contemporary art history final exam was to discuss the difference between art and entertainment. Most responded that it was a matter of purpose. The intention of the latter was to both "entertain" and make a

profit, (the audience was to be pleased—that is, it should have fun). Good entertainment might also impart interesting or important information, or it might just amuse. The purpose of art, on the other hand, was to communicate ideas and perceptions without consideration for their commercial viability or mass appeal. A few said that the question was outmoded, that the two were interchangeable. Money is the issue. Paradoxically, in the art world you often can't make what you dream up because you don't have enough money, while in Hollywood you often can't make what you want because the people with the money don't think enough other people will pay to see it. You retreat to the sanctity of the art world where a little sometimes goes a long way, but not for long. Either way the audience has to buy tickets. Without an audience there is no performance. Tickets for a performance these days cost anywhere from $7 to $25, which is more than the former audience of artists, friends and peers can afford on a regular basis, and more than a movie. So a new, broader audience is sought. Understandably so! But it's not just economics. There is also the desire and the need to reach a different audience, an ever-widening, changing audience—the audience that goes to Woody Allen movies, David Bowie concerts, and watches *Miami Vice*. How else can art have an effect in the larger world? Promotion is the name of the game. Without promotion there is no new audience and promotion costs money. Try getting gigs or grants without a slick video. See how far you go without an agent or management group. The art spaces are where you start, showcase, get reviewed, and develop a national profile, not where you stay. Performance is no longer a rowdy adolescent with a meager allowance hanging out in little gangs in the local neighborhood streets. Performance has come of age; it is another pop genre.

Having adopted Hollywood's methodology, appropriated its imagery, sought out its audience, what else is left for Performance Art but to move into its house? The art world has become Hollywood's farm team. It is to the late 20th Century what vaudeville was to the early 20th Century, what Ed Sullivan was to TV in the '50s. It can lead to bigger and better things. Like stardom. Like equal pay for equal work in the culture factory. From a tacky club in Alphabetland you can graduate to the equally tacky David Letterman Show. From art theater you can go to Broadway and on to the Academy Awards. You too can make it like Whoopi!

Showcasing in the art world can be faster and more effective than starting at the bottom in show biz. If you are a performer it's the perfect place to cut your teeth, develop a public persona and a following, get a gimmick and practice until you get good. The success of first generation crossover talents like Laurie Anderson and Eric Bogosian have made the art world a hot hunting ground for new talent. Besides, in the art world you're not just another performer—meat for someone else's recipe—but the creator of your own material. Isn't that what separates the artist from the actor, for example? Isn't that why we call it Performance Art?

There's a new territory on the map. Its borders are unstable. It keeps changing. It hasn't really got a name. It has a lot of names depending on who is talking and what language is being used. Eric Bogosian's *Drinking in America* and Lily Tomlin's *The Search for Signs of Intelligent Life in the Universe* are both in Broadway theaters a few blocks from each other. Both are soloists who perform a number of "characters" whom they have created. Both are social commentators. Both have a distinctive personal vision and voice, and neither appears to have compromised material for reasons of commercial appeal. Their differences are those of style, aesthetics and sex. Bogosian comes out of the art world, Tomlin out of show business. Bogosian calls himself a performance artist and is advertised in and reviewed by the *Village Voice*. Tomlin is not. Yet Tomlin was the m.c. for the *Arties*, the Franklin Furnace 10th year anniversary benefit event at which awards (like Oscars!) were presented for accomplishments in performance. Bogosian is a role model of someone who is making it on his own terms—saying what he has to say, the way he wants to say it. He's not selling out, just moving up. He's got the tiger by the tail. Tomlin is what many young performance artists aspire to, and few, if any, will achieve.

David Byrne and Laurie Anderson swim in the same stream (art entertainers on a mass-media stage). The difference is that Byrne is a much better navigator, a more versatile artist capable of playing on both shores: high art exercises with Robert Wilson on one side, rock movie success (*Stop Making Sense*) with Jonathan Demme on the other. He makes Wilson more "popular" and accessible, while giving Hollywood director Demme "art" credentials. All of it makes record albums. Talking Heads sells David Byrne. David Byrne sells Talking Heads. He's money in the bank. He can call his own shots.

Anderson was the art world's first "crossover" performance artist to get a Hollywood contract, leading the way like an avant-garde drum majorette while others gaped in awe and envy. It wasn't an accident. It was a goal. She's a smart girl. Four Warner Bros. albums and a movie later, she's done concerts around the world, been on *Saturday Night Live,* packed 'em in at big time rock 'n roll venues like Hollywood's Universal Amphitheater, and high art venues like BAM's Opera House. She's arrived, but she doesn't seem to know where to go next.

In the film *Home of the Brave* she merely recycles herself for the record, running through it one more time for the camera. Like she says, "This is the time, and this is the record of the time." The surface is slicker than ever but it feels like the insides are missing. The message is that the sharks are everywhere. The sharks need to be fed, but how many more times can she rearrange and rewrite *Language Is a Virus?* It's now as smooth as a milkshake.

Anderson, unlike Byrne, is stuck in midstream, caught in the crosscurrents, treading water. She keeps looking over her shoulder, kicking with one foot while the other is stuck in quicksand. Success has got her by the hair and ambivalence is snapping at her bum. Her stance is full of mixed signals. The

artist has one eye cocked at the pop star, but they're in the same boat! Her dilemma is a paradigm for Performance Art. She can't go back to that little town called Soho because it has been torn down and replaced by a shopping mall.

Where do you go when you can't go home? To the movies. The time is night. The scene is a downtown Manhattan studio. A young performance artist named Chelsea (Daryl Hannah) shows what she does to a rumpled Spencer Tracy-style D.A. who knows nothing about art (Robert Redford). This mini-performance, complete with slide projections, props, live and recorded autobiographical narrative text, music and choreographed movement, is not Hollywood's idea of a performance art piece, but the real thing. It was created by none other than Lin Hixson, L.A.'s leading exponent of large-scale interdisciplinary performance spectacles dominated by pop culture imagery. Her collaborators were Hannah, one of Hollywood's brightest rising stars, and associate producer Arnold Glimcher, owner of New York's prestigious blue-chip Pace Gallery. The movie is *Legal Eagles*. This big budget, star-studded film directed by Ivan Reitman (*Ghostbusters*) is one of the first major Hollywood features in which one of the main characters is a contemporary artist. The fact that she is a performance artist is fittingly ironic.

Hannah had read about Robert Wilson and others, and had seen Anderson's work and liked it. It was her idea to make Chelsea a performance artist instead of a painter—an astute move on Hannah's part. When screened for a test audience of several hundred post-adolescent suburban moviegoers, the performance piece rated as one of their favorite parts of the film. But from the generation that watches MTV this shouldn't be a surprise!

The Hollywood axiom being what it is (if something succeeds, do it again and again and again), we shouldn't be surprised if suddenly everyone wants to have a performance piece in their film too—even if it's just a cameo. Unfortunately, Hannah's performance and the juicy art-world plot that gave the film its raison d'être ended up as window dressing. No matter! Any day now producers and directors will be besieged with calls, press kits and video tapes from all the hot arts management and booking agents in the business making pitches and looking for deals. Performance has been waiting in the wings for this moment.

The real irony is that Hixson and Hannah's performance in *Legal Eagles* looks more like art than many performances do today, and it is treated with the same seriousness as the great art that graces the walls (De Kooning, Rauschenberg, Lichtenstein, etc.) throughout the film. But that can't be counted on. Not everyone has Glimcher's sophisticated art eye and knowledge. Far from it! Just remember, the movie business isn't really a business, it's a crap shoot! And performance is . . . just another part of the "industry"! CUT.

Let's go back to the beginning, to the sources, to performance as public ritual, to performance as ceremony, to performance as spiritual and religious invocation, to performance as catharsis and celebration in a social context.

In an interview with Lee Breuer and Bob Telson (the creators of *The Gospel at Colonus*) in Los Angeles, Breuer stated that "recent scholarship has led us to believe that Greek plays from 200 to 300 B.C. were political/religious gatherings. They weren't entertainments at all. . . . Everything that became known as Greek tragedy came spontaneously as a response to preaching. The singing and dancing were spontaneous. . . . It leads you to understand how theater started per se. There was a shaman or storyteller or a religious leader who spoke out to an assembled group of people; they started responding . . . those responses go into the call-and-response tradition found in contemporary African music. Theater could not have been born any other way." Breuer and Telson saw a direct parallel in black American preaching and popular music— gospel, blues and jazz. Telson: "When you go to a black Pentecostal church the spirit is summoned through the snare drum, the back beat, the hand clapping, the tambourines. . . . You grow up listening to pop music on the radio—Aretha Franklin, Wilson Pickett, James Brown—all of them came directly out of the church." Breuer: "Black preaching is a very high use of the English language, very poetic, very musical. . . . It had already gained acceptance and popularity in the context of popular music because all lead lyric readings, all lead vocals, are basically the same impulse that goes into black preaching. There's no higher expression of English . . . listen to what Ella Fitzgerald or Stevie Wonder or James Brown can do to a word!"

By presenting Sophocles' Greek tragedy *Oedipus at Colonus* as a black gospel service, Breuer and Telson redefined its original context and meaning in contemporary terms. In *The Gospel at Colonus* "high art" and popular culture come together in a truly authentic "trans-cultural" form that brings performance and theater back to its roots as an *unmediated* experience. It speaks directly through the heart and soul of universal human experience, emotionally, spiritually and philosophically. Clapping, singing, dancing, the viewer becomes involved in a way that more closely resembles a member of a congregation rather than a member of an audience. It is a participatory theatrical experience, not a Spectacle. It transcends artifice. Dare I call it "art"?

Jump cut. The context is the Church, not simply as place, but as producer and promoter. Now pan slowly to the right, to the far right, to performance as pop spectacle, to religion reinvented in the Hollywood vernacular as performance.

Rev. Robert H. Schuller's million-dollar pageant, *The Glory of Easter*, performed in his twelve-story glass Crystal Cathedral in Garden Grove, California, is the world's largest annual passion play. Christ's last week on earth from Palm Sunday to the crucifixion and ascension is recreated as a contemporary multi-media spectacle featuring movie stars, a cast of 400 volunteer per-

formers, a menagerie of animals including two baby leopards, a tiger, peacocks, goats and donkeys that outdoes Rachel Rosenthal's *The Others*, and state-of-the-art special effects worthy of George Lucas. The staging combines avant-garde theater/performance and the Hollywood film epic. Imagine Max Reinhardt, Meredith Monk, Cecil B. DeMille and Steven Spielberg rolled into one and reborn.

A Jerusalem marketplace comes to life on a two-story-high, 75-foot-deep terraced set with a purple carpeted runway through the center of the audience. Helmeted Roman soldiers ride down the aisles on horseback conjuring up memories of Charlton Heston, while Gregory Peck's voice narrates from Heaven via a multiphonic sound system equal to Lucasound. "Extras" mill about the balconies waving palm fronds, and Jesus comes into town with his gang like a cowboy evangelist whose reputation precedes him. Surrounded by an entourage of adoring groupies, he struts, prances and preaches like a cross between a pop rock star and an ambitious young politician on the campaign trail. Jesus is played like a media celebrity—the kind of guy who gets himself arrested for public value. In other words, he sets himself up. Pontius Pilate is played by Michael York a la Masterpiece Theater—a colonial official of the Empire trying to administer justice amongst the squabbling locals and religious fanatics, rather like Mountbatten in India. Herod, the Hugh Hefner of the ancient world, is accompanied by a bevy of dancing girls decked out like Las Vegas chorines.

Mary Magdalene sings Jesus a love song like a cross between Linda Ronstadt and Barbra Streisand doing a lounge act. Then she provocatively throws herself at his feet, kneeling as she perfumes his body, offering herself to him. The girl can't help it. More than love it's an obsession—Calvin Klein's Obsession.

The crucifixion is basically a small town lynching by an angry mob incited by a few scheming elders who get the Law to do their dirty work. We've seen it before in a hundred westerns. This time it's updated by the splendid hi-tech effects—a virtuoso display of lightning including laser beam lightning bolts that snap and crack across the Cathedral, followed by great claps of thunder. Jesus on the cross is lit up like an El Greco. Great clouds of blue fog roll in. Music from a 14,000-pipe Hazel Wright organ is accompanied by drums, trumpets and flutes. Mary Poppins in angel drag flies through the air singing. The stone at the tomb is rolled away by an earthquake.

It all comes to a stunning grand finale as two sides of the Cathedral part, opening like the docking doors of a giant space ship. The crucifix is backlit à la *Close Encounters of the Third Kind*, and Jesus ascends to heaven in a shaft of green light, beaming up like Mr. Spock to "go where no man has gone before."

"The world is a stage, the stage is a world of entertainment." And *The Glory of Easter* is a spectacle in which opulent technology has replaced spiritual substance, poetic vision and philosophical concerns about the nature and meaning of human existence. This is the world we are living in.

Where does that leave us in these cynical and decadent times? The art world is a suburb of Hollywood. Art doesn't live in the art world. It's too expensive! Art is in camouflage, regrouping. It may be found hiding out (under an alias) in a lot of unlikely places. Even in Hollywood. Only don't tell anyone please! It doesn't want any publicity.

STEPHEN PRINA, *Galerie Max Hetzler, 2/3. 1991.* **Installation view**

Courtesy of the artist, Los Angeles, and Luhring Augustine Hetzler Gallery, Santa Monica, California.

The Marriage of Art and Money

Carter Ratcliff

After discussing the ongoing dance between collectors, gallery dealers and auction houses, critic Carter Ratcliff argues that market value and esthetic value are two aspects or facets of the same phenomenon. The wish to be understood and the desire to be bought are part and parcel of one and the same process and cannot be isolated from one another. Adjustments in the art market are ongoing and necessary since the market is a "species of discussion and every lively discussion is full of extravagances. . . ." Even Marxist critiques become just another marketing ploy once the world is seen as a marketplace for distinctive commodities, including, and especially, artworks.

> *The whole business of man is the arts.*
> —WILLIAM BLAKE, *THE LAOCOON*, ca. 1820

> *The chief business of the American people is business.*
> —CALVIN COOLIDGE, 1925

Imagine that art and money are characters in a novel. If they were to marry, which novelist would best convey the motives of their union? Henry James, undeniably, for he understood that marriage is a market transaction, and that no market, not even the most crass, confines itself to monetary exchange. A financial deal always has an aspect of the social, in the large and the small senses of that word, and the social entails the esthetic. James's heroes and heroines often read like allegorical figures of art and money, nowhere more

Reprinted from Carter Ratcliff, "The Marriage of Art and Money," *Art in America* (July, 1988).

clearly than in *The American* (1879), the story of Christopher Newman, who comes out of nowhere and makes a fortune, chiefly in copper. By the age of 35 he has accumulated so much money that more would be pointless, so he sails to Europe.

In the Old World, Newman visits churches—470 of them, roughly—and contemplates marriage. As he says in Chapter Three, "I have succeeded, and now what am I to do with my success? To make it perfect, as I see it, there must be a beautiful woman perched on the pile"—i.e., on his money— "like a statue on a monument. She must be as good as she is beautiful, and as clever as she is good. . . . I want to possess, in a word, the best article on the market." If Newman gets his wish, he will acquire not merely a distinguished wife but a living art work, a statue marking the pinnacle of a fortune so monumental it has its own esthetic aspect. I believe James means us to understand that, like the western prairies, the American's money is sublime in its vastness. Newman zeros in on Madame de Cintré, an aristocratic young widow endowed with complex and subtle loveliness. Their marriage would join the sublime and the beautiful, an esthetic event so devoutly to be wished that when Newman's proposal is accepted he seems to have achieved the ultimate coup, a deal so gloriously profitable that it transmutes money, mere lucre, into something ethereal—a medium not of exchange but of life lived as if it were a work of art.

Though some characters in the story believe in this transformation, the hero, as far as I can tell, does not. James appears to let Newman understand that he can move from one market to another, but never escape the realm of the economic. To belong to Western culture, in the Old World or the New, is to compete. Four years as a Civil War officer left Newman "with an angry, bitter sense of the waste of precious things—life and time and money and 'smartness' and early freshness of purpose; and he had addressed himself to the pursuits of peace with eagerness and zest." He turned from military competition, which tears things down, to the commercial kind, which builds them up. However, on a trip to New York to clinch a bit of particularly sharp dealing, he suddenly feels "a mortal disgust for the thing I was going to do. . . . I couldn't tell the meaning of it; I only felt that I loathed the whole business and wanted to wash my hands of it." So he travels to Europe to find a third market, the one where Madame de Cintré, an allegorical figure of art, is the prize offered for successful competition.

In his art criticism, James writes of portraits and landscapes as if he were describing the characters of his novels and supplying them with scenic backdrops. The most refined of James's invented personages are emblems of art, and he wrote that art works are at their best when they emblemize people.[1] James's novels join with his criticism to suggest that emblems of both sorts take their value from marketplace transactions, some delicate and others not. In James's *The Awkward Age* (1899), toward the end of Book I, a character says that "in London . . . staring, glaring, obvious, knock-down beauty, as plain as a

poster on a wall, an advertisement of soap or whiskey, something that speaks to the crowd and crosses the foot-lights, fetches such a price in the market that the absence of it . . . constitutes . . . a sort of social bankruptcy."

This is brutal commentary and not applicable now precisely as it was in James's day. The economics of marriage and of personal image have changed. Nonetheless, his narratives still convince with their arguments that individuals are economic units, that every variety of meaning and value is generated by market transactions. Though Christopher Newman's aristocratic in-laws are particularly good at calculating the rates of exchange that transform cash into supra-monetary value, that knack is not the exclusive property of their class. William Blake, a social and esthetic radical shunted to the margins of the English art world, worked out such transactions with minute care. He began his annotations to the *Discourses* of Joshua Reynolds by announcing: "This Man was Hired to Depress Art"—with emphasis on the word "Hired." Blake saw the Academy as a monopoly that prevented deserving artists from finding their way to a fair market. Isolated from patronage, Blake devised complex strategies to compensate him, in imagination, for his hardships. Always in need of money, he never gave up hope for "a Fair Price & Proportionate Value & a General Demand for Art"[2] from a public somehow made indifferent to the snobbish authority of aristocratic connoisseurs.

When the hope of a fair market collapses, artists sometimes affect scorn for money. In our century Futurists ranted against "the slovenly and facile commercialism which makes the work of our most highly respected artists throughout Italy worthy of contempt"; Francis Picabia led the Dadas in their assault on "this odious trade: Selling art expensively"; André Breton tried to encourage the artist who works to satisfy not his need for money but "the personal needs of his mind." Offended by Salvador Dali's commercial shenanigans, Breton dubbed him "Avida Dollars" and expelled him from the Surrealist movement.[3] In the 20th century, whenever art and money threatened to marry, certain avant-gardists militantly refused to hold their peace. Despite their objections, the works of the European art movements— including products of the most violently anti-market stances—became valuable commodities. So did paintings and sculptures by the leading New York School artists, among them Jackson Pollock, Mark Rothko and others who nurtured phobias about selling out.

Pop artists sold well and seemed not to object. Taking consumer products as subject matter, their works gave those products back to the culture at large as images aglow with the aura of fine art. In a bliss of willful ignorance about compunctions that had tormented artists for more than a century, Andy Warhol reconciled Blake and Calvin Coolidge with the remark that "Being good in business is the most fascinating kind of art."[4] During the '60s, devotees of Pop art enjoyed a utopian state of affairs, a giddy sense of a world—or at least a world of images—made right by a union of art and money that appeared

to degrade neither party. Things were not so simple for admirers of Color-Field painting.

Clement Greenberg's criticism didn't so much establish a credible rate for the exchange of money and "correct" pictorial form as it defined "correct" form as utterly pure, hence impossible to conceive in even the most tenuous relationship with money. Thought on the subject was—officially, at least—extinguished, so sales could go forward without a thought, or at least none for the difficult meanings stirred up by the marketplace. That Greenberg served—unofficially—as a sort of dealer-curator made matters all the simpler. The power broker who issued pronouncements on "quality" also stood ready to assure collectors that certain paintings were extremely good buys. As members of the Color-Field salon assumed a posture of condescending distaste for the marketplace where Greenberg's judgments were, for a time, so persuasive, others on other scenes began cranking up the horror of lucre to the point where it inspired a new vision of art somehow freed from commerce.

In 1965 Barbara Rose praised Minimalist objects that "blatantly assert their unsaleability and functionlessness, . . . difficult, hostile, awkward and oversize" art works that flaunt a "refusal to participate, either as entertainment or as whimsical ingratiating commodity (being simply too big or too graceless or too empty or too boring to appeal)."[5] Minimalism displayed a strong and almost immediate market appeal, however, suggesting that collectors could not be deterred even by an object's complete lack of qualities traditionally thought seductive. So, a new tactic was proposed: art must fend off commerce by displacing esthetic intent from the object to something less substantial. Antimarket radicals imagined—or put on a good show of imagining—that with none of the usual goods to sell, the market could no longer impose a money taint on the artist's work.

In 1969 the Kunsthalle in Bern sponsored "When Attitudes Become Form," an exhibition with a motto: "Live in your head." Scott Burton's catalogue essay suggested that "art and ideas are becoming indistinguishable."[6] Concept, in other words, was replacing thing. Kynaston McShine wrote of the artists included in the "Information" show he organized for the Museum of Modern Art, New York, in 1970, that they employ "concepts . . . broader and more cerebral than the expected 'product' of the studio. . . . they are interested in ways of rapidly exchanging ideas, rather than embalming the idea in an 'object.' "[7] Moving at the speed of thought, the new art would not—could not—be snared by market mechanisms.

Of course the "Attitudes" show in Bern included plenty of salable work—paintings by Robert Ryman and Richard Tuttle, sculpture by Richard Serra. Featuring Rafael Ferrer's blocks of ice and scads of scruffily typewritten pages by Barry Le Va, Sol LeWitt and others, "Information" looked more resistant to commerce—but only at first glance. Not long into the 1970s, a bustling market for ostensibly unmarketable art works developed, as buyers developed a taste for the texts of the Conceptual artists and the photographic relics of perfor-

mance pieces. Earthworks bore no price tag, but their aura of unsalability generated a demand for documentation. As if to close, at long last, this chapter on art's failure to resist the usual market machinery, Michael Heizer's *Double-Negative*, an earthwork built in 1969–70, recently passed into the possession of the Museum of Contemporary Art in Los Angeles.[8]

The marriage of art and money seems blissful these days, when artists like Jeff Koons and Haim Steinbach do well, critically and commercially, with works that celebrate consumerism at least as enthusiastically as they question it. Avida Dollars is the moment's unsung culture hero, yet blasé attitudes about money obscure a persistent uneasiness. Still half-consciously fearing that a union with commerce besmirches art, we put the blame on art dealers. After all, when art and money marry, dealers are the brokers. Cast in that questionable role, they look resilient and smooth.

Weathering the 1973–74 recession without much trouble, dealers in contemporary art glided to the end of the decade more than ready to cash in on Neo-Expressionism's "return to the figure."[9] Galleries have boomed and multiplied in the 1980s. New York's East Village scene invented itself, sprawled, then contracted as a new art neighborhood appeared at the intersection of Broadway and Prince Street. Partly a SoHo annex, partly an economically upward migration from the East Village, this outpost on Lower Broadway does not yet feel permanent. It does look prosperous. Paradoxically, as the '80s art market flourishes, galleries seem to come in for less blame. Flashier, more aggressive players have begun to assume some of that burden. Sleek with profits, they inspire moralistic fingers to shift direction, like weathervanes. Dealers, too, have begun to point. Their targets are the auction houses.

Auctioneers are charged, first, with inflationary mischief that divorces esthetic merit from any reasonable assessment of market value. In what sense is van Gogh's *Irises* worth the $53.9 million it fetched at Sotheby's? Why not $5.39 or $539 million? The circus atmosphere of an auction encourages decimal points to leap about like wayward acrobats. Records are set, but not for all artists, all styles, all periods. Hence the indictment's second count: auctions narrow the art world's focus to the sort of object that goes well off the block. Much art is ignored, while a few varieties begin to glitter like financial instruments of a new kind—bearer bonds made of oil on canvas or sculpted metal. This is the weightiest charge: more effectively than gallery sales, bidding scrimmages on the auction floors don't simply taint art with a commercial flavor; they turn paintings and sculpture into a kind of money.

When the bidding sets a record, the event is news, and in any case auction houses must make their prices public. Though dealers are now required to post the prices of works on view, that is all—absolutely all—the monetary information they must or will provide. They will disclose no details about discounts to favored clients, the number of exhibited works actually sold, or the nature and extent of their back-room business in unexhibited works. In con-

trast to auction houses, the galleries form an unexamined and largely unregulated market. This permits discretion, a valuable commodity in itself. As Andre Emmerich puts it: "Galleries offer clients the opportunity to collect art in the absence of publicity." Though the nature of the case thwarts proof, it seems sensible to assume that certain collectors reap measurable benefits from this pecuniary hush. Buyers may also gain a less tangible advantage from the ambiance that accompanies financial tact: with no auctioneer's hammer threatening, a client can consult with the dealer, get to know a work of art, make an informed choice. A personal relationship with the dealer and his staff may develop, and this can lead to friendships with artists, with other collectors and with curators avid to borrow the works one has acquired. From the stillness of the dealer's viewing room, a way of life elaborates itself.

I have of course presented an idealized view of the advantages of buying from a gallery, but it would be too cynical to suppose that the ideal is wildly at variance with the facts. Many collectors report themselves pleased with buying from dealers, a satisfaction they owe in part to the friendships fostered by the privacy that galleries are so careful to preserve. When a dealer in the secondary market emerges as a collector, as they often do in the '80s, friendship between entrepreneur and client is strengthened by a cluster of converging interests.

Friendship aside, much of the art world seems united in distaste for the high-glitz commercialism of the auction houses. If art is to redeem money, shouldn't that redemption confer, at the least, a measure of genteel elegance? Some collectors revel in the journalistic clatter set off by record prices. Others prefer their consumption to be less conspicuous. They appreciate the power of a gallery's social ambiance to take the sharp commercial edge off the marriage of art and money. The finesse of the New York galleries sometimes permits buyers to believe, almost, that art-dealing is not a business like any other. Commercial realities fade or, if they insist on remaining visible, are cast into a flattering light.

Adam Smith argued that in seeking profits, a merchant is "led by an invisible hand to promote an end that was no part of his intention . . . pursing his own interests he frequently promotes that of the society more effectually than when he really intends to promote it."[10] Good businessmen unconsciously do good for the community, said Smith. The "invisible hand" is not market manipulation, as some commentators have thought. A benevolent force beyond any merchant's influence, Smith's "invisible hand" is a secular version of divine Providence. Guiding ordinary business people to provide social benefits above and beyond personal profit, this agent of a capitalist divinity settles matters so that a by-product of art-dealing is a transcendent *cultural* good. Or so dealers subtly encourage us to believe. No dealer claims outright that Providence has extended to the art market an "invisible hand" more refined and sophisticated than the one that guides ordinary markets. But all the dealers I

interviewed make the claim implicitly with the observation that, by its very nature, the gallery business performs public services of an elevated sort, and their yearly rounds of free public exhibitions, some of museum caliber, give this claim a degree of plausibility.

To hear some dealers tell it, no "invisible hand," crude or sophisticated, shapes the auction market. Once the bidding starts, there is only raw acquisitiveness, a Hobbesian state of war that pits each against each and God—or the auctioneer—against all. No higher good emerges, just the spectacle of art works converted directly into lucre. Pushed to extremes, this argument would conclude that there are two art markets, one beneficial, the other not. Of all the dealers I interviewed, only Phyllis Kind came close to saying this. The others confined themselves to expressing reservations, mild or vigorous, about the auction houses' effects on the market and on art itself. Few dealers claim to inhabit an art market separate from the auction market, yet they all imply, more or less straightforwardly, that they operate in a shared market in a calmer, more constructive way. The dealers claim in effect that when they arrange marriages between art and money, the outcome is more favorable to esthetic value that it is at auction.

The auction houses naturally do not accept this view. Martha Baer, the director of Christie's 20th-century fine arts department, says, "Many collectors make purchases both from dealers and at auction. There's a great deal of overlap in the two sets of clientele. In fact, galleries will often make purchases at auction for clients, and would be remiss if they didn't, assuming that an appropriate piece had appeared on the block. Dealers are very active participants in the auction market." To the charge that galleries provide personal attention that auction houses do not, Baer says, simply, "It's nonsense. We talk to clients all the time." Furthermore, the major houses present lectures and offer art appreciation courses.

Lucy Mitchell-Inness, vice-president of Sotheby's contemporary department, acknowledges that vigorous bidding creates certain problems for galleries. When unnamed Japanese corporations and other mega-bidders enter the fray, prices can quickly climb beyond a dealer's reach—or at least beyond what they expected to pay. Moreover, dealers who can afford to buy at auction find that certain clients shy away from paintings recently knocked down at heavily reported prices. Other clients have no such qualms, and, in general, says Mitchell-Inness, "There is a wide group of collectors who buy at auction and from dealers. Naturally some make all their purchases from galleries, but another group only participates in auctions. We make it easy for busy people to acquire art. They study our catalogues, attend the twice-yearly sales, and build a collection that way. It isn't necessary for them to go running around in the rain or enter into discussions about price with a seller. There are no negotiations in the salesrooms. Some people simply enjoy the sport of bidding at auction."

Only the most indignant dealers would disagree with Baer that "there's room enough for everyone—and not only enough room. Also interdependence. Galleries often consign works to auction houses, and of course the contemporary pieces we sell usually came into the market originally in gallery exhibitions" [before passing through their consignors' hands]. Yet, as dealers often told me, "The art market revolves around resale." Auctions have been indispensible to this resale—or secondary—market in contemporary art at least since Sotheby's sold off the Scull collection in 1973. For nearly two decades, the auction houses and the galleries have worked the same market on shared economic terms. If dealers wish to set themselves apart from the turmoil of the auctions, they must stress differences of style and method. Galleries are orderly places where advance schedules are determined in detail. Auction houses must take what turns up on consignment or whatever they, as art-stalkers, can drive from cover. So even as they boost the market in contemporary art, the auction houses must follow paths blazed by the galleries—or by some of them.

All high-powered dealers and many still gathering their strength are guided by some more or less articulate notion of what the history of art has been and ought to be, and these notions generate trends. The works on view at the auction houses' presale exhibitions of contemporary art can reflect current developments in only the roughest, fun-house way. Because of that roughness, because the auction houses can follow the contemporary market but not lead, and because they've made such a financial success of this tagging-after, some dealers accuse the auction houses of opportunism. These polemics are effective in shifting the money taint from dealing to auctioneering, yet it seems clear to me that, despite their wish to accomplish an elevated sort of good for the culture, galleries are as commercial as any other business.

If this is so, then the galleries might as well shelve their attempts to convince the art world that they are better than auctions at redeeming money—at elevating lucre to some transcendent plane. If galleries are no more nor less commercial than auction houses or business firms in general, then art is a commodity like any other and we will no longer have to go through the motions of shock or enlightenment when artists like Steinbach and Koons present works that reveal (yet again) the commodity status of art.

Above all, we will no longer have to feel qualms about the marriage of art and money. We will no longer have to wonder if it is possible to separate the esthetic value of an art work from its commercial value. For, as nonchalant about art and money as we have become, we still try to make that separation. We still assume that a price tag is one thing and a critical evaluation is another thing entirely. They are not, though it might be helpful to say at the outset that I am not going to argue that esthetic value is merely a function of market value, or that a critical judgment is a commercial judgment in disguise. My argument is expansive, not reductive.

I believe that our persistent habit of trying to separate market value from esthetic value is misguided, like the struggle to extricate a picture's content from its form—an impossible feat, and not because form and content are so intimately intertwined that we can't disentangle them. They are simply not separate things: "form" and "content" are the names of aspects—facets, if you like—of a single thing. As our interests shift, we focus on one aspect or another. Sometimes the criticism properly called formalist focuses on shape and color exclusively enough to convince us that the aspect of art we call content is somehow extraneous—added on—to an essence called form. But it is not. Content, no less than what we call form, is integral to every art work. The space in Claude's paintings makes no formal sense unless we acknowledge that he painted landscapes. The space in Mondrian's paintings makes no formal sense unless we acknowledge that an aspect of its form is its content of De Stijl polemics, and, moreover, that those polemics did not banish from Mondrian's art all vestiges of Claudian landscape. Likewise, Western art since the Renaissance makes no esthetic sense unless we recognize that what we call "esthetic" is only one aspect of art works whose other aspects include those called "entrepreneurial" or even "commercial." At its most "esthetic," art as we know it is always "selling" something—or many things, its own vision of the world first.

Somewhere near the top of the list of an art work's offerings is its physical presence. Even the Conceptualist's scrap of onionskin paper wants to get bought, in the narrow sense, by a collector. But just as there is no conflict between form and content, there is none between an art work's wish to make itself attractive, a must-have item, in the eyes of collectors and its attempt to persuade a general audience to accept its larger meanings. The two appeals are more than compatible, they are identical—different aspects of the same invitation to understand, to accept, to buy the work and its meanings, figuratively and literally. Some art looks so obscure or outrageous that it seems designed to repel collectors even as it makes a bid for critical notice. Think of Jackson Pollock's drip paintings when they were new or Leon Golub's horrific tableaux. If critics do take note of "difficult" work—if, in other words, there is an exchange between writer and artist on the level of analysis—a marketplace exchange often follows.

Western art gains its entrepreneurial flavor from the Western self. We define ourselves in competition for economic profits that, thoroughly examined, reveal other aspects—social, cultural, esthetic.[11] Likewise, the most transcendentally esthetic behavior or image reveals motives in some sense economic. The esthetic is an aspect of the economic, as the economic is an aspect of the esthetic. So to carry on—as some still do, in however desultory a way—the project of isolating the market value of an art work in the hope of excluding that supposedly crass, vulgar consideration from the realm of the esthetic is as misconceived a procedure as the formalist protocol that tries to banish content from the realm of form. We often say things like, "X is a good artist even though nothing was bought at the last show"; or, more to the point, "Y is bril-

liant, *even though* her works are fetching absurdly high sums." I'm suggesting that such remarks, not to mention our allegorical images of the marriage of art and money, rest on a nonexistent distinction.

But what, you might ask, about the $53.9 million paid for van Gogh's *Irises*? Surely here is an instance of economic value added to a painting with no, or little, bearing on its esthetic worth. Time and again I hear it said that van Gogh is great but prices like that are absurd. I agree with this chorus of protest but not wholeheartedly. *Irises* fetched a nonsensically high price, but it doesn't mean van Gogh was any less entrepreneurial than other Western individuals, or that his art was not intent, in its way, on selling itself, figuratively and literally. Even William Blake wanted to make sales, as his many prospectuses make obsessively clear. In 1793 he published an announcement of a series of etchings with this note: "The Labours of the Artist, the Poet, the Musician, have been proverbially attended by poverty and obscurity . . . owing to a neglect of means to propagate such works as have wholly absorbed the Man of Genius." But now, Blake continues, he has discovered a printing process that makes his illuminated poetry available cheaply; he is, he announces, "sure of his reward." But 15 years later, his reward had not come, and he rails against "the Oppression of [Sir] Joshua [Reynolds] & his Gang of Cunning Hired Knaves."[12] Blake saw in himself a modern individual, and in Reynolds a representative of a guild authority on a medieval model, the Royal Academy, whose chief purpose was to drag art and individuals backward.[13] As Adam Smith objected to the constraining effects of old-fashioned mercantilism, so Blake argued that the Royal Academy was outmoded the moment it appeared.

It may seem odd to pair the sober Adam Smith with the visionary Blake, but if we can get over the habit of seeing the commercial and the esthetic as separate orders of value, it will become clear that Blake and Smith shared the modern entrepreneur's faith that, with providential certainty, free markets generate the best outcome for all. There is an image of Blake as an archetype of the Romantic individual who defined personal freedom as a value independent of marketplace demands. If we set aside this long-standing image, we will see that Blake did the opposite of what is routinely supposed; that is, he defined freedom not in defiance of commerce, but rather in marketplace terms that, when looked at from another angle, become the terms of untrammeled Romantic self-expression.

Artists like Blake and van Gogh—I mean visionaries of the kind we too readily see as untainted by money or the thought of it—feel a particularly urgent need to win in the marketplace, to have their visions accepted in as many ways as possible, by purchasers, viewers, critics, historians, everyone. That is because they, more than others, feel marginal and unaccepted. Of course it is the nature of modern institutions to make us all feel that way to some extent. The forms of feudalism, by contrast, molded themselves to the human material at their disposal in a way that the forms of modern factories

and bureaucracies do not—or so we have believed ever since Horace Walpole began to play games with the Gothic at Strawberry Hill. However warped our view of the Middle Ages may be, our nostalgia for that era and for supposedly primitive, non-Western cultures is a strong sign that we feel bereft in our own times. Our institutions provide only so much acceptance and there are so many of us to compete for it. Look at the hordes of young people who come out of art school seeking the glamour of recognition as artists. How can we understand them—or our interest in art, for that matter—unless we acknowledge that esthetic aspirations cannot be formulated in our culture without formulating, in the same instance and with the same act, a desire for market success across the board, from the review columns to the collectors' living rooms? The entrepreneurial self looks nowhere without seeing a prospect for a sale.

But, I seem to hear, this doesn't quite dispose of the *Irises* problem. Surely economic value occasionally soars to a point where it splits off from any other sort of value, meaning that if we want to look at van Gogh's *Irises* as art, we must put its price tag out of mind. Maybe, but such compartmentalizing tactics remind me of Roger Fry's attempt to see the "plastic beauty" of Rembrandt's *Christ Before Pilate* apart from the "psychological truth" of the painting's narrative.[14] He set aside the narrative to concentrate on what, by his faulty logic, was leftover. I call his logic faulty because by removing one aspect of a painting from consideration he removed the entire work; aspects, by their nature, belong to a whole. Seeing *Christ Before Pilate* as form divested of content, Fry saw something other than what Rembrandt intended. Thus he didn't see the work, nor will we see *Irises* or think about it clearly if we try to purify the picture of the astonishing knowledge that someone paid $53.9 million to own it.

If we are to live in our historical moment, we have to look at *Irises* (or a reproduction of it) with a full sense of the price it fetched and try to see that outrageous number as part of what the painting means now. Maybe we can't do that. If we cannot, the painting will go unseen in its fullness. We will see in its place an image lacking that aspect we call "intention," for van Gogh intended this painting to sell, and it has, ten times since his death.

I hope it doesn't sound as if I am making common cause with laissez-faire ravers and all the other theodicists who assure us that whatever is, is right.[15] I don't say that every price is fair, any more than I would say that every critic's degree of emphasis on form or on content is just. A market is a species of discussion, and any lively discussion is full of extravagances, irrelevancies and outright silliness. What I am saying is that in these matters fairness and unfairness, justice and injustice, turn on the same question: how well balanced is the market's or the critic's treatment of an art work? Does it account for all the work's aspects? Does it bring those aspects into an equilibrium that reflects the wholeness of the work, its unity, such as it

is? Balance may not occur but it remains possible. If we think the latest price for *Irises* was thrown out of whack by a grotesque overemphasis on van Gogh's myth, we must also believe, consciously or not, that some price for the painting would be proper. And some price (don't ask me what) *would* be proper, for in our culture art works are commodities, as well as all the other things that they are.

Born beyond the clutches of the market, art must be seduced and prostituted to become a fit object for commerce—this melodramatic story is tattered now and often negleted, but still strong in a way, for it still provides a basis for our definitions of the esthetic. In rejecting the image of art as money's innocent victim, I don't deny that an entrepreneurial esthetic can produce abuses, in painting or sculpture or the marketplace, just as I don't deny that our entrepreneurial culture produced Blake's "dark Satanic Mills" and now expands the oppressive dreariness of the corporate bureaucracies. I agree with antimarket critics that for a quarter of a century the American art world has paid too much attention to money and the crasser forms of power. It's as if we had spent the last 25 years looking at the stars and stripes—and the auction prices—of Jasper Johns's Flags and ignoring the subtler sales pitch of the brushwork.

Those paintings of Johns, especially the monochromes, have textures as luxurious as the exquisitely tanned hides of endangered creatures. Johns gave the anxieties of Action Painting the supple allure of melancholy. His Flag paintings offer death in a seductive mode—the death of an icon, the Stars and Stripes; the death of Action Painting, an all-American style; the death of the New York artist as a two-fisted esthetic brawler. The offering was accepted, Flag paintings were bought, and in exchange Johns received a degree of legitimacy to apply to the account of the new model of the American artist he was bringing forth from the death of the old. He received a larger measure of legitimacy when museums bought his works literally and their curators bought, in a figurative way, Johns's claim to be not the only but nonetheless the most significant descendant of the New York School's first generation.

Meanwhile, the markets, both literal and figurative, for first generation figures like Willem de Kooning and Jackson Pollock boomed. They continue to boom. Only in markets for things like detergents or toothpaste does the acceptance of one commodity lessen another's chances. Detergents are all alike. Individuals and their works of art are not. The market for distinctive commodities, for emblems of individuals powerful to the point of defiance, is expansive—so expansive that, as we've seen, there has long been a demand among collectors, curators, critics and the general public for images that insist, sometimes belligerently, that they don't want to be consumed. This makes them irresistibly consumable, for we experience our world as a marketplace where the most vivid presences, the offerings most in demand, include artists and art works that make the most fuss, sincere or not, about never capitulating to the market. Likewise, Marxism has currency among Western critics not because it shows a way beyond the mechanics of capitalism but because, with their chal-

lenges to that market machinery, certain Marxist critiques take on a particularly salable aura of courageous individuality. Each new Marxist challenge, no less than the most off-putting innovations of Carl Andre or Hans Haacke, is an alluring image of an intrepreneurial self. When we learn to see this not as an ironic peculiarity but as a straightforward fact, we will have begun to get a clear view of our culture and its art.

Notes

1. "There is no greater work of art than a great portrait," said Henry James in "John S. Sargent" (1893), reprinted in *The Painter's Eye: Notes and Essays on the Pictorial Arts*, ed. John L. Sweeney, London, Rupert Hart-Davis, 1956, p. 227. For James's way of handling what might be called the economics of response, the exchange of approbation for meaning, when faced with landscape painting, see "The Norwich School" (1878), *The Painter's Eye*, pp. 152–57. A notable point here is that an observer of James's authority determines not only what degree of approbation to give to works of art, but the amount and nature of meaning he is to receive from them.

2. William Blake, "Annotations to Sir Joshua Reynolds's *Discourses*" (ca. 1808), *William Blake: Complete Writings*, ed. Geoffrey Keynes, London, Oxford University Press, 1969, pp. 445, 446.

3. Umberto Boccioni et al., "Manifesto of the Futurist Painters 1910," reprinted in *Futurist Manifestos*, ed. Umbro Apollonio, New York, 1973, p. 25; Francis Picabia, "DADA Manifesto" (1920), reprinted in *Dadas on Art*, ed. Lucy R. Lippard, Englewood Cliffs, N.J., 1971, p. 166; André Breton, "The Relationship Between Intellectual Work and Capital" (1930), reprinted in *What Is Surrealism? Selected Writings*, ed. Franklin Rosemont, New York, 1978, pp. 66–69.

4. Andy Warhol, *The Philosophy of Andy Warhol*, New York, 1977, p. 92.

5. Barbara Rose, "A/B/C Art" (1965), reprinted in *Minimal Art: A Critical Anthology*, ed. Gregory Battcock, New York, E. P. Dutton, 1968, pp. 294, 297.

6. Scott Burton, "Notes on the New," *When Attitudes Become Form*, Kunsthalle Bern, 1969, n.p.

7. Kynaston L. McShine, "Essay," *Information*, New York, Museum of Modern Art, 1970, p. 139. See also Carter Ratcliff, "SMS: Art in Real Time," *SMS: A Collection of Original Multiples*, New York, Reinhold-Brown Gallery, 1988, n.p. Organized by the American Surrealist William Copley in 1968, SMS ("Stop More Shit") was a utopian attempt to transform works of art from luxury goods into mass-produced objects available through the mail for a nominal fee. Two decades later, it is difficult to determine how ironically the project's participants espoused its utopianism. Among the contributers to SMS were such gallery stars as Roy Lichtenstein and Claes Oldenburg.

8. For a summary of antimarket agitation in the late 1960s and early '70s, see Lucy R. Lippard, *Six Years: The Dematerialization of the Art Object*, New York, Praeger, 1973. In her "Preface" (1969), pp. 7–8, Lippard wrote that "dematerialization" is "introducing a drastic solution to the problem of artists being bought and sold so easily, along with their art. Not, God knows, that the artists making conventional objects want that any more than anyone else, but their work unfortunately lends itself more easily to capitalist marketing devices." But in her "Postface" (1972), p. 263, she notes that "dematerialization" did not free artists "from the tyranny of a commodity status and market-orientation." One wonders if they wanted that freedom, for, as she acknowledges, artists who in 1969 had looked to her like antimarket radicals were in 1972 "selling work for substantial sums here and in Europe; they are represented by (and, still more unexpected, showing in) the world's most prestigious galleries. Clearly, whatever minor revolutions in communication have been achieved by the process of dematerializing the object . . . art and artist in a capitalist society remain luxuries."

9. Of course the return to the figure was a non-event. The figure never went away. See Carter Ratcliff, "Stampede to the Figure," *Artforum* 22, no. 10, Summer 1984, pp. 47–55.

10. Adam Smith, *An Inquiry into the Nature and Causes of the Wealth of Nations* (1776), Chicago, University of Chicago Press, 1976, vol. 1, pp. 477–78.

11. See Carter Ratcliff, "Dramatis Personae: Proprietary Selves," *Art in America*, Feb. 1986, and "Dramatis Personae: Rulers of Sensibility," *Art in America*, May 1986, on the interior realm—the sensibility—that must be discovered, mapped and, so to speak, improved for this competition to go forward in a thoroughly satisfying way; in other words, the self competes best on a playing field where, as the only effective player, it holds Napoleonic sway. Thus does the entrepreneurial self, spawned by marketplace competition, become, in private, a totalitarian monoplist.

12. Blake, loc. cit, and "Prospectus: To the Public" (1793), *Complete Writings*, p. 207.

13. Blake saw Joshua Reynolds and Thomas Gainsborough as England's delegates to the party of artists, such as Rubens and Rembrandt, who "Blotted & Blurred" their way to contemptibly generalized images ("Annotations to Reynolds's *Discourses*" [ca. 1808], *Complete Writings*, pp. 445, 469, 477). "All Sublimity," Blake says, "is founded on Minute Discrimination," and so the "great and golden rule of art, as of life, is this: That the more distinct, sharp and wiry are bounding line, the more perfect the work of art" (p. 453). So far, it could be said, Blake has merely stated a preference for the linear over the painterly. But he claims that the "rule of art" also applies to life, and later in this passage he gives formal matters a moral significance: "What is it that distinguishes honesty from knavery, but the hard and wiry line of rectitude and certainty in the actions and intentions? Leave out this line, and you leave out life itself; all is chaos again" ("A Descriptive Catalogue of Pictures" [1809], *Complete Writings*, p. 585). Painterly painters try to sell us a false, generalizing picture of reality, according to Blake, who scorns their wares but not the market; he wants to sell us images of the truth, which, as he sees it, requires particulars to be discriminated with a sharp line. These economics of the image have a political aspect. Particulars establish individuality, in things and in human beings, an important point in Blake's view, for only the individual's imagination can grasp the "Infinite & Eternal"—that is, the truth ("A Vision of the Last Judgment" [1810], *Complete Works*, p. 605). Each individual must be free to see the truth in his own way, for none but the vision of a liberated individual can establish truth: "As the Eye, Such the Object" ("Annotations to Reynolds's *Discourses*," p. 456). Only democratic government can tolerate such diversity, he believes, and only free markets can reward it. Politics and economics mix in Blake's diatribe against backward, monopolistic commerce that tries to preserve its power and oppress "Individual Merit" by imposing obscure, generalizing standards ("A Public Address" [ca. 1810], *Complete Works*, pp. 593–94)—for example, the standard of taste that leads to favorable judgments on the "Blotted & Blurred" images of painterly painters. Matters of politics are also matters of pictorial form. Consciously or not, every artist links form to economics to politics and back again to form. Adequate criticism traces those links in all their particularity.

14. Roger Fry, "Some Questions in Esthetics" (1920), reprinted in *Transformations*, Garden City, N.Y., Doubleday Anchor Books, 1956, pp. 28–29.

15. See Alexander Pope, "Essay on Man" (1733–34), 1. 289.

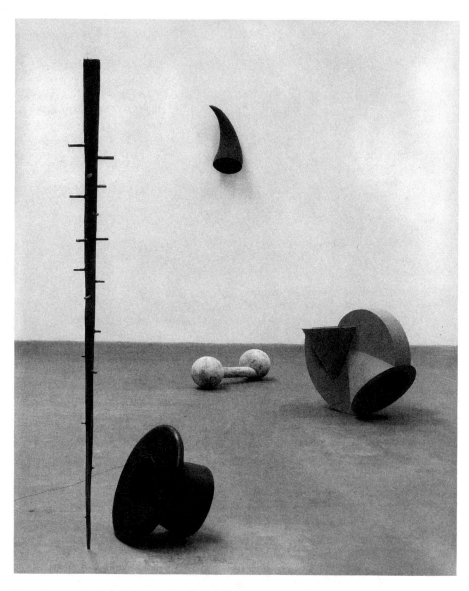

MARK LERE, Installation View. 6 October–3 November 1990.

Courtesy of Margo Leavin Gallery, Los Angeles. © Douglas M. Parker.

The Cultural Logic of the Late Capitalist Museum

Rosalind Krauss

Critic Rosalind Krauss analyses the complex relationship of Minimalism, which sought to subvert the art market by breaking with the "aesthetic of the original," to the development of the "museum industry." In practice, Minimalism lent itself to large scale "commodity production," while interest in the encounter between the work and "space, light, and the viewer's field of vision" prepared the way for the fragmented subject, "involved in a dizzying effort to decode signs that emerge from within a no longer mappable or knowable depth." With these changes, the viewer, the artwork, and the museum are reconceived as elements of an encounter in an artificial "hyperspace," with perhaps more in common with Disneyland than with the traditional museum context.

May 1, 1983: I remember the drizzle and cold of that spring morning, as the feminist section of the May Day parade formed up at République. Once we started moving out, carrying our banners for the march towards the Place de la Bastille, we began our chant. "Qui paie ses dettes s'enrichit," it went, "qui paie ses dettes s'enrichit," in a reminder to Mitterand's newly appointed Minister of Women's Affairs that the Socialists' campaign promises were still

Reprinted from Rosalind Krauss, "The Cultural Logic of the Late Capitalist Museum," *October* 54 (Fall, 1990).

 This text, written as a lecture for the September 10, 1990 meeting of the International Association of Museums of Modern Art (CIMAM) in Los Angeles, is being published here considerably before I have been able to deliver, as fully as I would have liked, on the promise of its title. The timeliness of the issues, however, suggested that it was more important to open them to immediate discussion than to wait to refine either the theoretical level of the argument or the rhetoric within which it is framed.

deeply in arrears. Looking back at that cry now, from a perspective firmly situated at the end of the '80s, sometimes referred to as "the roaring '80s," the idea that paying your debts makes you rich seems pathetically naive. What makes you rich, we have been taught by a decade of casino capitalism, is precisely the opposite. What makes you rich, fabulously rich, beyond your wildest dreams, is leveraging.

July 17, 1990: Coolly insulated from the heat wave outside, Suzanne Pagé and I are walking through her exhibition of works from the Panza Collection, an installation that, except for three or four small galleries, entirely fills the Musée d'Art Moderne de la Ville de Paris. At first I am extremely happy to encounter these objects—many of them old friends I have not seen since their early days of exhibition in the 1960s—as they triumphantly fill vast suites of galleries, having muscled everything else off the walls to create that experience of articulated spatial presence specific to Minimalism. The importance of this space as a vehicle for the works is something Suzanne Pagé is conscious of as she describes the desperate effort of remodeling vast tracts of the museum to give it the burnished neutrality necessary to function as background to these Flavins and Andres and Morrises. Indeed, it is her focus on the space—as a kind of reified and abstracted entity—that I finally find most arresting. This climaxes at the point when she positions me at the spot within the exhibition that she describes as being, for her, somehow the most riveting. It is in one of the newly stripped and smoothed and neutralized galleries made whitely luminous by the serial progression of a recent work by Flavin. But we are not actually looking at the Flavin. At her direction we are scanning the two ends of the gallery through the large doorways of which we can see the disembodied glow produced by two other Flavins, each in an adjoining room: one of these an intense apple green light; the other an unearthly, chalky blue radiance. Both announce a kind of space-beyond which we are not yet in, but for which the light functions as the intelligible sign. And from our point of view both these aureoles can be seen to frame—like strangely industrialized haloes—the way the gallery's own starkly cylindrical, International Style columns enter our point of view. We are having this experience, then, not in front of what could be called the art, but in the midst of an oddly emptied yet grandiloquent space of which the museum itself—as a building—is somehow the object.

Within this experience, it is the museum that emerges as powerful presence and yet as properly empty, the museum as a space from which the collection has withdrawn. For indeed, the effect of this experience is to render it impossible to look at the paintings hanging in those few galleries still displaying the permanent collection. Compared to the scale of the Minimalist works, the earlier paintings and sculpture look impossibly tiny and inconsequential, like postcards, and the galleries take on a fussy, crowded, culturally irrelevant look, like so many curio shops.

These are two scenes that nag at me as I think about the "cultural logic of the late capitalist museum," because somehow it seems to me that if I can

close the gap between their seeming disparateness, I can demonstrate the logic of what we see happening, now, in museums of modern art.[1] Here are two possible bridges, flimsy perhaps, because fortuitous, but nonetheless suggestive.

1. In the July 1990 *Art in America* there occurs the unanalyzed but telling juxtaposition of two articles. One is the essay called "Selling the Collection," which describes the massive change in attitude now in place according to which the objects in a museum's keeping can now be coolly referred to, by its director as well as its trustees, as "assets."[2] This bizarre Gestalt-switch from regarding the collection as a form of cultural patrimony or as specific and irreplaceable embodiments of cultural knowledge to one of eyeing the collection's contents as so much capital—as stocks or assets whose value is one of pure exchange and thus only truly realized when they are put in circulation—seems to be the invention not merely of dire financial necessity: a result, that is, of the American tax law of 1986 eliminating the deductibility of the market value of donated art objects. Rather, it appears the function of a more profound shift in the very context in which the museum operates—a context whose corporate nature is made specific not only by the major sources of funding for museum activities but also, closer to home, by the makeup of its boards of trustees. Thus the writer of "Selling the Collection" can say: "To a great extent the museum community's crisis results from the free-market spirit of the 1980s. The notion of the museum as a guardian of the public patrimony has given way to the notion of a museum as a corporate entity with a highly marketable inventory and the desire for growth."

Over most of the course of the article, the market understood to be putting pressure on the museum is the art market. This is, for example, what Evan Maurer of the Minneapolis Institute of Art seems to be referring to when he says that in recent years museums have had to deal with a "market-driven operation" or what George Goldner of the Getty means when he says that "there will be some people who will want to turn the museum into a dealership." It is only at the end of the essay, when dealing with the Guggenheim Museum's recent sales, that some larger context than the art market's buying and selling is broached as the field within which deaccessioning might be discussed, although the writer does not really enter this context.

But "Selling the Collection" comes back-to-back with quite another article, which, called "Remaking Art History," raises the problems that have been spawned within the art market itself by one particular art movement, namely Minimalism.[3] For Minimalism almost from the very beginning located itself, as one of its radical acts, within the technology of industrial production. That

objects were fabricated from plans meant that these plans came to have a conceptual status within Minimalism allowing for the possibility of replication of a given work that could cross the boundaries of what had always been considered the unreproducibility of the aesthetic original. In some cases these plans were sold to collectors along with or even in place of an original object, and from these plans the collector did indeed have certain pieces refabricated. In other cases it has been the artist himself or herself who has done the refabrication, either issuing various versions of a given object—multiple originals, so to speak—as is the case with the many Morris glass cubes, or replacing a deteriorated original with a contemporary remake as in the case of Alan Saret. This break with the aesthetic of the original is, the writer of this essay argues, part and parcel with Minimalism itself, and so she writes: "If, as viewers of contemporary art, we are unwilling to relinquish the conception of the unique original art object, if we insist that all refabrications are fraudulent, then we misunderstand the nature of many of the key works of the '60s and '70s. . . . If the original object can be replaced without compromising the original meaning, refabrication should raise no controversy."

However, as we know, it is not exactly viewers who are raising controversy in this matter, but artists themselves, as Donald Judd and Carl Andre have protested Count Panza's various decisions to act on the basis of the certificates they sold him and make duplicate versions of their works.[4] And indeed the fact that the group countenancing these refabrications is made up of the works' owners (both private collectors and museums)—that is, the group normally thought to have most interest in specifically protecting the status of their property *as* original—indicates how inverted this situation is. The writer of this essay also speaks of the market as playing some role in the story she has to tell. "As the public's interest in the art of this period grows," she says, "and the market pressures increase, the issues that arise when works are refabricated will no doubt gain prominence as well." But what the nature of either "the issues" or the "market pressures" might really be, she leaves it to the future to decide.

In the bridge I am setting up here, then, we watch the activity of markets restructuring the aesthetic original, either to change it into an "asset," as in the case outlined by the first article, or to normalize a once-radical practice of challenging the very idea of the original through a recourse to the technology of mass production. That this normalization exploits a possibility *already* inscribed in the specific procedures of Minimalism will be important to the rest of my argument. But for now I simply point to the juxtaposition of a description of the financial crisis of the modern museum with an account of a shift in the nature of the original that is a function of one particular artistic movement, to wit, Minimalism.

2. The second bridge can be constructed more quickly. It consists merely of a peculiar rhyming between a famous remark of Tony

Smith's from the opening phase of Minimalism and one by the Guggenheim's Director, Tom Krens, made last spring. Tony Smith is describing a ride he took in the early 1950s on the New Jersey Turnpike when it was still unfinished. He is speaking of the endlessness of the expanse, of its sense of being cultural but totally off the scale of culture. It was an experience, he said, that could not be framed, and thus, breaking through the very notion of frame, it was one that revealed to him the insignificance and "pictorialism" of all painting. "The experience on the road," he says, "was something mapped out but not socially recognized. I thought to myself, it ought to be clear that's the end of art." And what we now know with hindsight on this statement is that Tony Smith's "end of art" coincided with—indeed, conceptually undergirded—the beginning of Minimalism.

The second remark, the one by Tom Krens, was made to me in an interview and also involves a revelation on a turnpike, the Autobahn just outside of Cologne.[5] It was a November day in 1985, and having just seen a spectacular gallery made from a converted factory building, he was driving by large numbers of other factories. Suddenly, he said, he thought of the huge abandoned factories in his own neighborhood of North Adams, and he had the revelation of MASS MoCA.[6] Significantly, he described this revelation as transcending anything like the mere availability of real estate. Rather, he said, it announced an entire change in—to use a word he seems extremely fond of—*discourse*. A profound and sweeping change, that is, within the very conditions within which art itself is understood. Thus, what was revealed to him was not only the tininess and inadequacy of most museums, but that the encyclopedic nature of the museum was "over." What museums must now do, he said he realized, was to select a very few artists from the vast array of modernist aesthetic production and to collect and show these few in depth over the full amount of space it might take to really experience the cumulative impact of a given oeuvre. The discursive change he was imagining is, we might say, one that switches from diachrony to synchrony. The encyclopedic museum is intent on telling a story, by arraying before its visitor a particular version of the history of art. The synchronic museum—if we can call it that—would forego history in the name of a kind of intensity of experience, an aesthetic charge that is not so much temporal (historical) as it is now radically spatial, the model for which, in Krens's own account, was, in fact, Minimalism. It is Minimalism, Krens says in relation to his revelation, that has reshaped the way we, as late twentieth-century viewers, look at art: the demands we now put on it; our need to experience it along with its interaction with the space in which it exists; our need to have a cumulative, serial, crescendo towards the intensity of this experience; our need to have more and at a larger scale. It was Minimalism, then, that was part of the revelation that only at the scale of something like MASS MoCA could this radical revision of the very nature of the museum take place.

Within the logic of this second bridge, there is something that connects Minimalism—and at a very deep level—to a certain kind of analysis of the modern museum, one that announces its radical revision.

Now even from the few things I've sketched about Minimalism, there emerges an internal contradiction. For on the one hand there is Krens's acknowledgement of what could be called the phenomenological ambitions of Minimalism; and on the other, underscored by the dilemma of contemporary refabrication, Minimalism's participation in a culture of seriality, of multiples without originals—a culture, that is, of commodity production.

That first side, it could be argued, is the aesthetic base of Minimalism, its conceptual bedrock, what the writer of the *Art in America* article called its "original meaning." This is the side of Minimalism that denies that the work of art is an encounter between two previously fixed and complete entities: on the one hand, the work as a repository of known forms—the cube or prism, for example, as a kind of geometric a priori, the embodiment of a Platonic solid; and on the other, the viewer as an integral, biographically elaborated subject, a subject who cognitively grasps these forms because he or she knows them in advance. Far from being a cube, Richard Serra's *House of Cards* is a shape in the process of forming against the resistance, but also with the help of the ongoing conditions of gravity; far from being a simple prism, Robert Morris's *L-Beams* are three different insertions within the viewer's perceptual field such that each new disposition of the form sets up an encounter between the viewer and the object which redefines the shape. As Morris himself wrote in his "Notes on Sculpture," Minimalism's ambition was to leave the domain of what he called "relational aesthetics" and to "take relationships out of the work and make them a function of space, light, and the viewer's field of vision."[7]

To make the work happen, then, on this very perceptual knife-edge—the interface between the work and its beholder—is on the one hand to withdraw privilege both from the formal wholeness of the object prior to this encounter and from the artist as a kind of authorial absolute who has set the terms for the nature of the encounter, in advance. Indeed, the turn towards industrial fabrication of the works was consciously connected to this part of Minimalism's logic, namely, the desire to erode the old idealist notions about creative authority. But on the other hand, it is to restructure the very notion of the viewing subject.

It is possible to misread a description of Minimalism's drive to produce a kind of "death of the author" as one of creating a now all-powerful reader/interpreter, as when Morris writes: "The object is but one of the terms of the newer aesthetic. . . . One is more aware than before that he himself is establishing relationships as he apprehends the object from various positions and under varying conditions of light and spatial context." But, in fact, the nature of this "he himself [who] is establishing relationships" is also what Minimalism works to put in suspension. Neither the old Cartesian subject nor the tradi-

tional biographical subject, the Minimalist subject—this "he himself establishing relationships"—is a subject radically contingent on the conditions of the spatial field, a subject who coheres, but only provisionally and moment-by-moment, in the act of perception. It is the subject that, for instance, Maurice Merleau-Ponty describes when he writes: "But the system of experience is not arrayed before me as if I were God, it is lived by me from a certain point of view; I am not the spectator, I am involved, and it is my involvement in a point of view which makes possible both the finiteness of my perception and its opening out upon the complete world as a horizon of every perception."[8]

In Merleau-Ponty's conception of this radically contingent subject, caught up within the horizon of every perception, there is, as we know, an important further condition. For Merleau-Ponty is not merely directing us towards what could be called a "lived perspective"; he is calling on us to acknowledge the primacy of the "lived *bodily* perspective." For it is the immersion of the body in the world, the fact that it has a front and a back, a left and a right side, that establishes at what Merleau-Ponty calls a level of "preobjective experience" a kind of internal horizon which serves as the precondition of the meaningfulness of the perceptual world. It is thus the body as the preobjective ground of all experience of the relatedness of objects that was the primary "world" explored by the *Phenomenology of Perception.*

Minimalism was indeed committed to this notion of "lived *bodily* perspective," this idea of a perception that would break with what it saw as the decorporealized and therefore bloodless, algebraicized condition of abstract painting in which a visuality cut loose from the rest of the bodily sensorium and now remade in the model of modernism's drive towards absolute autonomy had become the very picture of an entirely rationalized, instrumentalized, serialized subject. Its insistence on the immediacy of the experience, understood as a bodily immediacy, was intended as a kind of release from the forward march of modernist painting towards an increasingly positivist abstraction.

In this sense, Minimalism's reformulation of the subject as radically contingent is, even though it attacks older idealist notions of the subject, a kind of Utopian gesture. This is because the Minimalist subject is in this very displacement returned to its body, regrounded in a kind of richer, denser subsoil of experience than the paper-thin layer of an autonomous visuality that had been the goal of optical painting. And thus this move is, we could say, compensatory, an act of reparations to a subject whose everyday experience is one of increasing isolation, reification, specialization, a subject who lives under the conditions of advanced industrial culture as an increasingly instrumentalized being. It is to this subject that Minimalism, in an act of resistance to the serializing, stereotyping, and banalizing of commodity production, holds out a promise of some instant of bodily plentitude in a gesture of compensation that we recognize as deeply aesthetic.

But even if Minimalism seems to have been conceived in *specific* resistance to the fallen world of mass culture—with its disembodied media images—and of consumer culture—with its banalized, commodified objects—in an attempt to restore the immediacy of experience, the door it opened onto "refabrication" nonetheless was one that had the potential to let that whole world of late capitalist production right back in.[9] Not only was the factory fabrication of the objects from plans a switch from artisanal to industrial technology, but the very choice of materials and of shapes rang with the overtones of industry. No matter that plexiglass and aluminum and styrofoam were meant to destroy the interiority signalled by the old materials of sculpture like wood or stone. These were nonetheless the signifiers of late 20th-century commodity production, cheap and expendable. No matter that the simple geometries were meant to serve as the vehicles of perceptual immediacy. These were as well the operators of those rationalized forms susceptible to mass production and the generalized ones adaptable as corporate logos.[10] And most crucially, the Minimalist resistance to traditional composition which meant the adoption of a repetitive, additive aggregation of form—Donald Judd's "one thing after another"—partakes very deeply of that formal condition that can be seen to structure consumer capitalism: the condition, that is, of seriality. For the serial principle seals the object away from any condition that could possibly be thought to be original and consigns it to a world of simulacra, of multiples without originals, just as the serial form also structures the object within a system in which it makes sense only in relation to other objects, objects which are themselves structured by relations of artificially produced difference. Indeed, in the world of commodities it is this difference that is consumed.[11]

Now how, we might ask, is it possible that a movement that wished to attack commodification and technologization somehow always already carried the codes of those very conditions? How is it that immediacy was always potentially undermined—infected, we could say—with its opposite? For it is this "always already" that is being tapped in the current controversy about refabrication. So, we could ask, how is it that an art that insisted so hard on specificity could have already programmed within it the logic of its violation?

But this kind of paradox is not only common in the history of modernism, which is to say the history of art in the era of capital; it could be said to be of the very nature of modernist art's relation to capital, a relation in which, in its very resistance to a particular manifestation of capital—to technology, say, or commodification, or the reification of the subject of mass production—the artist produces an alternative to that phenomenon which can also be read as a function of it, another version, although possibly more ideated or rarified, of the very thing against which he or she was reacting. Fredric Jameson, who is intent on tracing this capital-logic as it works itself out in modernist art, describes it, for example, in Van Gogh's clothing of the drab peasant world around him in an hallucinatory surface of color. This violent transformation, he says, "is to be seen as a Utopian gesture: as an act of compensation which ends

up producing a whole new Utopian realm of the senses, or at least of that supreme sense—sight, the visual, the eye—which it now reconstitutes for us as a semi-autonomous space in its own right."[12] But even as it does this, it in fact imitates the very division of labor that is performed in the body of capital, thereby "becoming some new fragmentation of the emergent sensorium which replicates the specializations and divisions of capitalist life at the same time that it seeks in precisely such fragmentation a desperate Utopian compensation for them."[13]

What is exposed in this analysis is then the logic of what could be called cultural reprogramming or what Jameson himself calls "cultural revolution." And this is to say that while the artist might be creating a Utopian alternative to, or compensation for, a certain nightmare induced by industrialization or commodification, he is at the very same time projecting an imaginary space which, if it is shaped somehow by the structural features of that same nightmare, works to produce the possibility for its receiver fictively to occupy the territory of what will be a next, more advanced level of capital. Indeed, it is the theory of cultural revolution that the imaginary space projected by the artist will not only emerge from the formal conditions of the contradictions of a given moment of capital, but will prepare its subjects—its readers or viewers—to occupy a future real world which the work of art has already brought them to imagine, a world restructured not through the present but through the next moment in the history of capital.

An example of this, we could say, would be the great *unités d'habitation* of the International Style and Le Corbusier, which rose above an older, fallen city fabric to project a powerful, futuristic alternative to it, an alternative celebrating the potential energy stored within the individual designer. But insofar as those projects simultaneously destroyed the older urban network of neighborhoods with their heterogeneous cultural patterns, they prepared the ground precisely for that anonymous culture of suburban sprawl and shopping-center homogeneity that they were specifically working to counter.

So, with Minimalism, the potential was always there that not only would the *object* be caught up in the logic of commodity production, a logic that would overwhelm its specificity, but that the *subject* projected by Minimalism also would be reprogrammed. Which is to say that the Minimalist subject of "lived bodily experience"—unballasted by past knowledge and coalescing in the very moment of its encounter with the object—could, if pushed just a little farther, break up entirely into the utterly fragmented, postmodern subject of contemporary mass culture. It could even be suggested that by prizing loose the old ego-centered subject of traditional art, Minimalism unintentionally—albeit logically—prepares for that fragmentation.

And it was that fragmented subject, I would submit, that lay in wait for the viewer to the Panza Exhibition in Paris—not the subject of lived bodily immediacy of 1960s Minimalism, but the dispersed subject awash in a maze of signs and simulacra of late 1980s postmodernism. This was not just a function

of the way the objects tended to be eclipsed by the emanations from themselves that seemed to stand apart from their corporeal beings like so many blinking signs—the shimmering waves of the floor pieces punctuating the groundplan, the luminous exhalations of the light pieces washing the corners of rooms one had not yet entered. It was also a function of the new centrality given to James Turrell, an extremely minor figure for Minimalism in the late 1960s and early 1970s, but one who plays an important role in the reprogrammation of Minimalism for the late 1980s. The Turrell piece, itself an exercise in sensory reprogramming, is a function of the way a barely perceptible luminous field in front of one appears gradually to thicken and solidify, not by revealing or bringing into focus the surface which projects this color, a surface which we as viewers might be said to perceive, but rather by concealing the vehicle of the color and thereby producing the illusion that it is the field itself which is focusing, that it is the very object facing one that is doing the perceiving *for* one.

Now it is this derealized subject—a subject that no longer does its own perceiving but is involved in a dizzying effort to decode signs that emerge from within a no longer mappable or knowable depth—that has become the focus of many analyses of postmodernism. And this space, which is grandiloquent but somehow no longer masterable by the subject, seeming to surpass the reach of understanding like an inscrutable emblem of the multinational infrastructures of information technology or of capital transfer, is often referred to in such analyses as "hyperspace." It, in turn, is a space that supports an experience that Jameson calls "the hysterical sublime." Which is to say that precisely in relation to the suppression of the older subjectivity—in what could be called the waning of affect—there is "a strange compensatory decorative exhilaration."[14] In place of the older emotions there is now an experience that must properly be termed an "intensity"—a free-floating and impersonal feeling dominated by a peculiar kind of euphoria.

The revision of Minimalism such that it addresses or even works to produce that new fragmented and technologized subject, such that it constructs not an experience of itself but some other euphorically dizzy sense of the museum as hyperspace, this revisionary construction of Minimalism exploits, as we have seen, what was always potential within Minimalism.[15] But it is a revision that is, as well, happening at a specific moment in history. It is happening in 1990 in tandem with powerful changes in how the museum itself is now being reprogrammed or reconceptualized.

The writer of "Selling the Collection" acknowledged that the Guggenheim's deaccessioning was part of a larger strategy to reconceive the museum and that Krens himself has described this strategy as somehow motivated or justified by the way Minimalism restructures the aesthetic "discourse." What, we might now ask, is the nature of that larger strategy, and how is Minimalism being used to serve as its emblem?

One of the arguments made by analysts of postmodern culture is that in its switch from what could be called an era of industrial production to one of commodity production—an era, that is, of the consumer society, or the information society, or the media society—capital has not somehow been magically transcended. Which is to say, we are not in either a "postindustrial society" or a "postideological era." Indeed, they would argue, we are in an even purer form of capital in which industrial modes can be seen to reach into spheres (such as leisure, sport, and art) previously somewhat separated from them. In the words of the Marxist economist Ernest Mandel: "Far from representing a 'postindustrial society' late capitalism thus constitutes *generalized universal industrialization* for the first time in history. Mechanization, standardization, over-specialization and parcellization of labor, which in the past determined only the realm of commodity production in actual industry, now penetrate into all sectors of social life."[16]

As just one example of this he gives the Green Revolution, or the massive industrialization of agriculture through the introduction of machines and chemicals. Just as in any other industrialization, the old productive units are broken up—the farm family no longer makes its own tools, food, and clothing—to be replaced by specialized labor in which each function is now independent and must be connected through the mediating link of trade. The infrastructure needed to support this connection will now be an international system both of trade and of credit. What makes this expanded industrialization possible, he adds, is the overcapitalization (or noninvested surplus capital) that is the hallmark of late capitalism. It is this surplus that is unlocked and set in motion by the falling rate of profit. And it in turn accelerates the process of transition to monopoly capitalism.

Now noninvested surplus capital is exactly one way of describing the holdings—both in land and in art—of museums. It is the way, as we have seen, that many museum figures (directors and trustees) are now, in fact, describing their collections. But the market they see themselves responding to is the art market and not the mass market; and the model of capitalization they have in mind is the "dealership" and not industry.

Writers about the Guggenheim have already become suspicious that it is the one exception in all this—an exception, most would agree, that will be an extremely seductive pattern for others to follow once its logic becomes clear. The *New York Times Magazine* writer of the profile on MASS MoCA was, indeed, struck by the way Tom Krens constantly spoke not of the museum but of the "museum industry," describing it as "overcapitalized," in need of "mergers and acquisitions" and of "asset management." And further, invoking the language of industry, he spoke of the museum's activities—its exhibitions and catalogues—as "product."

Now from what we know from other industrializations, we can say that to produce this "product" efficiently will require not only the break-up of older productive units—as the curator no longer operates as combined researcher,

writer, director, and producer of an exhibition but will be increasingly special-
ized into filling only one of these functions—but will entail the increased
technologization (through computer-based data systems) and centralization of
operations at every level. It will also demand the increased control of
resources in the form of art objects that can be cheaply and efficiently entered
into circulation. Further, in relation to the problem of the effective marketing
of this product, there will be the requirement of a larger and larger surface
over which to sell the product in order to increase what Krens himself speaks
of as "market share." It takes no genius to realize that the three immediate
requisites of this expansion are 1) larger inventory (the Guggenheim's acquisi-
tion of three hundred works from the Panza collection is a first step in this
direction); 2) more physical outlets through which to sell the product (the Salz-
burg and Venice/Dogana projects are potential ways of realizing this, as would
be MASS MoCA);[17] and 3) leveraging the collection (which in this case most
specifically does not mean selling it, but rather moving it into the credit sector,
or the circulation of capital;[18] the collection will thus be pressed to travel as
one form of indebtedness; classically, mortgaging the collection would be the
more direct form of leveraging).[19] And it also does not stretch the imagination
too much to realize that this industrialized museum will have much more in
common with other industrialized areas of leisure—Disneyland say—than it
will with the older, preindustrial museum. Thus it will be dealing with mass
markets, rather than art markets, and with simulacral experience rather than
aesthetic immediacy.

 Which brings us back to Minimalism and the way it is being used as the
aesthetic rationale for the transformation I am describing. The industrialized
museum has a need for the technologized subject, the subject in search not of
affect but of intensities, the subject who experiences its fragmentation as
euphoria, the subject whose field of experience is no longer history, but space
itself: that hyperspace which a revisionist understanding of Minimalism will
use it to unlock.

Notes

1. Throughout, my debt to Fredric Jameson's "Postmodernism, or The Cultural Logic of Late
 Capitalism," (New Left Review, no. 146 [July–August 1984], pp. 53–93) will be obvious.
2. Philip Weiss, "Selling the Collection," Art in America, vol. 78 (July 1990), pp. 124–131.
3. Susan Hapgood, "Remaking Art History," Art in America, vol. 78 (July 1990), pp. 114–123.
4. See Art in America (March and April 1990).
5. The interview took place May 7, 1990.
6. MASS MoCA (The Massachusetts Museum of Contemporary Art), a project to transform the
 750,000 square feet of factory space formerly occupied by Sprague Technologies Inc. into a
 museum complex (that would not only consist of gargantuan exhibition galleries, but also a
 hotel and retail shops), proposed to the Massachusetts Legislature by Krens and granted fund-
 ing in a special bill potentially underwriting half its costs with a $35 million bond issue, is now
 nearing the end of a feasibility study, funded out of the same bill, and being conducted by a

committee chaired by Krens. See Deborah Weisgall, "A Megamuseum in a Mill Town, The Guggenheim in Massachusetts?" *New York Times Magazine* (3 March 1989).

7. Robert Morris, "Notes on Sculpture," in G. Battcock, ed., *Minimal Art*, New York, Dutton, 1968.

8. Maurice Merleau-Ponty, *Phenomenology of Perception*, trans. Colin Smith, London, Routledge and Kegan Paul, 1962, p. 304.

9. This analysis of the contradictions internal to Minimalism has already been brilliantly argued by Hal Foster in his genealogical study of Minimalism. See Hal Foster, "The Crux of Minimalism," in *Individuals, A Selected History of Contemporary Art: 1945–1986*, Los Angeles, The Museum of Contemporary Art, 1986. His argument there, that Minimalism simultaneously completes *and* breaks with modernism, announcing its end, and his discussion of the way much of postmodernism in both its critical modes (the critique of institutions, the critique of the representation of the subject) and its collaborative ones (the transavant-garde, simulation) is nascent within the Minimalist syntax, both spatial and productive, is a complex articulation of the logic of Minimalism and anticipates much of what I am saying about its history.

10. This argument was already suggested by Art & Language's critique of Minimalism. See Carl Beveridge and Ian Burn, "Donald Judd May We Talk?," *The Fox*, no. 2 (1972). That Minimalism should have been welcomed into corporate collections came full circle in the 1980s when its forms served as the, perhaps unwilling, basis of much of postmodern architecture.

11. Foster, p. 180.

12. Jameson, p. 59.

13. Ibid.

14. Ibid., p. 61.

15. The various 1970s projects, organized by Heiner Friedrich and sponsored by the Dia Foundation, which set up permanent installations—like de Maria's *Earth Room* or his *Broken Kilometer*—had the effect of reconsecrating certain urban spaces to a detached contemplation of their own "empty" presence. Which is to say that in the relationship between the work and its context, these spaces themselves increasingly emerge as the focus of the experience, one of an inscrutable but suggestive sense of impersonal, corporatelike power to penetrate art-world locales and to rededicate them to another kind of nexus of control. Significantly, it was Friedrich who began, in the mid-1970s, to promote the work of James Turrell (he is also the manager, for the Dia Foundation, of Turrell's mammoth *Roden Crater*).

16. Ernest Mandel, *Late Capitalism*, London, Verso, 1978, p. 387, as cited in Foster, p. 179; and in Jameson, "Periodizing the '60s," *The Ideologies of Theory*, Vol. II, Minneapolis, University of Minnesota Press, 1988, p. 207.

17. Projects at different stages of realization include a Salzburg Guggenheim, in which the Austrian Government would presumably pay for a new museum (designed by Hans Holein) and endow its operating expenses in return for a New York Guggenheim-managed program, part of which would entail the circulation of the Guggenheim collection into Salzburg. In addition, there are negotiations for a Venice Guggenheim in the quarters of the former Customs House (the Dogana).

18. That as part of its industrialization the Guggenheim is willing to deaccession not just minor objects but masterpieces is a point made by "Selling the Collection," where Professor Gert Schiff is quoted as saying of the deaccessioned Kandinsky, "It really was a centerpiece of the collection—they could have sold almost anything but not that," and former director, now trustee, Tom Messer, is described as "uncomfortable with the transaction" (p. 130). Another detail in this report is the extraordinary spread between Sotheby's estimate on this Kandinsky ($10–15 million) and its actual sale price ($20.9 million). In fact, on the three works auctioned by the Guggenheim, Sotheby's underestimated the sales by more than 40 percent. This raises some questions about "asset management" in a domain, like the Guggenheim's, of increasing specialization of professional roles. For it is clear that neither the museum's staff nor its director had a grip on the realities of the market, and relying on Sotheby's "expertise" (not, of course disinterested), they probably deaccessioned one more work than they needed to in order to accomplish their target, which was the purchase of the Panza collection. It is also clear—not only from Schiff's comment but also from one by William Rubin to the effect that in thirty years of experience he had never seen a comparable Kandinsky for sale, and that

chances are that in the next thirty years there will not be another—that the separation of curatorial from managerial skills is wildly skewing the museum's judgment in the favor of those who stand to profit—in the form of fees and percentages of sales—from any "deal" that takes place: auctioneers, dealers, etc.

19. In August 1990, the Guggenheim Museum, through the agency of The Trust for Cultural Resources of The City of New York (about which more later), issued $55 million of tax-exempt bonds to J. P. Morgan Securities (who will presumably remarket them to the public). This money is to be used for the museum's physical expansion in New York City: the annex to the present building, the restoration and underground expansion of the present building, and the purchase of a warehouse in midtown Manhattan. Counting interest on these bonds, the museum will, in the course of fifteen years, have to pay out $115 million to service and retire this debt.

The collateral for these bonds is curious, since the issuing document reads: "None of the assets of the [Guggenheim] Foundation are pledged for payment of the Bonds." It goes on to specify that the museum's endowment is legally unavailable to be used to meet the obligations of the debt and that "certain works in the Foundation's collection are subject to express sale prohibitions or other restrictions pursuant to the applicable gift instruments or purchase contracts." That such restrictions apply only to "certain works" and not to all works is also something to which I will return.

In light of the fact that no collateral is pledged in case of the museum's inability to meet its obligations on this debt, one might well wonder about the basis on which Morgan Securities (as well as its partner in this transaction, the Swiss Bank Corporation) agreed to purchase these bonds. This basis is clearly threefold. First, the Guggenheim is projecting its ability to raise the money it needs (roughly $7 million per year over and above its current [the date in the bond issuance document is for FY 1988] annual expenses of $11.5 million [on which it was running a deficit of about 9 percent, which is *extremely* high for this kind of institution]) through, on the one hand, a $30 million fund drive and, on the other, added revenue streams due to its expansion of plant, program, markets, etc. Since its obligation is $115 million, the fund drive, even if successful, will leave over $86 million to raise. Second, if the Guggenheim's plans for increasing revenue (added gate, retail sales, memberships, corporate funding, gifts, plus "renting" its collection to its satellite museums, among others) by the above amount (or 70 percent above its current annual income) do not work out as projected, the next line of defense the bankers can fall back on will be the ability of members of the Guggenheim's board of trustees to cover the debt. This would involve a personal willingness to pay that no trustee, individually, is legally required to do. Third, if the first two possibilities fail and default is threatened, the collection (minus, of course, "certain works"), though it is not pledged, is clearly available as an "asset" to be used for debt repayment.

In asking financial officers of various tax-exempt institutions to evaluate this undertaking, I have been advised that it is, indeed, a "high-risk" venture. And I have also gleaned something of the role of The Trust for Cultural Resources of The City of New York.

Many states have agencies set up to lend money to tax-exempt institutions, or to serve as the medium through which monies from bond drives are delivered to such institutions, as is the case with The Trust for Cultural Resources. But unlike The Trust for Cultural Resources, these agencies are required to review the bond proposals in order to assess their viability. The review carried out by agency employees is clearly made by people not associated with the institutions themselves. The Trust for Cultural Resources, although it brokers the money at the behest of the government like the state agencies, has no staff to review proposals and therefore has no role in vetting the bond requests. What it seems to do instead is to give the proposal its bona fides. Given the fact that the members of the trust are also major figures of other cultural institutions (Donald Marron, for example, is president of the board of trustees of The Museum of Modern Art), the trust's own trustees are, in fact, potential borrowers.

LITA ALBUQUERQUE, *Site/Memory/Reflections.* **Detail from Koll Project. Monolith: 50′ high, 13′ wide, 2′ deep. Medallion: 10′ in diameter, black polished granite, and gold leaf**

Courtesy of the artist.

Toward an Ecological Self

Suzi Gablik

Author and critic Suzi Gablik suggests that the time is appropriate for a revolution in consciousness which would reorient the relationship between the individual and society, between the artist and the artworld. By moving beyond conventional notions of self and self-interest to embrace a larger ecological self, artists can promote an art of healing and participation. The Cartesian ego is shattered and the self is redefined as "relational rather than self contained." By moving beyond the "competitive mechanisms of the artworld," artists can begin cultivating a compassionate, ecological self in order to contribute to the realignment of society's values.

We seem to have reached a critical threshold between survival and ecocide, where to continue on our consumerist course is no longer viable. But how does a culture redefine itself? Modernism was the art of the rise and fall of the industrial age. Problems that Modernists were fascinated by, and attached great importance to, were without question linked to a certain view of the world and concern about what was important, which I believe is now changing. I believe that in the ecological future, art may come to signify a different set of behaviors and attitudes than it has within the Modern aesthetic paradigm.

The critic Arthur Danto has referred to the end of art history as a time when art does not end, but continues in a new realm that is characterized by nonpatriarchal, non-Eurocentric ideals. A new narrative is being created in which the old guidelines, based on the notion of masterpieces, the styles of the masters, originality, and aesthetics are no longer useful. The aesthetic, autonomous, and stylistic values of Modernism have ended. One could find devastation in the phrase "art history is dead," as a student of mine in Boulder said,

Reprinted from Suzi Gablik "Towards an Ecological Self," *New Art Examiner* (January 1991).

but the repercussions are far from devastating. Although the end to art history is threatening to some, to others it is a step in the redefining of our values that will further assist the change into a new paradigm.

All of us, to varying degrees, have internalized the dominator system and its ideal of autonomous, self-determining personalities, so that to speak of the end of a certain infrastructure of autonomous individualism—or what we have been calling Cartesian selfhood—is to threaten the axiomatic foundation of modern aesthetic practice and art history. "Our present idea of freedom," Wendell Berry has written in *The Hidden Wound*, "is only the freedom to do as we please: to sell ourselves for a high salary, a home in the suburbs, and idle weekends. But that is a freedom dependent upon affluence, which is in turn dependent upon the rapid consumption of exhaustible supplies. The other kind of freedom is the freedom to take care of ourselves and each other." It is the other kind of freedom which I shall try to address here.

Within modern culture, society has been characterized as a hostile rather than a resonant environment for the self-unfolding of the individual. A deep dualism existed within Modernism, between public and private that severed any connections between them and colored our view of art as basically a "private" affair. The politics of a contextual/connective aesthetics is very different; it tries to move beyond social passivity, culturally conditioned modes of distancing, and the denial of responsibility. The prestige of individualism has been so high in our culture that even for an artist like Christo, whose environmental projects such as *Running Fence* require the participation of *thousands* of people, the feeling of being independent and separate still dominates the psyche. In a recent interview in *Flash Art* (March/April 1990), Christo stated: "The work is irrational and perhaps irresponsible. Nobody needs it. The work is a huge individualistic gesture that is entirely decided by me. . . . One of the greatest contributions of modern art is the notion of individualism. . . . I think that the artist can do anything he wants to do. This is why I would never accept a commission. Independence is most important to me. The work of art is a scream of freedom." In a year fraught with art politics, sexual censorship, and the tyrannical Senator Jesse Helms (who seems almost singlehandedly to have undermined the durability of government support for the arts), Christo's "scream of freedom" continues to be the unwavering, ever-present, moral imperative that is always brandished politically as well as philosophically in the great tradition of Western thought. The entire structure of our thinking and experience has been pervasively shaped by this assumption of separateness as the absolute foundation on which we live our lives.

From the vantage point of individuality—the vision of a self in ultimate control, whose innermost impulse is self-assertion—it is virtually impossible to imagine the relational pattern between individuals and society changing. Individual freedom and individual uniqueness were cultural ideals summed up and embodied in the motifs of Romanticism; today, however, we find that a different cultural imperative is being argued and fought. "Today," states the

ecofeminist writer Charlene Spretnak in *Reweaving the World*, "we work for ecopeace, ecojustice, ecoeconomics, ecopolitics, ecoeducation, ecophilosophy, ecotheology, and for the evolution of ecofeminism . . . to refuse to let the dominant culture pave them over any longer with a value system of denial, distancing, fear and ignorance."

At the 1989 Mountain Lake Symposium held in Virginia, one of the presenters, artist Sidney Tillim, asked: "Do intentions matter? Does art, or do intentions, really matter if you can't make a living from them?" In a free society, he added, one has almost to improvise convictions. I should like to try and answer these questions by discussing the work of a young artist that evokes, at least for me, the essence of a new paradigm of intentions which, as I see it, presents art in a radically revised relationship with society, and tests its meaningfulness beyond the disinterested, disembodied, free play of the mind.

I first met Bradley McCallum when he was in the undergraduate sculpture department at Virginia Commonwealth University in Richmond, where he was making large, rather distinctive objects in welded steel. Somewhere along the way his consciousness changed, as did his basic commitments. He began thinking about how an audience would view and experience his work and realized that a lot of the experience was missing. He felt a need to engage the audience more directly and became interested in collaboration, feeling drawn at the same time to work with the homeless community in Richmond. Brad wanted to do this *as art*, that is, capitalizing on the same skills he used in making sculpture. He was not searching for independence, autonomy, or freedom so much as for the social need he sensed that art was meant to fulfill. His art soon became pragmatic, goal-directed, purposive, and charged with ethical sensitivity—all things that run counter to the teachings of aesthetic autonomy. He began to care less for originality than for results.

His studio was in an old Richmond carriage house near some alleys where the homeless hang out and pass by with their carts. In time Brad was able to make friends with some of them. His art emerged from these relationships. Brad observed that, at least in Richmond, ordinary grocery carts do not roll well on the bumpy cobblestone streets. He was aware of the prototype designs for shopping carts, the *Homeless Vehicles*, pioneered by Krzysztof Wodiczko, which at this point still exist primarily in the realm of art, not (yet) having been manufactured or provided in any numbers to the homeless. Brad decided on a different path, since his fundamental concern was with how to translate helping the homeless into a living artistic practice, an actual *modus operandi* that would go beyond a merely symbolic potential.

He, too, began by building a prototype cart, using a softer wire mesh than is found in commercial carts and welding it entirely by hand to make a deeper, more pliant basket. Most of the materials he was able to obtain free, from scrap metal companies and hospitals, whom he approached for donations of specially sized wheels, removed from broken wheelchairs and other disused medical equipment, that would be sturdy enough to make it over the cobble-

stones. Then he offered the prototype for a week to some of his homeless friends for use on a trial basis, inviting suggestions for its greater effectiveness from each potential user. This became the catalyst for further collaborations. One man, for instance, who had skin cancer, requested a little awning over his head that would shield his face from the sun while he pushed the cart around collecting cans. In order to accommodate the different needs of each person, Brad had to develop a certain trust and fluidity; to be open to interpenetration and blending, he had to develop a more transparent and permeable ego structure that would be receptive to an intertwining of self and other. Then he would create another cart, incorporating the new features, and give it to the person. Before Brad left Richmond for graduate school in New Haven, he had constructed and given away a total of 11 carts. For him, the finished carts are sculptures; for his senior thesis exhibition in downtown Richmond, he invited his homeless friends to bring their carts along for the opening if they wanted to.

During his first term at Yale in 1989, Brad introduced himself to Jackie, a middle-aged black woman who had been living in a small, abandoned city park, used temporarily to store materials for street repairs. Brad told Jackie that he was a sculptor and showed her photographs of the work he'd done with the homeless in Virginia. Initially, Jackie explained that she had no need for the mobile carts he'd made; later, in other conversations, she expressed a wish that the city would make park benches with awnings. This sparked an idea that they began to work on together. An aluminum structure with a backrest that jutted over at the top like a shelf was built and bolted to the park bench. Jackie was unhappy with certain features of the construction, but other homeless people liked it and said that they would happily use it in her place. They wondered why Brad felt the need to keep changing it, continuing to work with Jackie until both of them were satisfied with the result. Brad explained to them what he felt was important to collaboration: the freedom that comes from being unattached to the outcome. "Simply put," he said, "if I were to ignore Jackie and leave the awning as it was, I would violate a trust that is essential to the collaboration: the potential for learning from one another is realized by honoring this trust and listening. With Jackie, it meant reworking the awning to satisfy both our intentions." The actual object exchanged is secondary, for Brad, to the ethical values that are explicitly shared.

What finally emerged was far more functional and, in Brad's view, a more powerful image than the first attempt. The rigid back panel was removed and a tarpaulin attached to the remaining overhang in such a way that it could be rolled up and down on pulleys like a Mozart curtain to create a tent around the bench that was adaptable to all weathers. Ten days after the tarpaulin was added, the New Haven Recreation and Parks Department removed the whole structure and moved Jackie's belongings to a parking lot across the street, their justification being that no one is allowed to make a permanent shelter in a city park. On one level, Brad was pleased that the structure had stayed up

unmolested as long as it did; on another, he was worried that his work with Jackie had brought unnecessary attention to her place of refuge.

That same week, Brad was asked to participate in a First Year Students' Show at the Yale School of Art. As a way of documenting his collaboration with Jackie, he got permission to do a performance on the night of the opening. Jackie had many plastic bags filled with clothes that she and Brad decided to wash and use in the installation, which turned out to be ten washloads at the laundromat. In the exhibition space at school, slides of the park-bench construction were projected, with a statement on the wall describing the nature of the collaboration and questioning the extent to which artists should involve themselves in the community. The performance took place in a room adjacent to the main gallery, where Brad strung up a series of temporary wash lines and hung Jackie's clothes up to dry. During the opening he stayed in the room, ironing and then folding the clothes into neat piles. The piece was over when he had placed all the clothes into plastic bags and returned them to Jackie (which was long after the opening had ended). The intention was to demonstrate through a commonplace ritual that his interaction with Jackie continues beyond the making of functional sculpture, but also to provide a way for the audience to relate to Jackie's homelessness through her striving for identity by collecting clothes—which she then distributes to other homeless people.

Art which heals rather than confronts has not been highly valued by our society and the students at Yale were duly critical. They wondered, for instance, if by becoming involved in these people's lives, Brad might not be creating false hopes for them and even subtly exploiting their plight for his own good. Some felt that if he really wanted to help the homeless he ought to work in soup kitchens or for other institutions already addressing this problem. Also, wouldn't politics be a more effective medium than sculpture? And couldn't the problems of homeless people be solved just as well by buying them tents and camping gear, if indeed temporary shelters were the answer?

So why do I like this work so much? First of all, because it is not counterphobically tough. Nor does it aestheticize homelessness. Rather, it breaks the trance of economic thinking and legitimates another kind of motivation. It offers our society a different image of itself that is not based on the conspicuous consumption of valuable goods or the inevitability of self-interest. The quality of the response is crucial—it moves away from alienation and the mode of the helpless, isolated individual submissive to things as they are, which tends to shape all our interactions. To use ecologist Bill Devall's wonderful phrase, the work is "simple in means, rich in ends." In a consumption-oriented culture, the most important thing is to buy and own objects; the more things that can be bought and sold the better. This intense involvement with things, with consumption and one's own standard of living, seems to go hand-in-hand with a lack of involvement in social problems and relationships. "The mechanical division between self and world," writes Wendell Berry, "involves

an emotional dynamics that has disordered the heart of both the society as a whole and of every person in the society."

What is really at stake in the changes being discussed here cannot be totally divorced from the kind of beings individuals take themselves to be. In moving beyond conventional notions of self and self-interest, as the Buddhist scholar and ecologist Joanna Macy argues in *Sacred Interconnections*, and shedding them like an old skin or confining shell in order to engage more effectively with the forces and pathologies that imperil planetary survival, we are awakening to our larger, ecological self. For Macy, as for many others, the crisis that is threatening our planet, whether in its military, ecological, or social aspects, derives from a dysfunctional and pathogenic notion of the self. In awakening to our larger, ecological self, we will find new powers, according to Macy, undreamed of in our squirrel cage of separate ego. But, she adds, because these potentialities are interactive in nature, they manifest only to the extent that we recognize and act upon our interexistence. Through the power of his caring, Brad is able to extend his sense of self so that it also encompasses the self of Jackie; it is a real shift in identity. What we are really talking about is cultivating a new sort of person, one which includes patterns of interaction and interdependence that extend the self beyond the narrow ego and into the larger whole.

The possibility of constellating a self beyond the egoic one which has risen to power in the modern world and is maintained by our social consensus has been compellingly raised by David Michael Levin in all of his books, each of which argues in turn for "practices of the self" that do not separate the self from society and withdraw it from social responsibility. Many people find it difficult to imagine a self that is not shaped by the concept of an isolated individual fending for herself in the marketplace. They believe that economic self-interest is a given of human nature. In a recent issue of the newsletter *New Options*, however, editor Mark Satin wrote that during the 1980s, American culture began to move away from a focus on the rugged individual toward a focus on the caring individual. Caring individuals are less driven by materialistic values and status and have been described by Abraham Maslow as "meta-motivated"—they are not so preoccupied with basic needs such as security and survival. Theories of social Darwinism have led our culture to view the whole of existence as a competitive struggle for survival "of the fittest" and to falsely regard the environment as an object for exploitation. These ideas have been pumped into us from every direction. If a historically new kind of self—the ecological self—is truly emerging, it will eventually challenge our present society's primary assumption that human beings are basically selfish and motivated entirely by economics. Obviously what is being suggested is a revolution in consciousness as far-sweeping as the emergence of individualism itself was in the Renaissance. Our whole notion of what it means to be human may prove to have been inadequate and counterproductive.

The next evolutionary stage in consciousness will see a more integrated relationship between the masculine and feminine components in the psyche, which will replace the one-sided rule of the masculine as the dominant human consciousness. This is the inner basis of the ecological self. As Levin puts it in *The Opening of Vision:* "Archetypes which for too long have been constitutive only of femininity must be seen and valued as essential for the fulfillment of masculinity . . . [and] be integrated into its network of practices and institutions, transforming them accordingly." In the post-Cartesian, postpatriarchal identity, the so-called feminine values of caring and compassion will play leading roles. Levin has argued still further that since any change in cultural premises or dominant values begins in the individual's self-image, to redefine the self as relational rather than as self-contained could actually bring about a new stage in our social and cultural evolution. The restructuring of the Cartesian self, and its rebirth as an ecological self-plus-other or self-plus-environment, not only thoroughly transfigures our world view (and self-view) but, as I have been arguing myself, it is the basis for the reenchantment of art.

To see beyond the individual's perspective is to engage with the world from a participating consciousness rather than an observing one. The mode of distanced, objective knowing, removed from moral and social responsibility, has been the animating motif of both science and art in the modern world. As a form of thinking, it is now proving to be something of an evolutionary dead end. Indeed, cultural historian Morris Berman goes so far as to claim that the reenchantment of the world may necessitate the end of ego-consciousness altogether, for the reason that it may not be viable for our continuation on this planet.

Once we have changed the mode of our thinking to the methodology of participation we are not so detached. For the participating consciousness, things are no longer removed, separate, "out there." Objectivity serves as a distancing device, offering the illusion of impregnable strength, certainty, and control. Knowledge can then be used as an instrument of power and domination. Objective thinking negates the entire dimension of our visionary being. The self which challenges us to see beyond merely personal existence to intersubjective coexistence and community, the self expanded beyond a concern for one's own personal welfare, is the ecological self. If we strive for rather than give up on it, there is at least a possibility, Levin suggests, that we may move beyond the prevailing historical conditions, beyond the socialized ego and open up to our radical relatedness. Then being uniquely ourselves need not be cast in the category of the separate, Cartesian ego. Care and compassion are the tools of the soul, but they are often ridiculed by our society, which has been weak in the empathic mode. The feminine values of feeling, relatedness, and soul-consciousness have been virtually driven out of our culture by our patriarchal mentality. Gary Zukav puts it very concisely when he states, in *The Seat of the Soul,* that there is currently no place for spirituality, or the con-

cerns of the heart, within science, politics, business, or academia. Zukav doesn't mention art, but there is no particular hospitality there either.

"If you're out, you're out—you simply don't count," the artist Sandro Chia declared recently in an interview with Lilly Wei in *Art in America.* "Anything that happens must happen within this system. . . . I work for a few months, then I go to a gallery and show the dealer my work. The work is accepted, the dealer makes a selection, then an installation. People come and say you're good or not so good, then they pay for these paintings and hang them on other walls. They give cocktail parties and we all go to restaurants and meet girls. I think this is the weirdest scene in the world."

Most of us work within a system of categories provided by society. Patriarchal structures are especially strong in the art world. Becoming aware of how much they enslave us is the first step toward breaking the cultural trance. So far, as Lester Milbraith points out in *Envisioning a Sustainable Society,* this awareness is still confined primarily to women and now needs to spread to men. Many men will be receptive, he claims, especially if they perceive that a change in beliefs is essential for saving our ecosystem and society. We can be sure, however, that many other men will feel threatened by partnership ideas and values and will vigorously oppose the change. Sandro Chia's candid description of professional life in the art world is all too familiar, but it is a routine part of the trajectory of competition in our culture, where success is scoring and artists distinguish themselves through selling or not selling. Other distinctions, such as moral or immoral, are foreign to the enterprise and are likely to be pushed aside. It is hardly surprising that more and more artists are recoiling from this debilitating ideology.

How, then, can we shift our usual way of thinking so that we create more compassionate structures in our culture? The compassionate, ecological self will need to be cultivated with as much thoroughness as we have cultivated, in long years of abstract thinking, the mind geared to scientific and aesthetic objectivity: distant, cold, neutral, value-free. In *Has Modernism Failed?* I wrote, "generally speaking, the dynamics of professionalization do not dispose artists to accept their moral role; professionals are conditioned to avoid thinking about problems that do not bear directly on their work." Since writing this nearly a decade ago, it seems as if the picture is changing. The search for a new agenda for art has become a conscious one. Chicago artist Othello Anderson, who has been painting images of the world's forests burning and the effects of deforestation through acid rain, comments:

> Carbon and other pollutants are emitted into the air in such massive quantities that large areas of forest landscapes are dying from the effects of acid rain. Millions of tons of toxic waste are being poured into our lakes, rivers and oceans, contaminating drinking water and killing off aquatic life. Slash-and-burn forest clearing and forest fires are depleting the forests worldwide. Recognizing this crisis, as an artist I can no longer consider making art that is void of moral

consciousness, art that carries no responsibility, art without spiritual content, or art that ignores the state of the world in which it exists.

All of this is not to say that the social change envisioned here will happen quickly. The status quo is deeply entrenched and no new paradigm will suddenly eliminate the present order. Nevertheless, a social process can be accelerated or retarded. My impression is that artists who have restructured their personal reality away from the competitive mechanisms of the art world do not represent merely the response of isolated individuals to the dead-endedness of our present situation. They are prototypes living out the next epistemology of self. An increasing number of individuals understand the need for an ethical stance as central to the recovery of a meaningful society—and a meaningful art.

It is true that the value-based art they are trying to create still exists only at the margins of social change, but eventually a critical threshold is finally reached when enough people change their self-images and beliefs to begin the realignment of an entire society. It has been suggested that only five to ten percent of people need to change in order to create change in the whole. As social ecologist Murray Bookchin points out in *The Modern Crisis*, it is precisely to the "periphery" and the "margins" that we must look, if we are to find the "cores" that will be central to society in the future, for it is here that they will be found to be emerging. No doubt the previously entrenched paradigm will continue to exist alongside the later one, even after the other has more fully emerged, but with certain limitations, perhaps, in its relevance. Given the differences among us, we can safely assume that not everyone will agree that a relational, participatory, and ecocentric aesthetic is a good thing for all art.

Bibliography: Emphasis on Theory and Criticism Since 1970

ASHTON, DORE. *Out of the Whirlwind: Three Decades of Arts Commentary.* U.M.I. Research Press, 1987.

ASHTON, DORE. *Twentieth-Century Artists on Art.* Pantheon Books, 1986.

BATTCOCK, GREGORY, editor. *Idea Art.* Dutton, 1973.

BATTCOCK, GREGORY, editor. *Minimal Art.* Dutton, 1968.

BAUDRILLARD, JEAN. *Evil Demon of Images.* Philippe Tanguy, translator. Left Bank Books, 1987.

BAUDRILLARD, JEAN. *For a Critique of the Political Economy of the Sign.* Charles Levin, translator. Telos Press, Ltd., 1981.

BAUDRILLARD, JEAN. *Seduction.* Brian Singer, translator. Saint Martin's Press, Inc., 1991.

BENAMOU, MICHAEL and CHARLES CARAMELLO, editors. *Performance in Postmodern Culture.* Coda Press, 1977.

BLOOM, HAROLD, PAUL DE MAN, JACQUES DERRIDA, GEOFFREY HARTMAN & J. HILLIS MILLER. *Deconstruction and Criticism.* Continuum Publishing Company, 1979.

BOIS, YVES-ALAIN, THOMAS CROW, HAL FOSTER, DAVID JOSELIT, ELIZABETH SUSSMAN & BOB RILEY. *Endgame: Reference & Simulation in Recent Painting & Sculpture.* M.I.T. Press, 1987.

BOIS, YVES-ALAIN. *Painting as Model.* M.I.T. Press, 1990.

BRYSON, NORMAN. *Calligram: Essays in New Art History from France.* Cambridge University Press, 1988.

BRYSON, NORMAN, MICHAEL HOLLY & KEITH MOXEY, editors. *Visual Theory: Method & Interpretation in Art History & the Visual Arts.* HarperCollins, Publishers, 1991.

BURGIN, VICTOR. *The End of Art Theory: Criticism and Postmodernity.* Humanities Press International, Inc., 1986.

BURNHAM, JACK. *Great Western Salt Works.* Braziller, 1971.

BURNHAM, JACK. *The Structure of Art.* Braziller, 1971.

CARRIER, DAVID. *Artwriting.* University of Massachusetts Press, 1987.

COLPITT, FRANCES, CHRISTOPHER KNIGHT, PETER PLAGENS & ROBERT SMITH. *Changing Trends: Content & Style.* Fellows of Contemporary Art, 1982.

CRANE, DIANA. *The Transformation of the Avant-garde: The New York Art World, 1940–85.* University of Chicago Press, 1989.

DANTO, ARTHUR. *The Transformation of the Commonplace.* Harvard University Press, 1981.

DELEUZE, GILLES. *Cinema I: The Movement-Image*. University of Minnesota Press, 1986.

DELEUZE, GILLES. *Cinema II: The Time-Image*. Hugh Tomlinson & Barbara Habberjam, translators. University of Minnesota Press, 1986.

DERRIDA, JACQUES. *The Margins of Philosophy*. Alan Bass, translator. University of Chicago Press, 1984.

DERRIDA, JACQUES. *The Truth in Painting*. Geoffrey Bennington & Ian McLeod, translators. University of Chicago Press, 1987.

DOLAN, JILL. *The Feminist Spectator as Critic*. University of Michigan Press, 1991.

ECO, UMBERTO. *The Open Work*. Anna Cancogni, translator. Harvard University Press, 1989.

FEHER, MICHEL, editor. *Fragments for a History of the Human Body, Parts I–III*. Zone Books, 1989.

FOCILLON, HENRI. *The Life of Forms in Art*. Charles B. Hogan, translator. Zone Books, 1989.

FOSTER, HAL. *Recodings: Art, Spectacle, Cultural Politics*. Bay Press, 1985.

FRASCINA, FRANCIS, and CHARLES HARRISON, editors. *Modern Art & Modernism*. Harper & Row, 1983.

GABLIK, SUZI. *Has Modernism Failed?* Thames & Hudson, 1985.

GABLIK, SUZI. *Progress in Art*. Rizzoli, 1977.

GABLIK, SUZI. *The Reenchantment of Art*. Thames & Hudson, 1991.

GILBERT-ROLFE, JEREMY. *Immanence & Contradiction: Essays on the Artistic Device*. Out of London Press, Inc., 1985.

GOLDBERG, ROSELEE. *Performance Art: From Futurism to the Present*. Harry Abrams, Inc., 1988.

GOLDSTEIN, ANNE, MARY J. JACOB, ANNE RORIMER, & HOWARD SINGERMAN. *A Forest of Signs: Art in the Crisis of Representation*. M.I.T. Press, 1989.

GREENBERG, CLEMENT. *Art and Culture: Critical Essays*. Beacon Press, 1961.

HALL, DOUG. *Illuminating Video: An Essential Guide to Video Art*. Los Angeles Contemporary Exhibitions, 1990.

HASSAN, IHAB. *Paracriticisms*. University of Illinois, 1975.

HERTZ, RICHARD & NORMAN KLEIN. *Twentieth Century Art Theory*. Prentice Hall, 1990.

HOLT, NANCY, editor. *The Writings of Robert Smithson*. New York University Press, 1975.

HOPPS, WALTER. *Warhol Shadows*. Menil Foundation, 1987.

HUGHES, ROBERT. *The Shock of the New*. Knopf, 1981.

JOACHIMIDES, CHRISTOS M. *Metropolis: International Art Exhibition*. Rizzoli International Publications, Inc., 1991.

JOHNSON, ELLEN H. *American Artists on Art*. Harper & Row, 1982.

JOHNSON, ELLEN H. *Modern Art and the Object*. Harper & Row, 1976.

JONES, AMELIA. *The Politics of Difference: Artists Explore Issues of Identity*. University of California, Riverside Art Gallery, 1992.

KIRBY, MICHAEL. *Happenings*. Dutton, 1965.

KLEIN, NORMAN, editor. *Culture, Curers & Contagion*. Chandler & Sharp Publishers, Inc., 1979.

KRAUSS, ROSALIND. *Passages in Modern Sculpture*. Viking, 1977.

KUSPIT, DONALD. *Dialectic of Decadence*. Stux Press, 1992.

KUSPIT, DONALD. *The Critic is Artist: The Intentionality of Art*. U.M.I. Research Press, 1988.

KUSPIT, DONALD. *The New Subjectivism: Art in the 1980's*. U.M.I. Research Press, 1989.

LEVIN, KIM. *Beyond Modernism: Essays on Art from the 70's and 80's.* HarperCollins Publishers, Inc., 1989.

LEVIN, KIM. *Beyond Walls & Wars: Politics & Multiculturalism.* Midmarch Arts/ Women Artists News, 1992.

LIPPARD, LUCY. *Changing: Essays in Art Criticism.* Dutton, 1971.

LIPPARD, LUCY. *From the Center.* Dutton, 1976.

LIPPARD, LUCY. *Get the Message? Activist Essays on Art and Politics.* Dutton, 1983.

LIPPARD, LUCY. *Overlay: Contemporary Art and the Art of Prehistory.* Pantheon, 1983.

LIPPARD, LUCY. *Six Years: The Dematerialization of the Art Object.* Praeger, 1973.

LOEFFLER, CARL E. & DARLENE TONG, editors. *Performance Anthology: Source Book for a Decade of California Performance Art.* Contemporary Arts Press, 1980.

LOTRINGER, SYLVERE, general editor. *Semiotexte, Volumes 1–5.* 1974–81.

LUCIE-SMITH, EDWARD. *Art in the Seventies.* Cornell University Press, 1980.

MAMIYA, CHRISTIAN J. *Pop Art and Consumer Culture: American Super Market.* University of Texas Press, 1992.

MCFADDEN, SARAH & JOAN SIMON, editors. *Carnegie International.* Carnegie Museum of Art, 1988.

MCGILVERY, LAURENCE, editor. *Artforum, 1962–68: A Cumulative Index to the First Six Volumes.* Laurence McGilvery, 1970.

MEYER, URSULA, editor. *Conceptual Art.* Dutton, 1972.

MICHELSON, ANNETTE, ROSALIND KRAUSS, DOUGLAS CRIMP, & JOAN COPJEC, editors. *October: The First Decade.* M.I.T. Press, 1987.

NOCHLIN, LINDA. *Women, Art & Power.* HarperCollins Publishers, Inc., 1989.

O'DOHERTY, BRIAN. *Inside the White Cube: The Ideology of the Gallery Space.* Lapis Press, 1986.

PAZ, OCTAVIO. *Convergences: Essays on Art & Literature.* Helen Lane, translator. Harcourt, Brace, Jovanovich, Inc., 1987.

PINCUS-WITTEN, ROBERT. *Entries (Maximalism). Art at the Turn of the Decade.* Out of London Press, 1983.

PINCUS-WITTEN, ROBERT. *Postminimalism.* Out of London Press, 1977.

PLAGENS, PETER. *Moonlight Blues: An Artist's Art Criticism.* Books on Demand, 1986.

PLAGENS, PETER. *Sunshine Muse.* Praeger, 1974.

PODESTA, PATTI, editor. *Resolution: A Critique of Video Art.* Los Angeles Contemporary Exhibitions, 1986.

POLITI, GIANCARLO & HELENA KONTOVA, editors. *Flash Art Two Decades of History: XXI Years.* M.I.T. Press, 1990.

PROSYNIOK, JOANN R., editor. *Modern Arts Criticism, Vol. 1.* Gale Research, Inc., 1990.

RATCLIFF, CARTER. *Pressures of the Hand: Expressionist Impulses in Recent American Art.* State University of New York at Potsdam, Roland Gibson Gallery, 1984.

RAVEN, ARLENE, CASSANDRA LANGER & JOANNA FRUEH, editors. *Feminist Art Criticism: An Anthology.* HarperCollins Publishers, Inc., 1989.

RAVEN, ARLENE. *Crossing Over: Feminism and Art of Social Concern.* Tampa Museum of Art, 1989.

ROSE, BARBARA. *American Art Since 1900: A Critical History.* Praeger, 1975.

ROSE, BARBARA. *Autocritique: Essays on Art and Anti-Art, 1963–87.* Grove Weidenfeld, 1988.

ROSENBLUM, ROBERT. *Modern Painting in the Northern Romantic Tradition: Friedrich to Rothko.* Harper & Row, 1975.

ROSKILL, MARK & DAVID CARRIER. *Truth and Falsehood in Visual Images.* University of Massachusetts Press, 1983.

ROTH, MOIRA, editor. *The Amazing Decade: Women and Performance Art in America 1970–1980.* Astro Artz, 1983.

SAYRE, HENRY M. *The Object of Performance: The American Avant-Garde Since 1970.* University of Chicago Press, 1970.

SCHECHNER, RICHARD. *Essays on Performance Theory.* Routledge, 1988.

SCHJELDAHL, PETER. *The Seven Days Art Columns.* The Figures, 1990.

SELZ, PETER. *Art in a Turbulent Era.* U.M.I. Research, 1988.

SMAGULA, HOWARD. *Currents: Contemporary Directions in the Visual Arts.* Prentice-Hall, 1983.

SOLOMON, ALAN. *New York: The New Art Scene.* Holt, Rinehart & Winston, 1967.

SONFIST, ALAN, editor. *Art in the Land.* Dutton, 1983.

SONTAG, SUSAN. *Against Interpretation.* Dutton, 1966.

SULEIMAN, SUSAN R. *Subversive Intent: Gender Politics and The Avant-Garde.* Harvard University Press, 1992.

TOMKINS, CALVIN. *Post to Neo: The Art World of the Nineteen Eighties.* Viking Penguin, 1989.

TOMKINS, CALVIN. *The Scene: Reports on Postmodern Art.* Viking Press, 1976.

TSUZUKI, KYOICHI. *Outsider Art, No. 50.* Books Nippan, 1990.

VALE, V. & A. JUNO, editors. *Re-Search, No. 12: Modern Primitives.* Re/Search Publications, 1987.

WALLIS, BRIAN, editor. *Art After Modernism.* The New Museum of Contemporary Art, New York, 1984.

WALLIS, BRIAN, TOM FINKELPEARL, PATRICIA PHILLIPS, GLEN WEISS, & THOMAS LAWSON, editors. *Modern Dreams: The Rise and Fall and Rise of Pop.* M.I.T. Press, 1988.

WHEELER, DANIEL. *Art Since Mid-Century.* The Vendome Press, 1991.

WHITNEY MUSEUM OF AMERICAN ART STAFF. *Biennial Exhibition, 1991.* W. W. Norton & Company, 1991.

WOLLEN, PETER, GREIL MARCUS, TOM LEVIN, MARK FRANCIS, ELIZABETH SUSSMAN, MIRELLA BANDINI & TROELS ANDERSON. *On the Passage of a Few People Through a Rather Brief Moment in Time: Situationists 1957–1972.* M.I.T. Press, 1989.

WOLLHEIM, RICHARD. *Art and Its Objects.* Cambridge University Press, 1980.

Articles—I: Defining Modern and Postmodern Art

APPLE, JACKI. "Slouching Toward the Next Millennium: Some Meditations on Art and the Year 2000." *High Performance* (June 1989).

BANNARD, WALTER DARBY. "Notes on American Painting of the 60's." *Artforum* (January 1970).

BLISTENE, B. "A Conversation with Jean-Francois Lyotard." *Flash Art* (March 1985).

BORDEN, LIZZIE. "Three Modes of Conceptual Art." *Artforum* (June 1972).

BUCHLOH, BENJAMIN H.D. "Allegorical Procedures: Appropriation and Montage in Contemporary Art." *Artforum* (September 1982)—"Figures of Authority, Ciphers of Regression." *October* (Fall 1982).

BUREN, DANIEL. "Function of the Studio." *October* (Fall 1979).

CARRIER, DAVID. "Baudrillard as Philosopher, or, The End of Abstract Painting." *Arts* (September 1988).

CARRIER, DAVID. "Recent Aesthetics and the Criticism of Art." *Artforum* (October 1979).

CLARK, T.J. "Clement Greenberg's Theory of Art." *Critical Inquiry* (September 1982).

CRIMP, DOUGLAS. "On the Museum's Ruins." *October* (Summer 1980).

CRIMP, DOUGLAS. "The End of Painting." *October* (Spring 1981).

ELDERFIELD, JOHN. "Grids." *Artforum* (May 1972).

FOSTER, HAL. "Between Modernism and the Media." *Art in America* (Summer 1982).

FOSTER, HAL. "The Art of Spectacle." *Art in America* (Summer 1982).

FOSTER, HAL. "The Expressive Fallacy." *Art in America* (Summer 1982).

FRIED, MICHAEL. "Art and Objecthood." *Artforum* (Summer 1967).

FRIED, MICHAEL. "How Modernism Works: A Response to T. J. Clark." *Critical Inquiry* (September 1982).

GABLIK, SUZI. "Art Beyond the Rectangle, a Call for a Useful Art." *New Art Examiner* (December 1989).

GILBERT-ROLFE, JEREMY. "Beyond Absence." *Arts* (October 1988).

GILBERT-ROLFE, JEREMY. "The Politics of Art." *Arts* (September 1986).

GRAHAM, DAN. "Art in Relation to Architecture/Architecture in Relation to Art." *Artforum* (February 1979).

GRAHAM, DAN. "Signs."*Artforum* (April 1981).

GREENBERG, CLEMENT. "Modern and Postmodern." *Arts* (February 1980).

HAFIF, MARCIA. "Getting On With Painting." *Art in America* (April 1981).

HERTZ, RICHARD. "A Critique of Authoritarian Rhetoric." *Real Life Magazine* (Summer 1982).

HOBERMAN, J. "In Defense of Pop Culture: Love, and Death in the American Supermarket Place." *Village Voice Literary Supplement* (November 1982).

HUEBLER, DOUGLAS. "Sabotage or Trophy? Advance or Retreat?" *Artforum* (May 1982).

KAPROW, ALLAN. "Non-Theatrical Performance." *Artforum* (May 1976).

KAPROW, ALLAN. "The Real Experiment." *Artforum* (December 1983).

KRAUSS, ROSALIND. "The Originality of the Avant-Garde: A Postmodernist Repetition." *October* (Fall 1981).

KUSPIT, DONALD. "Art, Criticism and Ideology." *Art in America* (Summer 1981).

KUSPIT, DONALD. "Tired Criticism, Tired 'Radicalism.'" *Art in America* (April 1983).

LARSON, KAY. "Critical Reflections." *Artforum* (October 1990).

LAWSON, THOMAS. "The Uses of Representation." *Flash Art* (March/April 1979).

LAWSON, THOMAS. "Too Good to be True." *Real Life Magazine* (Autumn 1981).

LYOTARD, JEAN-FRANCOIS. "Critical Reflections." *Artforum* (April 1991).

MASHECK, JOSEPH. "Cruciformality." *Artforum* (Summer 1977).

MASHECK, JOSEPH. "Iconicity." *Artforum* (January 1979).

MCEVILLEY, THOMAS. "Heads It's Form, Tails It's Not Content." *Artforum* (Summer 1982).

MELVILLE, STEPHEN. "Notes on the Reemergence of Allegory, the Forgetting of Modernism, and the Conditions of Publicity in Art and Criticism." *October* (Spring 1980).

MORRIS, ROBERT. "Notes on Art As/And Land Reclamation." *October* (Spring 1980).

NASH, MICHAEL. "Video Projections." *Artweek* (December 1989).

NEHER, ROSS. "Bathysiderodromophobia." *The Fox 3* (1976).

OWENS, CRAIG. "The Allegorical Impulse: Toward a Theory of Postmodernism." Parts I, II. *October* (Spring, Summer 1980).

PARDEE, HEARNE. "Durational Perception." *Arts* (December 1988).

PEPPE, MICHAEL. "Why Performance Art Is So Boring." *High Performance* (Spring/Summer 1982).

RATCLIFF, CARTER. "Art and Resentment." *Art in America* (Summer 1982).

RATCLIFF, CARTER. "Critical Thought, Magical Language." *Art in America* (Summer 1980).

RATCLIFF, CARTER. "The Short Life of the Sincere Stroke." *Art in America* (January 1983).

ROSE, BARBARA. "A New Aesthetic," catalogue essay. *A New Aesthetic* (Gallery of Modern Art, Washington, 1967).

ROSE, BARBARA. "Abstract Illusionism." *Artforum* (October 1967).

ROSENTHAL, MARK. "From Primary Structures to Primary Imagery." *Arts* (October 1978).

ROSLER, MARTHA. "For an Art Against the Mythology of Everyday Life." *Journal of the Los Angeles Institute of Contemporary Art* (June/July 1979).

ROTH, MOIRA. "Visions and Re-Visions." *Artforum* (November 1980).

SALLE, DAVID. "New Image Painting." *Flash Art* (March/April 1979).

SCHJELDAHL, PETER. "Falling in Style." *Vanity Fair* (March 1983).

SINGERMAN, HOWARD. "Paragraphs Towards an Essay Entitled 'Restoration Comedies'." *Journal of the Los Angeles Institute of Contemporary Art* (Summer 1982).

STARENKO, MICHAEL. "What's an Artist to Do? A Short History of Postmodernism and Photography." *Afterimage* (January 1983).

TILLIM, SIDNEY. "The Function of Art as a Form of Value." *Artforum* (May 1983).

TUCKER, MARCIA. "'Bad' Painting," catalogue essay. *"Bad" Painting* (The New Museum, 1978).

Articles—II: Artists and Artworks

ALLOWAY, LAWRENCE. "The Revival of Realist Criticism." *Art in America* (September 1981).

BOIS, YVES ALAIN. "Ryman's Tact." *October* (Winter 1981).

BOURDON, DAVID. "A Heap of Words About Ed Ruscha." *Art International* (November 1971).

BOURDON, DAVID. "A Redefinition of Sculpture," catalogue essay. *Carl Andre Sculpture 1959–1977* (Laguna Gloria Art Museum, Austin, Texas, 1978).

BROOKS, ROSETTA. "Violence and the Sacred." *Artforum* (January 1991).

BURNHAM, JACK. "Alice's Head: Reflections on Conceptual Art." *Artforum* (February 1970).

BUTTERFIELD, JAN. "Interview With Wayne Thiebaud." *Arts* (October 1977).

CASTLE, TED. "Jene Highstein: A Full Roundness." *Artforum* (November 1979).

CASTLE, TED. "Suzanne Harris: The Energy of Time." *Artforum* (Summer 1980).

COLLINS, JAMES. "Painting, Hybrids and Romanticism: John Baldessari." *Artforum* (October 1974).

CRAVEN, RICHARD. "Richard Serra and the Phenomenology of Perception." *Arts* (March 1986).

CRIMP, DOUGLAS. "Richard Serra: Sculpture Exceeded." *October* (Fall 1981).

DECTER, JOSHUA. "The Greenberg Effect: Comments by Younger Artists, Critics and Curators." *Arts* (December 1989).

DELAHOYD, MARY. "Seven Alternative Spaces: A Chronicle, 1969–1975," catalogue essay. *Alternatives in Retrospect* (The New Museum, 1981).

DROHOJOWSKA, HUNTER. "Alexis Smith R Tist." *Artforum* (October 1987).

FERNANDES, JOYCE. "Exposing a Phallocentric Discourse: Images of Women in the Art of David Salle." *New Art Examiner* (November 1986).

GABLIK, SUZI. "The Graffiti Question." *Art in America* (October 1982).

GABRIELSON, WALTER. "Narrative/Humanist Painting in Los Angeles in the Seventies," catalogue essay. *Decade* (Art Center College of Design, 1981).

GARDNER, COLIN. "A Systematic Bewildering: The Art of John Baldessari." *Artforum* (December 1989).

GARDNER, COLIN. "Brave New World." *Artforum* (February 1991).

GARDNER, COLIN. "The Space Between the Words: Lawrence Weiner." *Artforum* (November 1990).

GELDZAHLER, HENRY. "Hockney Abroad: A Slide Show." *Art in America* (February 1981).

GILBERT-ROLFE, JEREMY. "Abstract Painting and the Historical Object: Considerations on New Paintings by James Hayward." *Arts* (April 1987).

GILBERT-ROLFE, JEREMY. "Appreciating Ryman." *Arts* (December 1975).

HAFIF, MARCIA. "True Colors." *Art in America* (June 1989).

HICKEY, DAVE. "Available Light," catalogue essay. *The Works of Edward Ruscha* (San Francisco Museum of Modern Art, 1982).

HORVITZ, ROBERT. "Chris Burden." *Artforum* (May 1976).

KAPROW, ALLAN. "Roy Lichtenstein," catalogue essay. *Roy Lichtenstein at Cal Arts* (California Institute of the Arts, 1977).

KONTOVA, HELENA. "From Performance to Painting." *Flash Art* (March 1982).

KOZLOFF, MAX. "The Poetics of Softness," catalogue essay. *American Sculpture of the Sixties* (Los Angeles County Museum, 1967).

LARSON, KAY. "For the First Time Women Are Leading Not Following." *Art News* (October 1980).

LEIDER, PHILIP. "Stella Since 1970," catalogue essay. *Stella Since 1970* (The Fort Worth Art Museum, 1978).

LEVIN, KIM. "The Agony and the Anomie." *Arts* (April 1986).

LEWIS, JAMES. "Beyond Redemption: Mike Kelly." *Artforum* (Summer 1991).

LINKER, KATE. "Melodramatic Tactics." *Artforum* (September 1982).

LIPPARD, LUCY. "The Structures, The Structures and the Wall Drawings, The Structures and the Wall Drawings and the Books," catalogue essay. *Sol LeWitt* (Museum of Modern Art, 1978).

LOEFFLER, CARL. "Popularizing the Populist or Performing Popularistic Populism." *Art Com* (Number 20, 1983).

LYOTARD, JEAN-FRANCOIS. "The Works and Writings of Daniel Buren." *Artforum* (February 1981).

MAGNANI, GREGORIO. "Gerhardt Richter Interview." *Flash Art* (May/June 1989).

MAKSYMOWICZ, VIRGINIA. "Dangerous Transgressions." *Women Artists News* (Spring/ Summer 1990).

MARKS, LAURA U. "Reinscribing the Self." *Afterimage* (December 1989).

MCEVILLEY, THOMAS. "James Lee Byars and the Atmosphere of Question." *Artforum* (Summer 1981).

MELVILLE, STEPHEN V. "The Time of Exposure: Allegorical Self-Portraiture in Cindy Sherman." *Arts* (January 1986).

MELVILLE, STEPHEN. "How Should Acconci Count For Us?" *October* (Fall 1981).

NEMSER, CINDY. "Subject-Object: Body Art." *Arts* (September/October 1971).

NODELMAN, SHELDON. "Sixties Painting and Sculpture." *Perspecta 11 Yale Architectural Journal* (1976).

OTTMAN, KLAUS. "The Solid and the Fluid: Bartlett, Laib, Kiefer." *Flash Art* (Summer 1985).

OWENS, CRAIG. "Amplifications: Laurie Anderson." *Art in America* (March 1981).

OWENS, CRAIG. "Back to the Studio." *Art in America* (January 1981).

OWENS, CRAIG. "Phantasmagoria of the Media." *Art in America* (May 1981).

OWENS, CRAIG. "Telling Stories." *Art in America* (May 1982).

PERRONE, JEFF. "Jan Groover: Degrees of Transparency." *Artforum* (January 1979).

PINCUS-WITTEN, ROBERT. "Blasted Allegories: The Photographs of John Baldessari," catalogue essay. *John Baldessari: Art as Riddle* (University Art Galleries, Wright State University, 1982).

PINCUS-WITTEN, ROBERT. "Entries: Annette Lemieux." *Arts* (September 1988).

PINCUS-WITTEN, ROBERT. "Entries: Nice Again." *Arts* (December 1988).

PLAGENS, PETER. "Present Day Styles and Ready Made Art." *Artforum* (December 1966).

RATCLIFF, CARTER. "Dramatis Personae: Dim Views, Dire Warnings, Art-World Cassandras." *Art in America* (September 1985).

RATCLIFF, CARTER. "Mostly Monochrome." *Art in America* (April 1981).

RATCLIFF, CARTER. "The Work of Roy Lichtenstein in the Age of Walter Benjamin's and Jean Baudrillard's Popularity." *Art in America* (February 1989).

RICARD, RENE. "Not About Julian Schnabel." *Artforum* (November 1981).

RICKEY, CARRIE. "Decoration, Ornament, Pattern and Utility." *Flash Art* (June/July 1979).

RICKEY, CARRIE. "Naive Nouveau." *Flash Art* (Summer 1980).

ROBBINS, D. A. "The 'Meaning' of 'New'—The 70s/80s Axis: An Interview With Diego Cortez." *Arts* (January 1983).

RORIMER, ANNE. "Michael Asher: Recent Work." *Artforum* (April 1980).

ROSENBERG, HAROLD. "Twenty Years of Jasper Johns." *The New Yorker* (December 26, 1977).

ROTH, MOIRA. "Towards a History of California Performance." Parts I, II. *Arts* (February, June 1978).

RURIN, WILLIAM S. "Frank Stella," catalogue essay. *Frank Stella* (Museum of Modern Art, 1970).

SCHJELDAHL, PETER. "David Salle: Interview." *Journal of the Los Angeles Institute of Contemporary Art* (January 1979).

SCHJELDAHL, PETER. "The Ardor of Ambition." *Village Voice* (February 23, 1982).

SCHOR, MIRA. "Girls Will Be Girls." *Artforum* (September 1990).

SCHOR, MIRA. "Patrilineage." *Art Journal* (Summer 1991).

SIEGEL, JEANNE. "After Sherrie Levine." *Arts* (June 1985).

SIEGEL, JEANNE. "The Artist/Critic of the '80's: Peter Halley and Stephen Westfall." *Arts* (September 1985).

SMITH, BARBARA. "Paul McCarthy." *Journal of the Los Angeles Institute of Contemporary Art* (January 1979).

SOLOMON, ALAN. "New York: The Second Breakthrough 1959–64," catalogue essay. *New York: The Second Breakthrough 1959–64* (University of California, Irvine, 1969).

SONTAG, SUSAN. "Fragments of an Esthetic of Melancholy." *Art in America* (September 1986).

SPECTOR, BUZZ. "Under Midwestern Eyes." *Artforum* (October 1986).

STIMSON, PAUL. "Fictive Escapades: Douglas Huebler." *Art in America* (February 1982).

STUCKEY, CHARLES. "Andy Warhol's Painted Faces." *Art in America* (May 1980).

TUCKER, MARCIA. "An Iconography of Recent Figurative Painting." *Artforum* (Summer 1982).

VAN BRUGGEN, COOSJE. "The Realistic Imagination and the Imaginary Reality of Claes Oldenburg," catalogue essay. *Claes Oldenburg: Drawings, Watercolors and Prints* (Moderna Museet, 1977).

WALLACE, JOAN, and GERALYN DONOHUE. "Edit deAk: An Interview." *Real Life Magazine* (Spring/Summer 1982).

WESTFALL, STEPHEN. "Anything, Anytime, Anywhere: Arte Povera at P.S.I." *Art in America* (May 1986).

WORTZ, MELINDA. "Surrendering to Presence: Robert Irwin's Esthetic Integration." *Artforum* (November 1981).

Index